THE BIG BOOK OF PAINTING PAINTING BOOK OF PAINTING BOOK O

PAINTINGS BY FERDINAND PETRIE PHOTOGRAPHS BY JOHN SHAW

WITHDRAWN BECAUSE:

Bad Condition

Out-of-Date
Low Demand

Fauquier County Public Library

FAUQUIER COUNTY PUBLICATIONS/NEW YORK

11 Winchester Street Warrenton, VA 20186

Artwork on pages 10-33 by Graham A. Scholes

Copyright © 1990 by Watson-Guptill Publications

First published in 1990 in the United States by Watson-Guptill Publications, a division of Billboard Publications, Inc., 1515 Broadway, New York, N.Y. 10036

Library of Congress Cataloging-in-Publication Data

Petrie, Ferdinand, 1925-

The big book of painting nature in watercolor / paintings by Ferdinand Petrie: photographs by John Shaw.

ISBN 0-8230-0499-6

1. Watercolor painting—Technique. 2. Landscape painting—

I. Shaw, John, 1944- . Technique.

ND2240.P48 1990

751.42'2436—dc20

89-48707

CIP

All rights reserved. No part of this publication may be reproduced or used in any form or by any means—graphic, electronic, or mechanical, including photocopying, recording, taping, or information storage and retrieval systems—without written permission of the publisher.

Manufactured in Singapore

First printing, 1990

3 4 5 6 7 8 9 10 / 94 93 92 91 90

Contents

	Introduction	11
	TREES	
MAPLE	Capturing the Feeling Created by Backlighting	36
MAPLE LEAVES	Rendering Delicate Leaves and Branches with Strong Color	40
MAPLE LEAVES	Working with Sharp Contrasts of Light, Color, and Focus	43
MAPLE LEAVES	Capturing the Brilliance of Autumn Leaves	46
CONIFERS AND MIXED DECIDUOUS FOREST	Making Sense of Distant Masses of Color	48
BEECH	Achieving a Feeling of Depth Using Light, Cool Colors	52
DECIDUOUS FOREST	Learning How Fog Affects Color and Form	56
DAK LEAVES AND ACORNS	Mastering the Color and Texture of Leaves and Acorns	58
BIRCH	Experimenting with Fog	60
BIRCH BARK	Creating Texture with Line	61
DAK	Working with Closely Related Values	62
ASPEN AND GOLDENROD	Balancing Brilliant Flowers and a Tree-filled Background	66
ASPEN LEAVES	Mastering the Tiny Highlights Created by Dew	70
ASPEN LEAF	Painting a Rain-Spattered Leaf	72
AUTUMN LEAVES	Capturing Complicated Reflections in Water	74
MIXED DECIDUOUS FOREST	Using Monochromatic Greens to Depict Dense Foliage	76
CYPRESS	Recording the Delicate Growth Around the Base of a Tree	78
CYPRESS ROOTS	Painting Green Leaves Against a Rich Green Background	80
SPRUCE SEEDLING	Painting a Sharply Focused Subject Against a Soft Background	82
SPRUCE	Establishing the Values Created by Heavy Fog	83
PINE AND ASPEN	Establishing Distance Using Subtle Colors	86
PINE	Capturing the Feeling of a Snowy, Overcast Day	91
PINE NEEDLES	Using Pure White to Pick Out Patterns	93
PINE NEEDLES	Mastering Complex Geometric Patterns	94

LARCH	Painting a Complicated Scene Set Near Water	96
LARCH NEEDLES	Rendering Intricate Macro Patterns	99
SAGUARO CACTUS	Capturing Light and Shade in Macro Patterns	100
SAGUARO CACTUS	Picking Up Patterns Formed by Middle Values and Highlights	101
WILLOW	Suggesting the Lacy Feeling of Delicate Foliage	104
ASH	Manipulating Color and Structure to Achieve a Bold Effect	108
ASH	Making a Delicate Tree Dominate a Cloud-filled Landscape	111
ELM	Working with Foliage Set Against a Dark Blue Sky	112
ELM	Learning to Work with Strong Blues and Greens	114
BLACK OAK	Learning to Focus in on a Landscape	118
WALNUT LEAVES AND BARK	Working with Contrasting Textures and Colors	122
BLACK WALNUTS	Discovering Color in a Seemingly Monochromatic Subject	124
DOGWOOD AND CONIFER	Contrasting Delicate Lights with Heavy Darks	126
DOGWOOD FLOWERS	Establishing the Texture of Pure White Flowers	130
APPLE BLOSSOMS	Capturing the Structure of Delicate Flowers	132
APPLES	Analyzing the Colors of Familiar Objects	136
ELM	Rendering a Tree Against a Stark Winter Sky	138
ELM	Capturing a Tree at Twilight	140
FERNS AND WHITE CEDAR	Working with Pattern and Texture	142
RED PINE	Painting a Tree Viewed from Below	146
PINE NEEDLES	Looking for Pattern in an Intricate Closeup	149
PRUCE	Balancing Dramatic Clouds and Strong Color	152
	SKIES	
DARK DAYBREAK	Capturing the Stormy Colors of Dawn	158
POND AT DAWN	Learning to Work with Reflected Light	160
DEEP BLUE SKY	Depicting a Monochromatic Sky	164
SWEEPING RAIN CLOUD	Learning How to Distinguish Warm and Cool Blues	165
CIRRUS CLOUDS	Exploring Lively, Distinct Cloud Patterns	168

ALTOCUMULUS CLOUDS	Depicting a Complex Overall Cloud Pattern	170
CLOUD MASSES	Learning to Simplify Dramatic Cloud Formations	172
LIGHT RAYS	Discovering How to Depict Rays of Light	174
EARLY MORNING	Capturing a Strong Silhouette Against an Early Morning Sky	178
STRATUS CLOUDS	Using a Wet-in-Wet Technique to Depict Cloud Masses	182
GRAYSKY	Balancing a Dramatic Cloud Formation and a Plain Gray Sky	184
CLOUD SPIRAL	Using a Clean, Sharp Edge to Hold the Shape of a Cloud	186
RAINBOW	Capturing the Beauty of a Rainbow	189
BILLOWY CLOUDS	Discovering How to Work with Late Afternoon Light	191
STORM CLOUDS	Working with Dense Cloud Masses	194
CUMULUS CLOUDS	Using Opaque Gouache to Render Thick, Heavy Clouds	198
DESERT MOUNTAIN SKY	Learning How to Handle Complex Patterns	202
CLOUD MASSES	Rendering the Shape and Structure of Clouds	204
FLAT CUMULUS CLOUDS	Achieving a Sense of Perspective	206
CLOUDS AT SUNSET	Experimenting with Bold Color	208
CLOUDS AT TWILIGHT	Capturing the Play of Light and Dark at Twilight	210
FILTERED TWILIGHT	Using a Light-to-Dark Approach to Show Subtle Value Shifts	214
SUNSET	Mastering Complex Atmospheric Effects	217
MOON AT SUNSET	Working with Reflected Light	219
DAWN	Painting Around Clouds	222
SUN HALO	Capturing the Feeling of an Icy Winter Sky	226
SOFT WINTER SKY	Learning to Control the Contrast Between Snow and Sky	228
FLAT WINTER SKY	Rendering a Simple Winter Landscape	231
CLOUD-FILLED DAWN	Experimenting with Dark Clouds and Brilliant Light	232
PALE AUTUMN SKY	Laying In a Cloud-Shrouded Sky and a Vivid Foreground	236
SUNSET STORM	Sorting Out Abstract Patterns	238
COLORFUL LIGHT	Using Underpainting to Capture Afternoon Light	240
SUNSET AND REFLECTION	Painting a Sunset over a Lake	244
WINTER SUNRISE	Capturing the Feeling of Fog	246

MIDWINTER SCENE	■ Balancing a Cool Foreground and a Warm, Dramatic Sky	
MOUNTAIN DAWN	Working with Subtle Shifts in Color and Value	
DRAMATIC DAWN	Mastering Strong Contrasts of Lights and Darks	
MOONLIGHT	Staining a Painted Sky with Clear Water to Suggest Clouds	
FULL WINTER MOON	Learning to Paint a Moonlit Scene	
DRANGE SKY	■ Handling the Contrast Created by a Silhouetted Foreground	
AUTUMN SUNSET	Working with Strong yet Subtle Contrasts	
PRAIRIE SUNSET	Capturing the Drama of a Sunset	
COLOR-STREAKED SKY	■ Laying In a Sky Composed of Delicate Slivers of Color and Light	
BRILLIANT RAINSTORM	Evoking the Feeling of a Rain-Filled Afternoon Sky	
APPROACHING STORM	Painting a Dark Sky Set Against a Lush Summer Landscape	
BRIGHT SUMMER SKY	Narrowing In on the Foreground	
	WATER	
	XX/A/MODES	
WATERFALL	Capturing the Power of a Waterfall	
MOUNTAIN LAKE	Working with Strong, Clear Blues	
RIVER	Learning to Handle Closely Related Values	
THIN GLAZE	Painting Delicate Ice	
STILL LAKE	Using Brushstrokes to Separate Sky and Water	
CIRCLES	Rendering Soft, Concentric Ripples	
SUMMER FOG	Conveying How Fog Affects Water	
LATE AFTERNOON LAKE	Controlling the Brilliance of Sunset over Water	
	E-main Air and Air North D. G. Air	
REFLECTED CITY LIGHTS	Experimenting with Neon Reflections	
REFLECTED CITY LIGHTS QUIET STREAM	Animating a Dark, Still Stream	
	•	
QUIET STREAM	Animating a Dark, Still Stream	
QUIET STREAM Leaves on a pond	Animating a Dark, Still StreamPicking Out the Patterns Formed by Floating Vegetation	

FOREST SNOW	Sorting Out a Maze of Snow-Covered Branches	316
FROST-TIP PED GRASSES	Using Opaque Gouache to Render Frost	320
LIGHT FOG	Establishing Mood Through Underpainting	322
REFLECTIONS ON WATER	Painting Water on an Overcast Day	326
CLINGING ICE	Exaggerating the Contrast Between Lights and Darks	330
MIRRORLIKE REFLECTIONS	Depicting Dramatic Reflections Cast on a Lake	332
CROWDED RIVER	Manipulating Color and Light	336
WHITE WATER	Highlighting a Quickly Moving Stream	340
SPARKLING WATER	Exploring Reflections and Light	344
RUSHING STREAM	Painting Rapidly Flowing Water	348
DRIPPING RAIN	Moving In on Detail	352
RAINDROPS CLOSEUP	Learning How to Paint Transparent Drops of Water	354
BRIGHT DROPLETS	Masking Out Highlights	355
COLORS IN A LAKE	Maintaining a Flat, Decorative Look	356
SHIELDED STREAM	Mastering Soft, Unfocused Reflections	358
DRAMATIC WATER	Rendering Bold, Brilliant Reflections	360
WATER JETS	Using Diluted Gouache to Depict Translucent Water	364
WATER WALL	Working with Soft, Diffuse Patterns	368
FOGGY STREAM	Controlling Color and Value	369
ROCKY SHORELINE	Handling Transparent Water and Reflections Simultaneously	372
TRANSPARENT WATER	Depicting the Abstract Beauty of Water in Motion	376
GLITTERING WATER	Pulling Out Highlights with a Razor	378
HEAVY SURF	Separating Sky from Water	380
CRASHING WAVES	Emphasizing a Light-Streaked Wave	384
DCEAN SPRAYS	Capturing Soft, Glistening Spray	388
GENTLE WAVES	Deciphering the Subtle Colors Found in Waves	390
WHITE ON WHITE	Painting a White Bird Set Against Light Water and Waves	392
SANDY RIPPLES	Relying on Values to Capture an Abstract Pattern	394
	Index	396

Introduction

Watercolor is the most exhilarating painting medium—nothing else is as immediate, as fresh, or as versatile. It's practical as well. It doesn't cost a fortune to paint with watercolors, there's no bulky equipment to tote about, no messy cleanup is required, and you don't have to devote days to one picture (unless you want to). The colors available are dazzling, brilliant because their transparency allows the clean white watercolor paper to shine through. You'll work with shimmering blues and greens, deep jewel-like reds and purples, glorious golds and yellows, and rich, resonant earth tones.

Watercolor is endlessly challenging, too, even though it seems simple at first. The liquid paint can easily run out of control, going just where you don't want it to go. Colors mixed together spontaneously can quickly turn to mud instead of the lovely bluish-green you had in mind. And if you don't plan your strategy before you start and then work quickly, you may find that the wash you "just" laid in is dry when you are ready to drop in another color.

HOW THIS BOOK IS ORGANIZED

This book brings you all the know-how you need to begin painting nature in watercolor. You'll start with the basics, the essential materials and techniques, then you'll go on to explore special effects that can add sparkle to your works, such as spattering and stippling. Once you have a thorough understanding of watercolor techniques, you can begin any of the 135 lessons that make up this book.

First you will explore ways to depict trees, bushes, flowers, bark, fruit, and even cacti. Next you'll learn to render skies—quiet skies, cloudy skies, and dramatic skies; afternoon light, dawn, twilight, and moonlight. Finally, you will find practical ways to paint all kinds of water in all of water's guises, not

just rivers, lakes, and oceans, but ice, fog, mist, and snow.

Each lesson concentrates on a concrete problem that you are likely to encounter when you paint nature. First the challenges that each situation presents are analyzed, then a working procedure is outlined. You will find that many situations have more than one solution, and you will come to understand how and why decisions are made as you read about how each of the paintings is executed.

The lessons explain all the steps in the painting process, clearly pointing out what is done and how it is accomplished. Many of the lessons have step-by-step demonstrations that make it easy for you to see how the painting evolved.

Supplementary assignments are included throughout the book, either elaborating on a point covered in the lesson or branching out in a new direction. All the lessons are designed to get you involved in painting with watercolor and take you beyond the limits of the illustrated demonstrations.

Feel free to turn to any lesson; they need not be read in order. However, since some of the assignments are based on the lessons, it may be helpful to read the corresponding lesson before you work on an assignment.

THE PHOTOGRAPHS

Unlike many painting instruction books, this volume includes the actual photographs the artist worked from as he executed his paintings. These photographs are an invaluable aid in understanding how to translate the world around you into good paintings. Spend a little time looking at the photograph and at the finished painting before you read the lesson, and you'll start to understand how the artist interpreted what he saw.

These superb photographs can help you discover new subject matter and new ways of composing your paintings. As you study a photograph, note how the photographer composed the scene—the angle he used, the way he framed his subject, the light that he captured, and any unusual effects that he achieved. Then, when you are outdoors, try to apply what you've learned as you search out new ways of seeing the world around you.

If you are just beginning to paint and don't have much experience framing compositions, try using a viewfinder. They are easy to make. Measure the watercolor paper you will be working on, then divide its height and width by 4 (by 5 or 6 if you are working on really big paper). Draw a rectangle in the resulting size on a piece of cardboard. then cut the rectangle out using a hobby knife or scissors. Outdoors, hold the cardboard up and look through it at the landscape, and try to envision all possible views. Don't just look at the subject horizontally: try looking at it vertically, too. Step closer to your subject, then try looking at it from a distance.

Viewfinders make it easy to ignore distracting elements and to find and focus on a subject. They simplify preliminary work, just as studying the beautifully composed photographs in this book will do.

DEVELOPING YOUR OWN STYLE

As you work through the lessons in this book, don't feel you have to copy them. As often as possible, try to think of fresh solutions to the problems posed here. Look at each photograph before you read the lesson. Analyze it, trying to figure out how you would approach the scene if you encountered it outdoors. Then read the lesson critically. If the solution we offer seems more effective than the one vou've thought of, follow it, but if you prefer your own approach, give it a try. There's no one way to paint the landscape.

Materials

Simply put, buy the best brushes, paper, and paint that you can afford. Cheap brushes won't hold a point, they break down quickly, and they are endlessly frustrating to work with. Inferior paper can't stand up to much water. It also absorbs color poorly, rips and shreds easily, and tends to buckle and form depressions. Inexpensive grades of paint contain fillers that streak and make colors look weak and dull.

When it comes to other supplies, keep them simple. No gadget will make you a great painter, and lots of them will make it harder for you to be your best.

If the initial outlay for brushes, paper, paints, and miscellaneous supplies seems considerable, take heart. Good supplies will last a lot longer than less expensive ones, and they will make painting much, much more pleasurable.

BRUSHES

Good brushes cost a lot—a large round sable can cost hundreds of dollars, more than you might imagine—yet used properly, they can easily last for many, many years. Not a bad investment, considering how well they perform.

The types most often used in watercolor painting are rounds and flats. Round brushes are bullet shaped, with a full body that tapers

Here are the brushes you will need (left to right): a 1-inch flat, a rigger, a very small (size 1) round, a medium (size 6 or 7) round, and a large (size 12 or 14) round. Buy the best you can afford.

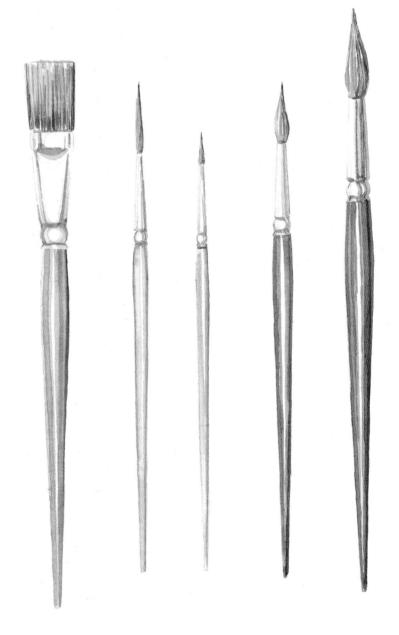

to a point. You will use these brushes constantly. Flat brushes have square-shaped heads. They are great for laying in big washes of color.

Red sables are the best rounds, but they cost a fortune. Happily, many substitutes are available. Choices include brushes made from other animal hairs and from synthetics. Ask your art supplier for recommendations.

If you do decide to buy a sable, have a sales clerk test it first. The brush should be dipped into water, then snapped downward. The body should instantly assume a point. If it doesn't, try another brush.

Buy one large round (size 12 or 14), a medium-size round (size 6 or 7), and, if you like, a very small round (size 1) for details. For other detailed work you can also use a rigger, a brush with a tall, thin head that is perfect for rendering fine lines.

If you are on a budget, don't spend a lot on a flat. Buy an inexpensive 1-inch synthetic brush or even a 2- to 3-inch housepainter's brush. It will work just fine for laying in washes and for moistening paper with clear water.

A delightful variety of effects can be had by experimenting with other types of brushes. Japanese hake brushes are great for rendering drybrush passages. Japanese bamboo brushes are extremely flexible. They can easily cover large areas of paper and their pointed tips are good for fine, detailed work. Bright bristle brushes (standard tools in oil painting) are strong and durable; use them to work color off the paper when things go awry. Try using, too, the other bristle brushes that are usually associated with oil painting. Sable or synthetic fanshaped brushes can lay in soft contours or feathery details.

Master the classics first, then go on and explore other ways of working with watercolor.

Caring for Your Brushes

Use your brushes *only* for watercolor. Rinse them thoroughly after every use, then squeeze all water from the hairs. If a brush won't give up some stubborn pigment, wash the brush with mild soap, then rinse it. Shape round brushes to a point, the flats flat, then let them dry. Never leave brushes standing in water, and always store them "heads" up. When carrying brushes from place to place, roll them carefully in paper towels or a dish towel, or strap them onto heavy cardboard with rubber bands. Or try rolling them inside a slatted bamboo placemat and fastening the mat with a rubber band. The bamboo forms a rigid casing for the brushes.

PAPER

Professional-quality watercolor paper is expensive, but worth every penny. It accepts liquid paint with ease, retains moisture beautifully, and comes in a variety of surfaces that accommodate the full range of effects you may want. Since good paper is expensive, treat it carefully. Store loose sheets out of sunlight and away from dirt in a cabinet or closet. Make sure the storage space is dry, since humidity can cause paper to mildew. The paper should be stored flat to prevent creases and curling.

Some manufacturers place a watermark on their papers. You can tell you are looking at the right side of a sheet when you can read the watermark from left to right. Know, however, that the "wrong" side is often equally suitable for paint. Should a painting get off to a bad start or get muddled along the way, don't throw the paper away. In-

stead, try soaking it and gently removing the paint with a bristle brush. Or just turn the sheet over and use the other side.

Choosing the Right Paper Surface

Three textures are available: rough, cold-pressed, and hot-pressed. Rough paper has the most "tooth." As you run a brush over its surface you can see how the paint adheres to the elevations, leaving the depressions sparkling white. Wonderful effects can be had using this paper, but because of its extreme tooth, mastering it can be difficult.

At the other extreme is hotpressed paper, which has an almost totally smooth surface and its own difficulties. Paint can get out of control, running away from the brush because there aren't any elevations to stop it. Prolonged contact with water is risky; subjected to it, hot-pressed paper easily rips and shreds. It is excellent for careful, painstakingly detailed work. Many contemporary realist artists prefer working with hot-pressed paper.

Cold-pressed is an ideal all-purpose paper. It has a good amount of tooth—enough to suit rapid, spontaneous work—and its surface is sturdy enough to stand up to repeated washes. Its texture allows you to create a lively sparkle, but it's not so rough that it becomes hard to handle. Cold-pressed paper was chosen to illustrate all the lessons in this book.

Choosing the Right Paper Weight

Professional watercolor paper comes in weights ranging from as little as 70 or 90 pounds to as much as 300. The weight is determined by what a ream (500 sheets) of standard-size paper (22 × 30 inches) adds up to. Obviously, thicker, heavier paper is sturdier than thinner, lighter stuff.

The weights most often used by professional artists are 140 and 300 pounds. For most purposes 140-pound paper is ideal, and for quick color sketches you may need only 90-pound paper. When you know you'll be using a lot of water, choose 300-pound stock.

Choosing the Right Paper Size

Standard sheets of watercolor paper measure 22×30 inches. Larger sheets known as double elephants are about 26×40 inches, and are carried by specialized suppliers and many mail-order houses. Both standard sheets and double-elephant sheets can be used whole or cut in half or in quarters, depending on your needs. Ten-yard rolls of paper are also available through mail-order stores and in some large cities. For convenience, artists who work mostly in watercolor usually keep rolls of watercolor paper on hand.

Whenever you cut sheets of watercolor paper, save the odds and ends that remain. You can use them to test colors you have mixed or to get a feeling for how the paper handles. Larger leftovers have their own uses. It can be a refreshing change of pace to work on paper cut to unconventional sizes. Try, for example, painting a landscape on a square sheet or on a long rectangular one.

Watercolor Blocks

Blocks of watercolor paper are great for working outdoors. In a block, individual sheets are bound together on all four sides, which keeps the paper rigid. After you have completed a painting simply cut the sheet away from the block.

Blocks are more expensive than loose sheets, and some painters find they are inhibiting because their thickness can interfere with the free-flowing motion of the arm.

Stretching Paper

Wet watercolor paper tends to buckle, especially light- and medium-weight paper. Most of the time, tacking or taping the dry paper to a drawing board can minimize the problem. If you plan on using a great deal of water, however, tacking and taping may not be enough. Stretching the paper can keep it from buckling. (This is rarely necessary if you are using 300-pound paper.)

Soak the paper in a tub of water for an hour or more (even overnight). Let some of the water run off, then tack, tape, or staple the paper to a drawing board. Once wet, stretched paper shrinks; pulled taut, it becomes a tough, durable, and resilient surface that is perfect for watercolor.

Unless you are intentionally working with damp paper (see "Working Wet-in-Wet" on page 26), allow plenty of time for the paper to dry.

PAINTS

Transparent watercolors are available in pans and in tubes. The pans usually come snapped into metal trays; each pan contains dry paint that readily dissolves when water is added. Pan paints are lightweight, easy to carry, and great for working outdoors.

Tubes are more versatile. They are filled with semi-moist pigment that responds to water much more quickly than the dry paint in pans. Using pigment that comes in tubes, you can rapidly mix together as much color as you need.

Different grades of watercolor are available. Student grades are cheaper than professional grades, but they are no bargain, since the fillers in them dull the color and lessen the brilliance of the paint.

Be a miscr with your paints. Roll the tubes up tightly from the bottom every time you use them. Before you close a tube, wipe its neck off with a damp paper towel. If a lid is hard to remove, don't yank it off. Instead, hold a lit match to the cap for a few seconds until the paint caked on inside softens. When a tube appears to be empty, cut it open with a hobby knife to see if there is any paint left inside.

GOUACHE

Transparent watercolor will be your

primary medium, but sometimes you may also use gouache, opaque watercolor. Its opacity is a blessing, for you can apply gouache over layers of transparent watercolor, even over the darkest hues. This gives you the freedom to add bright light passages to a painting that seems too dark. It is also invaluable for painting small light details at the end that can be almost impossible to paint around.

White gouache has special uses. It can be dropped into a pool of transparent watercolor and then manipulated to achieve a variety of effects. When painting a sky, for example, you can lay in a blue wash, then drop in white gouache, pulling the white pigment around with a brush to suggest the soft feeling of a cloud.

SHOPPING FOR PAINTS

Before you purchase a tube of paint, squeeze it gently between your fingers. If it is hard to the touch, the paint may be old and beginning to dry. Choose, instead, one that feels soft. Never buy tubes that are cracked or leaking.

Before you open a new tube of paint (or one you haven't used for a while), knead it lightly between your fingers to make sure that the pigment is mixed adequately with the other ingredients. If you see an oily substance when you open the tube, put the cap back on and continue to knead the tube for a few more minutes.

CHOOSING A PALETTE

A palette is the work surface onto which you squeeze your paints. You don't need a fancy one—a white dinner plate can do—but it's easier to mix colors on a well-designed palette, and it's easier to keep a good palette clean.

A typical palette has a series of wells into which you squeeze paint. The wells most often surround a flat surface on which you can mix your colors. Some palettes have more than 40 wells; others have just 10 or 12. The number of wells you need obviously depends on the number of paints you use. Some palettes have

lids that snap shut, others don't.

Working with an inexpensive plastic palette (many are available) can be frustrating; some don't stay rigid, others rip, and they all tend to tip over easily. Buy a palette made of lightweight metal covered with enamel, or a sturdy plastic model. If the palette you choose doesn't have a lid, keep your paints moist by covering them with a damp rag or damp paper towels when you have finished painting. If you won't be painting for a few days, don't cover them, since mold can easily form on moist paint.

DRAWING BOARDS AND TABLES

Your work surface can be a piece of hardboard, Masonite, Plexiglas, or plywood, or a professional drawing table. A simple plywood board is the least expensive choice and it works as well as any other. With any drawing board you can freely adjust its angle. Rest one end on a table and elevate the other end with a few books. Make sure you get a board large enough to accommodate standard-size sheets of paper (22×30 inches) with enough room all around for tape.

Professional drawing tables have adjustable surfaces that allow you to regulate the degree of angle. They can be expensive, however, and they are obviously useful only in the studio.

SPONGES, PAPER TOWELS, AND TISSUES

Sponges are handy for moistening paper with water and for cleaning up spills. (You can even sponge color onto the paper to achieve certain effects.) Natural sponges are superior to synthetic ones: they move more lightly over the surface of the paper and don't abrade it the way less expensive synthetic kinds do. Keep paper towels or tissues on hand, too, to blot up mistakes before they get out of hand and to wipe off dirty brushes. Both can also be used to pick up, blot up, or wipe away color as you paint. Since vou will be working with a lot of water, you may want to keep a soft. absorbent terrycloth towel at hand, too.

WATER CONTAINERS

Whether you work indoors or out, you need two water containers. One is for cleaning brushes; the other is for fresh water you can dip clean brushes into as you paint. Get large containers that are easy to carry. A large plastic jug with a handle is great for toting water when you're painting outdoors.

PENCILS, ERASERS, TAPE, AND TACKS

You will need a pencil for preliminary drawings, and a pencil sharpener. (You may prefer a mechanical pencil—it's a matter of taste.) A soft kneaded eraser can pick up mistakes without hurting the paper. For fastening paper to a drawing board, use ½-inch to 1-inch masking tape or tacks, which work best if you will be drenching your paper with water.

Some artists like to lay in their preliminary drawings with a small brush that has been dipped into a neutral tint; others like to use pen and ink. If either of these approaches appeals to you, you will need the appropriate equipment.

RAZOR BLADES

Keep a razor blade or a hobby knife at hand to cut large sheets of paper to size. These tools are useful, too, for scratching highlights out of a painting. Do this carefully—the technique is explained later.

ODDS AND ENDS

Keep matches on hand to open stubborn tubes of paint. An atomizer can quickly moisten paper or wet a palette that's filled with hardened paint. A bar of soap will make cleaning up easier, and a toothbrush is a valuable tool for spattering paint. When planning to work outdoors, don't forget bug repellent, a wide-brimmed hat, and sunglasses. A campstool is a nice extra, too.

STORING AND CARRYING SUPPLIES

Plastic fish-tackle boxes are great for storing watercolor supplies. You can find them in hardware stores, sporting goods shops, and in some art-supply stores. They're lightweight, easy to carry, and cleverly designed to hold a lot of equipment. A typical box has two or more shelves that pull out to reveal compartments that are perfect for storing tubes and pans of paint. Beneath them is a deep storage area, good for brushes, paper towels, sponges, and the like.

SETTING UP YOUR WORK SPACE

You may be lucky enough to have a real studio, a room devoted solely to your painting. Most of us, alas, have to make do with more modest quarters. Whether you work out of a studio or out of a drawer, however, you will find it much easier to paint what you want to paint if you organize all of your equipment in a consistent way.

Keep brushes and water containers on one side of your drawing board (the right side for right-handed artists, the left side for lefties). Your palette should be nearby on the same side, with tubes of paint within easy reach. Sponges, tissues, and the like are easiest to find if they are always in the same place. Even tools that you only use occasionally should never be far away; keep erasers, razors, matches, and tacks stored close to your workplace.

STORING YOUR PAINTINGS

If you have paid top dollar for quality watercolor paper, be sure that you store your finished works away from possible contaminants. Paper is extremely sensitive to temperature and moisture, and high-quality paper can easily stain if it comes in contact with inexpensive paper like newsprint.

If you must stack your finished paintings, place a piece of acid-free paper on top of each one. If possible, store them upright.

To keep paintings from curling, buckling, creasing, or tearing, mount them on acid-free boards, then mat and protect them with acid-free paper.

When you frame your watercolors, make sure to protect them with glass or Plexiglas. Airborne contaminants can rapidly discolor and stain unprotected paintings.

Color

Color is wonderful; each of us sees and responds to it in unique ways. Yet many artists feel overwhelmed by the vast range of hues and color relationships that exist, and by the seemingly infinite possibilities color offers for personal expression. Handling color may seem complicated at first, but once you grasp the basic vocabulary, all you need to do is explore.

UNDERSTANDING COLOR

Red, yellow, and blue are called primary colors—colors that cannot be mixed from any other colors.

Mixing these colors together results in the secondary colors: green (yellow plus blue); violet (blue plus red); and orange (red plus yellow). Tertiary colors result when secondary and primary colors are mixed together, yielding such colors as blue-violet and yellow-green. An easy way to illustrate color relationships is to place the colors on a color wheel.

Colors that lie across from each other on the color wheel are said to be complementary.

True primary colors exist only theoretically. The colors you buy in

tubes and pans aren't "true." Of the many blues available, some tend toward green, others toward violet. And the secondaries and tertiaries have their own color personalities, too. The only way to understand the colors you use is to experiment with them.

COLOR CHARACTERISTICS

Every color has three main characteristics: hue, value, and intensity. *Hue* is the easiest to understand; yellow is a hue, and so is blue, pink, brown, violet, and any other color you can name.

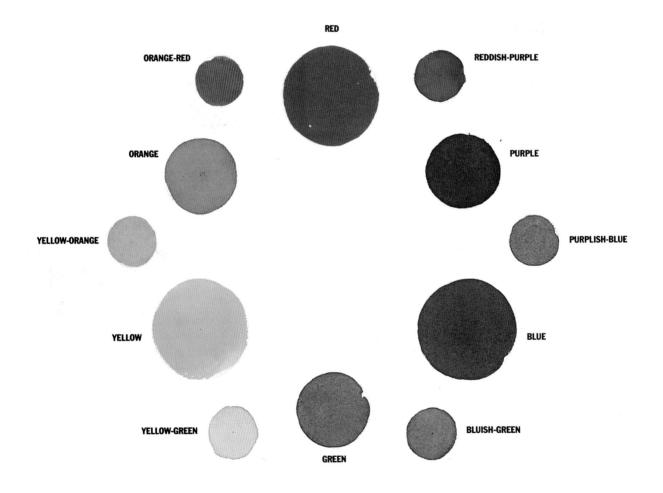

Large circles indicate primary colors. Medium-size circles indicate secondary colors. Small circles indicate tertiary colors.

Value measures how light or dark a hue is. White is high in value; black is low. All colors can be measured the same way. If you have trouble distinguishing how light or

Fauquier County Public Library

Item(s) Checked Out On:

12/20/2022

Patron ID:

4224

TITLE

The big book of painting nature in watercolor / paintings by Ferdinand Petrie; photographs by John Shaw.

BARCODE 1000253035

DATE DUE 01-10-23

COST

\$29.95

Number of items checked out: 1

Total cost to buy these items: \$29.95

Value of your library: Priceless!

Fauquier County Public Library 540-422-8500 fauquierlibrary.org red duller and less intense. Chrome yellow is intense; a little mauve makes the yellow grayer and duller.

TEMPERATURE

Color is often described in terms of "temperature"; some colors are considered warm, others cool. Broadly speaking, red, yellow, and orange are warm colors, and blue, green, and violet are cool. Yet within a hue, temperature varies. Alizarin crimson is a cool red, cadmium red a warm one. If you look at the two hues next to each other, the difference becomes obvious. Al-

izarin crimson tends toward the blue side of the color wheel, cadmium red toward the yellow. Ultramarine is a cool blue, cerulean a warm one. Note that temperature can change in context. Against cool blue and violet, alizarin crimson is warm. Cerulean blue looks cool beside cadmium red.

Temperature is a useful compositional tool, for warm colors tend to advance and cool ones recede. Adding mauve to a distant vista pushes it backward visually. Spattering bright yellow in the foreground of a painting can push that area forward.

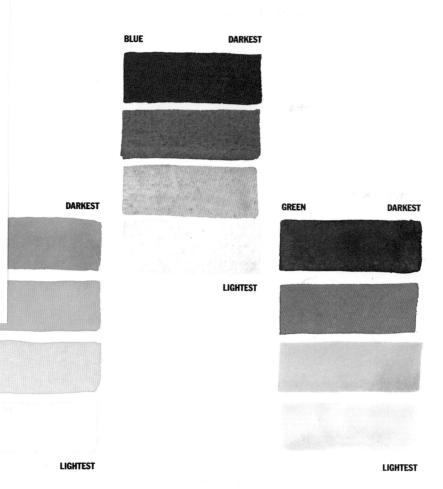

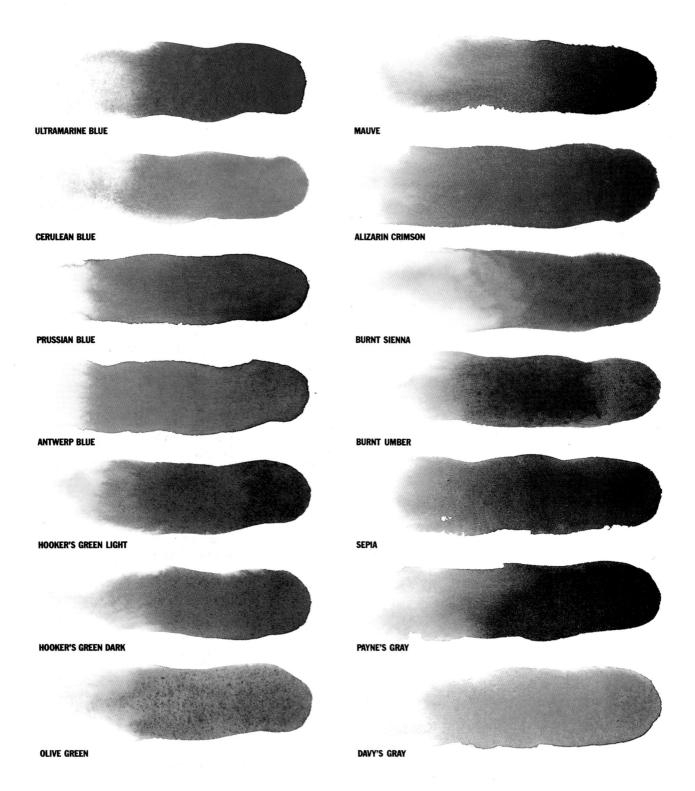

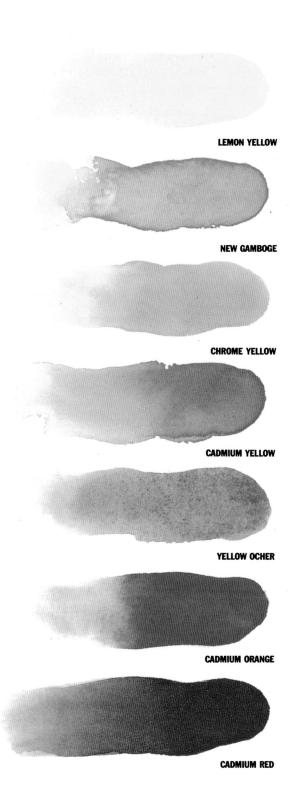

SELECTING YOUR PALETTE COLORS

An incredible range of colors is available to the watercolor artist; anyone could easily choose thirty or more paints. It's simpler, however, and preferred by most professionals, to work with a limited palette, one made up of ten to fifteen colors. By mixing these together, you will discover hundreds, even thousands of hues.

Most of the paintings in this book were completed using less than ten colors; many of them are made up of just five or six. In all 135 lessons, a total of 21 colors appear:

BLUES
Ultramarine blue*
Cerulean blue*
Antwerp blue
Prussian blue

GREENS Hooker's green light Hooker's green dark* Olive green*

YELLOWS
Cadmium yellow*
Chrome yellow
Lemon yellow
New gamboge*
Yellow ocher*
Cadmium orange*

REDS Cadmium red* Alizarin crimson*

VIOLETS Mauve*

EARTH TONES Burnt sienna* Burnt umber Sepia*

GRAYS Davy's gray* Payne's gray*

*Colors marked with an asterisk are those used most frequently.

ORGANIZING YOUR PALETTE

Lay colors onto your palette the same way every time you paint and soon you will be able to reach for the hue you want without even thinking. Figure out what progression works best for you. Some artists start with blue, then move on to green, vellow, orange, red, and purple, finally adding gravs and earth tones. Others like putting all the cool colors on one side and the warm ones on the other. If you like to work with many, many colors, putting those you use most often on one palette may be a good solution; less frequently used ones can be near at hand on a second palette.

EXPLORING YOUR PALETTE

The only way to learn how color works is to systematically practice mixing colors. Record what you do, then refer to your practice sheets later on when you are searching for

- a particular color. To get started, try the following color exercises.
- 1. Paint a swatch of every color on your palette to become acquainted with each one. Label them.
- 2. Paint a long, wide stripe in one color, then let it dry thoroughly. Next, cross it with one short stroke of every other color on your palette. This exercise will show you how each color is affected by others.
- 3. Study shifts in value. Mix a strong wash of one color, paint a color swatch, then add a little more water to the wash. Paint another swatch, then add still more water to the wash. Continue this way until the color almost totally fades away.
- 4. Mix two colors together five or six times, each time varying the amounts. How does a little alizarin crimson affect ultramarine blue? How does a lot affect it?

- 5. Mix complementary colors together in equal parts. Try mauve with cadmium yellow, ultramarine blue with cadmium orange, Hooker's green with alizarin crimson. The results should be grayish or brownish.
- 6. Add just a little of one color to its complementary color. See how just a hint of mauve changes yellow, how ultramarine changes orange, and so on.
- 7. Experiment mixing warm colors together, cool colors together, and warm and cool colors together. Alizarin crimson is a cool red; cadmium red a warm red. Ultramarine is a cool blue; cerulean blue a warm blue. Lemon yellow is cool; cadmium yellow is very warm. Do two warm colors mixed together result in a warm color? How does a warm red mix with a cool blue?

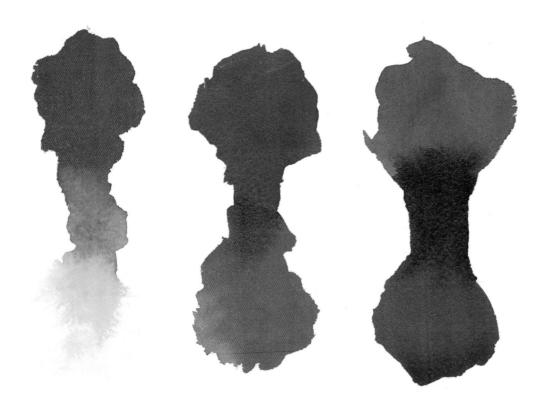

When you mix complementary colors, you get grayish or brownish hues.

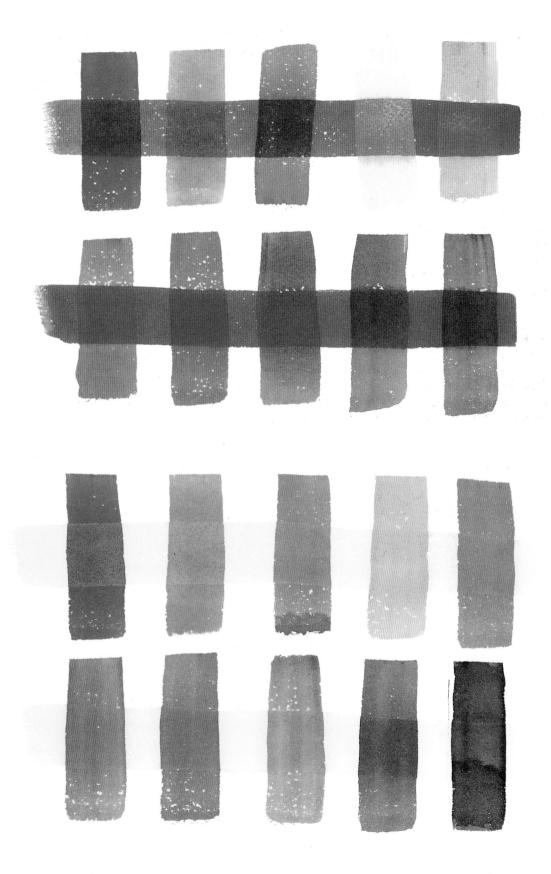

Try this exercise with every color on your palette to see how all the hues interact.

Working with Watercolor

Flat and graded washes are the backbone of watercolor painting. Neither is difficult to master, so practice them over and over again until you can do them instinctively. First, though, learn to hold a brush comfortably.

HOLDING THE BRUSH

For maximum flexibility and spontaneity, hold the brush a few inches away from the ferrule, the metal part of the brush between the handle and the hairs. If your fingers are too close to the ferrule, your wrist will get tight and locked and you won't be able to make any broad, expressive strokes. There will be

times when you will want to move in tightly toward the ferrule—for example, when you are painting tiny details and want total control of the brush.

If you find your arm tensing up as you paint, put the brush down, shake your hand in the air, then rotate your wrist for a minute or two.

FLAT WASHES

The aim of a flat wash is to apply color evenly over part or all of a sheet of paper. Executing a flat wash is simple, but its simplicity can be deceptive, since wet paint does have a mind of its own. As you lay in

a wash, paint can run toward the bottom of the paper before you want it to, or it can settle unevenly on the paper. *The easiest way to* control any wash is to work slowly.

Begin by mixing a pool of color on your palette or in a cup. Load a large flat brush with the wash. Starting at the top of the paper, move your brush across the sheet in undulating horizontal strokes. You should slant the paper slightly away from yourself. After each stroke, wait for the paint to settle, then add an overlapping stroke. When the entire wash has been laid in, pick up any surplus paint that has settled at the bottom.

Using a large flat brush, lay in a broad stroke of color across the top of the paper. Let the paint run toward the bottom of the stroke.

Slowly add an overlapping stroke of paint.

After the last stroke is down, let the paint settle toward the bottom of the paper, then pick up any surplus paint with a brush.

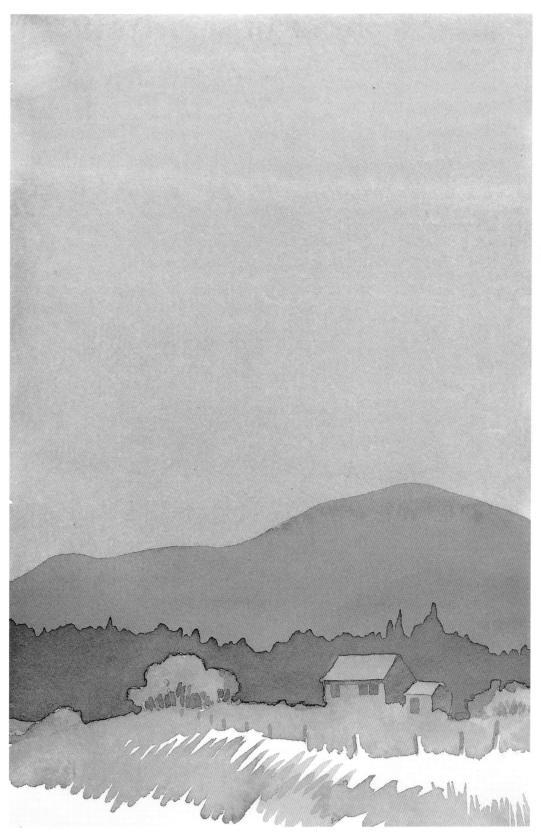

When the wash has dried, proceed with the rest of the painting.

GRADED WASHES

A graded wash is light at one end and dark at the other. Start at the dark end. Lay in one stroke, then add some water to your brush along with the paint. With the next stroke add still more water, and so on. If you want the light end to be really light, finish with a stroke of clear water. Slowly let the remaining color settle into it, then blot up any extra paint.

Instead of moving from dark to light, you can shift from one color to another. Change hues gradually as you move down the paper. When painting a sky, for example, you might start at the top of the paper with a mixture of ultramarine blue and alizarin crimson, then gradually get rid of the alizarin crimson and add cerulean blue. Next, you could decrease the amount of ultramarine and add a little yellow ocher. Just be sure that the transitions between the colors are graceful; add and subtract hues gradually.

Lay in a stroke of color with a large brush.

Add increasing amounts of water to the color as you lay in subsequent strokes.

Finish with a very pale stroke, or with a stroke of water. Let the wash settle to the bottom of the paper, then use a brush to pick up remaining paint.

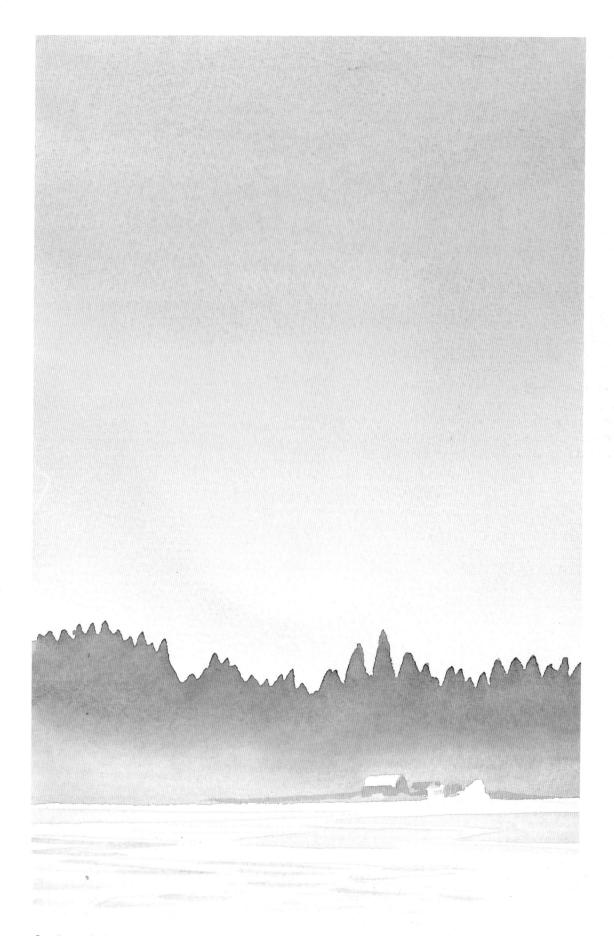

Let the wash dry, then work on the rest of your painting.

WORKING WET-IN-WET

Paint applied to wet paper behaves differently than does paint applied to dry paper. The color blurs softly, creating wonderful, subtle patterns. With practice you can learn to control the patterns by tilting and turning the paper and by pulling the color around with a brush. You will never totally control the paint, however, which is partly why working wet-in-wet is so much fun and so challenging.

You are working wet-in-wet when you drop color into a damp wash. You are also working wet-in-wet when you moisten paper with clear water using either a brush or a sponge before you start to paint. Experiment with both.

You should experiment, too, with soaking paper before you paint. Let the paper stay in the water for several hours—or even overnight—then take it out and let the surface moisture evaporate. The paper should feel slightly damp when you begin to paint. The moisture that remains in the paper's fibers will interact with the paint you apply a little more reliably than you can hope for when only the surface of the paper is wet. You will find, too, that as the paper continues to dry, the paint you apply will leave crisper, more definite edges. In one painting you can easily get several different effects.

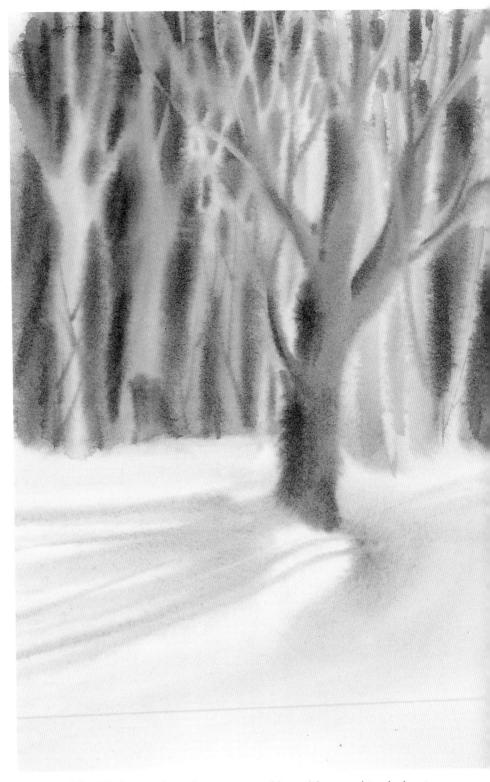

The soft, diffused background seen here was created by applying a variety of colors to moist paper. As each stroke of pigment was applied, it bled into those surrounding it.

The dark, moody sky was created by dropping dark color onto a lighter wash. Holding the paper and tilting it directed the color toward the lower right corner of the picture.

Here, after the sky had been painted, and while the paper was still damp, dark color was dropped into the paint. Holding the paper and tilting it to the lower left created the strong streaks of gray.

THE DRYBRUSH TECHNIQUE

Immensely popular with landscape artists, the drybrush technique is ideally suited to depicting weathered surfaces, scraggly grasses and foliage, the irregular texture of ice, and countless other elements. Because it works so well, drybrush can become something of a cliché; as with any other technique, use it only when appropriate.

It's easy to learn drybrush. First, dip a brush into paint, then wipe some of the color off with a paper towel, or squeeze it out with your fingers. When you pull the "dry"

brush across the uneven surface of the watercolor paper, the paint will adhere to the paper's elevations. leaving the depressions crisp and white. The amount of pressure you apply to the brush determines the look of your brushstrokes. When vou apply very little pressure, a great deal of white will show through the paint; if a great deal of pressure is applied, only small specks of white will flicker through. The amount of paint you load your brush with can also determine how your brushstrokes look: The less paint, the "dryer" the effect.

Here, a 1-inch flat brush moderately loaded with paint has been rapidly pulled across the paper to create the grasses beneath the trees. The strokes all move in one direction; they've obviously been made with a sure hand.

Here, the drybrush technique creates a nice contrast between the rocks and the grasses. The grasses have been painted in drybrush with a flat brush from which some of the color has been squeezed. The rocks are rendered with a moderately loaded round brush, then a flat brush with very little paint has been pulled rapidly over them.

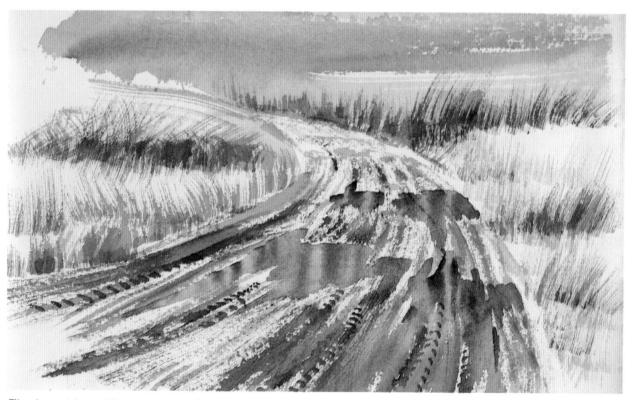

The sky and the puddles are painted with a moderately loaded round brush. The surface of the road and the grasses have been rendered using the drybrush technique. Note the sense of direction that can be achieved; some grasses seem to blow to the left, others to the right, and the furrows in the road sweep back toward the horizon.

CREATING HIGHLIGHTS WITH AN ERASER

You can use a white plastic eraser to pull out highlights after you have finished a painting. Wait until the paper is dry, then apply a little water to the area you want to lighten. Mop up the water with a tissue, then quickly erase the color. In the painting at right, the whites on the pine in the foreground were pulled out with an eraser, and so was the snow on the tree behind the pine.

For a different effect, use a soft eraser on a dry painting without first moistening the paper. You'll find that some colors come up almost completely and others hardly come up at all.

MASKING OUT LIGHTS

At times you will want to keep part of the paper white while you paint over it. For this you will need a resist, either masking tape or liquid frisket. Use masking tape when you want to protect an area that has a clear, precise shape—something like a shed. For less defined areas—a jumble of flowers or highlights that flicker on water, for example—use frisket.

Frisket resembles rubber cement. Paint it on the paper with an inexpensive brush reserved for frisket alone. To remove it, gently rub it off the paper with your fingers or with a tissue.

Here, frisket was brushed onto the paper to block out the shape of the tree at left before any color was applied. Next, a light brown wash was spread across the sky. When it dried, frisket was painted onto the paper to mask out the trees on the right. After the rest of the painting was completed, all the frisket was rubbed off, revealing the bright white tree on the left and the pale brown trees on the right.

STIPPLING

Once you know how to use it, stippling will become a powerful tool. The technique is simple. After moistening a round brush with paint, gently press the tip of the brush against the paper to create small dabs of color. In the painting at right, the dabs range from fairly large passages of yellow to the small touches of green. Vary the pressure you put on the brush to create a variety of strokes.

SQUEEZING OUT COLOR

Lights can be pulled from a wash using the handle of a brush (or anything similar). This works best with fairly dark color and for fairly fine detail, as in the painting below. Lay in the color, then let it start to dry; it's easiest to remove paint when it's not too liquid. Push the brush handle through the color gently, but with a little pressure, forcing the paint away from the paper. *Don't use too much pressure*: Damp paper can easily rip.

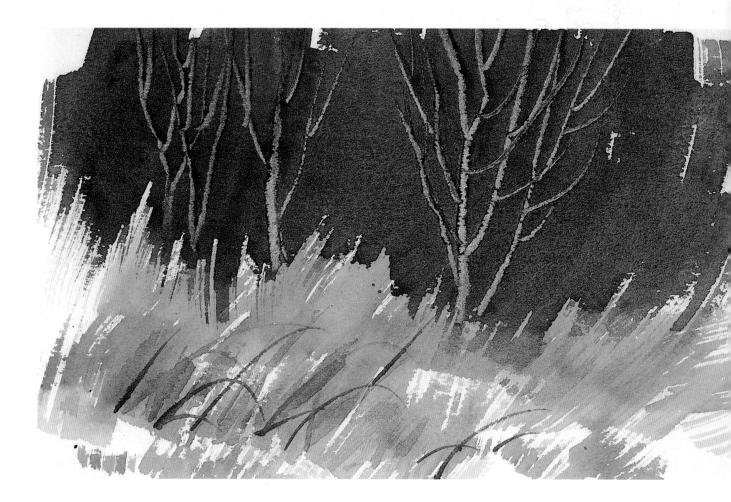

SPATTERING

A favorite technique that's easy to use, spattering can create fascinating surface textures and patterns. Load a brush with paint, shake or squeeze some of it off, then hold the brush close to the paper. Rap the handle sharply with your other hand to spatter paint onto the surface. A little practice will teach you how to direct the flow of paint.

For a finer spray of paint, use a toothbrush. Dip the brush into the paint, hold it close to the paper, then run your thumb along its bristles. Once again, practice will teach you how to control the paint.

In the painting at top right, blue has been spattered onto the paper with a toothbrush, suggesting the salt spray that rises as water pounds against the rocks.

WIPING OUT LIGHTS

Soft white clouds and pale misty skies can be simply and wonderfully rendered by wiping paint away with a damp brush, as shown in the center painting. After you have laid in the sky, let the paint settle for a minute, then take a brush that has been moistened with clear water and wipe the color off the paper.

LIFTING OUT COLOR

When you want to create soft puffy clouds, try lifting color off the paper with a tissue or a paper towel. Paint the sky, let the color settle for a minute, then gently dab the color up with a light touch. Move your fingers in an undulating way to create the soft, uneven shapes you see in the painting at the bottom of this page.

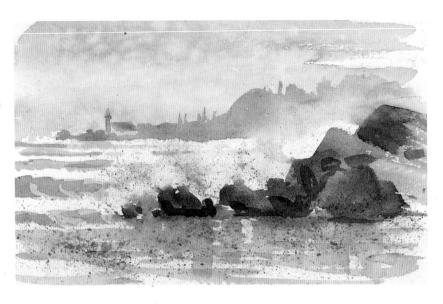

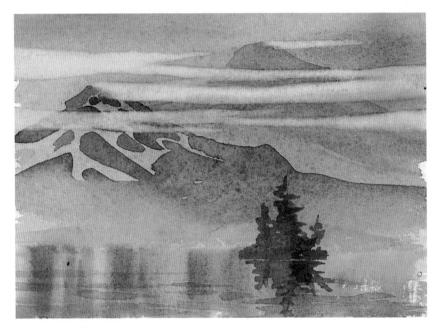

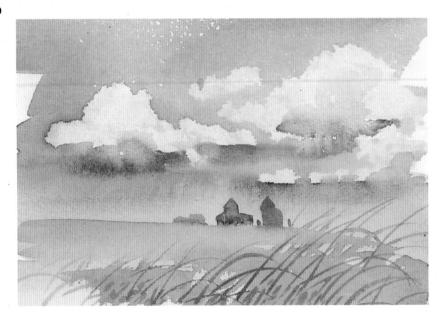

SCRATCHING OUT LIGHTS WITH A RAZOR

A razor blade is a great tool for picking out small shimmering highlights. In the painting at top right, one was used to pull out bright passages from the water's surface. Whites like these could never be masked out, and it would be impossible to paint around them. Instead, lay in the water and *let the paper dry thoroughly*. When it is bone dry, quickly run a razor blade over the paper.

Practice this technique before you use it. If the paper is even slightly moist, you can easily tear it. Finally, if you know you will be scratching out highlights with a razor, paint on heavy, 300-pound paper.

CREATING WHITES WITH GOUACHE

To a purist, adding gouache to a watercolor to pick out bright whites may seem like cheating, but used carefully—and not too often—gouache can be a wonderful tool. Here it would have been difficult (or even impossible) to mask out the small white boats or to paint around them. Their masts are very fine, and so are the reflections in the water. Instead, the artist painted them in gouache after the rest of the painting had been completed.

MAPLE

Capturing the Feeling Created by Backlighting

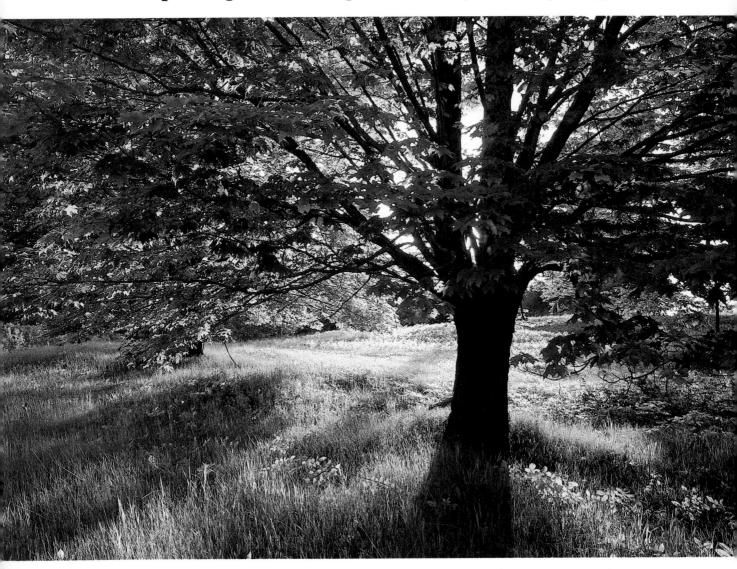

PRORI EM

There's so much going on here—all the patterns of dark and light—that it's hard to simplify the scene enough to let the radiance of the field shine through.

SOLUTION

Since the brilliant yellows and yellowish-greens are so important here, work them out first. Yellow is an easy color to intensify or lighten as you develop the painting.

On a late summer afternoon, this maple is in sharp contrast to the sun-filled meadow behind it.

STEP ONE

In a complicated painting like this, a preliminary sketch is especially important. Establish the horizon and the shape formed by the spreading branches, and suggest the way the foreground seems to rush back to a point on the horizon behind the trunk. Begin simplifying right away: Leave the sky white. All the yellows and greens will warm it up eventually. Finally, lay in all the sunlit spaces with a strong wash of new gamboge.

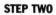

Once the yellow wash has dried, it's time to start building up the greens. Mix new gamboge with ultramarine, then darken it with Payne's gray. By using varying amounts of the three pigments, you can make several harmonizing shades. Begin painting with an intermediate shade, laying down the fairly bright greens, then, using a deeper mixture, develop the moderately dark areas found mostly in the foreground.

STEP THREE

When values matter as much as they do here, put in the darkest values before you've added a lot of gradations to the lighter ones. This way, you can judge how the light and intermediate values change when they're put next to the darkest ones, and then adjust them. The trunk goes down first, then the darkest masses of leaves.

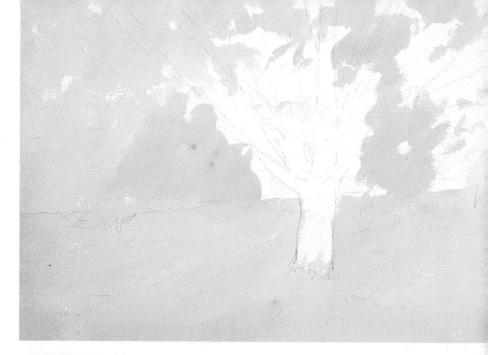

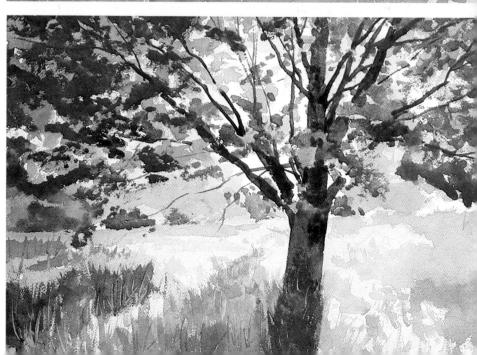

The leaf masses have a lively, irregular quality. To get this look, use a technique known as scumbling. Load your brush with lots of pigment, then drag its side over the paper.

The crisp, clean white paper gives the feel of the light sky, and immediately establishes the lightest value—important when you're working with so much bright yellow and dark green.

ASSIGNMENT

It's easy to find an appealing backlit scene-sit under any shady tree looking through its branches into the sunlight. But before you set up your paper and paints, make sure you've chosen a subject that will help you master the points we've covered here. You'll be learning how to balance extreme contrasts created by deep shadows and dazzling sunshine. Composition isn't an issue, so select a simple tree with a clean silhouette, set against a fairly uncomplicated background. Most important, the tree's crown should be fairly solid, without a lot of sky showing through its leaves and branches.

Start with the sunlit area in the background. Experiment with controlling the strong yellows, then go on and build up your greens. Minimize texture and detail. Most important, don't pay too much attention to the sky; indicate it by leaving the paper white. For now, just concentrate on your yellows and greens.

To get the kind of texture you see in the foreground, use the tip end of your brush, a palette knife, or a razor blade and pull out light areas when the paint is still slightly damp.

MAPLE LEAVES

Rendering Delicate Leaves and Branches with Strong Color

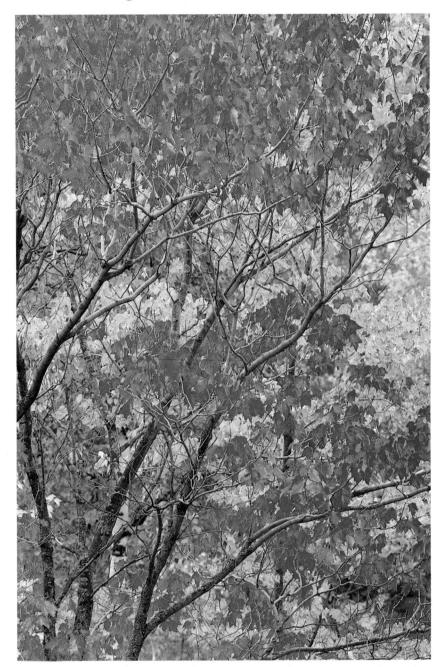

PROBLEM

The colors that dominate this autumn scene are strong, yet the trees themselves are delicate. If color overpowers the structure of the trees, the painting won't work.

SOLUTION

Analyze the masses formed by the three dominant colors and lay them down working from cool to warm tones. Don't make the masses too heavy or you'll lose the scene's delicacy.

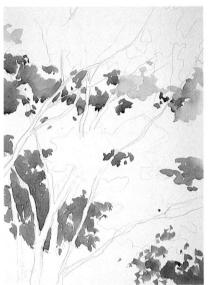

STEP ONE

Keep the drawing simple, concentrating on the way the branches grow and the overall areas of color. Begin with the coolest color, green. It's going to tend to recede into the background when the yellows and reds are added, so put it down first. This will make it much easier to evaluate how each subsequent color affects it.

The intense red leaves of a maple in autumn dominate this vibrant, colorful tangle of branches and leaves.

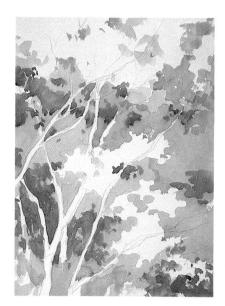

STEP TWO

After the greens are dry, begin building up the yellows. Don't just look for the obvious yellow areas; analyze how yellow permeates the entire scene. As you work, don't be afraid to put the yellow down right over the green. This freedom will keep your brushstrokes looser, and it will also add warmth to the cool green passages that you cover.

STEP THREE

Even though the red leaves in the photograph have so much texture, concentrate on flat color first. Work with a shade a little lighter than you think you'll need—it can be easy to underestimate the power of red. Before you begin texturing the leaves, put down the trunk and major branches of the tree.

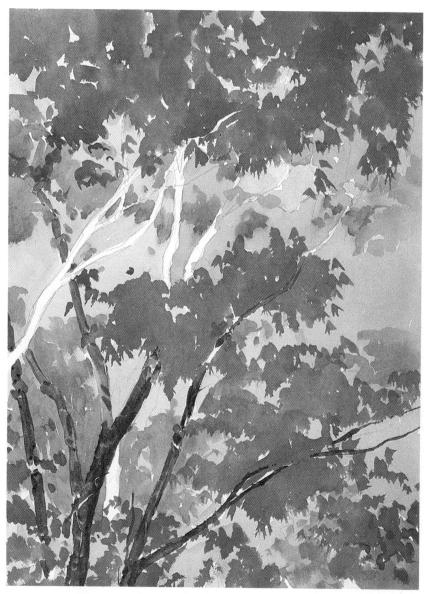

FINISHED PAINTING (overleaf)

When you evaluate a painting like this in its final stages, you can see how many shades of red may be necessary to suggest the delicate texture of the leaves. As you build up texture, work from light to dark. Load your brush with paint, then dab it lightly onto the paper. Don't drag it across the paper or lay on the paint too heavily. A light, irregular touch is most effective in getting across the feeling of lots of little leaves. The deepest reds that you finally add give structure to the leaf masses, and suggest the play of light and

dark on their surface. If, in the end, your painting still looks too heavy, examine the way you've treated the trunks and branches. In a tree like the maple shown here, lots of little twigs and branches are obvious in the fall. Even though they're not very prominent in a scene like this, by adding them you can enhance the feeling of how an autumn tree actually looks. To render them, use opaque paint and a drybrush technique, concentrating on those closest to you.

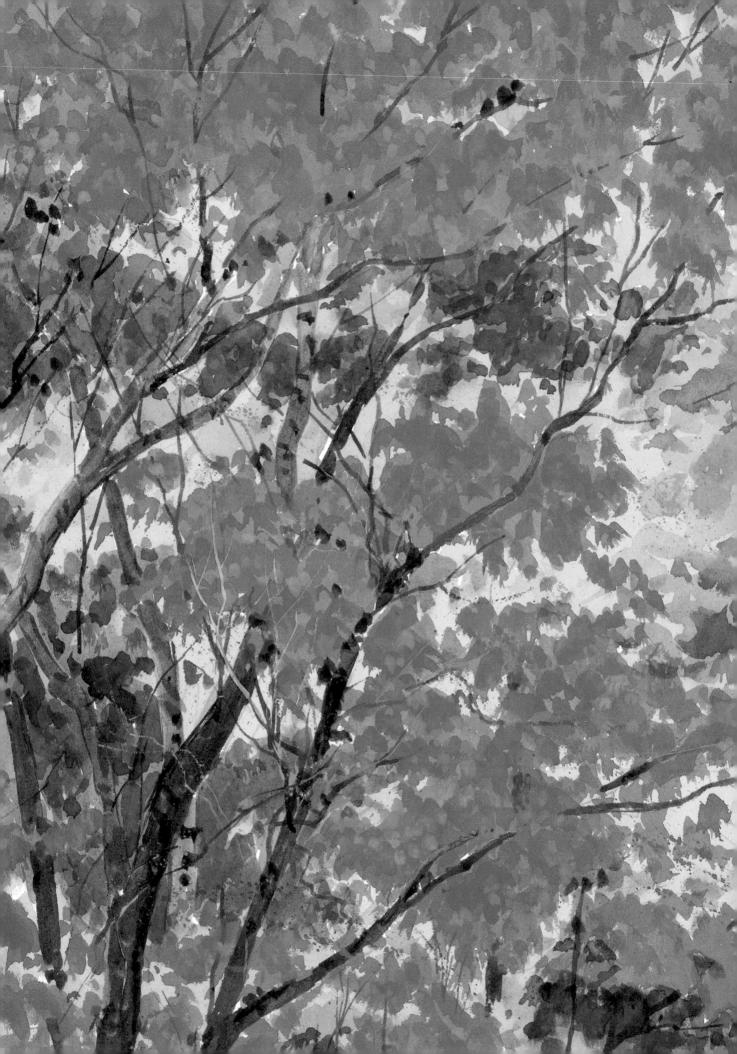

MAPLE LEAVES

Working with Sharp Contrasts of Light, Color, and Focus

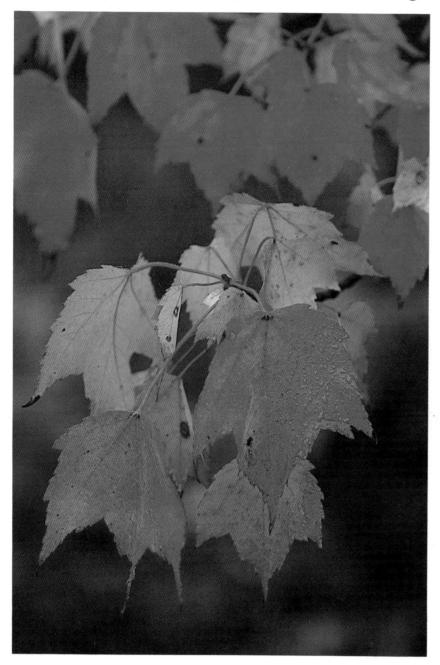

Set against a soft, dark background, these maple leaves are brilliant and sharply defined.

PROBLEM

Here you'll be working with two very different situations. The colorful leaves in the foreground are crisply defined and well illuminated, while the background is soft and dark.

SOLUTION

To keep the background soft, paint it first using a wet-in-wet technique. Choose a strong, heavy paper. Mask out the leaves in the foreground—you'll paint them last.

STEP ONE

You'll want a heavy paper that can stand up to all the moisture you'll be using. The 300-pound sheet used here takes a lot of water and work without buckling. Begin with a detailed drawing of the leaves in the foreground, then mask them out. When you pick up the masking solution later, you'll be able to maintain their hard edges. Wet the background, then begin to lay down the dark foliage. Use a lot of color here to keep the area from becoming dead.

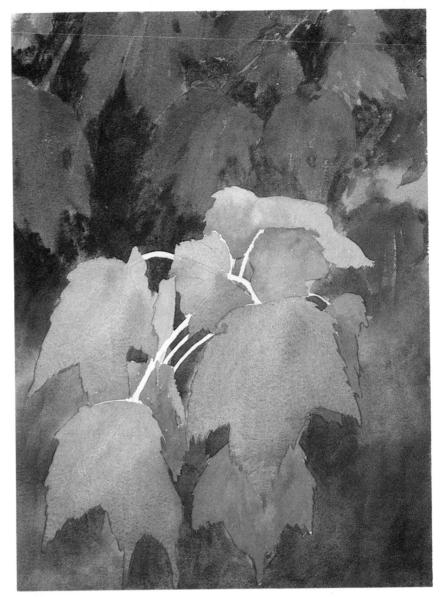

STEP TWO

Continue to develop the background. For very dark areas like those in the lower half of the painting, continue to use a broad palette. Five colors are used here: vellow ocher, sepia, mauve, olive green, and ultramarine. Because the paper's wet, you have freedom to play around, putting color down, then picking it up again with a dry brush or paper towel if it's not working out. As the paint dries, scratch out a little detail with the back of the brush.

STEP THREE

Remove the masking fluid, then paint the leaves in the foreground using graded washes of red, vellow, and orange. You want these leaves to stand out from the darker ones behind them, so work slowly, constantly gauging how the two areas work together. The foreground reds here still seem a little lackluster; they'll have to be intensified.

FINISHED PAINTING

After you've painted the leaf stems, stop and evaluate how well the painting works. Here, to brighten the leaves in the foreground, deeper concentrations of vellow and orange were put down.

But when you change one value, you change them all. Adiusting the foreground threw the background out of kilter; suddenly it seemed far too light, and the foreground too dark. A dark wash of Hooker's green, burnt sienna, and ultramarine was put down over most of the painting (but not the brightest foreground leaves), pushing the dark areas back and pulling the maple leaves out toward the front of the painting.

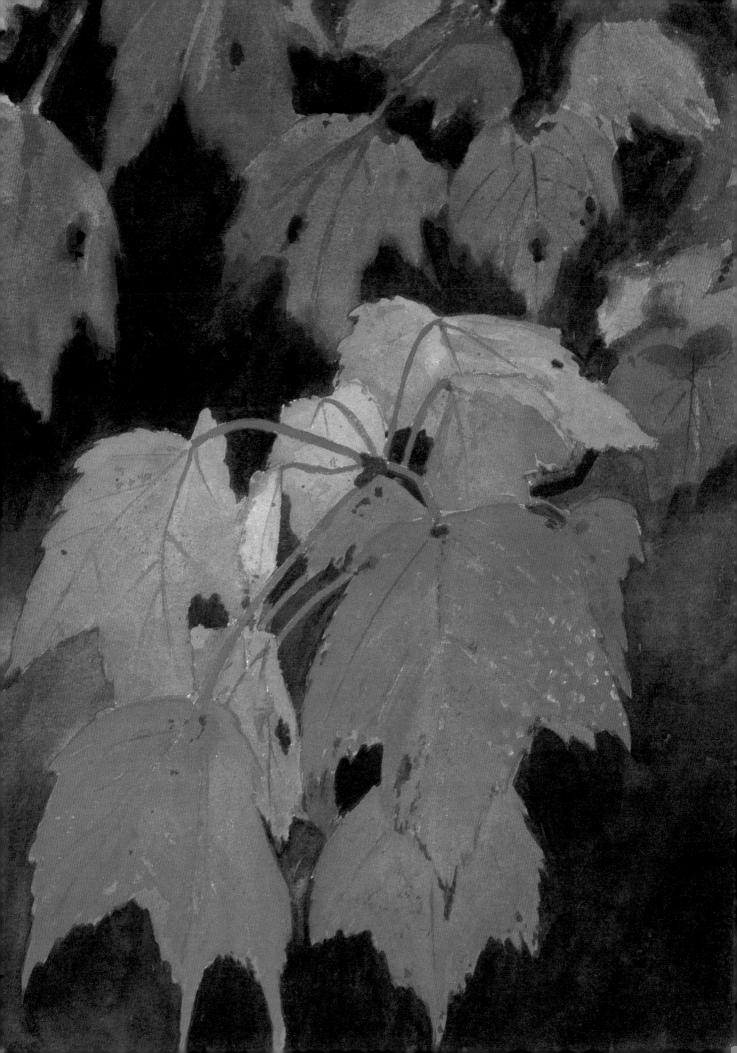

MAPLE LEAVES

Capturing the Brilliance of Autumn Leaves

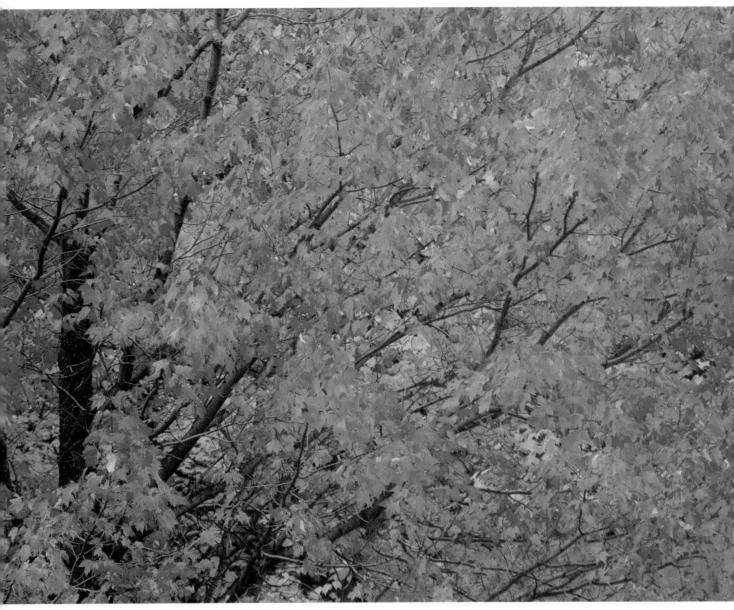

PROBLEM

The point here is to convey the exciting, vibrant feeling of fall foliage. If you get too involved with detail, you'll lose the spontaneity of the scene.

SOLUTION

Work with bold, loose strokes, concentrating on the slight variations in color that occur. Simplify, and try to pick out whatever pattern there is.

Glorious masses of richly colored maple leaves blend together in fall.

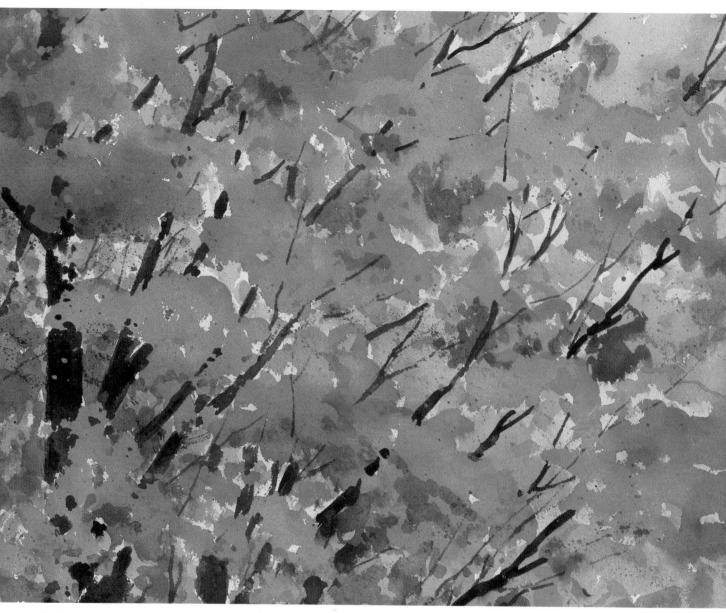

Usually the easiest watercolor approach involves working from light to dark, but there are exceptions. Here, for example, almost all of the colors have about the same value; the pattern the leaves form is created by color, not by darks and lights, so an alternate way of working will be most effective.

Begin by following the rhythm created by the strongest color, red. Use a big, round brush to help keep your strokes strong and loose. Be sure to leave some holes in the leaf masses to sug-

gest their lacy quality, and keep their edges lively. After you've tackled the patterns that the reds form and while your paint is still wet, drop some darker pigment onto the red areas. Blend in the darker paint, again using fluid strokes.

When the paper has dried, it's time to add the yellows, golds, and greens. Just as before, the patches of paint should have erratic, uneven contours. While the paper is still wet, drop bits of darker paint into your washes and work them about to keep the

surface from becoming too flat.

Next, add the trunk and branches. Since they pull the scene together by getting across the tree's structure, stop and think before you begin to paint. The branches should reach outward and embrace all areas of the painting and they should connect, one to another. Vary the heaviness and the shape of your strokes, and be sure that they don't get too tight. As a final touch, spatter a small amount of paint in the areas that seem a little flat—here, the corners.

CONIFERS AND MIXED DECIDUOUS FOREST

Making Sense of Distant Masses of Color

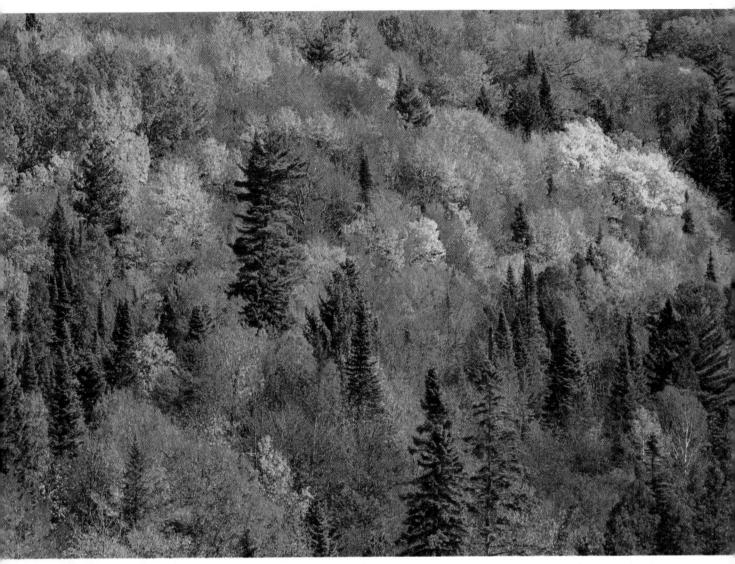

PROBLEM

The orange, red, and yellow masses may first catch the eye, but it's the deep green conifers that define the structure of this landscape.

SOLUTION

Develop the brightest areas first, paying attention to the way in which the vibrant masses blend together. Then, to punctuate the scene, add the deep greens.

For as far as the eye can see, an autumn hillside is covered with a glorious mass of brightly colored trees.

STEP ONE

In your drawing, try to map out the basic fields of color. Don't get too literal here; what you want is just a simple outline to help you keep the patterns in mind as you begin to paint. Concentrate especially on the most brilliant areas and on the outlines created by the green trees. Next, start laying down the very brightest colors, here pure lemon yellow and cadmium red.

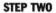

Wet the entire paper except for the sections where you've established the yellow and red. Begin to lay in various shades of yellow, orange, and red. As you work, you'll discover the close value relationships between your reds and oranges, and how they tend to blend together. Vary the strength of your washes to strengthen or weaken the values, and try to keep the painting lively. You're aiming for a dynamic surface, with lots of variation in both color and value.

STEP THREE

While the paper is drying, start adding definite shapes to the reds and oranges. If necessary, rewet some areas and then blend the colors together; this procedure is used here in the lower left corner. When the paper has dried, begin adding the dark green trees. Give their shapes some definition.

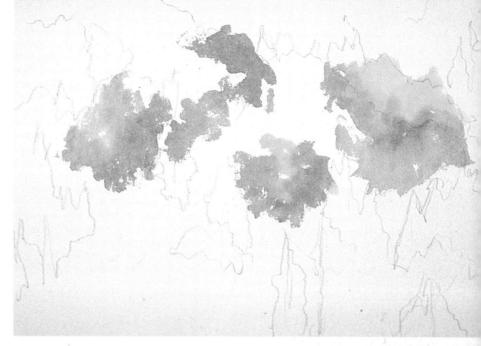

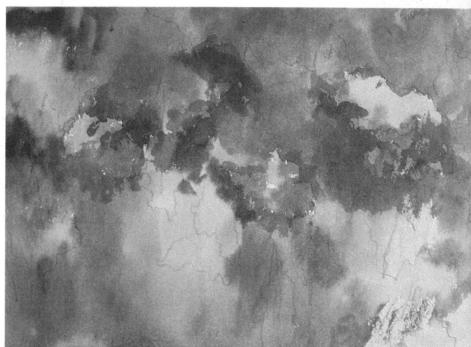

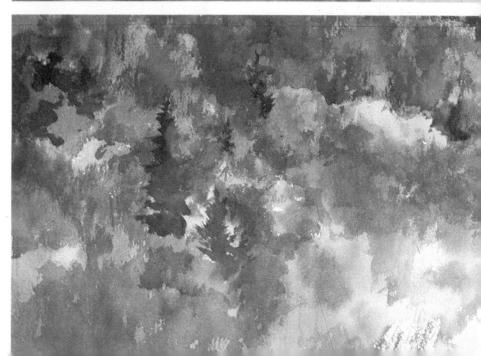

FINISHED PAINTING

The dark green conifers struck in last give the finished painting a sense of depth. They break up the indistinct orange and red masses, and get across a feeling of how the trees run up the hillside.

The yellow areas put down first have the lightest value in the painting. Just like the dark greens, though not as dramatically, they help indicate the patterns formed by the trees.

ASSIGNMENT

Anyone who paints wants to encounter and capture a dazzling autumn hillside like the one shown here. Don't wait until you find such a spectacular composition. Almost anywhere in the fall—even in a city park—you can see masses of deciduous trees in blazing color.

Here the main point is to learn to balance masses of intense color. Of course, you will also be balancing values. Instead of building up your painting from pale washes, as we've done here, work with strong color, almost straight from the tube. Don't bother to sketch the scene you've chosen; you'll be executing several quick paintings.

Work rapidly, laying down broad areas. Limit yourself to three or four colors and add the darkest value last. When you're done, analyze the pattern the colors create. Is it too evenly distributed over the paper? Or do some colors fall into clumps in one area? Keep on trying, constantly evaluating what you've done, until you are satisfied with the patterns you achieve.

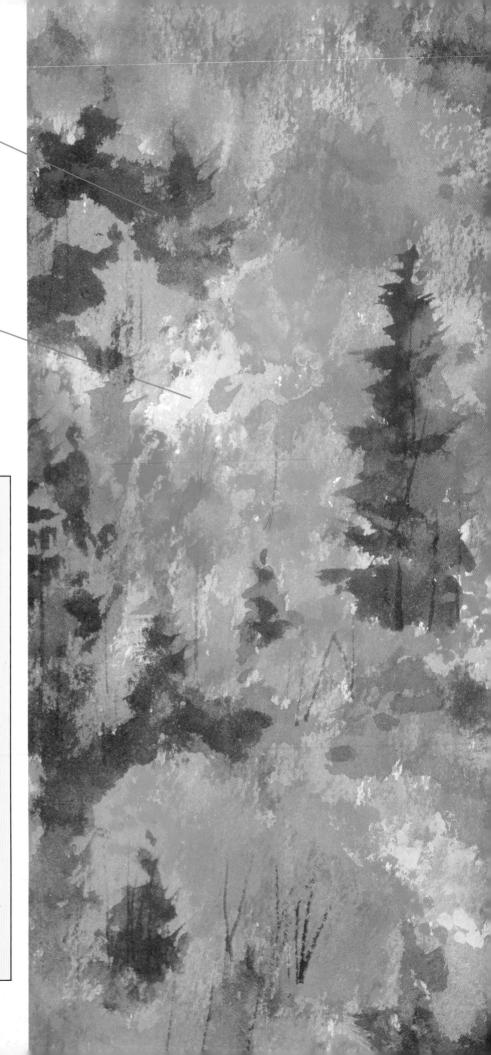

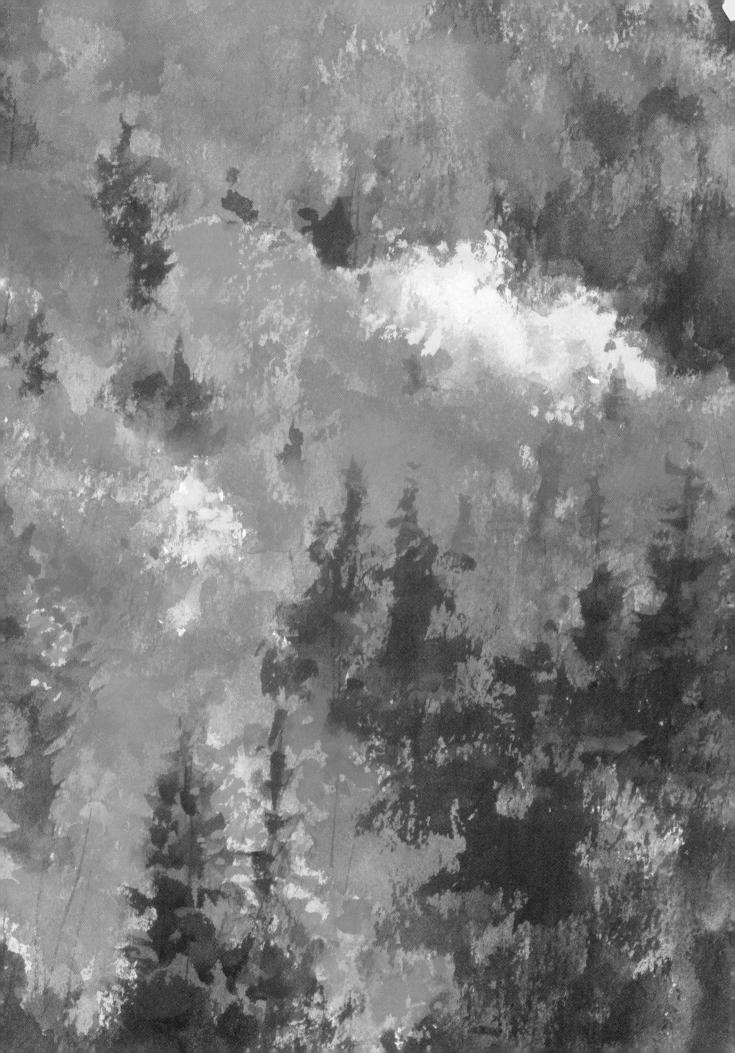

BEECH

Achieving a Feeling of Depth Using Light, Cool Colors

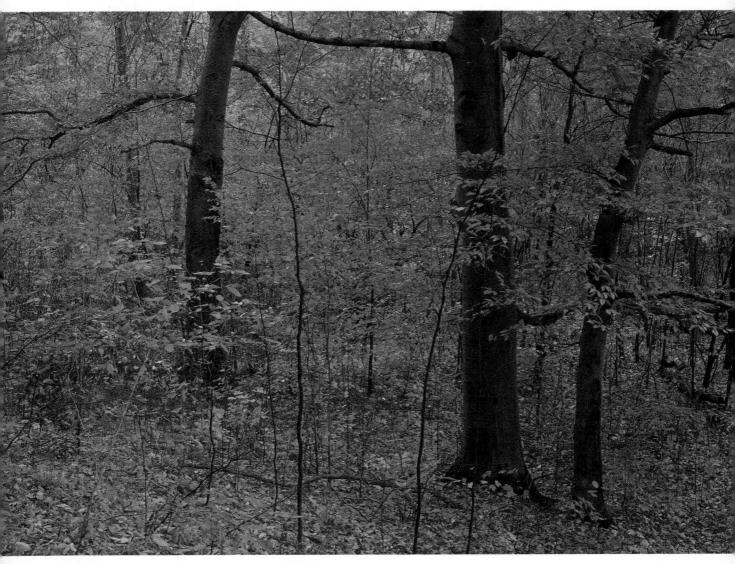

PROBLEM

These trees stretch back endlessly to the horizon yet their leaves are all the same color. It's going to be hard to create a feeling of depth.

SOLUTION

Here you've got to edit what you see. To indicate depth, simplify the background and paint it with cool colors that suggest how the edges of objects soften as they recede.

Deep in a forest in autumn, older beech trees are surrounded by seedlings, while fallen leaves carpet the forest floor.

STEP ONE

Sketch in the trunks in the fore-ground, then begin to lay in the background using a wet-in-wet technique. The wash used here is made up of cool colors—mauve, ultramarine, and cerulean blue—with just a touch of warm alizarin crimson. Apply the wash using long vertical strokes to suggest the shape of the distant tree trunks, and be sure to leave some white areas between your strokes.

Just as soon as the wash dries, put down the tree trunks in the foreground. Since their value is the darkest in the scene, having them there will make it possible to gauge the value of the leaves as you begin to paint them. Pick out the color masses formed by the leaves and start adding these broad areas.

STEP THREE

Continue to develop the middletone values in the leaves, adding a little dark pigment—here burnt sienna—to your palette. A lot of the darkest of these middle-tone areas lie on the forest floor; using a darker wash here helps pull the ground down and differentiates it from the canopy above.

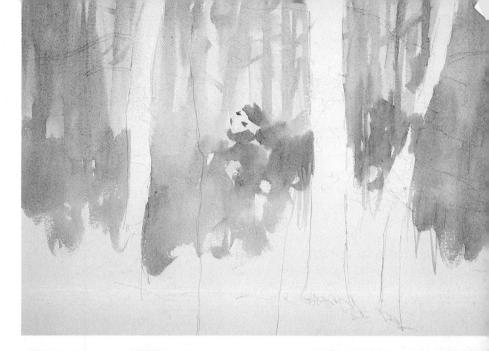

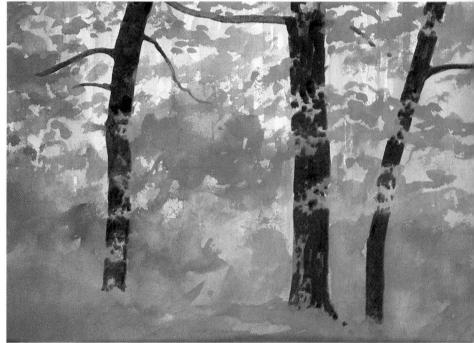

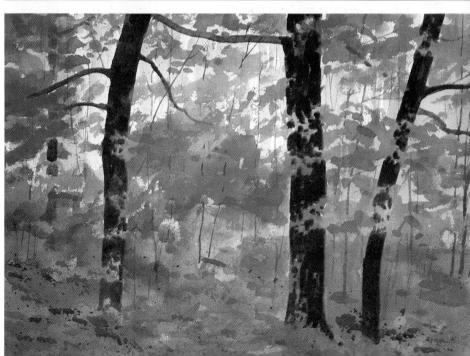

FINISHED PAINTING

Finish the painting by adding detail and texture. Use opaque gouache for the lightest leaves; you can apply it over the dark trunks and the middle-tone leaf masses. As you work, look at the pattern you're creating. Don't be too faithful to the scene in front of you; instead, keep your eye on the surface of the painting. If parts seem too static, enliven them with the gouache. To suggest the twigs and leaf litter on the forest floor, try spattering some dark wash on the bottom of the painting. During this final phase, stop constantly and evaluate what you've done; don't get so carried away with the texture that you overwork any one area.

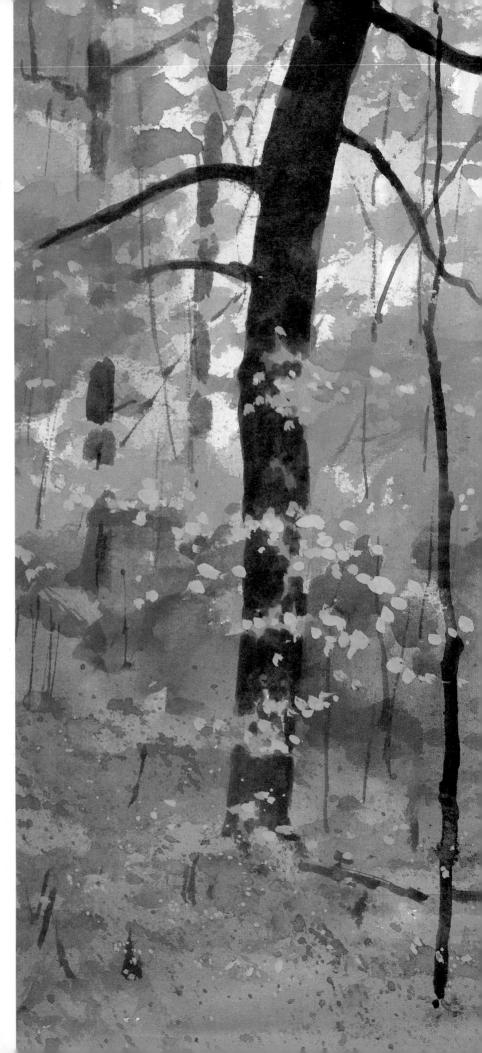

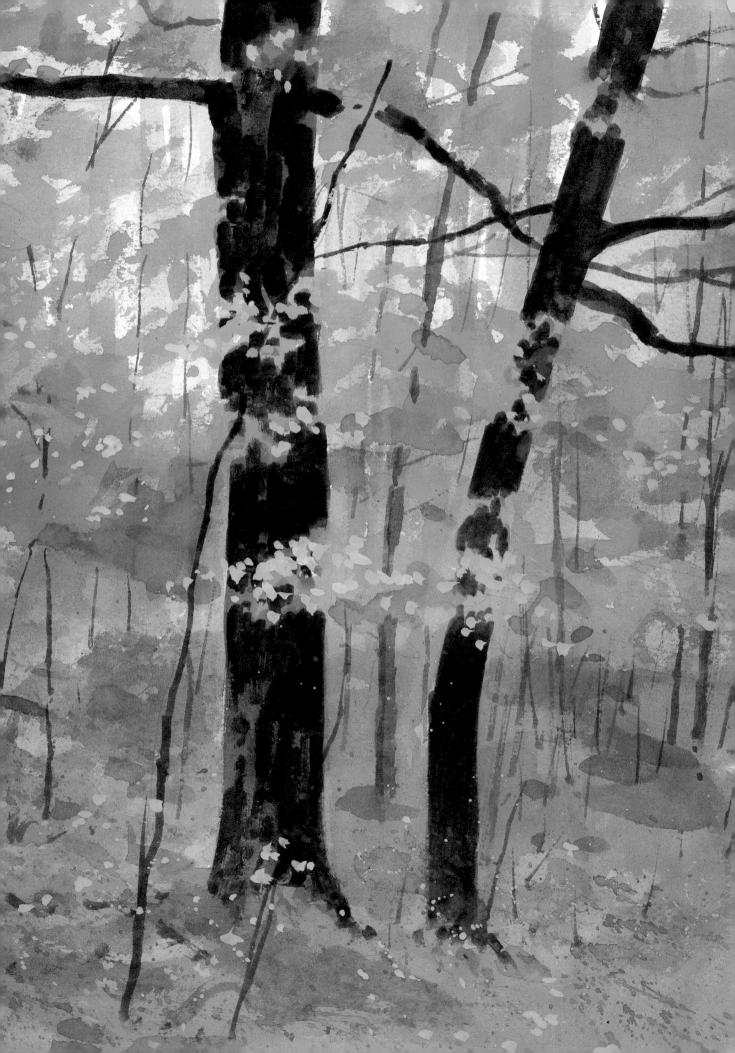

DECIDUOUS FOREST

Learning How Fog Affects Color and Form

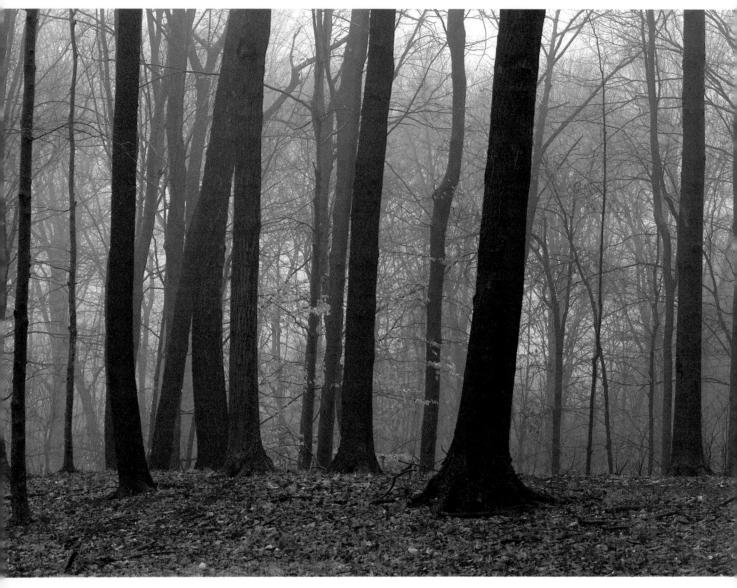

PROBLEM

Because it softens colors and the edges of objects, fog creates special problems, especially when your subject is as strong as these tree trunks.

SOLUTION

Minimize detail to suggest the effect of the moisture-laden air and use cool colors to subdue distant objects.

Begin by setting down the distant background with a pale ocher wash. While your paper is still damp, use a shade just slightly darker to indicate the soft, indefinite treelike forms in the rear. Here burnt sienna and ultramarine are added to the ocher to make it increasingly duller and darker. Continue to darken your paint as you work toward the foreground; each time you do so, increase the amounts of burnt

sienna and ultramarine just a little bit. You don't want the trees to become so dark that the effect of the fog is lost. Once you've completed the tree trunks, it's time to add the few leaves that cling to the branches and those that carpet the forest floor. These leaves still have a hint of the warm color they bore in autumn, but you'll want to subdue this warmth to capture the feeling of the fog; everything appears a little lighter

On a cold winter morning, a light fog envelops a deciduous forest.

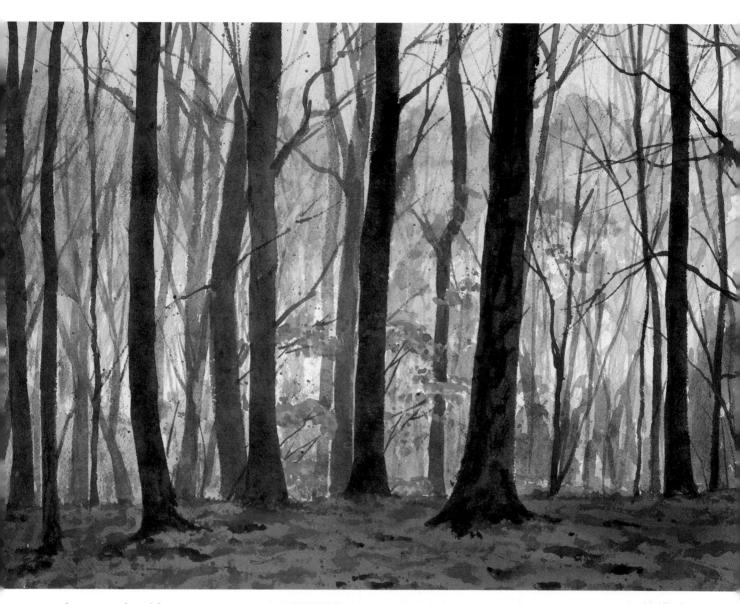

and grayer when it's seen through foggy or hazy air. To depict the soft leaves on the trees farthest back, dilute your paint slightly. Use restraint in the immediate foreground, just mixing two or three colors and applying them sparingly. If you go overboard here and make the foreground too intricate, you'll lose the misty impression you've been striving to create.

ASSIGNMENT

Experiment with muting colors so you'll be prepared when you encounter a situation like this. You'll need cadmium red, ultramarine, burnt sienna, and Payne's gray. The red is the color you're going to use in each swatch. Paint four patches of red, then, while they're wet, drop in each of the other colors, one in each swatch. Make sure that some of the red remains clear and strong. After the paper has dried, stand back and judge the effect each introduced color has created. Are some swatches more lively than others? And are some a little muddy? For your next step, put two colors into each swatch of red and proceed in the same fashion. Variations are infinite, so continue to experiment. When you begin applying what you've learned to your paintings, you'll discover which combinations work best for you.

OAK LEAVES AND ACORNS

Mastering the Color and Texture of Leaves and Acorns

PROBLEM

The acorns are clearly the focus of this scene, but you have to pay attention to the leaves as well. Their rich color and intricate patterns act as a backdrop for the acorns.

SOLUTION

Work on your base colors first, then go back and narrow in on texture and detail. Don't get caught up in any one area as you render the leaves; what makes them the backbone of this scene is their lively uniformity.

To achieve a three-dimensional effect, the acorns are painted with a flat brush run slowly up and down each acorn. Several washes build up their rich, mellow color and the patterns on the cap of the acorn on the left. Capturing the highlights calls for white gouache. Since the acorns are so closely related in color to the leaves on which they rest, set them off by darkening the area around them.

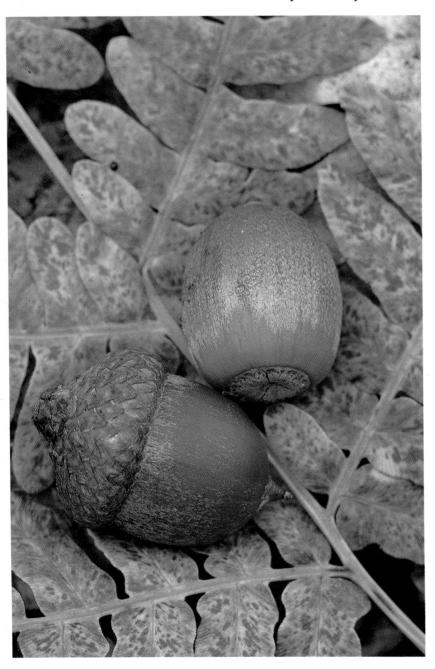

Brightly colored acorns lie cushioned on softly mottled gold and brown leaves.

ASSIGNMENT

You don't have to travel far to find appealing watercolor subjects-it just takes a little practice to learn to focus in on the simple things that are all around you. Go into a park, or even your own backyard, and look at the leaves and twigs that lie under the trees. Execute a detailed drawing of a foot or two of the ground. This sketch will train you to look at everything you see, from minute bits of leaf litter to pinecones and leaves. Next, pick just one detail from your drawing—something like the acorns here-and narrow in on it. Sketch the detail, making it much larger than lifesize, then begin your painting.

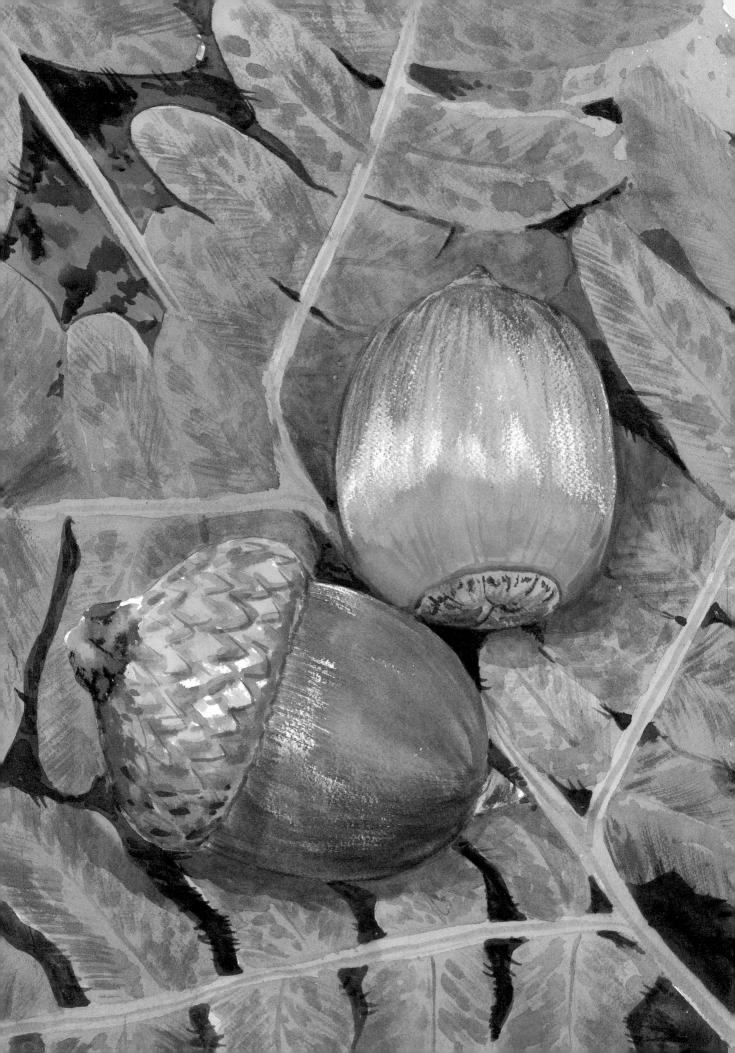

BIRCH

Experimenting with Fog

PROBLEM

It's easier to show how fog softens objects and makes them cooler and grayer when you're working with strong color. Here the trees themselves are mostly white and gray, and those in the foreground where the fog hasn't yet penetrated are sharply focused.

SOLUTION

Lay in a shroud of cool light gray over the background to set it off from the birches in the foreground. Play with the contrast in focus between the two areas to get across the feel of how the fog is creeping in on the scene.

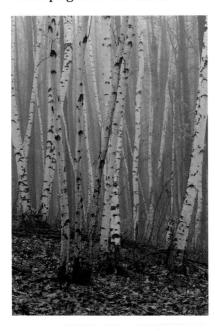

Fog softly rolls in on a stand of birches, veiling those farthest away.

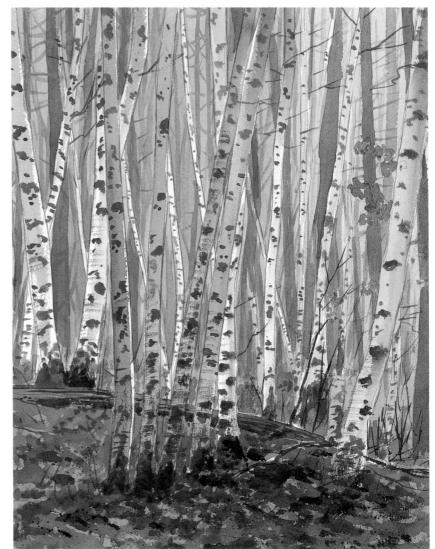

☐ Birches are among the most appealing of trees, at least in part because of the strong abstract patterns their thin, elegant trunks form when they're massed together. Make sure your drawing captures their graceful lines before you attack the painting.

First think through the soft, muted background. For control, and to build up a strong, rhythmic pattern, stick to just three values; even the darkest will be very light. Working around the trees in the foreground, lay in the very lightest wash. Then, using the two almost imperceptibly darker washes, paint in the trees that are blanketed with fog.

You'll want warmer tones in the foreground to separate it from the area that's covered with fog, so add a little burnt sienna and yellow ocher to your gray. Carefully work out the play of light on the surface of the nearby birches. For some, let the white paper alone—it will add crisp passages to the finished painting. To depict the texture of the trunks and their fine branches, use dark gray. Finally lay in the ground with a pale ocher wash, then enliven it with rich burnt sienna and gray. Don't get carried away with detail, or you'll pull attention away from the trees.

BIRCH BARK

Creating Texture with Line

PROBLEM

Two things are going on here. Although the pattern created by the fissures may seem flat and abstract, the trunk itself is three-dimensional. You have to suggest that the trunk is round, and not just get swept away by its surface detail.

SOLUTION

Forget surface detail until the very end. First work out the play of light and dark on the trunk.

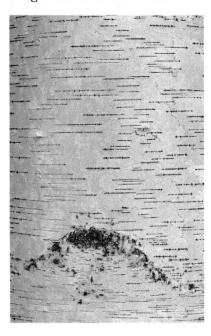

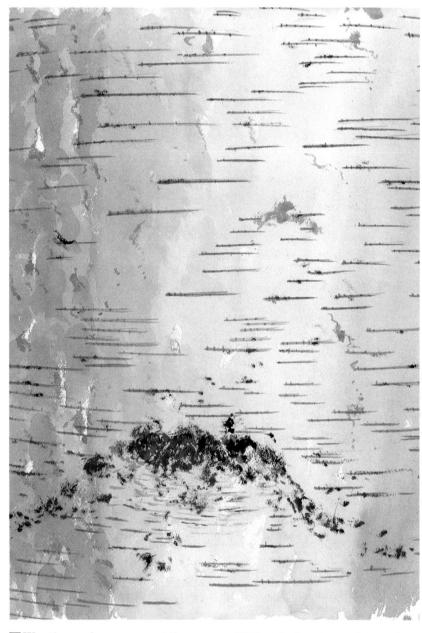

White, papery birch bark bears a simple yet intricate pattern formed by horizontal fissures and ridges. ☐ Wet the entire paper and then apply an overall wash. To achieve the light gray color seen here, use Payne's gray and just a touch of yellow ocher. Make the wash darkest toward the sides of the paper to suggest how the trunk curves back. This isn't an even wash; leave bits of paper white and establish uneven patches of shading. Now give the paper a chance to dry.

With a darker tone of gray, lay in the horizontal lines, varying their strength as you work. When they have dried, add detail. Using a dry brush and a still darker gray, dab small vertical touches of paint on the horizontal lines. This technique makes the ridges seem to be breaking open and pushing away from the trunk. Finally, add the very dark area near the bottom.

Working with Closely Related Values

PROBLEM

The value of the darkening sky is almost exactly the same as that of the oak. Unless you're very careful, the tree and the sky are going to run together.

SOLUTION

Keep the sky lightest near the horizon and behind the tree, gradually darkening it as you move up and outward.

On a cold, crisp winter evening at dusk, this oak stands silhouetted against a rapidly deepening sky.

STEP ONE

Sketch the tree with heavy, dark strokes; once the wash is put down, you'll need to see your drawing through the dark paint. As you sketch, pay close attention to the tree's shape. Indicate the outline formed by the crown; this oak's shape is gently rounded and made up of strong, stout branches that almost touch the ground.

When you're laying in a graded wash like this, it's easiest to work from light to dark; turn the paper upside down so the lightest area—the horizon—is on top as you work. Begin with the warmest colors—here alizarin crimson and cadmium orange. Make the wash the very lightest around the tree to create a halo effect. Here the darkest parts of the sky are rendered with cerulean blue and ultramarine.

STEP THREE

As the wash dries, prepare the paint you'll use for the tree and foreground. You want the color to be dark, but not too stark. Here Payne's gray and sepia are darkened with ultramarine, a good color to try whenever you're tempted to use black. As you begin to paint, indicate the trunk and major limbs, and establish the tree's overall shape. Don't let the horizon get too fussy.

ASSIGNMENT

Choose a simple scene, one without too much detail, then do quick watercolor sketches of it at different times of day, especially at dawn and dusk. Spend just a few minutes on each painting. Use only one color; a good choice is a fairly neutral color like Payne's gray. As you work, become aware of how the light changes from minute to minute as the sun rises and sets. Once you've begun to control your lights and darks, you're ready to broaden your palette.

Use a dry brush to indicate the details. These rough strokes give the feeling of lots of little branches without pulling attention away from the tree's gnarled trunk. They're also soft enough to suggest how fading light affects detail.

In the finished painting, the tree successfully stands out against the sky, in large part because of the careful use of the graded wash. Note especially the subtle difference in value between the sky in general and the parts of it that surround the tree.

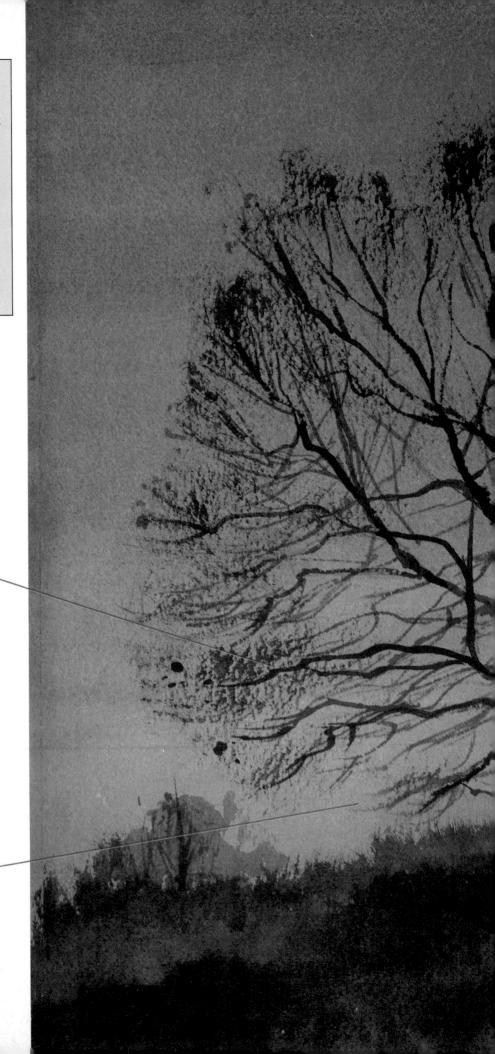

ASPEN AND GOLDENROD

Balancing Brilliant Flowers and a Tree-filled Background

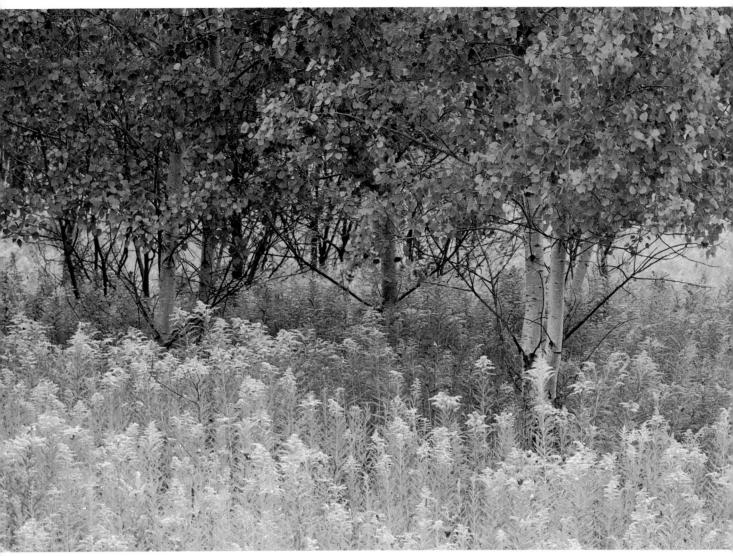

PROBLEM

When you walk into a glorious setting like this, the flowers can seem so amazingly brilliant that you may overemphasize them and fail to develop the entire scene.

SOLUTION

Paint the flowers last, so you can gauge how their color reacts with all the others you use. Mask them out before you begin to paint, and render them with gouache.

On a hot, hazy afternoon in August, this lush field of goldenrod catches the brilliant light shining through a stand of aspens.

STEP ONE

Massed together, trees in full foilage seem to merge. Your preliminary drawing will keep you aware of the scene's structure.

Next, lay in a pale green wash for the background. It takes experience to judge how pale the background really is; even though the paint will dry lighter than it goes down, start with a paler wash than you think you need. Paint the dark areas in the foreground.

Continue to build up the distant background, articulating the trunks of the small trees farthest away. At the same time, keep your eye on the middle ground. After you've set down the intermediate greens, add texture to this area while the paper is still wet. Lighten some areas by picking up paint with the tip end of the brush; darken others by spattering them with slightly darker pigment.

STEP THREE

Begin to work out the foreground. Keep it as lively as possible. Use a variety of greens in a variety of densities to indicate the tall stems that support the flowers. Here some are even done with pale yellow. Enrich the colors in the middle ground, too. Here yellow ocher suggests that the goldenrod extends all the way to the horizon. Next, remove the masking fluid.

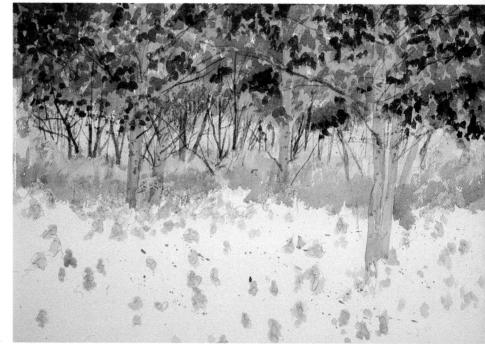

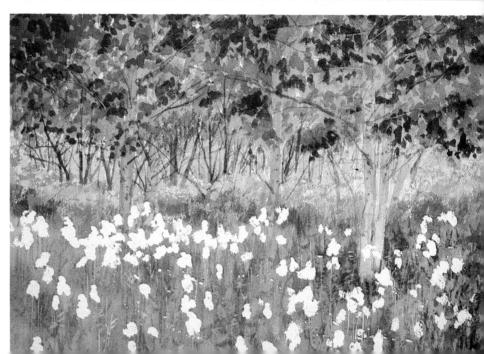

FINISHED PAINTING

About all that's left to be done now are the flowers themselves. To paint them, use opaque gouache, dabbing it on quickly. After the paint dries, evaluate how successfully you've indicated space and how effectively you've developed the relationships between the goldenrod and aspen. Are the flowers in the middle ground too brilliant? If so, soften them by applying a light wash of

dull green. This pushes them farther back, and makes the flowers in the foreground seem more immediate. You may want to use the same green wash to suggest the details and shadows on the flowers that are closest to you. Next, look at the trees. Do those in the foreground seem closer than those farther back? If not, add touches of strong dark green to their leaves.

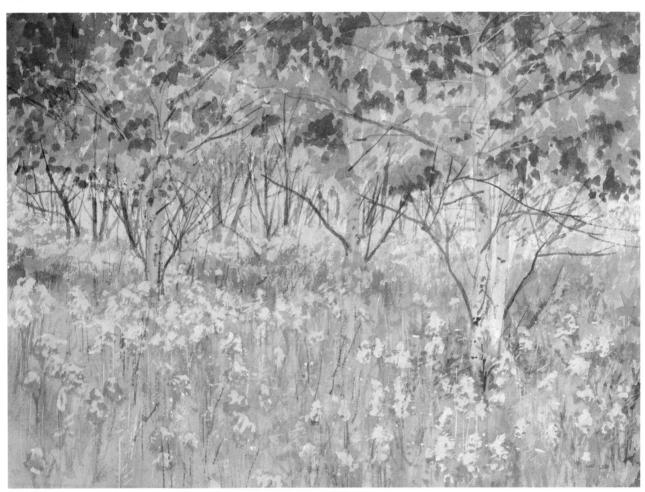

DETAIL

When you move in close and look at a detail like this you see how richly textured the finished painting is and how carefully its layers have been built up—from the initial light green wash to the final dabs of dark green. Examine the field of goldenrod and its complexity of detail. Note how the stems and flowers have been developed and how they help organize the final painting. If they were less carefully rendered, the foreground

could easily become flat and uninteresting.

The middle ground has also been worked out meticulously. There's a clear sense of the hazy light shining through the aspen, then falling onto the goldenrod. The flowers and trees seem to carpet the landscape all the way to the horizon. Finally, the crisp, clean branches in the foreground contrast sharply with the paler, hazier ones farther back.

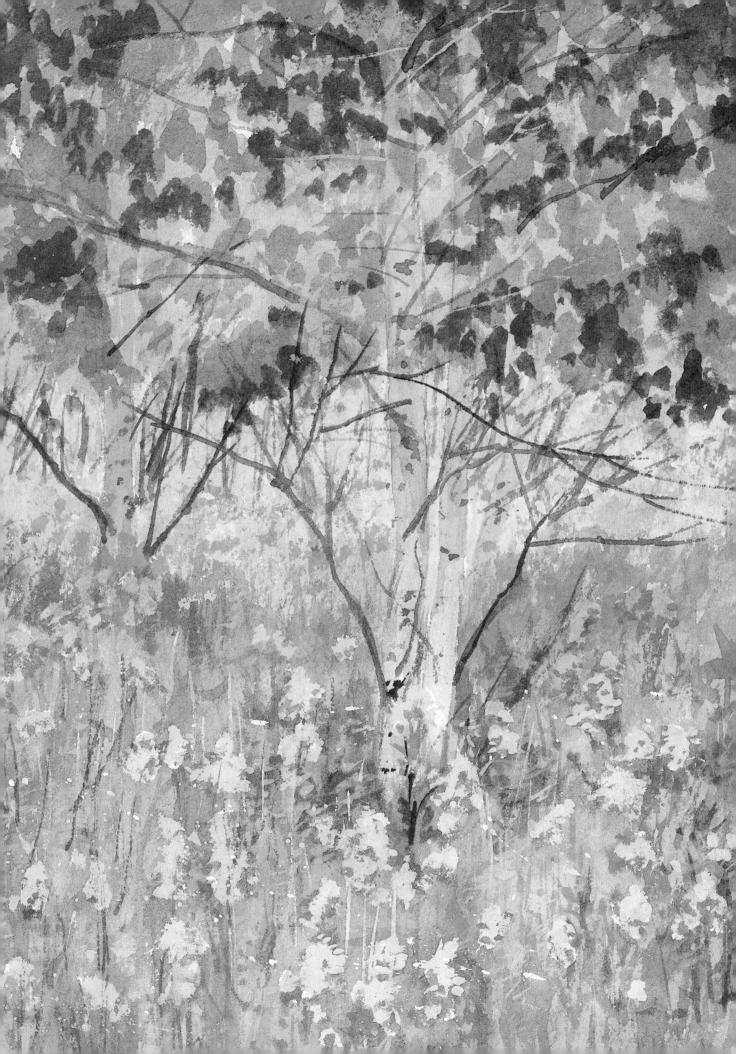

ASPEN LEAVES

Mastering the Tiny Highlights Created by Dew

PROBLEM

This bold and elegant composition gains complexity because of the tiny beads of water on the leaves and stems. You'll want to suggest the intricacy of the leaf surfaces without sacrificing the clean lines of the composition.

SOLUTION

If the background is dark enough, the dewdrops will be thrown into sharp relief, so don't be afraid to use deep, dark paint. ☐ Execute a preliminary drawing. The leaves needn't be masked out because their shapes are fairly simple and easy to paint around. To capture the rich, mottled look of the background, work with a wet-in-wet technique. Slowly drop cerulean blue, Payne's gray, and Hooker's green light onto the paper, then blend them softly. Use really intense color here.

Wait for the background to dry, then paint the leaves with one flat wash. It's vital that you leave a white border around the leaves, so work carefully. Mix a slightly darker shade of green and then put down the areas between the veins. Next intensify the largest veins with orange-yellow paint and then indicate the shadows in the upper left corner with rich dark green.

In rendering the stems, leave the edges white to hint at the dewdrops that cling to them. For this kind of exacting work, you'll need the control that a fine brush offers. As a final touch, spatter little drops of yellow-ocher on the leaves, and add touches of brown and orange to indicate spots where the leaves are worn.

In the finished work there are only three distinct values—pure white, very dark blue, and an intermediate green. The simplicity of this scheme enhances the elegance and grace of the painting.

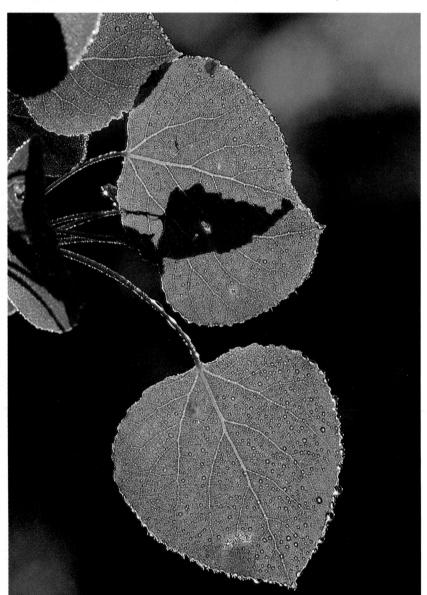

ASSIGNMENT

Set up a simple still life—a group of leaves or even an apple— against a piece of dark fabric that won't reflect much light; velvet and corduroy are perfect. Shine a strong light on the subject and study the highlights that form. In your painting these highlights will have the lightest value, the cloth the darkest, and the leaves or fruit an intermediate one. To show the highlights, leave the paper white.

Most people don't have much trouble with the light and intermediate values, but they're afraid to really lay on dark pigment. That's the challenge here. Concentrate on the background, making it quite a bit darker than you want it to be in the end. Remember, watercolor dries several shades lighter than it looks when it's wet.

At dawn, minute drops of dew cling to bright green aspen leaves.

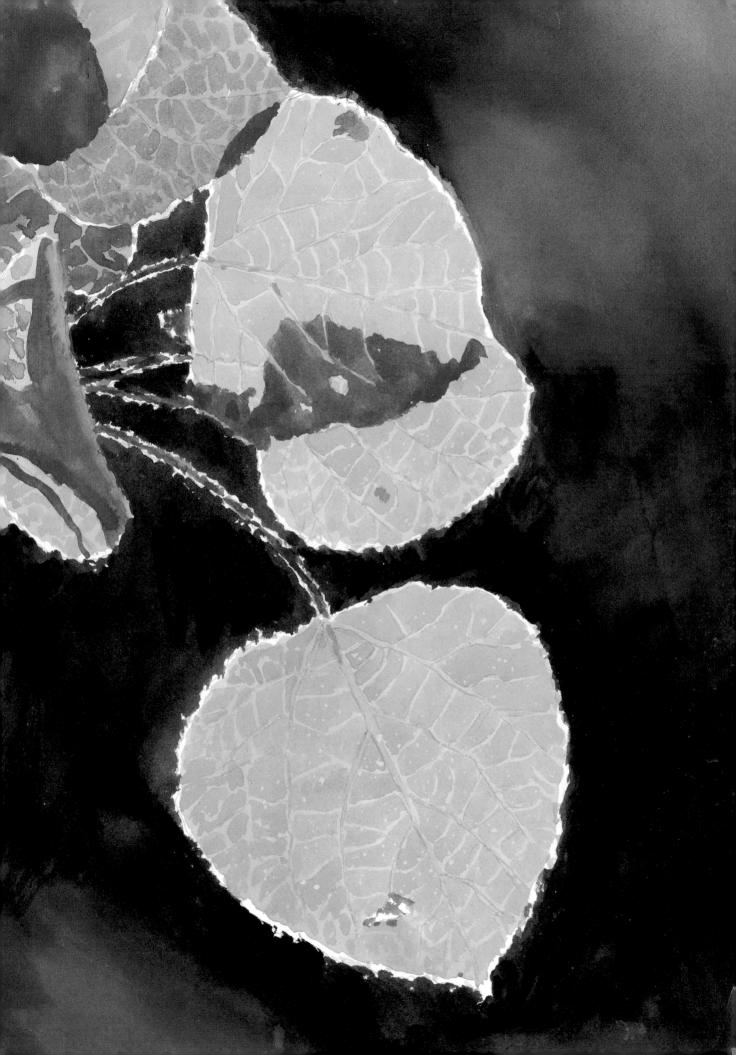

ASPEN LEAF

Painting a Rain-spattered Leaf

PROBLEM

Raindrops are awfully hard to paint. They're three-dimensional yet transparent. Here the situation is made even more difficult because the brightly colored leaf they hover on is resting on a dark mass of fronds.

SOLUTION

Don't worry too much about the contrast between the fronds and the aspen leaf—it's the raindrops that make this picture interesting. Concentrate on them, discovering how each seemingly transparent drop is built of shadows and highlights.

Here's where the fun starts. For the aspen leaf, try a graded wash that shifts from yellow to red. Keep the colors clear and bright to build up contrast with the dark background. When the leaf is dry, begin work on the raindrops. For each one, put down a little dab of dark color, then, using a fine brush moistened with clear water, soften the color, pulling it around the base of the drop. For interest, vary the size and the shape of the drops.

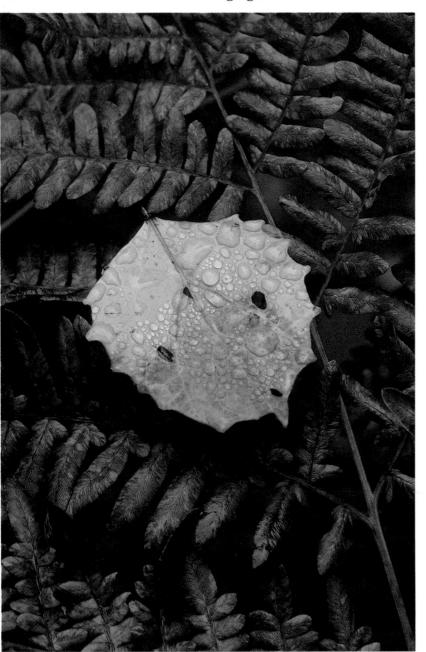

NOTE

Shadows and highlights play about on the surface of these shimmering raindrops. Notice how the color that forms the dark, shadowy area toward the bottom of each drop gradually becomes paler as it is pulled upward, then almost disappears when it reaches the top. It takes a light touch to master this technique, so be sure to do a few sample raindrops before you start to paint. After executing each drop, clean your brush before you turn to the next one, and remember to moisten the brush with clear water after you've put down the initial dab of color.

Splashed with rain, an aspen leaf lies atop a nest of rich brown fronds on the forest floor.

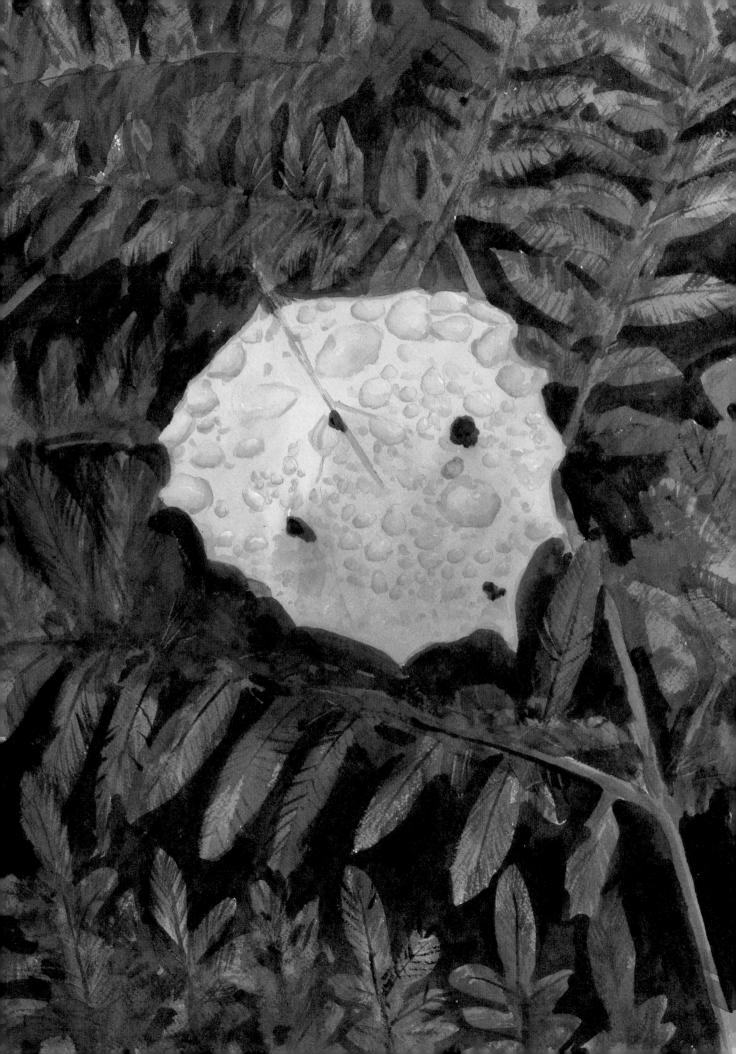

Capturing Complicated Reflections in Water

PROBLEM

The leaves are crisp and well defined, but the patterns formed by the water are difficult to read. Concentrate on them—they're going to pull the painting together.

SOLUTION

Do the most difficult area, the water, first. If you don't capture the power of the reflections and the ripples right away, start over. If you wait and execute the water last, you may have to do the entire painting again and again.

☐ Since you'll be working around the leaves first, a precise drawing makes a difference. After vou've completed your sketch, wet the area behind the leaves, then, going from light to dark, drop your colors onto the wet paper. As you work the colors around, keep your eye on the subtle patterns that the reflections create and on the more dynamic ones formed by the rippling water. Simplifying the ripples can help to heighten their bold feeling of movement. Here, for example, only three shades of blue can be seen. Use strong brushstrokes. but don't let the ripples overpower the soft, blurred reflections that you've already established.

After the paper is dry, lay in the leaves, beginning with flat washes, then rendering texture. This step is important. The leaves must be rich with detail or they'll look flat next to the intricate water.

NOTE

The pale pastel leaves act as a foil for the strong swirling ripples of blue that run thoughout the painting. Unlike the blue passages, which are rendered with dense pigment, the leaves are built up from delicate washes of blue, yellow, green, ocher, and brown. As a final step, their veins and textural details are added with slightly darker paint. The unexpected slash of red in the lower left corner does more than just set off the pale leaves—it also directs the eye toward the center of the painting.

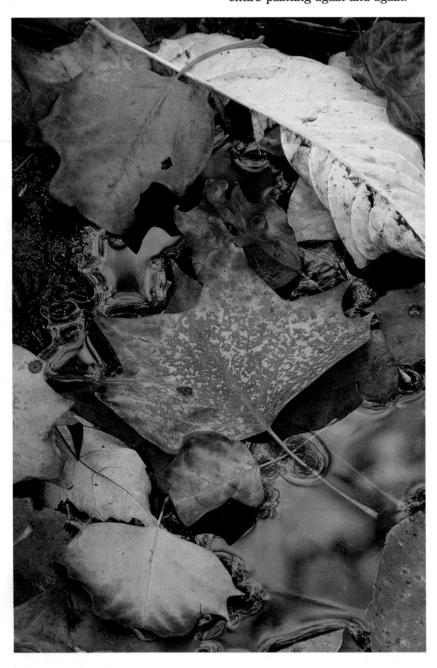

A jumble of autumn leaves lying together casts reflections in brilliant blue water.

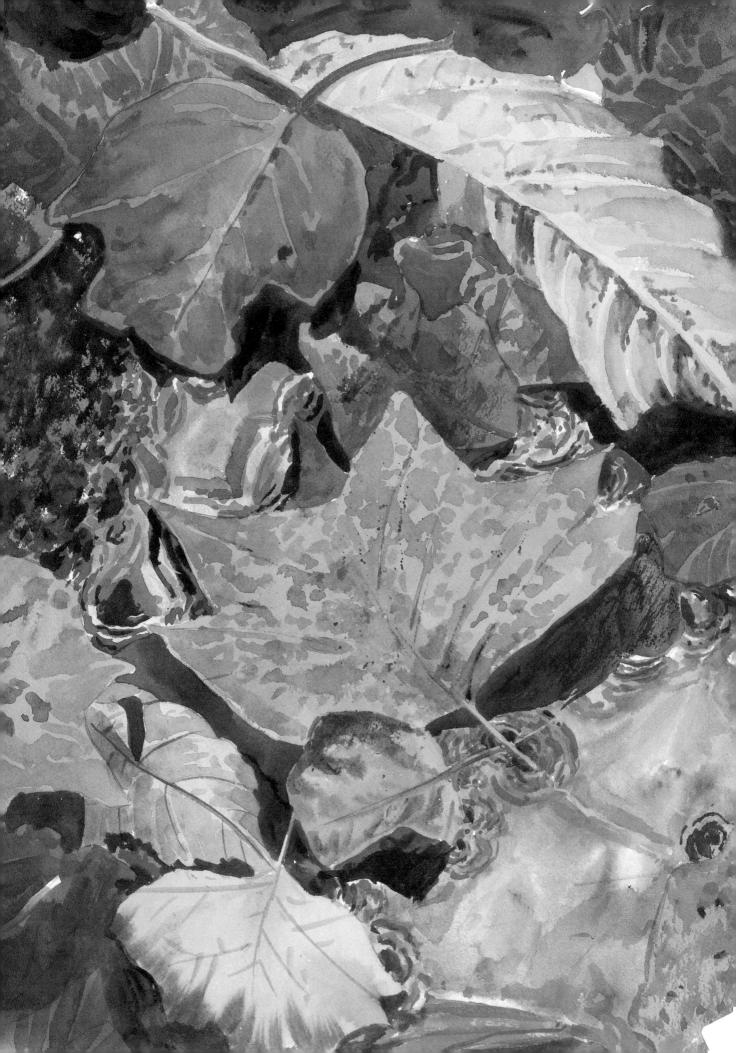

Using Monochromatic Greens to Depict Dense Foliage

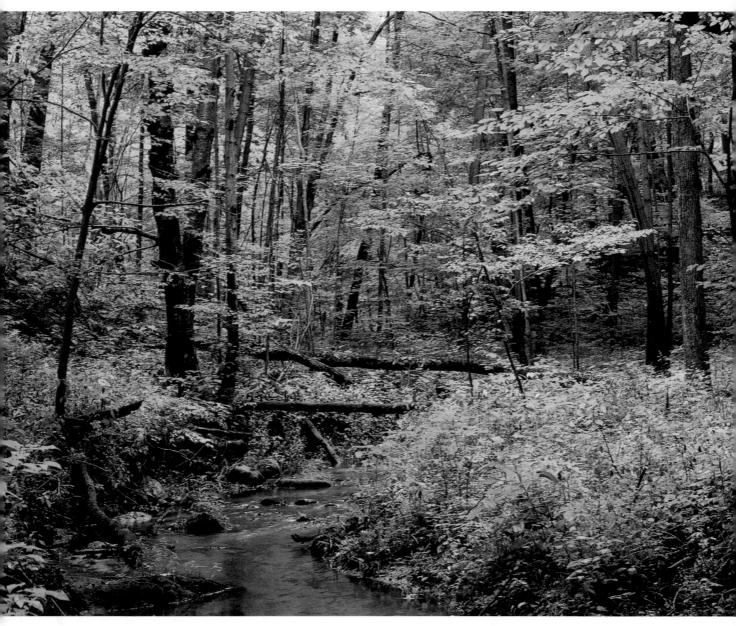

PROBLEM

In the heat of late summer, trees in full foliage present an almost unrelieved screen of green. It takes some thought to decipher the structure of scenes like this one.

SOLUTION

Analyze the pattern formed by the dark, light, and intermediate greens. The light values will be the most difficult to discover; there aren't very many, and if you lose them, your painting will lack sparkle. As you search for pattern, remember why greens are so difficult. Their values are almost identical. The traditional light-to-dark approach is best for this kind of painting, so begin by covering the entire surface, except for the area where the water will go, with a very light yellow-green wash.

Next—and this is the most difficult step—look for the rhythmic movement of intermediate green throughout the scene. The dark greens come next. These should

Deep in a deciduous woods, trees and undergrowth crowd together near a slowly flowing stream.

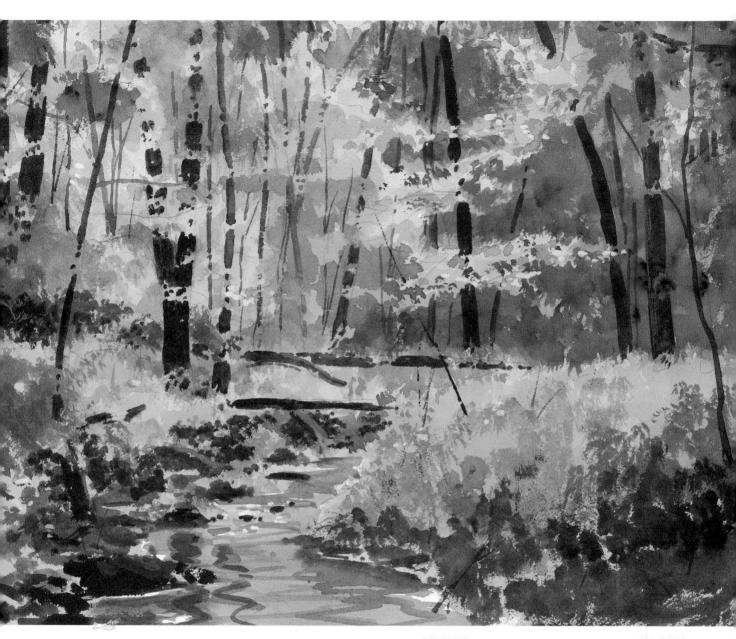

have more punch than the lighter washes, so dab paint onto the paper forcefully. Finally, add the tree trunks and the stream. Use a little imagination here; the blue passage in the stream you see in the finished painting may not be obvious in the photograph, but it adds a lively touch and breaks up the monochromatic green scheme.

ASSIGNMENT

Experiment blending greens before you tackle a difficult forest scene like this one. Start by learning how to mix warm and cool tones.

To mix a warm green, take ultramarine and new gamboge. First add just a bit of the blue to the yellow, then gradually add more and more. Each time you change the ratio of blue and yellow, paint a test swatch. To increase the warmth still further, you can add a little burnt sienna.

For your cool greens, follow the same procedure but use cerulean blue and cadmium yellow. To make the greens you mix still cooler, try adding a little Hooker's green light.

After you've completed your test swatches, compare them.

CYPRESS

Recording the Delicate Growth Around the Base of a Tree

PROBLEM

The dark tree trunks could easily overpower the greens, and if they do, you'll lose the lush, verdant quality that makes this scene so arresting.

SOI LITION

Work mostly in middle tones, using darker washes just for texture and detail. To make the green leaves that grow out of the trunks really stand out, use gouache.

Now turn to the ground. Start with a graded wash mixed from new gamboge and olive green. Work from the darkest areas in the background to the lighter ones up front, then add texture. Begin with small dark touches that spiral back into the painting, then load your brush with bright green paint and spatter the paint densely over the ground. Turn to the flora growing out of the trunk. Working loosely, render the leaves. Some can be soft and unfocused, but for the most part, pay attention to their shape. Finally, add just a few detailsthe small pink touches in the rear and the foliage springing out of the fallen trunk in the immediate foreground.

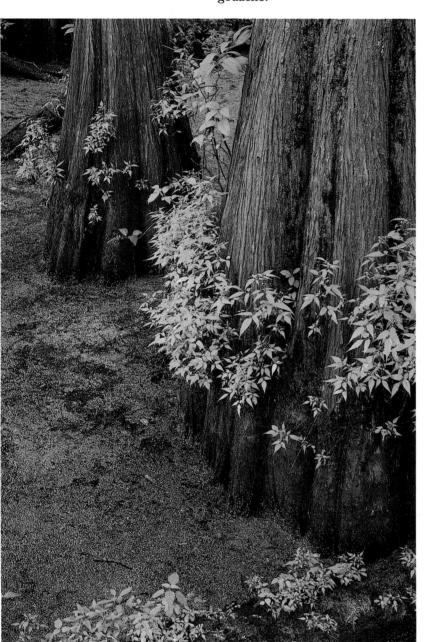

NOTE

Dense spattering is ideal for depicting masses of tiny details—here the lush, wet surface of the swamp. When you're working with this much spattering, stop from time to time and evaluate how much you've laid down. If the spatters become too dense, they'll run together and you'll lose the interesting, uneven patterns that make the surface of the painting dynamic. Try to vary the size of the spatters, too, to keep your work from becoming monotonous.

Massive cypress trunks rising from wet, swampy soil support fresh, brilliant spring growth.

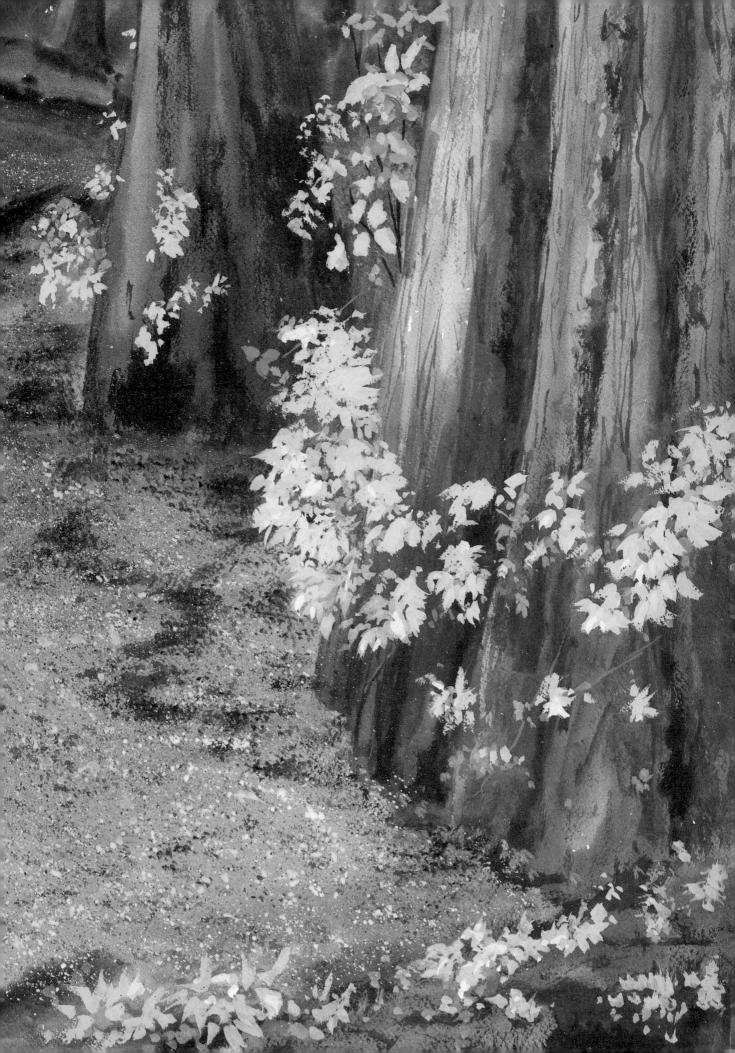

CYPRESS ROOTS

Painting Green Leaves Against a Rich Green Backdrop

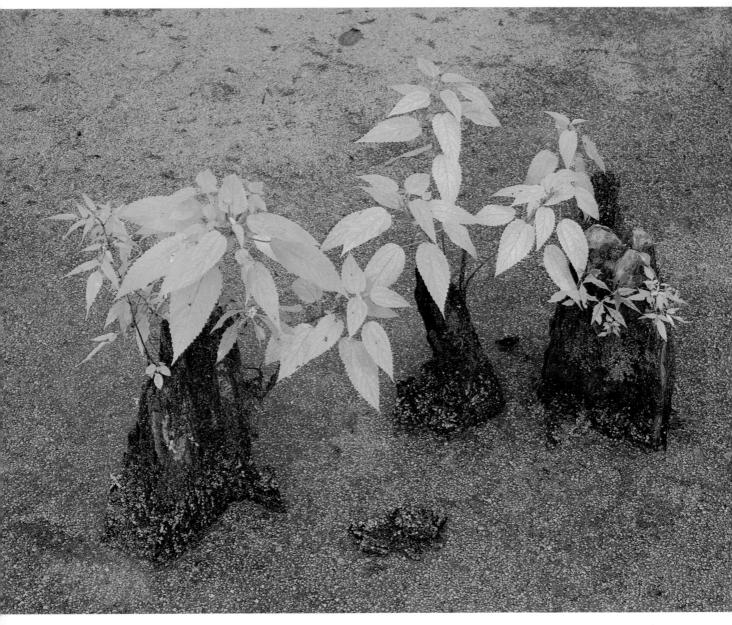

PROBLEM

Because the light is so diffuse and subdued, there is hardly any contrast here. The swampy ground is just slightly darker than the leaves.

SOLUTION

Mask out the leaves and build up the background first. When you add the leaves later, you'll be able to control their color and value and set them off from the darker ground. Execute a careful drawing of the knees, then mask out the leaves. Start the background by laying in a mottled wash—here made up of olive green, new gamboge, yellow ocher, and Payne's gray. Before you begin to add texture to the background, paint in the trunks. Next, load a brush with wet paint and spatter it over the ground.

Now it's time to remove the masking fluid and lay in the bright green leaves. To set them off

from the background, make them a little lighter and brighter than they actually are. Next, intensify some of the greens in the leaves, then paint in their veins with light, delicate strokes.

When you are almost done with your painting, gauge how successfully the ground relates to the knees. If it looks a bit too light—and it did here—wash it with Hooker's green. Then, to heighten the shadowy areas near the knees, add a light blue wash

Deep in a swamp, underwater cypress roots send oddly shaped "knees" to the surface.

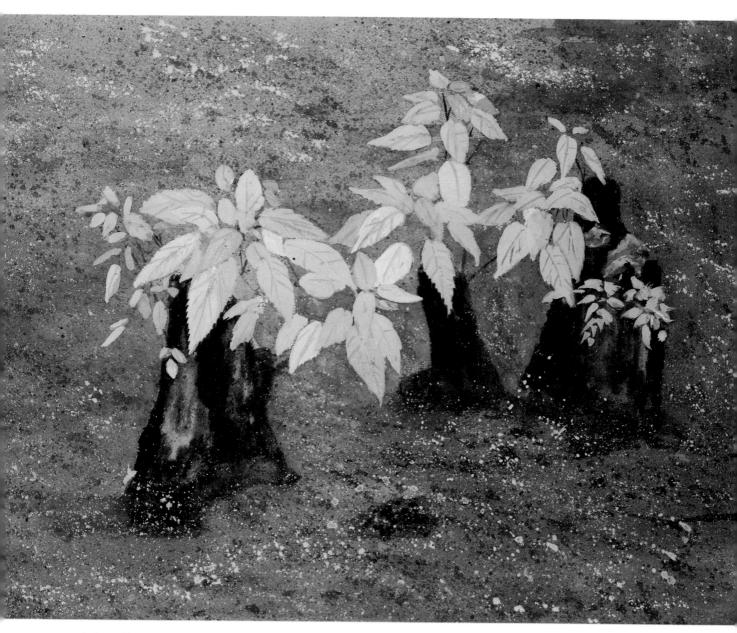

around the stumpy growths. Finally, with the same green used to intensify the color of the leaves, spatter still more paint over the background.

Note how effective the final touches are: the subtle blue wash not only picks out the shadows beneath the knees, it also helps pull the background away from the leaves and stumps; the spattering keeps the final wash from becoming too dominant.

ASSIGNMENT

Learn the different effects you can create with spattering. You'll need a large sheet of paper, small and large brushes, a toothbrush, and a tube of paint. Mix a good amount of the pigment with plenty of water—the paint should be very wet.

Take a small round brush and load it with color. Holding it over the paper, tap the brush, first with your hand, then with another brush. Experiment directing the flow of the spatters by striking the brush on one side as well as from above.

Next, try a big round brush to create larger spatters. Finally, wet a toothbrush with paint and run your thumb across the bristles to get a rich flow of tiny speckles.

SPRUCE SEEDLING

Painting a Sharply Focused Subject Against a Soft Background

PROBLEM

To focus in on a subject, you have to train yourself to downplay what lies beyond it. It takes some practice to learn to subdue unimportant elements.

SOLUTION

Mask out the foreground—the real subject of your painting—and lay in a wet-in-wet background. Make sure you get a realistic feel by using related colors in both areas. Try to suggest that if the viewer merely looked up and redirected his gaze, the background would spring into focus.

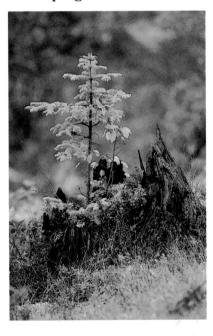

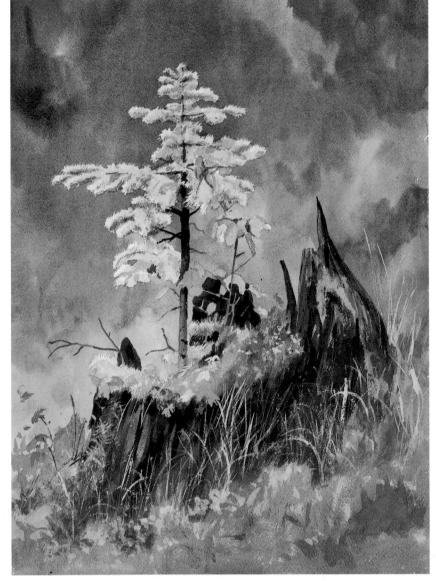

seedling and trunk, so a careful drawing is a must. Next, figure out where you'll want to maintain a sharp edge—here the stump and spruce, and the surrounding growth—then cover those sections with masking fluid. Before you begin the background, take a wet sponge and soak the paper. Now begin to drop in the paint, gently working it around to keep the surface fluid. When the paper

☐ There's a lot of detail to the

starts to dry, add brighter colors; since the paper is damp, not wet, the paint will hold its shape yet still remain soft.

Next, peel off the masking solution and paint the seedling, trunk, moss, and flowers. Finally, to soften any harsh transitions between the foreground and background, dab a bit of gouache onto the edges of the seedling and the surrounding growth.

Moss, grass, and wildflowers surround a tiny spruce seedling rising out of a jagged tree stump.

SPRUCE

Establishing the Values Created by Heavy Fog

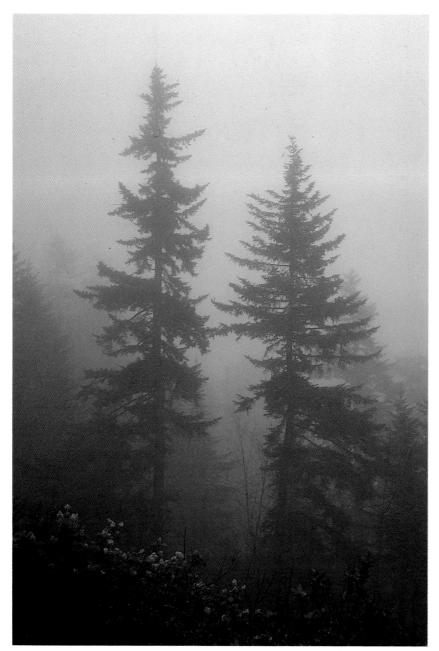

PROBLEM

Here, the scene's so foggy that all of the values run together and nothing has any definition. The soft background will be particularly difficult to paint.

SOLUTION

Even though the fog almost totally obscures the trees in the background, define their shapes using successive layers of very light wash. Make the foreground more sharply focused than it actually appears.

STEP ONE

You'll be working with a wet-inwet technique for much of the background so use sturdy 300pound paper. After your sketch, mask out the flowers and grass in the foreground; they'll be executed last. Next, wet the entire paper, and begin laying in a graded wash. Here it's made up of Davy's gray and yellow ocher. As you approach the foreground, intensify the wash with Payne's gray and ultramarine.

On an early spring morning, these spruce trees dominate a fog-covered mountainside.

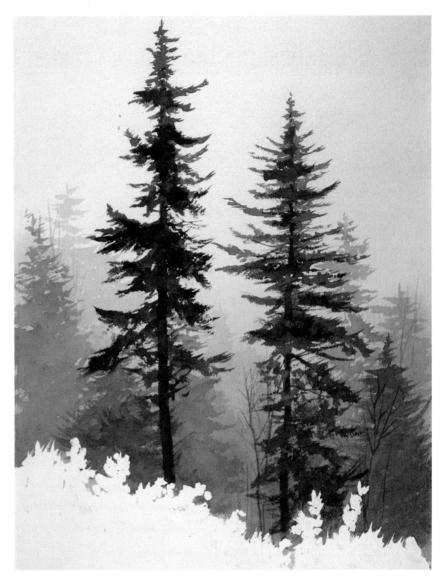

STEP TWO

After the background has dried, prepare a wash of Davey's gray, cerulean blue, and vellow ocher, then begin depicting the lightest trees in the background. Don't add texture or detail; just show their silhouettes. When they're dry, add slightly darker trees, then, when the intermediate ones have dried, add still darker trees. Each layer should be only slightly darker than the previous one.

STEP THREE

Put in the tall trees in the foreground. To make these trees really dominate the composition, paint them in a slightly darker value than what you actually see. It's essential that you capture the grace and beauty of the branches silhouetted against the lighter trees and the sky without adding very much detail. To break up the masses formed by the branches, paint the trees using two closely related shades. Using a few simple strokes, suggest the scraggly undergrowth.

As a final step, remove the mask from the foreground area and lav in a wash of green. Once this has dried, render small branches with vertical strokes. making sure to leave the white of the paper to indicate flowers.

FINISHED PAINTING

Quick, sure brushwork makes the finished painting strong and unified. In the tall, dark trees in the foreground it suggests the weight of the branches. To achieve the effect seen here, work from the trunk outward: the brush becomes drier toward the periphery of the trees, and helps convey the rough feel of their needles. The spring flowers that lie in the immediate foreground establish the season and lend a splash of color. Rendered with vertical strokes, they continue the upand-down sensation established by the tall trees throughout the painting.

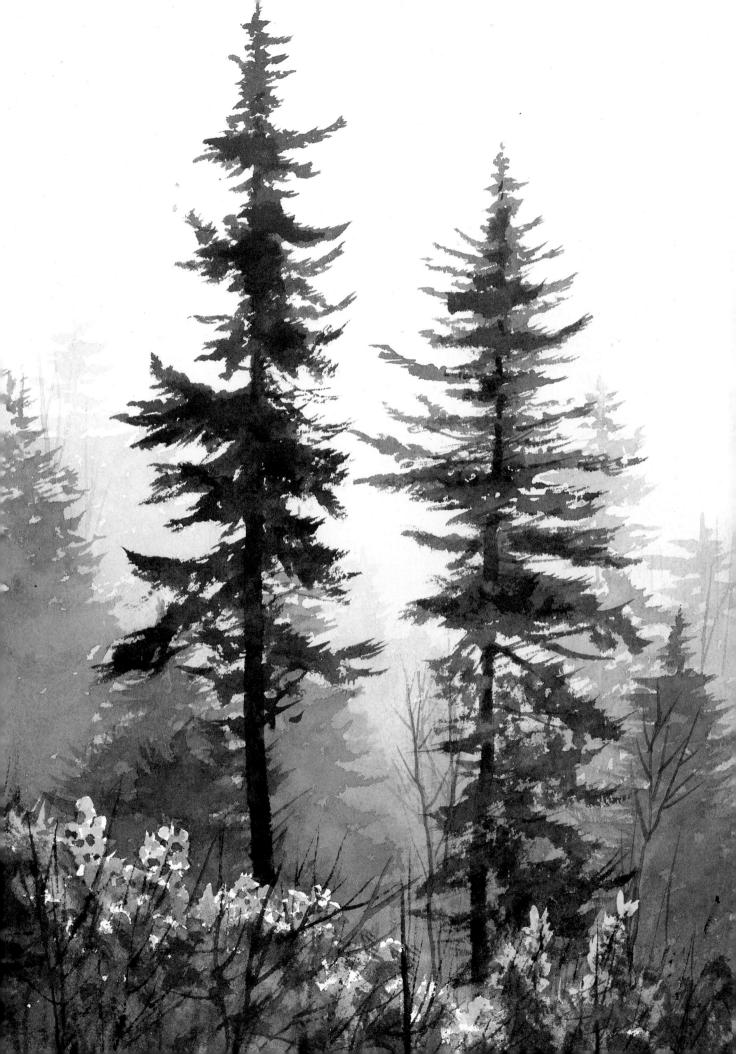

Establishing Distance Using Subtle Colors

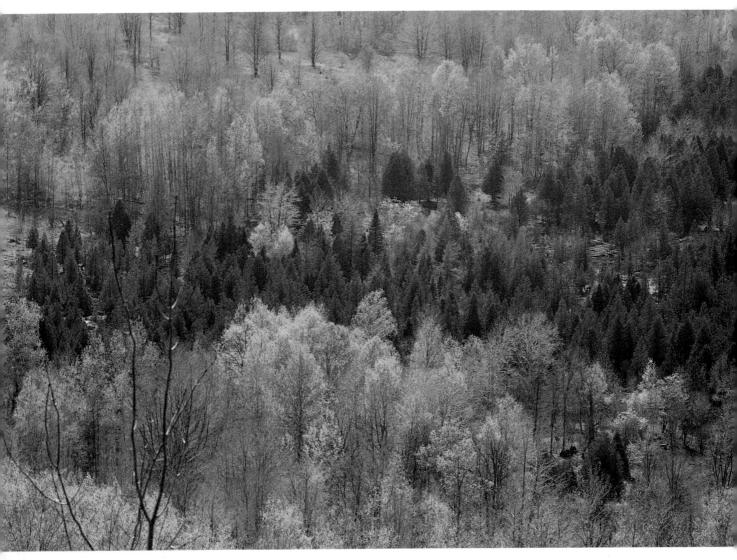

PROBLEM

Creating a sense of distance is going to be tough here. The stands of aspen are made up of very pale colors that are almost the same in the foreground and background.

SOLUTION

Since the scene breaks into such strong horizontal zones, use vertical strokes to suggest the structure of the individual trees. At the end, details will pull out the foreground.

Stands of pine and aspen spread across a spring hillside on an overcast afternoon.

STEP ONE

There really isn't much to draw here, so just mark down the divisions between the major color zones. Prepare pale washes of yellow and mauve; with yellow pick out the central portion of the painting, and apply the mauve to indicate the far distance. Working with a broad palette—here mauve, burnt sienna, yellow ocher, alizarin crimson, new gamboge, and Hooker's green light—begin developing color masses.

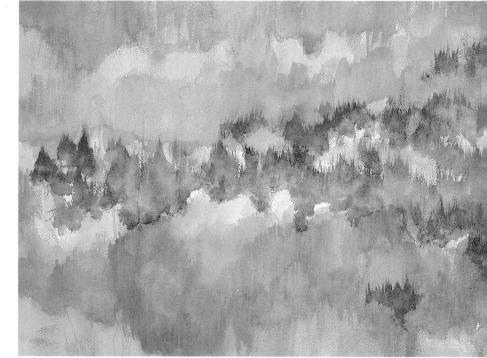

STEP TWO

Add the pine trees to the central zone. Continue to use vertical strokes and minimize detail. If this section becomes too fussy, it's going to be just about impossible to get across the feeling that it's located behind the pale aspen in the foreground.

STEP THREE

With a darker green, indicate the shadows that fall on the pine trees. This is the time to begin defining the aspen trees as well. Continuing to use vertical brush-strokes, lay down intermediate washes over the paler ones you've already established.

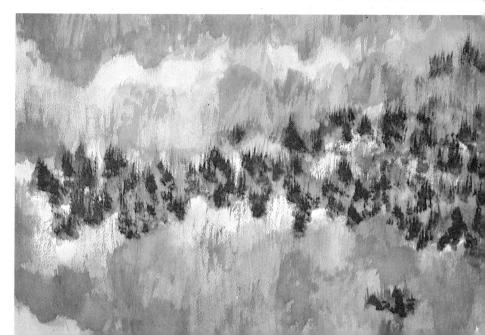

FINISHED PAINTING

To achieve the final colors, build up the horizontal color zones with washes of deeper value. Then, as a final touch, sketch in the spindly tree trunks with a lettering brush. This will give the textured effect that suggests the look of a hillside forest.

These passages of light greenish-yellow paint also help pull the foreground out toward you. Because they're more brilliant than any of the other pastel hues used, they seem closer and more immediate.

Without these scraggly branches, the entire painting would flatten out. Added at the very end, they quickly establish the foreground. Emphasizing one detail like this often sharpens all the spatial relationships that you've set up.

PINE

Capturing the Feeling of a Snowy, Overcast Day

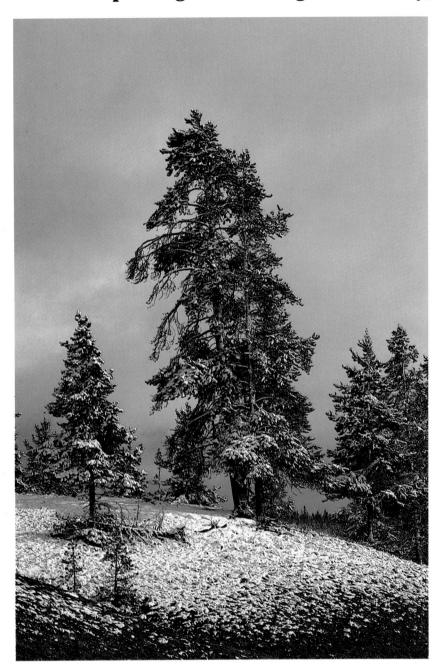

PROBLEM

Here you want to capture the mood created by the overcast sky, yet maintain the brilliance of the snow. Value relationships between snow and sky can be extremely difficult to capture.

SOLUTION

Instead of concentrating on the patterns formed by the snow, begin with the sky. To pull these two areas together, the wash used for the sky can pick out shadows in the snow.

STEP ONE

After you sketch the scene, wet the area above the horizon and lay in the sky with a graded wash. Don't feel bound to match the colors that you see exactly. Here, for example, the purplish wash immediately creates the feeling of a cold winter day. Intensify the wash close to the horizon, and put in the small trees in the background. Put down the dark brown foreground with diagonal strokes, leaving the white of the paper to indicate the snow-covered hillside.

On a cold, overcast day in winter, snow frosts a group of pines set on a hillside.

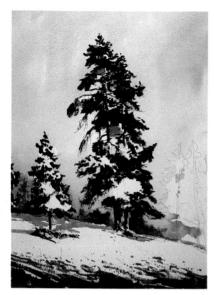

STEP TWO

Continue to develop the darkest values, painting the trees closest to the foreground. Leave some of the paper untouched to suggest how the snow hugs the branches. As you paint, simplify the shape of the tree as much as possible—there's already enough going on here.

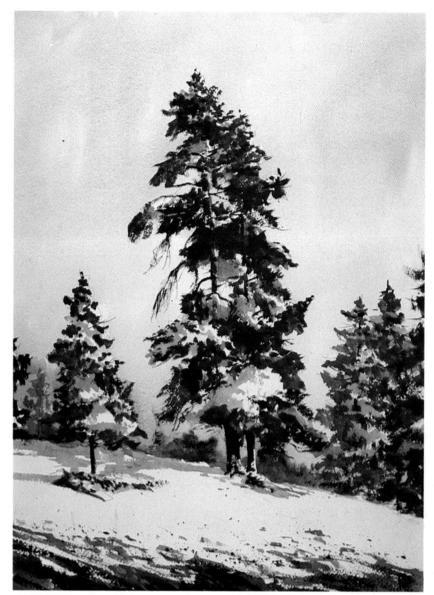

STEP THREE

Using slightly lighter hues, finish painting the trees that lie in the background. Analyze how the light reflects off the masses of snow in the branches, and paint in their shadows. As you work, keep in mind the direction of the light, building up the shadows in a logical way.

FINISHED PAINTING (overleaf)

When you look closely at the branches of the trees, you can see how many colors have been used—very few of them greens. Browns, ochers, and blues are much more resonant than most greens, and help convey the brooding quality of the purplish winter sky.

The purple wash used to depict the sky and the shadows on the ground pull the two areas together. The portions painted wetin-wet seem much softer and farther away than the area just beneath the tree.

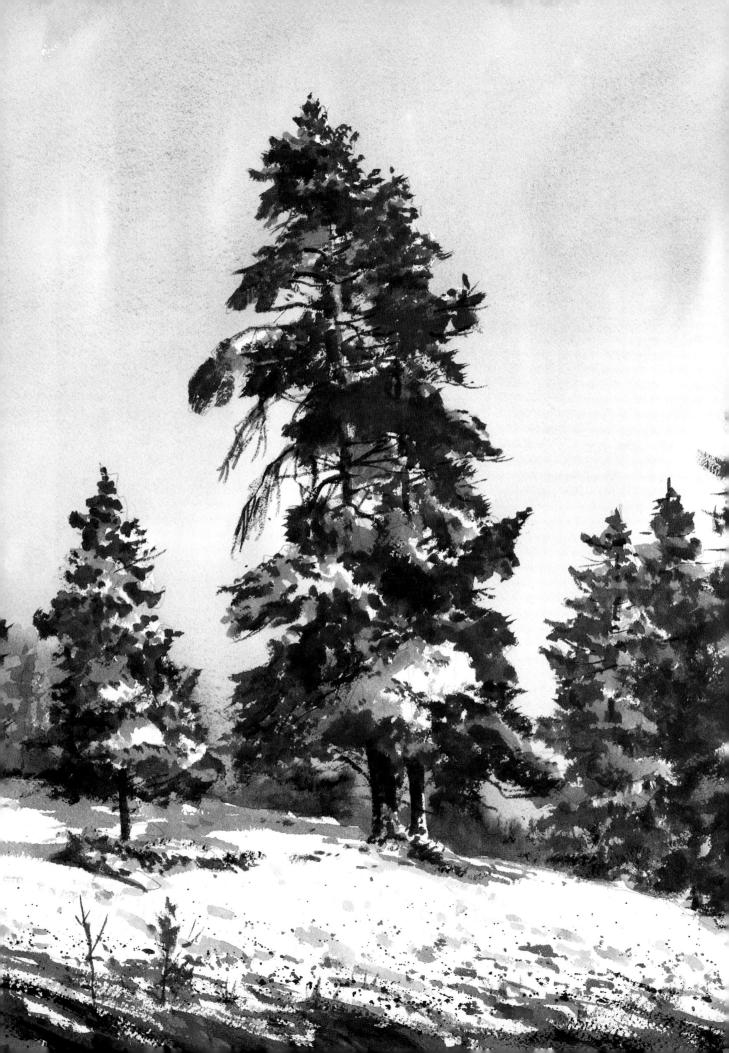

PINE NEEDLES

Using Pure White to Pick Out Patterns

PROBLEM

They're really isn't much to hang onto here. Everything in the background is soft and muted, and the pine needles in the foreground are obscured by snow.

SOLUTION

Make the snow dominate your painting. First work out the subtle gradations in the background, saving the snow for the final step.

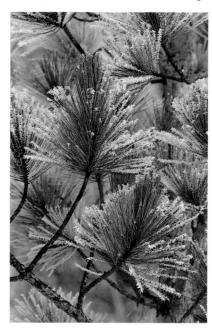

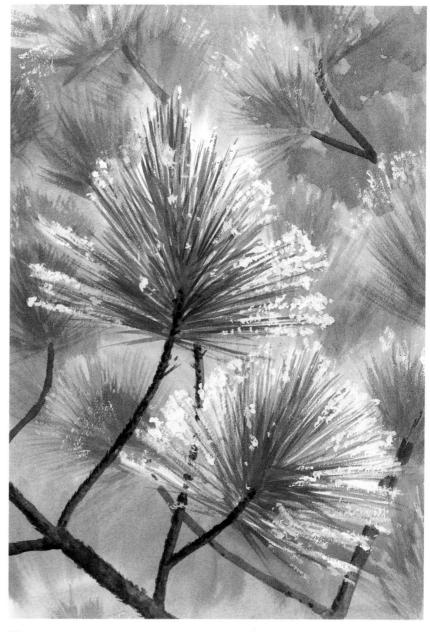

Seen at close range, these pine needles lie under a heavy, thick coat of snow. ☐ It's hard to figure out where to begin because, except for the snow, everything is closely related in value. If you look closely, though, you can see the directions in which the masses of needles move. On wet paper, lay in the background with muted colors, following the radiating pattern of needles spreading out from branches. Next, work on the dark needles closest to you.

The patterns formed by the

snow are the focus of your painting, so think them through before you begin. At first the whites seem equally important, but if you look carefully, you'll see that only those in the foreground really stand out. Paint them first, using gouache; to suggest how the snow settles, dab the paint onto the needles. For the snow in the background, use a brush that is almost dry, moving it quickly and lightly across the paper.

PINE NEEDLES

Mastering Complex Geometric Patterns

PROBLEM

Capturing the beauty of these patterns is just part of the problem. You'll also want to depict the interplay between the raindrops and the web, and achieve a sense of depth.

SOLUTION

With a complicated subject like this one, it's essential that you find a consistent approach before you begin to paint. Figure out how the needles have fallen. You'll want to paint those on the bottom—the darkest ones—before you move close to the surface. Mask out the lightest needles, then develop the dark background.

☐ When you begin to paint the complex background, you'll quickly discover that it's impossible to depict everything that you see, so concentrate on rich color. Keep the darkest areas near the corners of the painting: in the center, use cool, muted tones. For the intermediate values—the orange-brown needles beneath the very lightest ones—use gouache; its opacity provides a strong contrast to the transparent quality of the needles resting on top. Work loosely, constantly following the pattern that the needles form. Next, remove the masking fluid and lay in the lightest needles. Start with pale washes, gradually adding detail. Finally, broken dabs of bright white gouache suggest the shimmering raindrops that rest on top of the web.

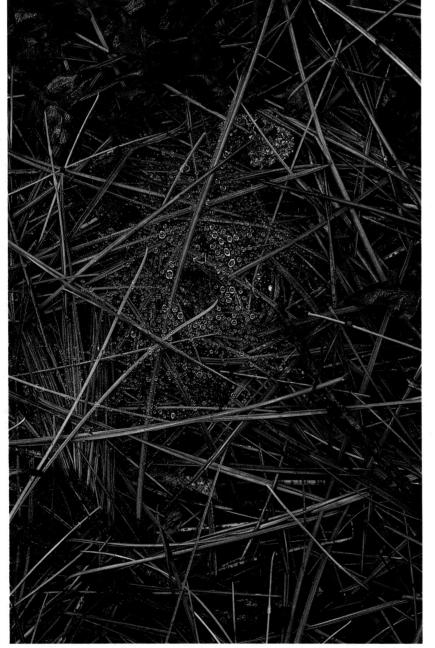

NOTE

Observe how the complex layering of darks and lights works in this painting. The brightly colored needles that were masked out first spring into focus; painted with clear, brilliant green and yellow, they rest on top of the orangish-brown needles rendered in gouache. At the very bottom, the murky deep brown successfully conveys a feeling of depth.

Raindrops hover on fallen pine needles and atop a delicately woven spider's web.

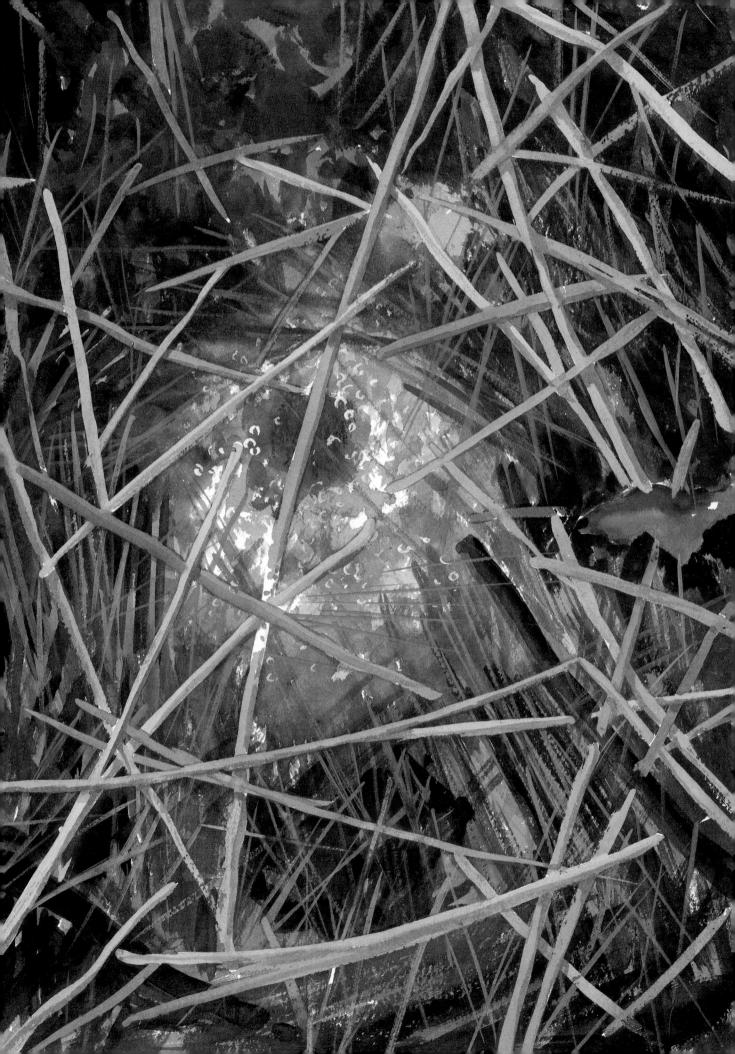

Painting a Complicated Scene Set Near Water

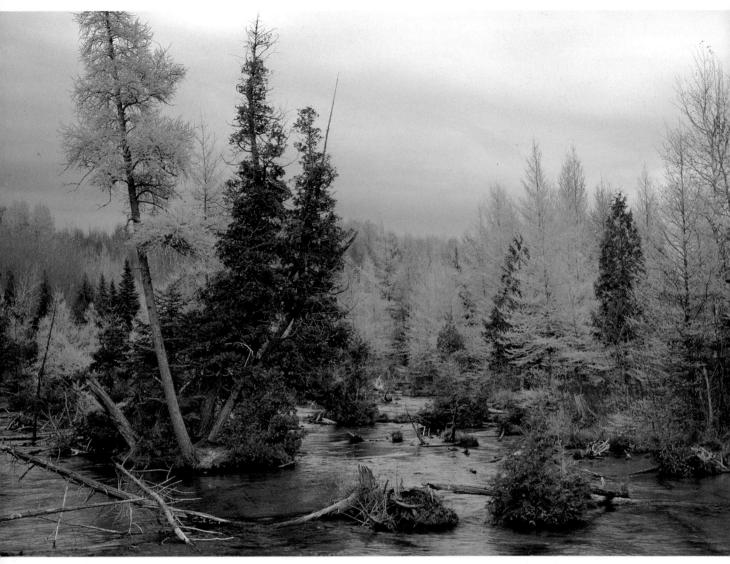

PROBLEM

Sometimes there's so much happening in a scene that you don't know quite where to begin. That's true here—there's an overcast sky, radiant fall foliage, and the water.

SOLUTION

Complicated scenes like this are easiest to handle using a conventional light-to-dark approach. Paint the sky first, then the background and foreground.

Close to a river's edge, larches crowd together, casting their reflections in the water.

STEP ONE

When a scene is this complex, sketch it fairly carefully, indicating all the major parts of the composition. Since the cool, overcast sky is so important in establishing mood, set it down first. Wet the entire sky, then begin at the top with the lightest areas. Add blue near the tree tops while the other washes are still wet. Next, after the sky washes have dried, paint in the light orange trees and set down a mauve wash behind them to suggest the distant landscape.

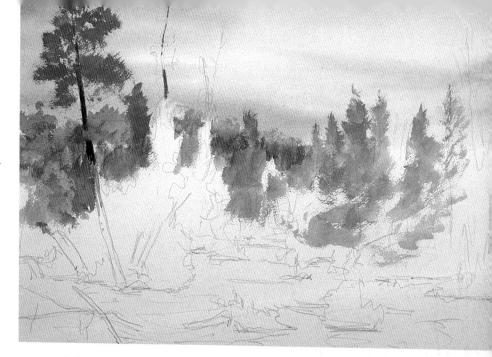

STEP TWO

As you begin to introduce darker values, try using a lot of mauve and gray to paint shadows and details—these colors strongly suggest the smoky quality of an overcast day. After the middle values are laid down, paint the dark green trees near the water.

STEP THREE

Before you start painting the river and the reflections in the water, add detail and texture to the trees. Look closely at the values you've established; often you'll find an area you've neglected that seems too light or too dark. Here, for example, the mass of trees on the right was too light. Darkening them helps balance the rest of the painting.

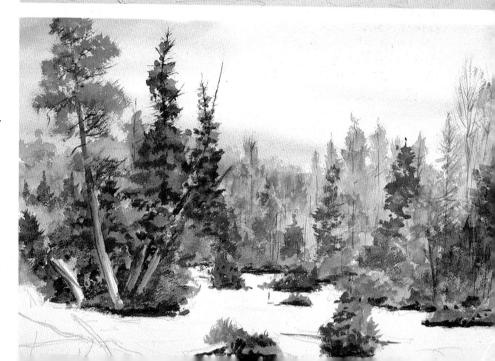

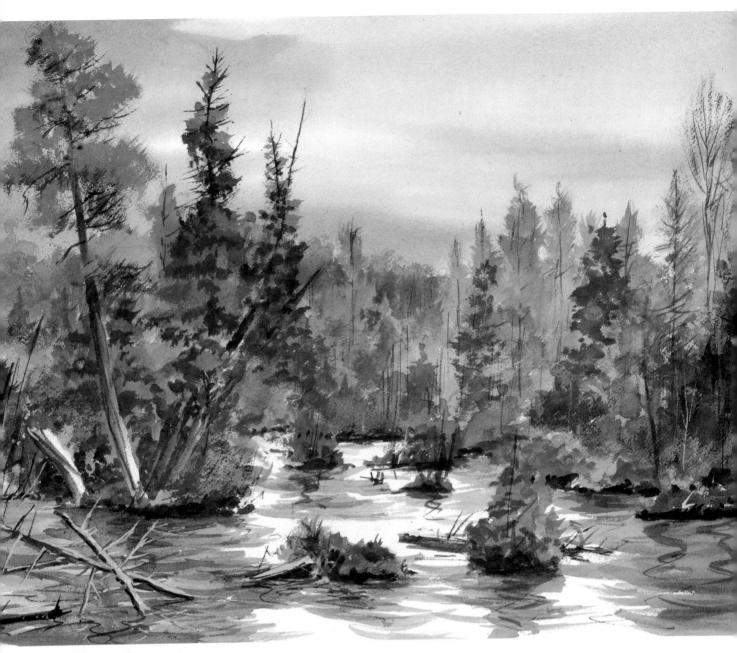

FINISHED PAINTING

Almost everything that makes this painting work happens in its final stages. Look at the painting and the photograph of the scene on the previous pages to see how important your interpretation of a subject is. In the photograph, the water is really pretty much the same color throughout, but if you paint it with a uniform wash, you're going to weigh your painting down. Instead, try and figure out what the painting needs to keep it alive. Here a lot of white

paper is left exposed. This not only sharpens the perspective—the white area zooms back toward the horizon—but it also suggests how the sun and water interact. To indicate the areas of water to the left and right of the white area, use a wet-in-wet technique, laying down a smoky wash first. Then, while the paper is still wet, paint in the reflections. Finally, in the lower left corner paint in the branches of the dead wood.

ASSIGNMENT

The way you handle water can determine how a finished painting looks, even when it's just a minor element in a composition. To discover its power, select a scene where the water is almost incidental, such as a quiet stream surrounded by groups of trees.

First, paint the landscape as literally as possible. Next, render everything except the water in the same fashion; then begin to play around with your treatment of the stream. Use several approaches, experimenting with the different effects.

LARCH NEEDLES

Rendering Intricate Macro Patterns

PROBLEM

It takes a lot of curiosity and creativity to detect the myriad patterns that lie in minute objects, and a bold touch to paint them like the giants they really are.

SOLUTION

It's all too easy to become tense and tight when you're painting something tiny. To stay loose, a good preliminary sketch is essential. Take a lot of time drawing the outlines of the needles before you begin to paint. Work on a large sheet of paper and magnify your subject several times.

Not much more than an inch long, these frost-encased larch needles create an overpowering impression when seen up close.

You'll never be able to paint around the complex pattern formed by these needles, so mask them out when you've completed your sketch. The needles are so lively that you'll want to downplay the background—use a flat wash. Wet the paper with a sponge, then drop in ultramarine and yellow ocher, working the paint over the surface of the paper. Once you've removed the

mask, begin to paint the needles. Here they're rendered in yellow ocher, cadmium orange, and Hooker's green, with just enough white areas left clean to suggest the frost. In some places, the pure white paper may seem too brilliant, and may even detract from the power of the needles. Use a wash of cerulean blue to tone down the discordant areas.

SAGUARO CACTUS

Capturing Light and Shade in Macro Patterns

PROBLEM

The dramatic pattern these spines etch out seems simple at first, but it's really made up of a complex play of light and dark. If your contrasts aren't bold enough, your painting won't have any life.

SOLUTION

Paint all of the darks first, then pick out the lights using gouache. To convey the needlelike feel of the spines, your brushwork must be strong yet precise. Start by painting the background, both the light vertical ridges and the dark areas that lie between them.

The sharp gray spines of a saguaro cactus shoot out from its thick, succulent trunk. ☐ These spines are growing out of thick, columnlike ridges that protrude from the saguaro's trunk. To make this relationship clear, paint the trunk a little lighter than it actually is; if it's too dark it will recede and the spines will seem to be dangling on threads against a dark, distant backdrop. Vary your greens a little too, to suggest what you can't really see, the texture of the trunk.

Next, lay in the dark bumps in the center of each group of spines; then wait until the paper's dry before you tackle the spines. The success of your painting is going to rest on how well you capture their light and dark patterns, so work with just three values—one light tone, one middle one, and a dark. Finally, add a few spines with a dry brush, then apply a blue wash to cool down the shadows that flitter over the spines.

SAGUARO CACTUS

Picking Up Patterns Formed by Middle Values and Highlights

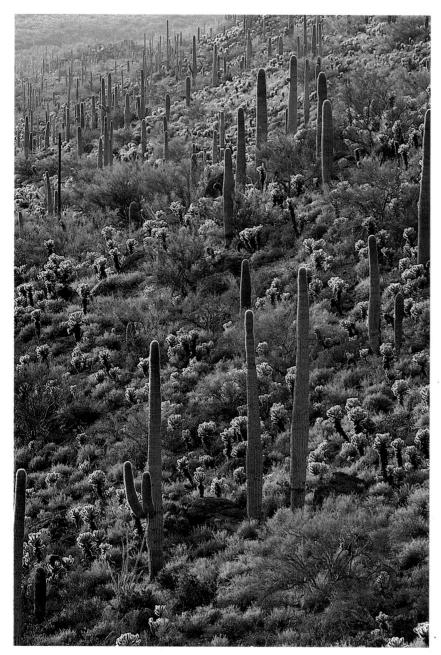

PROBLEM

This is an awfully confusing scene. Even though there are lots of strong verticals and light areas, they create very little pattern, making it hard to organize a painting.

SOLUTION

About the only way to make this kind of scene work is to focus on what you see and capture whatever pattern exists. Concentrate on highlights and try to figure out the pattern they form.

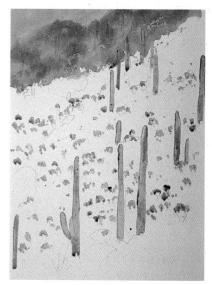

STEP ONE

To convey the time of day and the direction of the sunlight, rely on highlights. Mask these highlights out as soon as you've finished your sketch; if you paint them last you can control their brilliance. Now move on to the hazy area in the upper left corner. Instead of using a flat wash, develop this area with a variety of values and colors to suggest texture.

Late in the afternoon in the Sonoran Desert, these saguaro cacti and the flowers beneath them stretch as far as the eye can see.

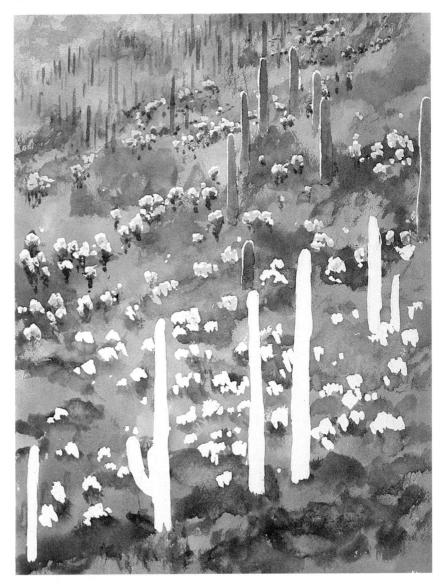

STEP TWO

Working from light to dark, build up the entire surface of the painting. You're working mostly with middle values here. To keep them from seeming bland and uninteresting, continue to use a variety of colors as you explore the subtle gradations of light and dark that you see. What's important here is catching the pattern that the lights and darks create.

STEP THREE

Remove the masking fluid. As you begin to paint the cacti and flowers, remember to leave the areas that catch the afternoon sun white. What you're setting up is a strong feeling of backlighting. The cacti in the foreground are worked with a slightly deeper value than those that lie behind them.

FINISHED PAINTING

Painted with cool, hazy colors, the cactus-filled background is separated from the middle ground by a diagonal ridge of flowers. But the division doesn't seem artificial since some of the cacti that are rooted in the middle ground extend up into the rear zone.

Like the rest of the painting, most of the detail in the foreground is worked in a range of middle values. Yet even though few strong darks or lights are employed, a rich and interesting texture is achieved by breaking up all the masses of color with lively brushwork.

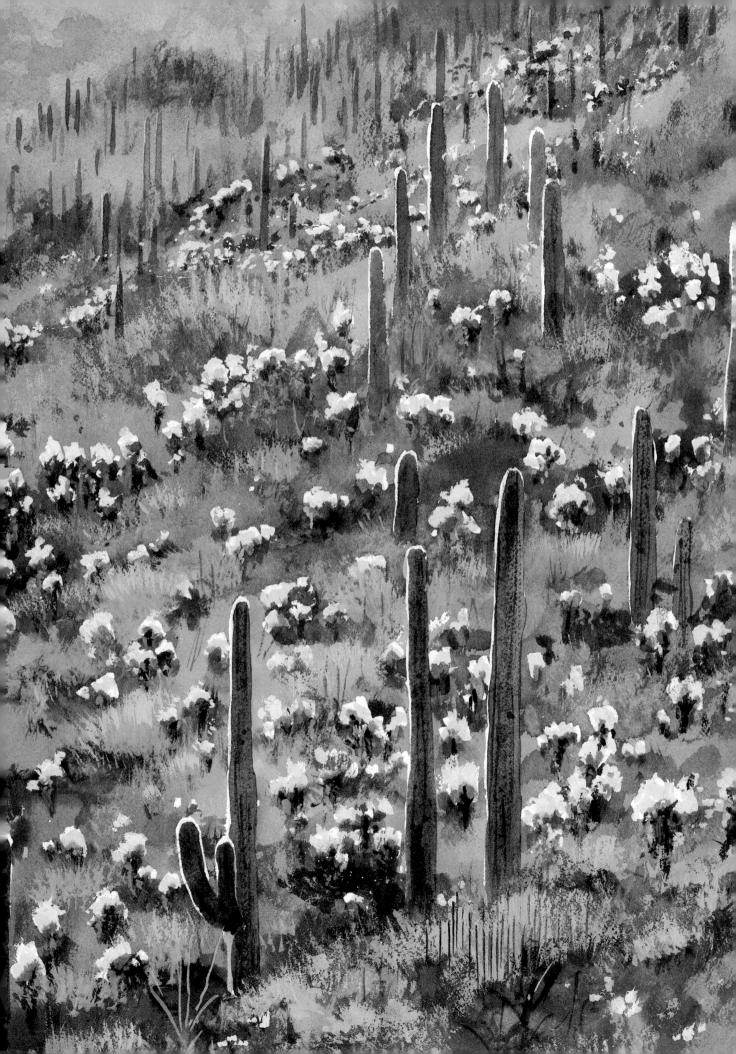

Suggesting the Lacy Feeling of Delicate Foliage

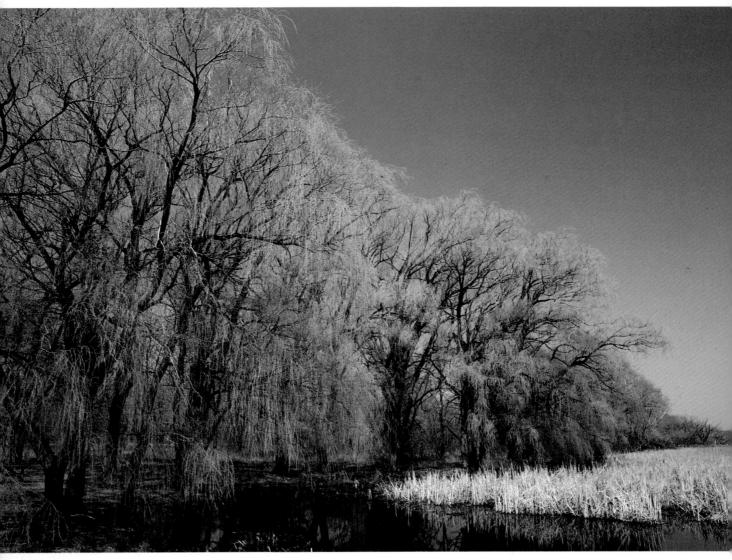

PROBI FM

Weeping willows are large and massive, yet their branches and leaves are soft and graceful. Capturing these qualities simultaneously is tough.

SOLUTION

Before you paint the delicate leaves, work out all the other elements. The foliage can be added last, using opaque gouache.

Set against a deep blue sky on a spring afternoon, these weeping willows sweep back dramatically toward the horizon.

STEP ONE

First sketch the scene, then lay in the sky with yellow ocher, ultramarine, and cerulean blue. Although at first the sky appears to be fairly uniform in color, note how it becomes lighter gradually near the horizon; use a graded wash to show this progression. Work quickly; if the paint is applied slightly unevenly it will appear more lifelike.

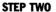

When you're looking at a scene like this, it can be hard to see beyond the most obvious elements, the trees in the foreground. Try to pick out the most distant masses first, then paint them using cool colors. Next, develop the foreground; it will be the darkest area in the painting, and, consequently, will do a lot to establish your value scheme. You don't have to wait until you've painted the trees to put in their reflections; go ahead and paint them now.

STEP THREE

As you start to depict the trees, concentrate on the trunks, the largest branches, and the large masses formed by the leaves. It's especially important to simplify when you're working with something as delicate as a weeping willow, for you'll never be able to show every little detail.

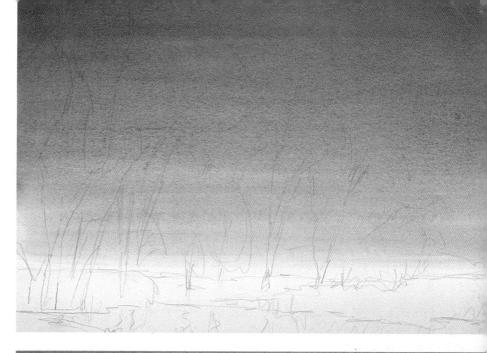

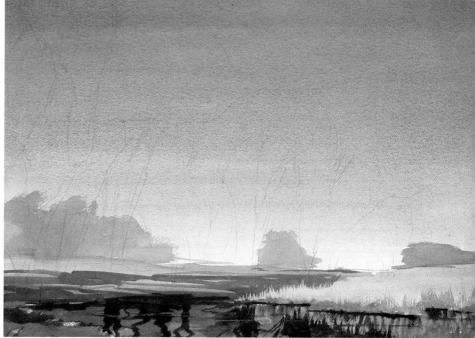

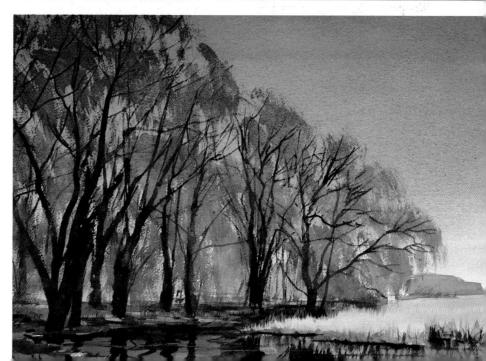

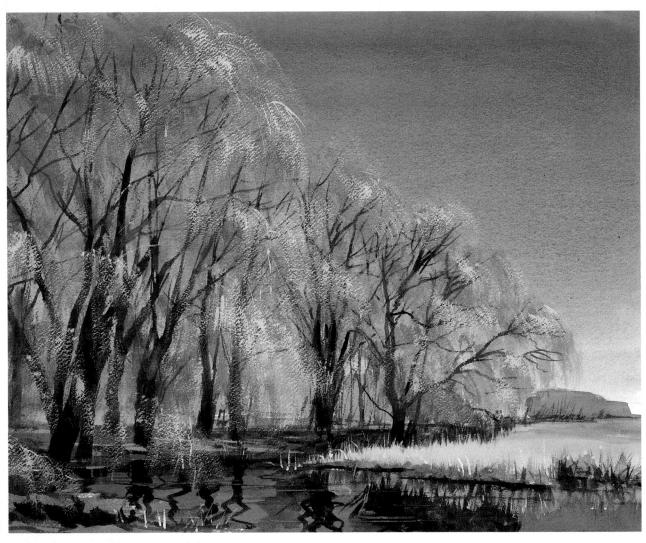

FINISHED PAINTING

Now's the time to emphasize the willow's lacy quality. Since so much of the subject's appeal comes from the way the weight of the foliage bends the branches down, be sure to indicate how they sweep toward the ground. Use a fine brush: moisten it with gouache, then delicately run it across the paper. When the foliage is finished, make any necessary refinements. Here, for example, the tree trunks need to be darkened slightly. Many different types of brushstrokes are used in this painting, ranging from those depicting the fine marsh grass to those showing the bold reflections of the trunks in the water. Note, too, how successful the drybrush technique is in showing the lacy quality of the willow branches. The drybrush

strokes also lighten the fairly heavy trunks; the structure of the trunks is still obvious, but the cascading yellow and green touches veil them, making them less dominant.

DETAIL

When you move in on a detail like this tangle of trunks, branches, and leaves, you can see how important it is to simplify a complicated subject. Through simplification, the overall pattern formed by the weeping willows becomes apparent. When you are working on something as complex as this scene, stop frequently and evaluate your painting. Try to determine when you have achieved a pleasing degree of complexity, then stop before the subject becomes too fussy.

ASSIGNMENT

Select a tree like a weeping willow, one with delicate, trailing branches. You needn't worry about the sky or the foreground; just concentrate on the structure of the tree. What you'll be doing is much the same as dressing a mannequin.

First paint the trunk and the major branches. When they're dry, apply a dull green wash to indicate the areas where the leaves mass together. Note how the transparent watercolor softens the dark branches. Finally, experiment with gouache. Use a drybrush technique; note how the strokes break apart as the brush moves over the rough paper, revealing the underlying layers of watercolor.

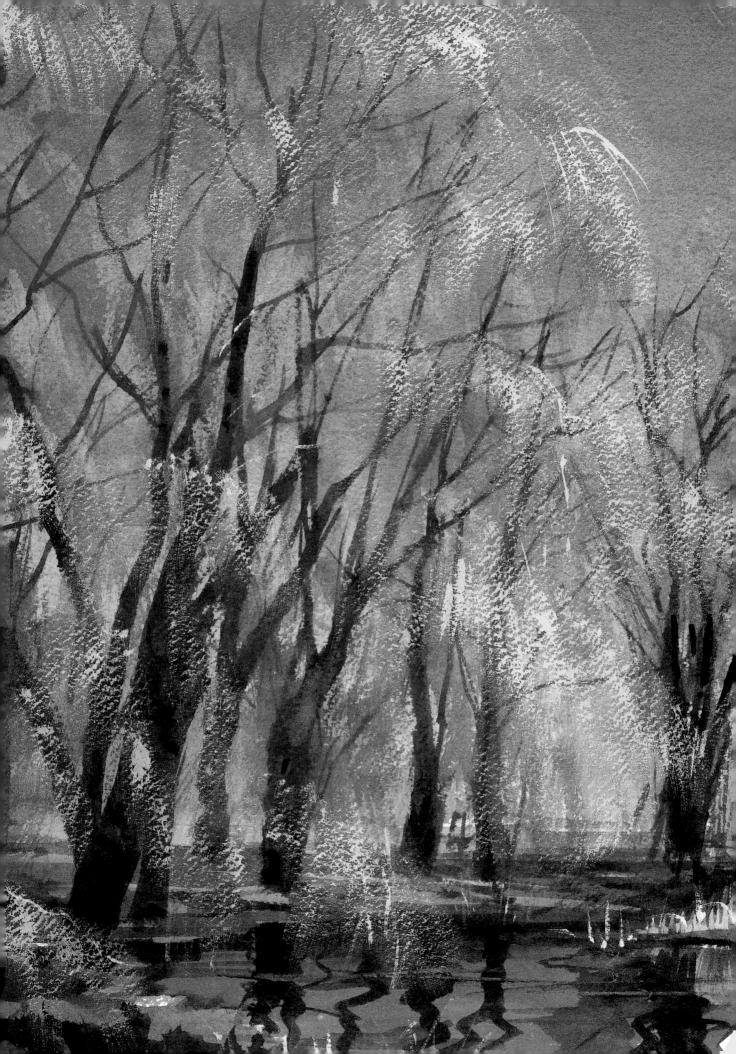

Manipulating Color and Structure to Achieve a Bold Effect

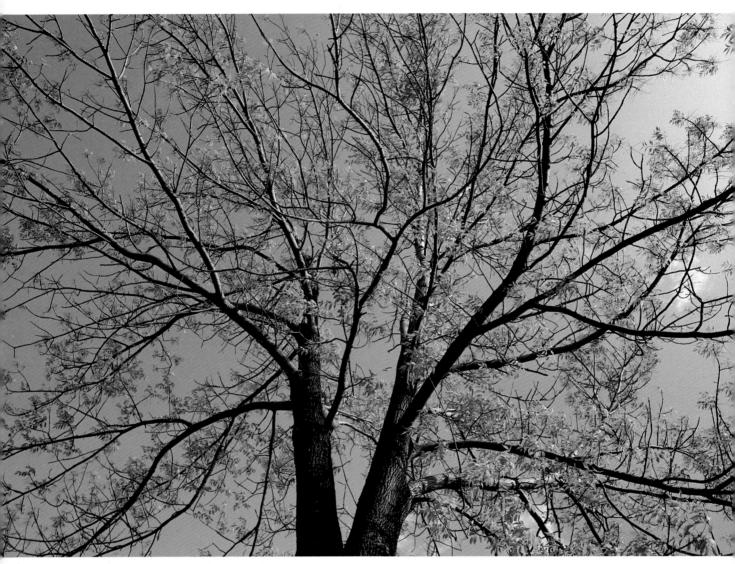

PROBLEM

Don't underestimate the power of what seems at first to be a fairly tame subject. You have to do more than simply paint what's in front of you—you've got to interpret it.

SOLUTION

A good part of the solution lies in composition. Make the crown shoot boldly beyond the edges of the paper, then intensify the strength of the branches and leaves, and lay in a bold sky.

Seen from below, the wispy branches and tender leaves of this tall white ash stand against a slowly moving sky.

STEP ONE

Draw the tree, concentrating on the main branches and the way they move out toward the edges of the paper. Next, analyze the sky. Unless a sky is filled with dramatic clouds, most people read it as flat blue, but, in fact, its color can vary a great deal; here it's most intense on the left. To render it, turn the paper on its side, and put down a graded wash.

STEP TWO

After the sky wash has dried, paint in the trunk and then start in on the branches. Selecting the right kind of brush makes all the difference when you're rendering delicate lines. Try a lettering brush or a rigger; both are very thin brushes that are ideal for this kind of work. Be careful, though; these brushes—especially the rigger—can be difficult to control. Experiment with them before you start to paint.

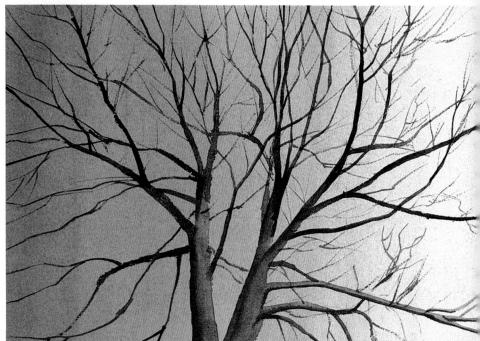

STEP THREE

Analyze the way you've treated the branches. They should look logical—that is, they should relate to one another, with none starting suddenly in midair. Make any necessary corrections, then tackle the leaves. Using gouache, dab paint forcefully onto the paper. Use an old brush, or even a sponge, for this rough work.

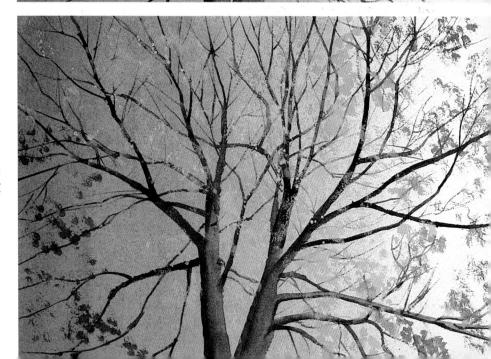

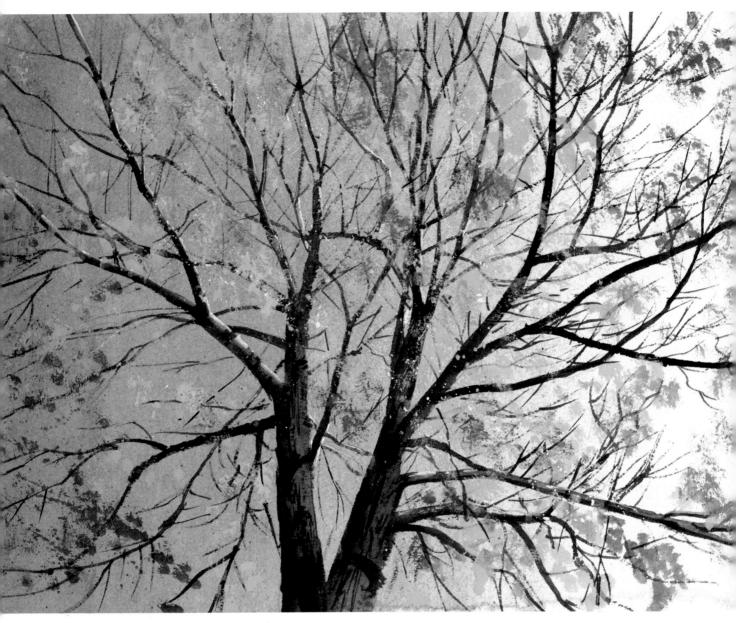

FINISHED PAINTING

Pick up the rigger again and fill in the tiny branches between the larger ones and then add texture to the tree trunk. Finally, spatter a few bright dashes of yellowishgreen paint over the leaves to make the center of the painting come alive.

ASSIGNMENT

When you're painting trees, you'll discover that every season has its own problems. In spring, when foliage just starts to appear, the leaves are rarely dense enough to form masses. If you paint them in too heavily, you'll lose the suggestion of fresh, young growth, but if you're too tentative, your painting will lack spunk.

Begin by painting the skeleton of a tree—its trunk and branches. Just use one color here, and don't be too concerned with accuracy. Next, take bright green gouache and begin to paint. Try a variety of approaches. With an old brush, dab the paint onto the paper, varying the paint's density and the size of your strokes. Next, try a drybrush technique, and take advantage of the paper's bumpy surface to break up your strokes. Finally, experiment with a small sponge. First soak it with paint and dab it onto the paper, then try it when it's fairly dry. After you attempt each technique, stop and evaluate the effect.

ASH

Making a Delicate Tree Dominate a Cloud-filled Landscape

PROBLEM

This ash could easily get lost in your painting. Its branches, twigs, and leaves are so fine that they hardly show at all against the cloudy sky.

SOLUTION

To achieve the effect you're aiming at, play around with colors and values and even with the structure of the tree itself. Emphasize what has to be strong and downplay what seems overpowering. Begin with the sky, then do the background and foreground, saving the tree for last.

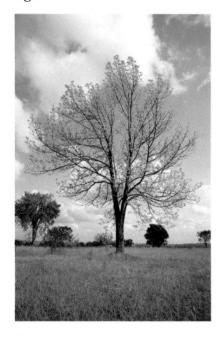

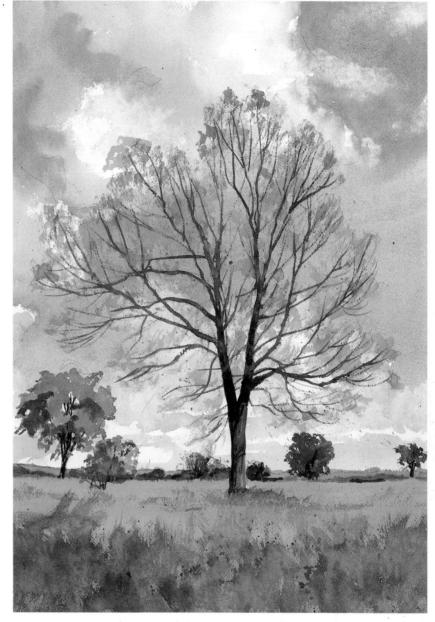

Its springtime foliage just beginning to appear, this white ash rises against a cloudy sky.

☐ The first step toward making this tree dominant is lightening the sky. As you lay in your wash, work around the clouds, then go back and soften the edges of the cloud masses using a brush dipped into clear water. You'll want to capture the shadowy portions of the clouds next; use a gray wash, then soften the contours with clear water.

Next tackle the background and foreground, keeping them simple,

with a minimum of detail. The only unusual thing that happens here is the emphasis placed on the ocher grass behind the tree. By making it brighter than it actually is, you pull the viewer's eye away from the sky and right to the base of the tree. Use license with the tree, too, darkening its branches just a bit. Finally, to add the leaves, dab paint gently onto the paper.

Working with Foliage Set Against a Dark Blue Sky

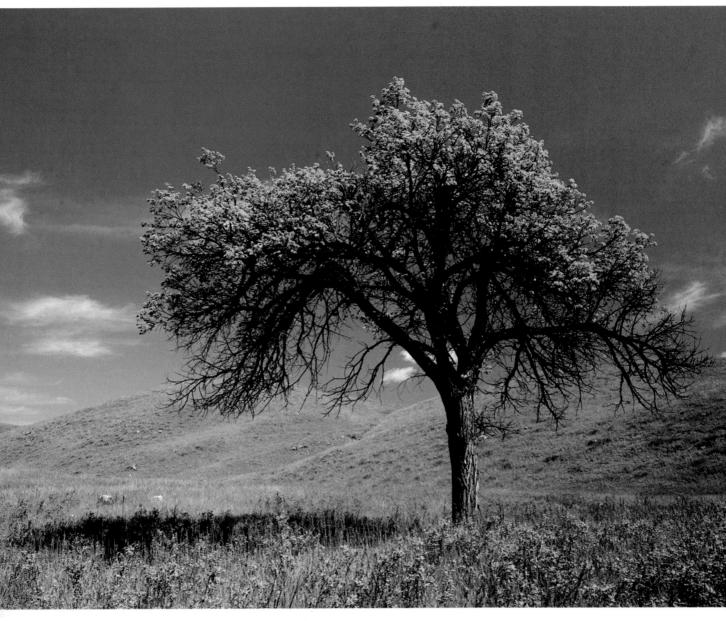

PROBLEM

Since the sky is so important here in establishing the mood of the scene, you'll want to emphasize it, but not at the expense of the tree.

SOLUTION

Go ahead and paint the sky as you see it. By adjusting the values of the greens, you'll be able to make the tree stand out against the dark blue. Because you're trying to increase the drama of the tree and sky, use a simple straightforward approach for the prairie and the hills.

☐ To capture the intense blue at the top of the scene, use pure ultramarine. As you near the bottom, temper its strength with cerulean blue. While the paint is still wet, take a tissue or small sponge and wipe out the clouds, then add their highlights with white gouache. When the blue wash has dried, render the hills and foreground with flat washes of yellow-ocher, Hooker's green, burnt sienna, sepia, and mauve, then go back and lay in a little

A rich blue sky, filled with meandering clouds, sets a dramatic stage for this handsome elm.

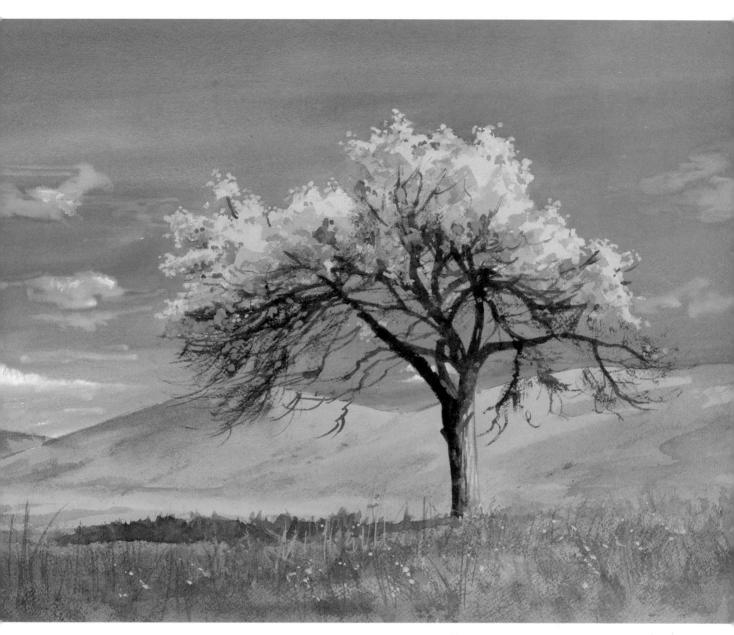

texture and shadow. For the tree's bright foliage, you'll need a strong middle tone to make the leaves stand out against the sky. Dab the paint on, trying to capture how clusters of the leaves cling to the branches. To indicate the shadowy areas on the leaves, use paint just one value darker. Next, render the trunks. Finally, to clarify what's close and what's far away, put in the tall grasses in the foreground with a fine brush.

ASSIGNMENT

Don't be afraid to use strong, dramatic color when a situation calls for it. It's surprising how intensely watercolor pigment can be applied before it loses its transparency.

To learn the limits of the medium, try painting a dark tree trunk. First sketch the trunk, then moisten the paper with clear water. Drop sepia, burnt sienna, and Hooker's green light onto the paper, mixing the colors as you work. Use a lot of pigment, and experiment with varying its density.

In some areas, add a little water to the paper to dilute the paint; in others, apply the paint straight from the tube. You'll discover that only when you use pure, thick, undiluted pigment do you lose the transparency that characterizes watercolor paint.

ELM

Learning to Work with Strong Blues and Greens

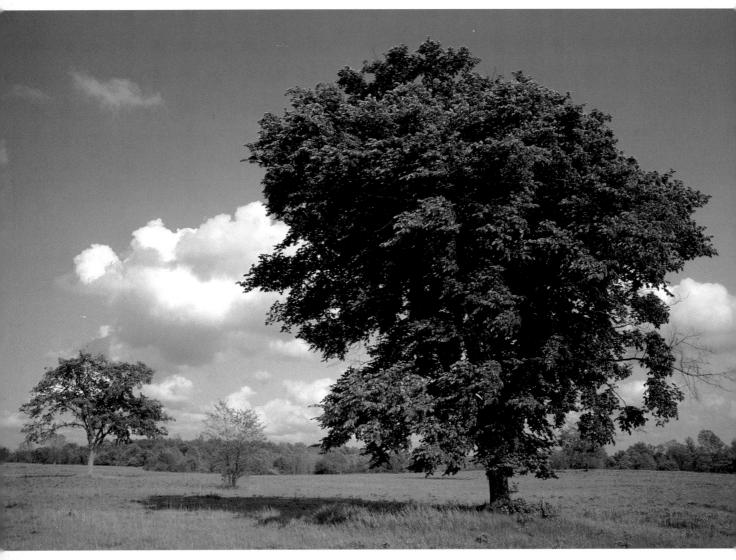

PROBLEM

Deep blues and greens like those seen here go together so naturally that it's easy to forget the problems they pose. They have to be treated with care because their values are so very close together.

SOLUTION

Paint the sky first, then balance the greens you use against it. You'll want to use just a few shades of green in order to keep the picture simple and fresh.

An elm in fresh springtime foliage harmonizes with a deep blue sky.

STEP ONE

Sketch the basic lines of the composition; then begin to paint the sky, leaving white paper to indicate the smaller clouds. Work around the tree in the foreground without being too fussy; eventually the green will cover whatever bits of blue stray into the area of the crown. Next, using pale washes, execute the dramatic cloud formation. Keep the clouds soft; get rid of any harsh touches right away using a brush dipped into clean water. Finally, paint in the trees that lie along the horizon.

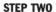

In late spring or in summer, trees like this are fairly easy to capture in paint. Their leaves have pretty much filled out and they form clear-cut masses. Before you begin, think through the main masses you see in the crown. Start with the lightest areas, using just two or three slightly different washes, all based on one green pigment. The key to this step is to keep the masses simple. Next, using broad, sweeping strokes, add a light wash to indicate the ground. While it is wet, start developing the shadow cast by the large elm. Next, add the tree trunk.

STEP THREE

Just as you did in step two, analyze the way the lights and darks in the crown break up before you start to add the dark shadows, and as you render them, continue to use bold, simple strokes. Next, turn your attention to the foreground. Put down the darkest part of the shadow cast by the tree, then indicate the tall grass growing right in front of the elm. For the grass, use short, up-and-down strokes.

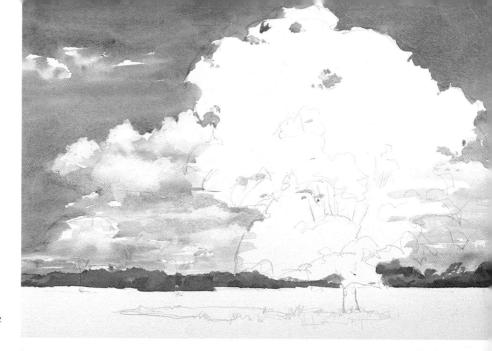

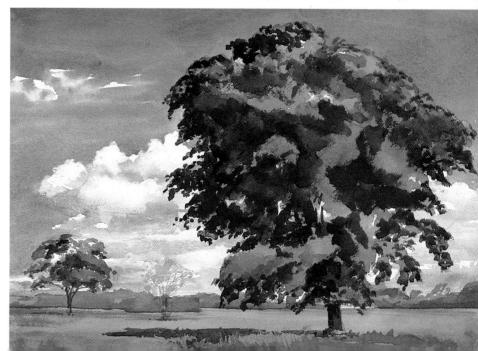

FINISHED PAINTING

In completing your painting, work sparingly. Too much detail now will get in the way of the fresh, uncomplicated scene you've developed. Here spatter small touches on the foreground, add a few fine branches to the large elm, and intensify any shadows that may seem weak.

Here dabs of green break up the monotony of the large dark areas. But since the dabs are in the same color as some of the medium-value green, applied in step two, they don't interfere with the overall harmony of the finished painting.

These clouds are dramatic, yet—they appear restrained and don't fight for attention with the rest of the picture. This is, in large part, because of the strong statement the elm in the foreground makes. Its simplicity makes it much more powerful than it would be were it filled with intricate detail.

The spattering applied at the very end is also restrained. Just enough has been added to pull the foreground toward the viewer.

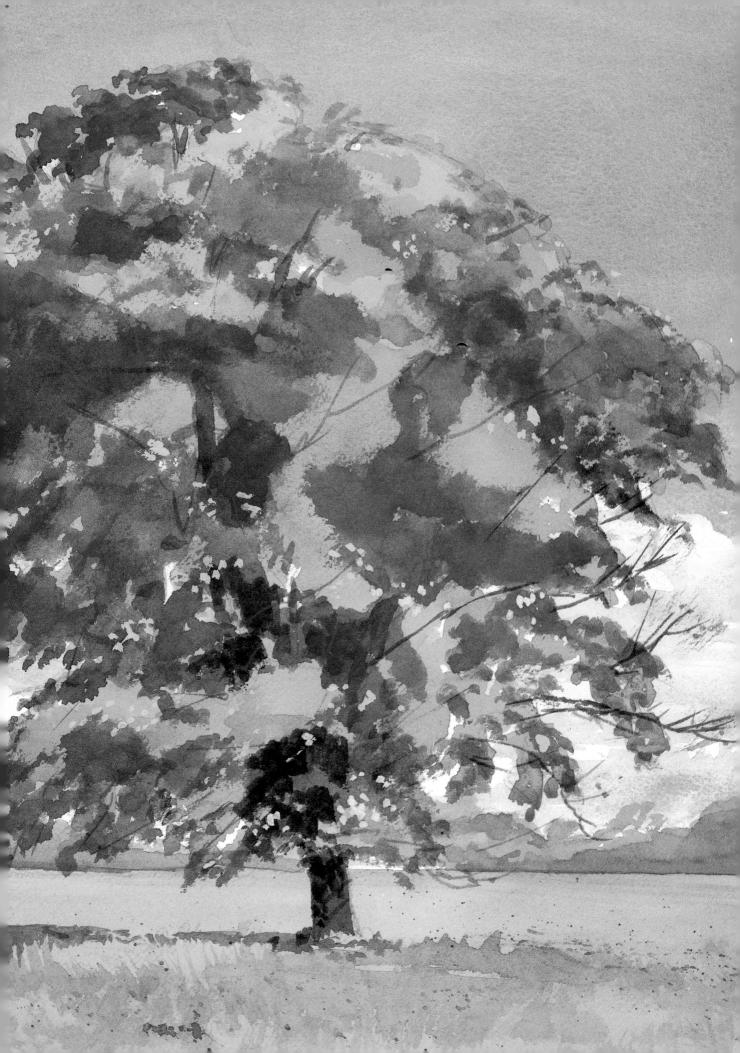

BLACK OAK

Learning to Focus in on a Landscape

In a field of prairie grass on a September afternoon, these black oaks dominate the landscape.

PROBLEM

Here we've moved in fairly close to the scene, so close that the trees and grass form an almost abstract pattern against the patches of sky.

SOLUTION

Try to minimize the places where the sky shines through the foliage, but don't eliminate them altogether. If you do, your painting will be heavy and dead. For control, use the traditional lightto-dark approach.

STEP ONE

In a situation like this, packed with dark masses, you've got to learn to look beyond what's in the foreground. Temporarily forget the trees and focus on the sky. Since so much of the composition is taken up by the dark trees, vou'll want some bright passages to shine through. In the upper right corner the sky is almost imperceptibly darker than below and to the left. For the lightest parts, just leave the white paper alone. Along the horizon line, lay down the distant trees. Here fairly bright colors are used; they'll be subdued by the washes applied later.

STEP TWO

Now start developing the tree masses in the rear and the fore-ground. First lay in the brightest areas, then gradually add darker washes, saving the very darkest for last. Since the trees and the prairie grass fill almost the entire scene, don't just concentrate on one area; work over the whole surface. As you paint, remember to simplify the leaf masses. Their lacy quality will be suggested by bits of sky.

STEP THREE

As you begin to paint the large tree in the foreground, slowly increase the value of your greens. First, work with a green just slightly darker than those you've used previously, then continue to use darker shades. The final ones will be as dark as the tree trunk. Next, turn to detail. Using a fine brush, add the small twigs. Work rapidly, letting just the tip of the brush skate over the paper. Continue using a fine brush to indicate the grasses in the foreground.

FINISHED PAINTING

The grass that lies under the trees in the foreground is a little weak and has to be darkened. That done. all that's really left are touches of light green detail in the foreground. As a last touch, a few spatters of bright vellow in the lower right corner suggest a group of wildflowers.

DETAIL ONE

A detail like this points out how strongly greens affect the way we see other colors. The patches of white look fairly stark when they're isolated as they are here, but seen in the context of the whole painting, they appear pale blue. The passages in the background that were painted in step one no longer seem bright; the strong greens have subdued them.

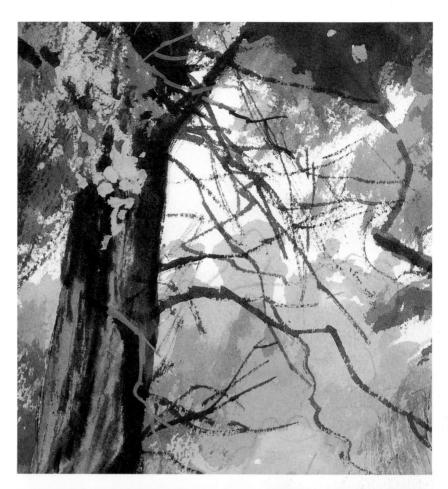

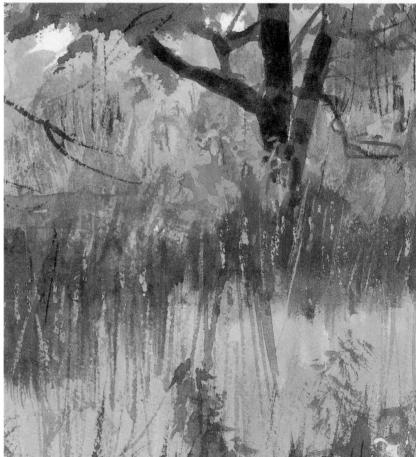

DETAIL TWO

Here's another example of how different colors work with green. The tips of the prairie grass are painted with peach, a color that falls roughly opposite green on the color wheel and that consequently enhances it. Using complementary colors like this is a good way to add accents to a painting that seems too monochromatic.

WALNUT LEAVES AND BARK

Working with Contrasting Textures and Colors

PROBLEM

Two elements are fighting for attention and have to be balanced: the rough texture of the walnut bark and the graceful leaf patterns.

SOLUTION

Capture the patterns the leaves form with a careful sketch, then go to work on the bark. Develop its texture completely and then turn to the leaves.

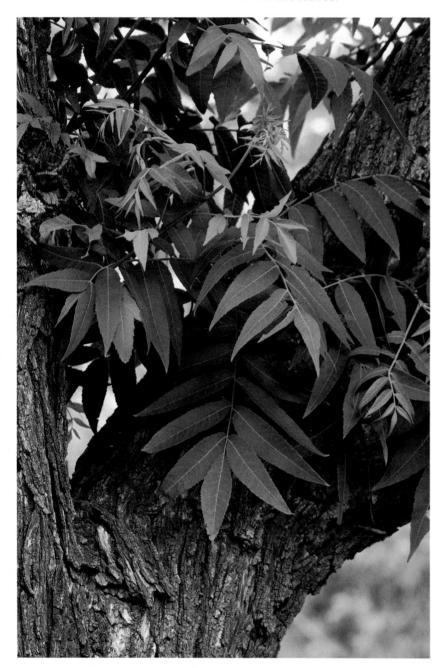

One of the basic decisions you have to make when you work with watercolor is when to mask out an area. As a rule, it's only necessary when you want to keep a clean, crisp edge. Here, the bark is so roughly textured that it won't matter if the leaf edges are a little indistinct, so masking isn't important.

To capture the bark's coarse, uneven texture, use all the techniques you can muster. Start with a wet-in-wet approach, dropping in shadows and rough passages, then begin to experiment. Although it wasn't necessary here, if you want you can scratch some areas out with a razor or smear the paint with your finger or a piece of cloth.

Rendering the leaves is easy because of the effort taken with the preliminary drawing. Start with the darkest leaves, picking out the pattern they form, then go on and paint the middle- and light-tone ones.

ASSIGNMENT

Look for a branch that has fallen to the ground, preferably one with lots of overlapping leaves. At home, prop the branch against a wall, then begin to sketch it. Do a careful drawing, paying attention to the major twigs and stems and how they connect, but don't get overly concerned with minute details.

When the drawing is completed, mix a couple of warm and cool greens, then begin to paint. As you work, concentrate on two things: the patterns that the leaves form and the shadows that the leaves cast on one another.

The drooping leaflets of an Arizona walnut tree cascade down its rough, craggy bark.

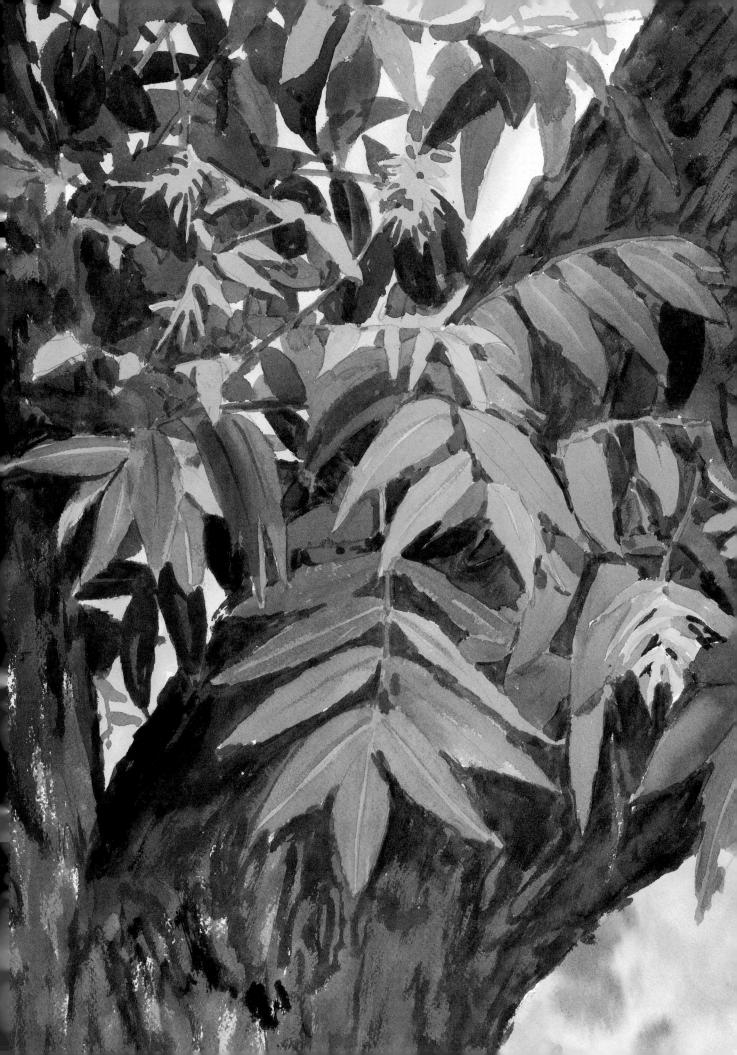

BLACK WALNUTS

Discovering Color in a Seemingly Monochromatic Subject

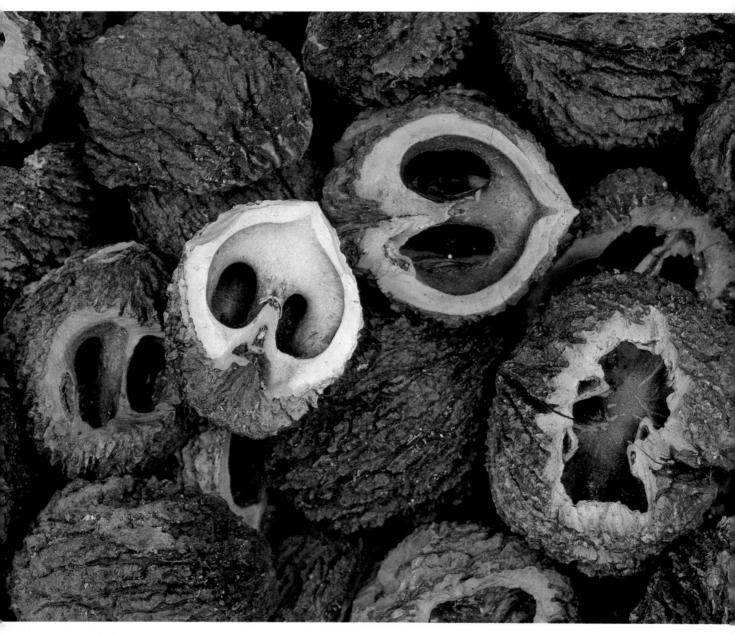

PROBLEM

It's easy to approach a subject like this thinking in terms of just two or three colors. If you do, your painting will end up leaden and uninteresting.

SOI LITION

Search for the colors that lie hidden in the scene, then load your palette with blue, purple, and yellow, as well as the expected grays and browns. Sketch the walnuts carefully; your drawing should be rich with detail, and should even portray the texture of the nuts' surfaces. Next, reinforce your sketch with very dark paint, here sepia and Payne's gray; you can work in India ink if you want crisper, darker lines. What you're doing is creating an armature on which to build your painting.

As you lay in middle-tone washes over the dark areas of the

Cracked open by hungry squirrels, black walnuts lie in piles on the forest floor.

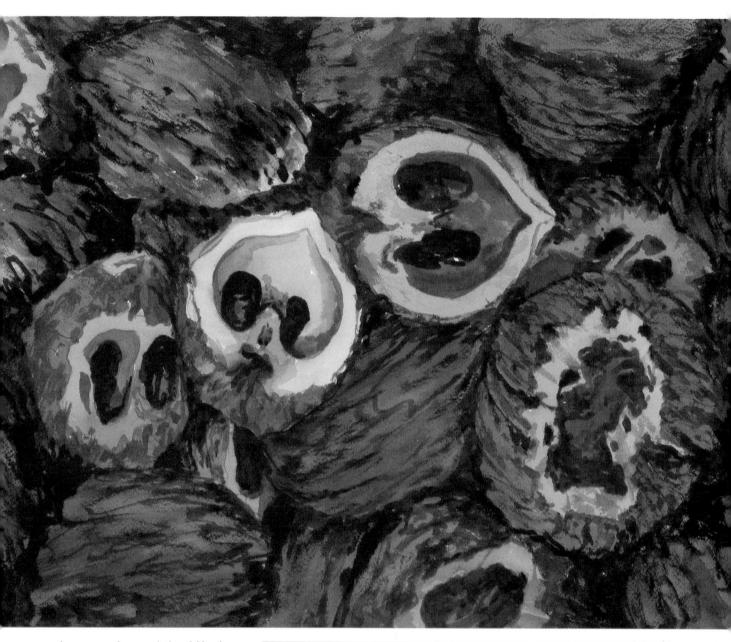

walnuts, explore subtle shifts in color. Mauve, cerulean blue, and burnt sienna come into play here. For the light interiors, mix yellow ocher with burnt sienna. Once all the colors and values are laid in, go back and add detail. Since your washes will have softened some of the dark lines you established first, complete the painting by sharpening them with more sepia and gray.

ASSIGNMENT

Pile a group of pinecones on a table, then sketch them. Since your drawing is going to be the backbone of your painting, you'll want it to be accurate and to have a fair amount of detail. Next, take a fine brush and cover the lines of your drawing with India ink, then let the ink dry.

Analyze the pinecones, looking for subtle gradations in color. Exaggerate those that you see as you begin to lay in washes of paint over the India ink. As the washes dry, go back and reinforce the color in some areas. Don't worry about overworking your painting; the ink isn't going to run or fade, so it gives you a lot of freedom to experiment.

DOGWOOD AND CONIFER

Contrasting Delicate Lights with Heavy Darks

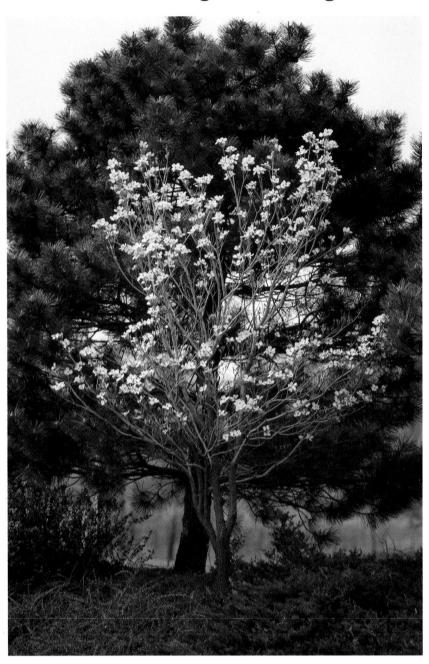

In late spring, a dogwood's brilliant pink flowers form an unexpected pattern against a dark, massive conifer.

PROBLEM

You don't see many scenes like this—the juxtaposition of the dogwood and the conifer seems almost contrived. And if something looks contrived in nature, it's hard to make it seem natural in a painting.

SOLUTION

Paint almost the entire scene as if the dogwood weren't there, saving the blossoms for the very end.

STEP ONE

Like most conifers, this one's crown has a strong shape. Capture it in your drawing. Next, mask out the dogwood blossoms. You can't mask each one, so try to simplify them, picking out the pattern they form. Next, with a pale blue wash, paint the sky. To depict the softly focused area under the trees, use a lavender wash, and when it's dry, prepare a slightly darker wash to suggest the undergrowth. Here some of the dark lavender paint is also applied to show a mass of the dogwood blossoms. Finally, develop the foreground.

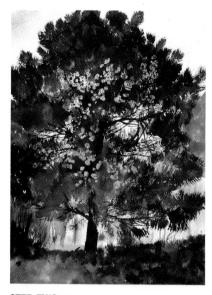

STEP TWO

When you're dealing with something as powerful as this dark tree, the way you apply your paint is critical. Your brushstrokes have to be forceful and must indicate the effect created by the needles. Here a flat, fan-shaped brush is ideal. Load it with paint, then move it decisively over the paper. Pay attention to the shadows on the undersides of the branches; to render them, use slightly darker paint. Note here how miniscule bits of paper are left white, helping break up the massiveness of the crown.

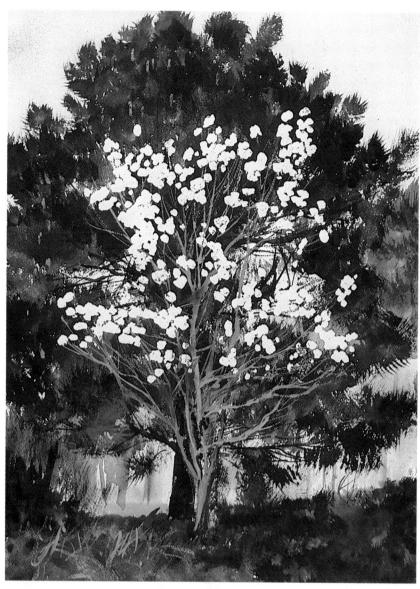

STEP THREE

Complete the conifer, then dab on touches of brown to suggest its cones. Paint the trunk and branches of the dogwood with opaque gouache, here a mixture of purple, white, and a little yellow ocher. The trunk has to be dark enough to seem lifelike, yet light enough to stand out against the conifer, so do some test color swatches before you begin to paint. For the branches, use a fine brush, pulling it quickly over the paper. Be sure that you get across the feeling created by the tangle of branches; have your strokes cross one another, and keep them fluid and lively.

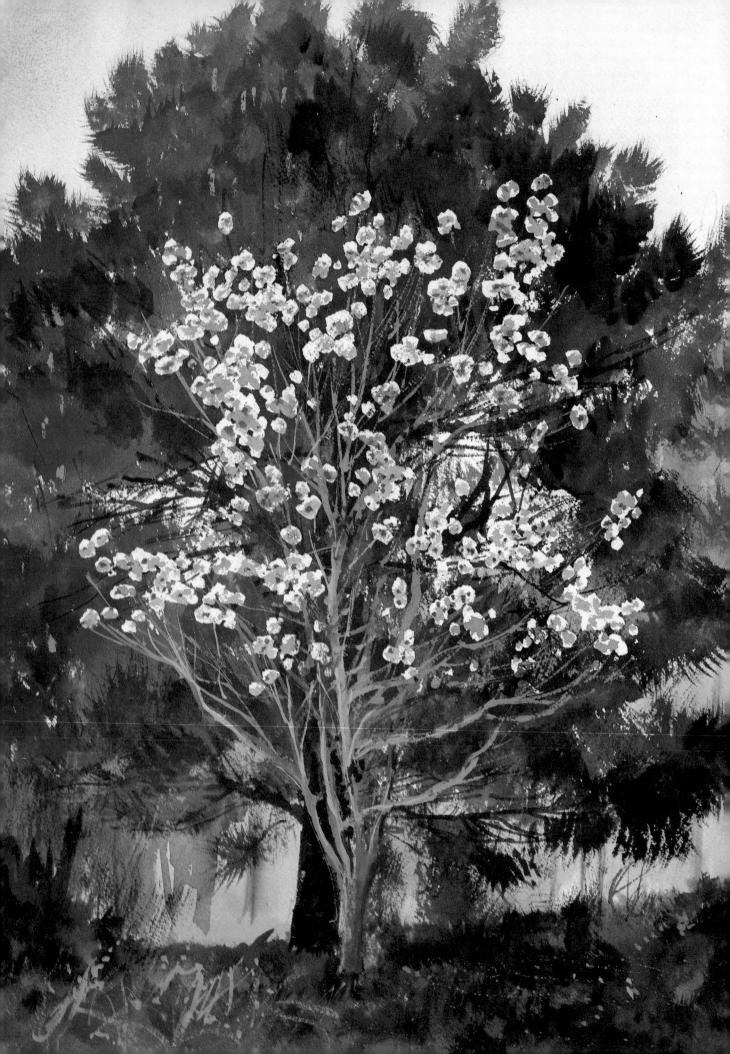

FINISHED PAINTING

Remove the masking fluid. For the blossoms, work in layers. beginning with a very pale shade, then adding slightly darker, richer details. Unlike the flowers, the small twigs and branches are mostly one color, but touches of dark brown break up any monotony; for the larger branches and the trunk, two shades hint at how the sun is hitting the dogwood tree.

Even though the ground in front of the dogwood tree is relatively unimportant in this composition, it has a fair amount of detail, such as the spatters of light green. This type of texture is important here; it balances all of the pattern formed by the dogwood blossoms and the conifer.

DETAIL

Don't be afraid of dramatic contrasts between darks and lights. Here the light pink flowers stand in bold relief against the dark tree, yet in the context of the scene they seem natural.

Notice how the flowers unfold in layers of color—the very palest pink lies toward the rim, with progressively darker shades toward the center. When you're working from light to dark and you want to keep the shifts in color clean and crisp, wait until each layer is dry before you add the next one.

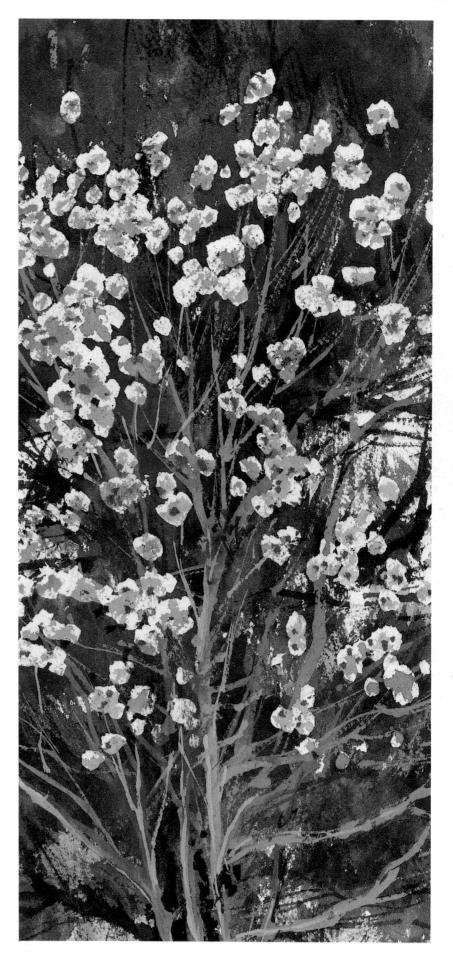

DOGWOOD FLOWERS

Establishing the Texture of Pure White Flowers

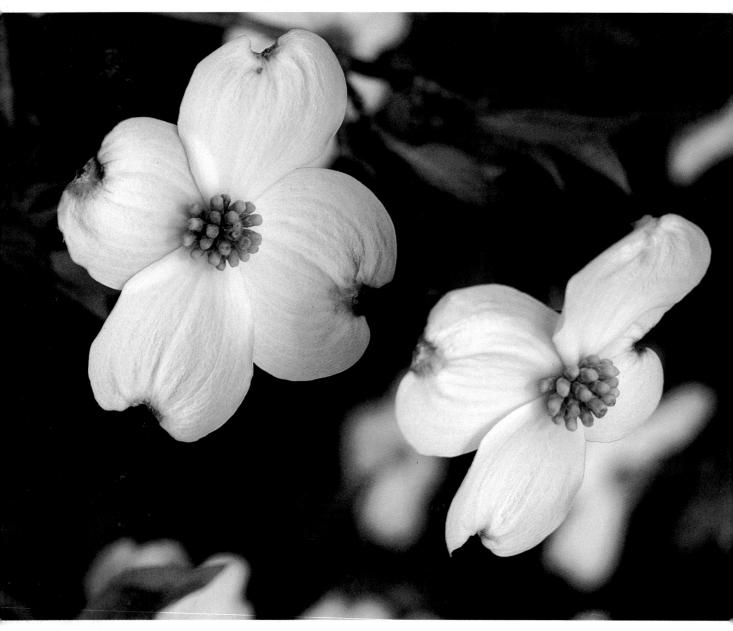

PROBLEM

The texture of pure white objects is revealed by very subtle shadows and highlights. These fine gradations can be extremely difficult to capture.

SOLUTION

Go ahead and exaggerate the texture of the flowers with a gray wash. If you keep the background dark enough, the flowers will look white.

In early spring, a flowering dogwood tree bursts into bloom, heralding the leaves that will soon appear. ☐ After you draw the flowers, mask them out to keep their edges crisp and clear. Next, paint the background. Working with a wet-in-wet technique, lay in rich, intense color—darker color, in fact, than that which you see. Mute the unfocused flowers and leaves by darkening them slightly and softening their edges. Next, peel off the masking solution and begin work on the blossoms. With broad, sweeping strokes, apply a

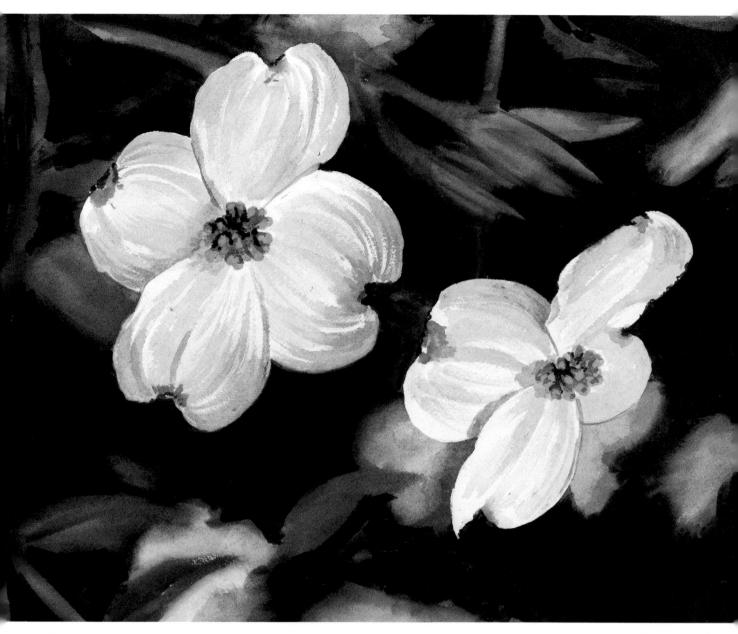

light gray wash to indicate their fine surface ridges. Your brushwork will convey how the blossoms move in space; for example, the gray wash used on the bottom petal of the flower at the left shows how it moves backward, toward the flowers that lie beyond it. Finally, render the tiny flowers in the center of each blossom, and lay in the pink and gray touches on the edge of each petal.

ASSIGNMENT

Set up two still lifes, one with a pale flower set against a dark background, the other with a dark flower set against a light background. Sketch both subjects.

When you turn to the pale flower, you'll want to mask it out to keep its edges crisp. Next, lay in the entire background. As you begin to paint the flower, you can gauge how dark its surface detail should be to harmonize with the backdrop.

With the dark flower, the procedure is just the opposite. Paint the flower first. Once you have completed it, you'll be able to decide how light or dark you want the background to be.

APPLE BLOSSOMS

Capturing the Structure of Delicate Flowers

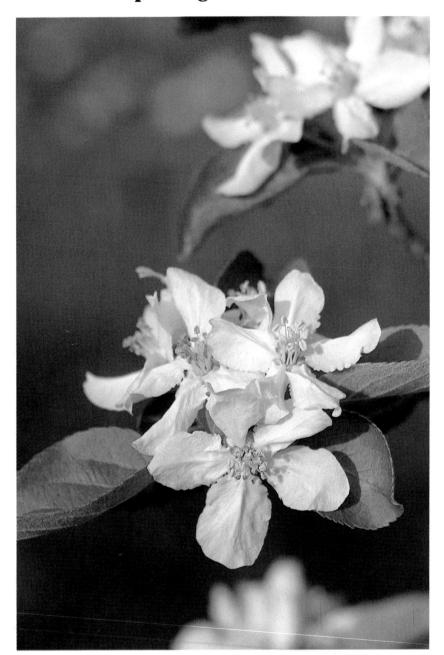

PROBLEM

When you're dealing with floral subjects, it's often hard to convey their structure, especially when the flowers are pale and delicate.

SOLUTION

Let your drawing shine through the transparent watercolor. It will add a subtle sense of order to the finished painting, and a graceful touch as well.

STEP ONE

Execute a careful drawing; remember, it's going to be part of the finished work. Next, wet a brush with clear water and moisten the area around the flowers. As you drop in your paint and begin to lay in the background, keep the edges around the flowers in the foreground sharp. The background here is made up of alizarin crimson, Hooker's green light, and Payne's gray.

In early spring, showy pink apple blossoms catch the warmth of late afternoon sun.

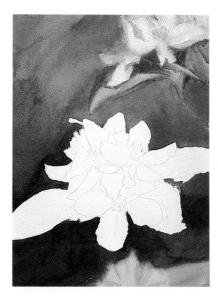

STEP TWO

Finish the background, softening any harsh areas with clear water. Next, paint the softly focused flowers and leaves in the foreground and background using cadmium red, alizarin crimson, Hooker's green light, yellow ocher, and cadmium orange. The colors should look diffused and hazy, yet not too soft; they're easier to control if the paper is just slightly wet.

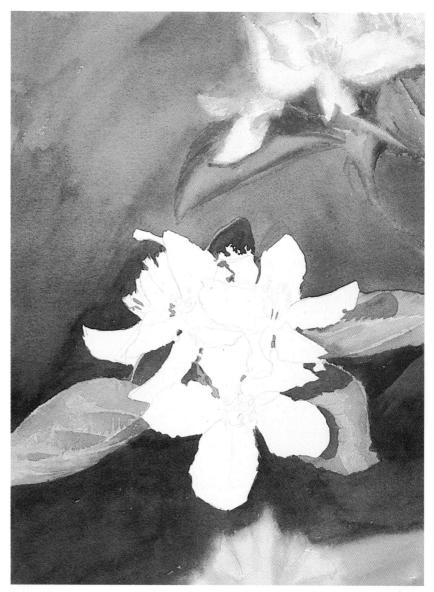

STEP THREE

Leave the center of interest—the sharply focused apple blossoms—till last. First, render the leaves that surround them. Don't be too exacting here; the leaves shouldn't pull attention away from the flowers. Apply a wash of Hooker's green light, then add yellow ocher, new gamboge, and burnt sienna to your palette as you depict their shadows and details.

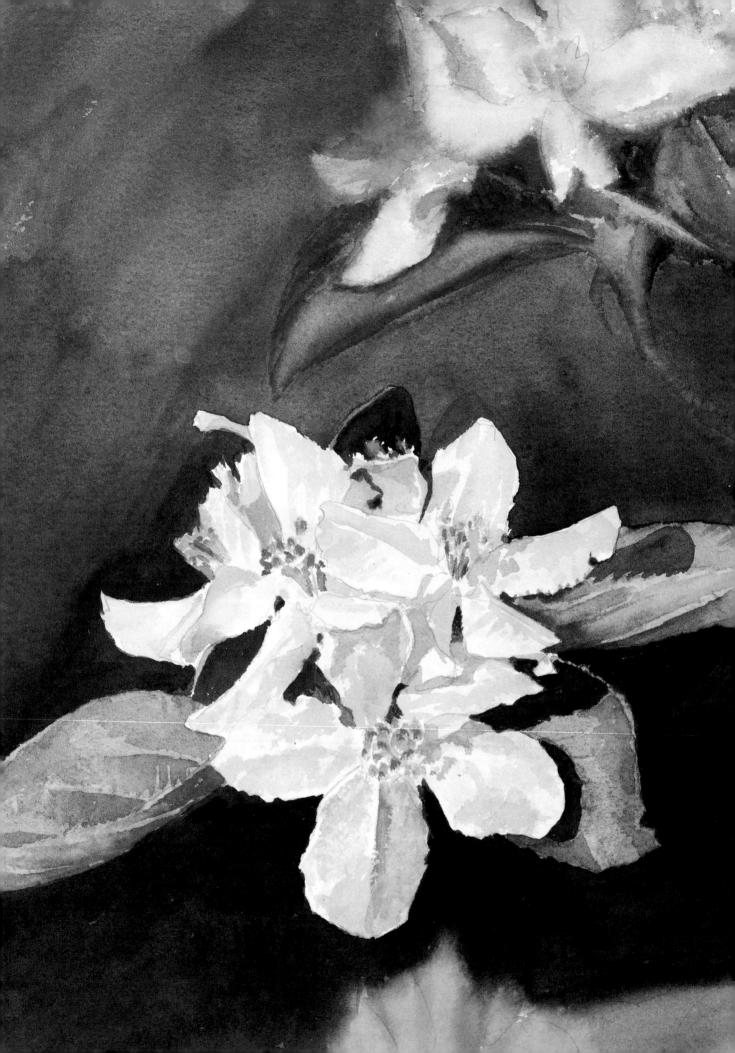

FINISHED PAINTING

Now comes the most important step-adding the delicate shadows and highlights that play about on the apple blossoms. Using very light washes and loose, fluid brushstrokes, lay in the shadows. Let bits of the brilliant white paper alone—these passages will make up the highlights. Finally, dab brilliant orange and gold into the center of each blossom.

DETAIL

In the finished painting, the lyrical lines of the drawing support the layers of wash that make up the apple blossoms. In situations like this one, when the drawing is going to play a large role in the success of a work, think through the kinds of line you might use before you begin to sketch. Were the pencil lines thicker or harsher here, they would overpower the delicate flowers.

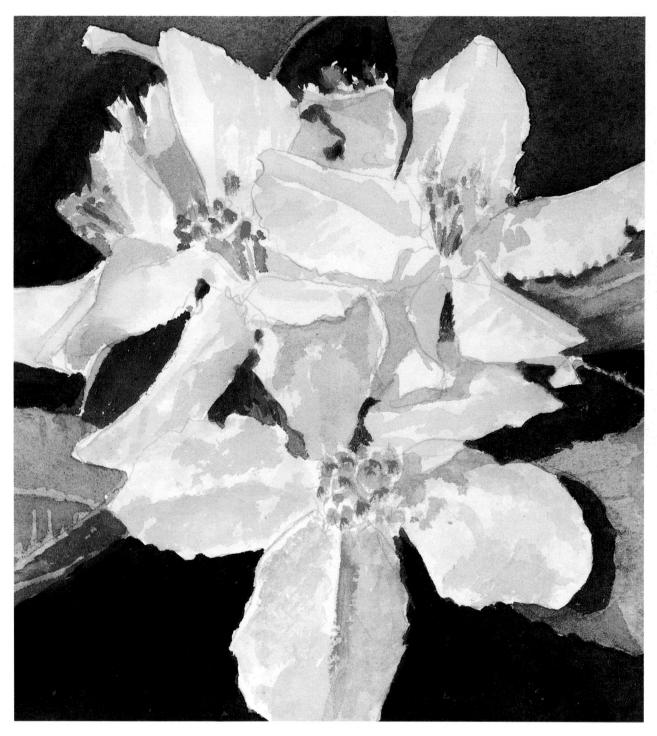

Analyzing the Colors of Familiar Objects

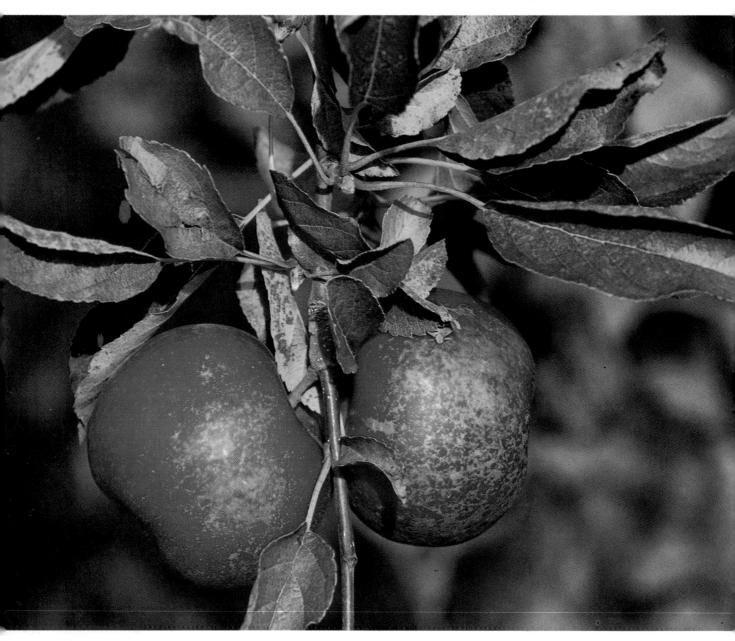

PROBLEM

These apples are richly mottled with gold, yet many people would ignore the yellow areas and just concentrate on the obvious reds. When you approach a familiar object, it's hard to come to it with a fresh point of view.

SOLUTION

Build up the apples slowly, starting with a deep gold wash. Add the red last.

Sunlight pours down on the branch of an apple tree, picking up highlights on the bright fruit and leaves.

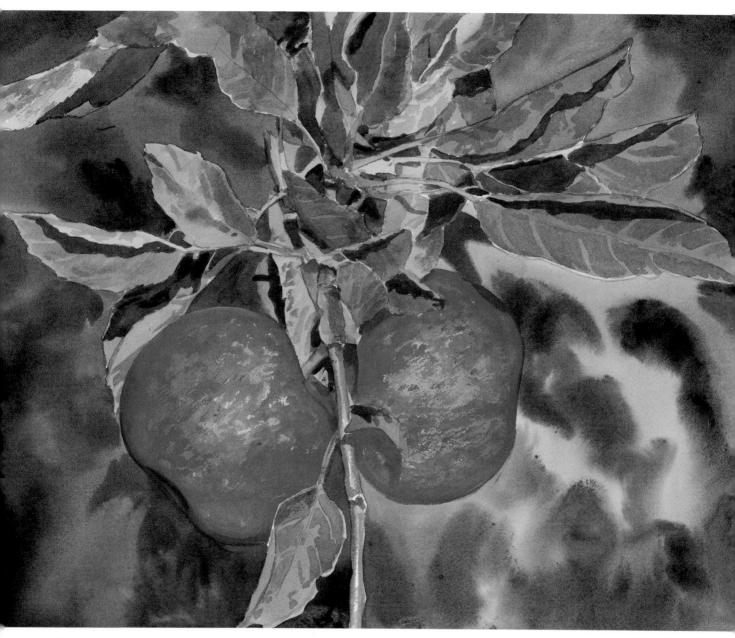

☐ Sketch the scene, then wet the background and begin to drop in your color. Instead of masking out the apples, paint around them; you'll achieve a softer, warmer effect. As you work in the greens and browns in the background, keep the values darkest on the left.

Let the background dry, then turn to the leaves. Execute the lightest areas first, then gradually add the shadows. As you develop the leaves, rely on warm and cool colors to indicate contrasting areas of light and shade. Next, add a purplish wash to some of the leaves to indicate their dark, brittle undersides.

To capture the brilliant yellow speckles that run across the surface of the apples, begin by putting a pale ocher wash over the fruit. Let the wash dry, then take pure cadmium red and work in the deep red skin with a fairly dry brush. To depict the darkest, richest reds, increase the density of your pigment.

Rendering a Tree Against a Stark Winter Sky

PROBLEM

After trees have lost their leaves in fall, it's hard to suggest the fine network of twigs that endures until spring. If the twigs are painted too forcefully, they'll look artificial.

SOLUTION

Don't try to paint each and every twig. Instead, lay in a light wash along the edges of the branches to suggest how the spidery twigs mass together.

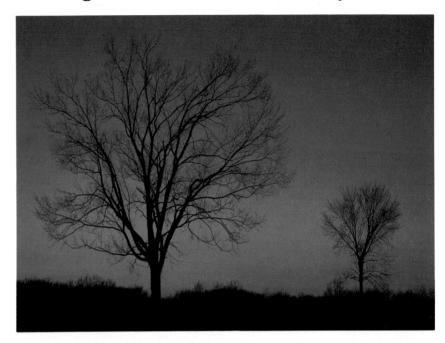

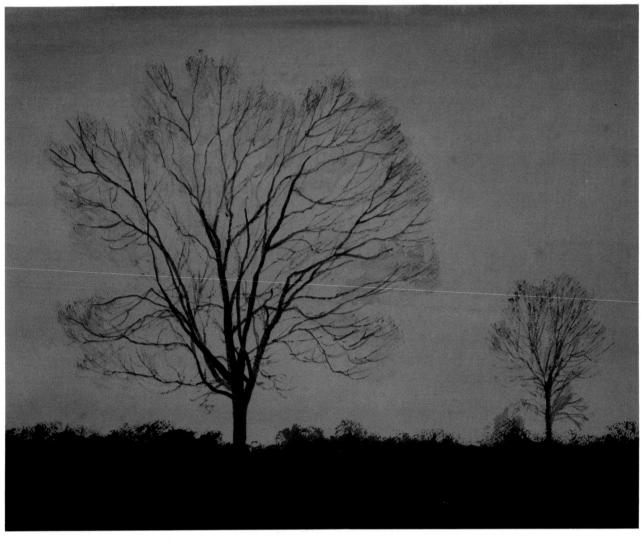

After a careful drawing, lay in the sky with cadmium red; to highlight the trees, darken the top of the paper and its far right side with alizarin crimson.

Next, begin to lay in the tree trunks and the largest branches with a dense blend of sepia and ultramarine. Use the same mix to render the dark, flat foreground; while the paint is still wet, take a dry brush and pull the pigment up along the horizon to create an interesting, uneven line.

Next, lay in patches of a light wash to indicate how the twigs mass together near the edges of each tree's crown. The wash should be light, but not so light that it gets lost next to the bright sky. Finally, lay in wispy, feathery strokes around the edges of the crowns.

DETAIL

The swatches of pale wash used to suggest the twigs are laid down with loose, fluid strokes, their uneven contours mimicking the shapes formed by the masses of twigs. The feathery strokes that radiate outward from the edges of the swatches of wash break up any area that has become too regular and convey the spidery feel of a tree's crown in fall.

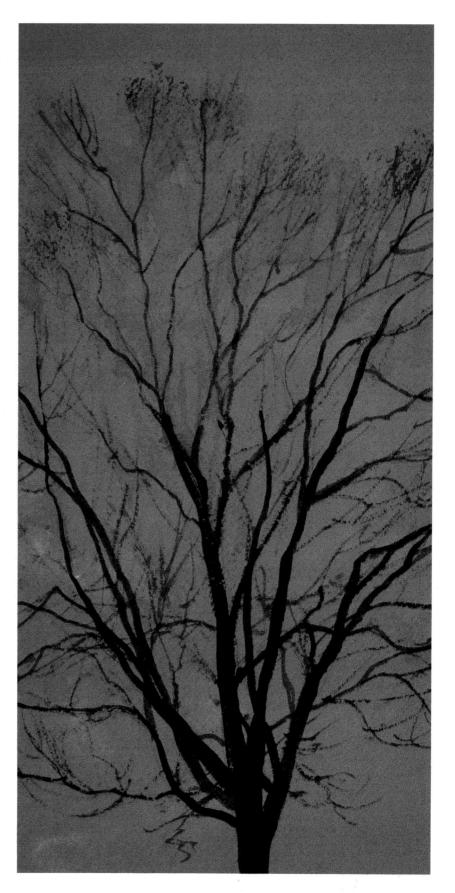

On a cold winter evening, two elms stand against a deep red sky.

Capturing a Tree at Twilight

PROBLEM

In spring, when a tree's foliage is just beginning to fill in, it takes a light touch to suggest the lacy, delicate patterns that the leaves etch against the sky.

SOLUTION

Stippling is ideal for conveying the soft, delicate feel of spring leaves. Work with a fine brush, paying close attention to the patterns formed by the leaves.

Crowned with fresh spring foliage, an elm tree is silhouetted against a purple sky at twilight.

☐ Sketch the scene, then lay in the sky with a graded wash; use pure ultramarine at the top of the paper, then gradually blend it with mauve. When the sky is dry, paint the tree trunk and branches.

To render the leaves, take a fine brush—preferably an old one—and moisten it with pigment. Begin to dab it lightly onto the paper, constantly keeping the tree's shape in mind. When your brush becomes a little dry, keep on stippling—these lighter, rougher passages will keep the brushwork from becoming monotonous.

Finally, lay in the foreground, then, with feathery strokes, depict the grass growing along the horizon. The pigment used to paint the leaves is fairly dense—it has to be if it's going to stand out clearly against the deepening sky. Note the lively, irregular shapes formed by the stipples; each dab has a slightly uneven edge. To achieve this effect, manipulate the paint with the tip of your brush as you lay it onto the paper.

FERNS AND WHITE CEDAR

Working with Pattern and Texture

PROBLEM

The rich, lush ferns are obviously the focus of this scene, but if you treat the tree trunk too superficially it will look artificial and hard to decipher.

SOLUTION

Pay equal attention to the tree trunk and the patterns formed by the ferns. Because the ferns will be more difficult to render, execute them first.

Masses of lush, delicate ferns crowd against the curving trunk of a white cedar.

STEP ONE

Once you have finished your sketch, begin to work on the ferns. Lay in an uneven wash made up of cool and warm tones, mixing the paint after you've dropped it onto the paper. To create a focal point, use warmer tones near the center of the paper and cooler and darker ones toward the edges. Here the background is made up of Hooker's green light, lemon yellow, cerulean blue, and ultramarine.

STEP TWO

Begin to build up the ferns. With two values of green—one very dark and the other a middle tone—work around the light wash laid down in step one. You are actually silhouetting the light areas of the ferns, adding the darker tones to pull out their shapes. Use the darkest value cautiously. The washes employed are mixed from Hooker's green light, ultramarine, and new gamboge.

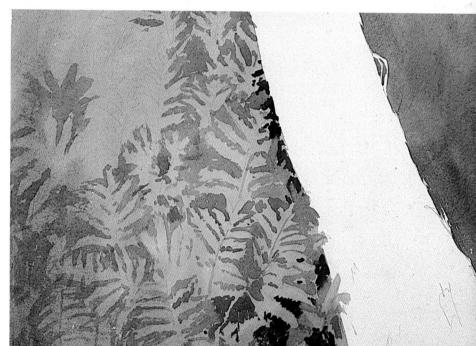

STEP THREE

Finish the background. As you move toward the edges of the paper, don't be too literal. What matters is capturing the impression the ferns create, and the pattern they pick out. The more precisely rendered ferns near the tree will concentrate attention in one area. Next, using Payne's gray, cerulean blue, and yellow ocher, lay in the tree trunk with an uneven wash.

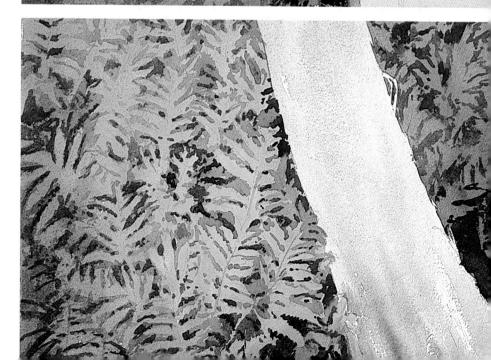

FINISHED PAINTING

Add sepia to your palette and begin to render the trunk's texture. Small, broken, vertical strokes convey the rough feel of the bark and enhance the sweeping arc the trunk traces against the mass of rich green.

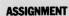

Take a fern or a delicate branch with lots of small leaves and prop it against a light background. Next, shine a light on it, one strong enough to cast dark shadows. Sketch the scene.

Working with just three values—one light, one dark, and one a middle tone—begin to paint. As you work, keep the contours of the fern or leaves delicate and graceful; this can be difficult when there is so much harsh contrast between the lights and darks. Concentrate, too, on the pattern formed by the shadows.

RED PINE

Painting a Tree Viewed from Below

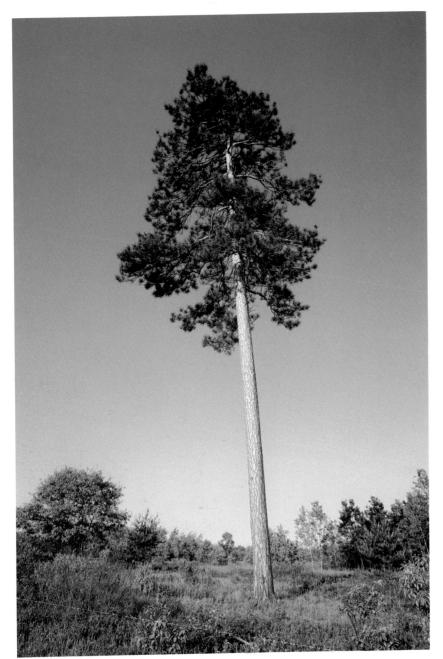

PROBLEM

A lot of the tree's power comes from the dramatic way it is set against the sky. To convey this drama, the long pale trunk has to stand out against the light blue sky near the horizon.

SOLUTION

Apply masking solution to the trunk and its spreading branches. When you remove the mask, you'll be able to adjust the values of the lights.

STEP ONE

Sketch the scene, then mask out the trunk and the light branches. Lay in the sky with a graded wash. Since it's easiest to work from light to dark, turn your paper upside down. To achieve the rich blue seen here, work with cerulean blue, ultramarine, and yellow ocher.

In late summer, a majestic red pine stands boldly against a clear blue sky.

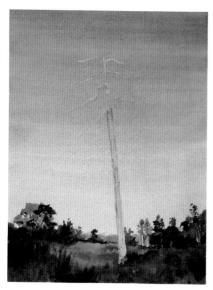

STEP TWO

Paint the foreground. Since the tree's crown is well removed from the horizon, feel free to use a lot of lively color and brushwork; it won't detract from the tree's power. Use drybrush technique to render the tree tops farthest away, and leave some of the distant tree trunks white. The colors here are mixed from Hooker's green light, new gamboge, yellow ocher, sepia, and mauve.

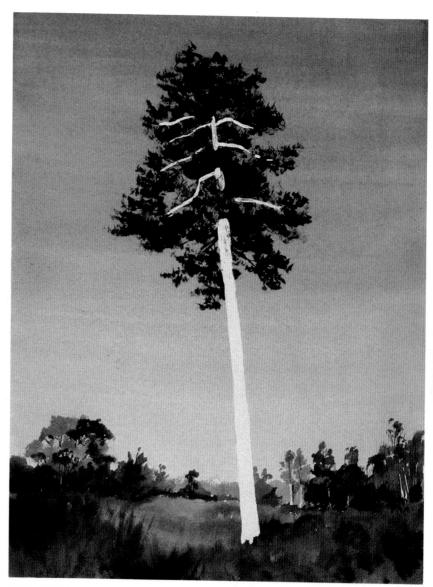

STEP THREE

Now tackle the pine. Emphasize its bold silhouette with your strokes. Take an old brush and load it with paint; use just barely enough water to keep the pigment moist. Dab on the color, working outward from the center of the tree. Try to achieve rough, irregular strokes that grow faintest toward the crown's edge.

FINISHED PAINTING (overleaf)
Remove the masking fluid and lay in the trunk. First, put down a pale wash, then add a darker tone along one side to portray how light strikes its surface. Finally, spatter a little gold paint on the immediate foreground.

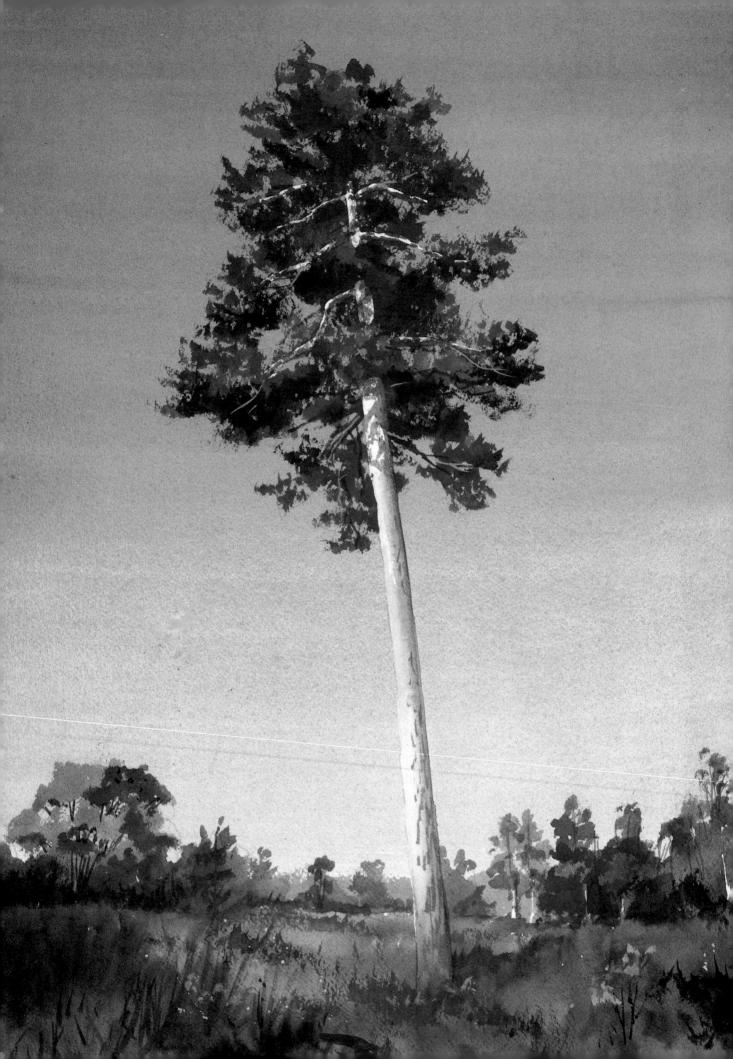

PINE NEEDLES

Looking for Pattern in an Intricate Closeup

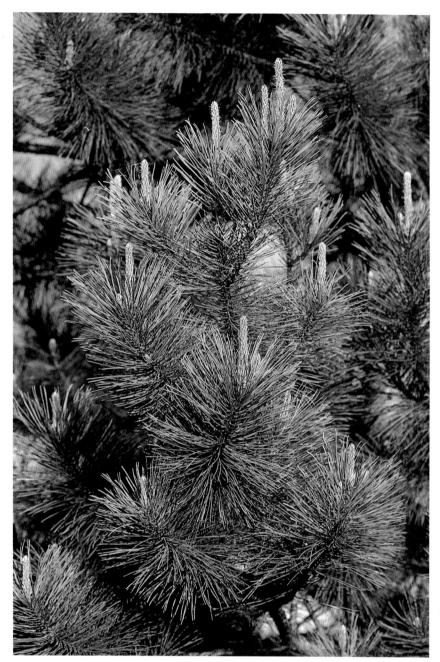

PROBLEM

When a closeup has as much detail as this one does, you can lose your way in it. Find something to hang onto right away, or your painting will be a mass of details without any structure.

SOLUTION

Look for the simple patterns formed by the middle and dark values, then emphasize them to organize your painting.

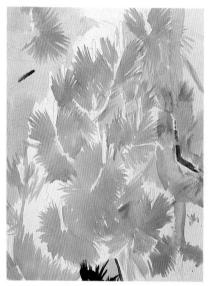

STEP ONE

Sketch the basic lines of the composition, then analyze its structure. You'll see that the tall branch tips form a simple S-shaped pattern. Begin to lay in the background—the blues of the sky, the middle-tone greens that coil throughout the composition, and the mauve trunks at the far right.

Bundles of slender green pine needles spring out from scaly brown branches.

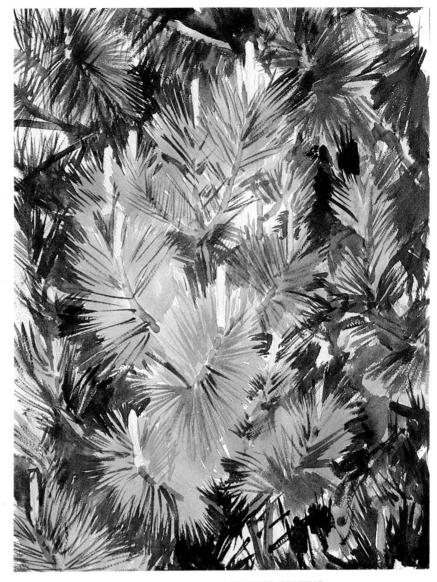

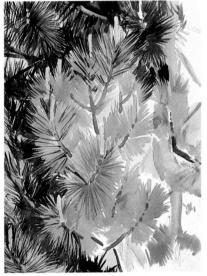

STEP TWO

Start adding the darker pine needles on the left. To keep them from pulling attention away from the S-shaped pattern you've established, minimize their detail. Keep your stokes simple and, in some areas, mass them together so densely that they look almost solid. Before you go any further, paint in the branches and their tall tips.

STEP THREE

Develop the rest of the background. Cluster the darkest areas at the top of the painting and at the far edges and continue to simplify your brushstrokes. As you paint, follow the directions in which the needles grow.

FINISHED PAINTING

Texture the branches with a deep brown wash, then adjust the values slightly by darkening portions of the background.

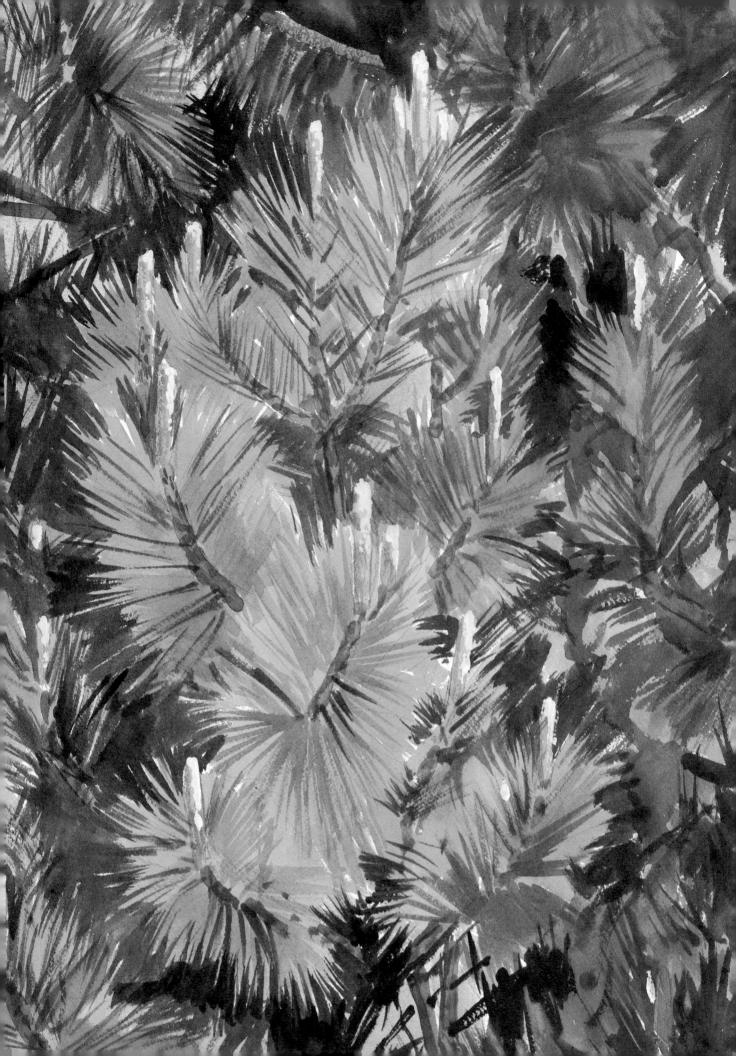

Balancing Dramatic Clouds and Strong Color

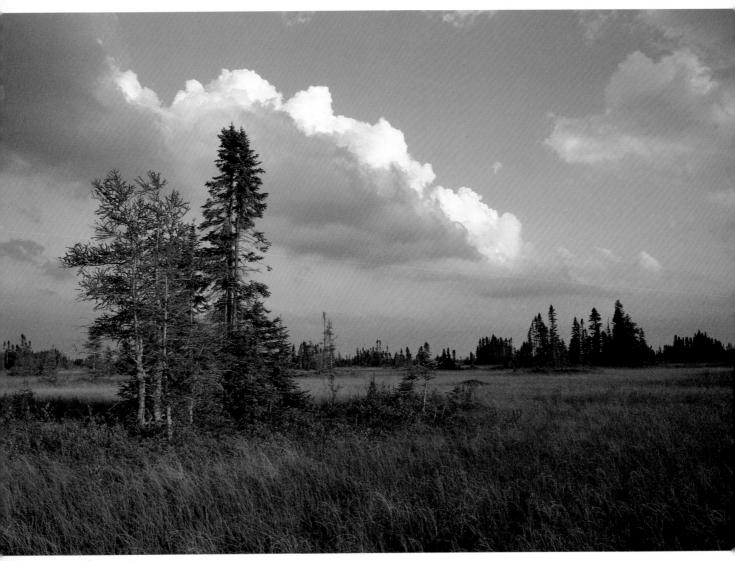

PROBLEM

The glorious cloud formations that fill the sky have to look fresh and unstudied. Their undersides are dark and shadowy, and if they're not handled lightly, the sky will seem heavy and dull.

SOLUTION

Execute the sky first and, if you lose your spontaneity, start over again right away. As you work, constantly soften the shadowy areas on the clouds with clear water.

Spectacular clouds sweep over a golden autumn landscape punctuated by spruce trees.

STEP ONE

In your preliminary sketch, very lightly draw the shapes of the clouds; use your drawing as a rough outline when you begin to paint. Lay in the clear blue sky in the background, then tackle the formations. Work from light to dark, softening all the transitions between areas with clear water. Finally, lay in a few small clouds right over the blue sky.

Develop the trees that lie along the horizon line. Don't make them too pale; the forceful sky has to be balanced with fairly strong color throughout the landscape. Next, using rich, warm tones, develop the foreground. For the time being, just worry about its basic color; detail will be added later.

STEP THREE

Add the trees and the shrubs in the foreground. First, use a pale gold wash to render the spruce trunks; then concentrate on their foliage. Here a rust wash applied in the center of the cluster of trees holds them together and relates them to the field beyond. Next, build up the leaves, using short, scraggly strokes and concentrating on how the branches move out from the trunks.

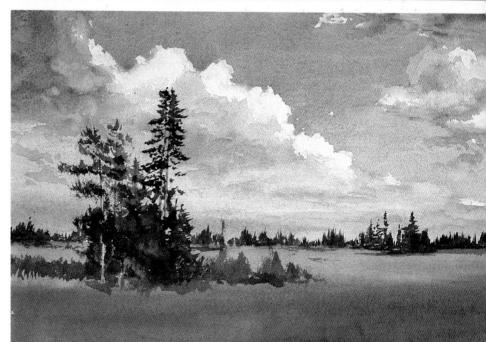

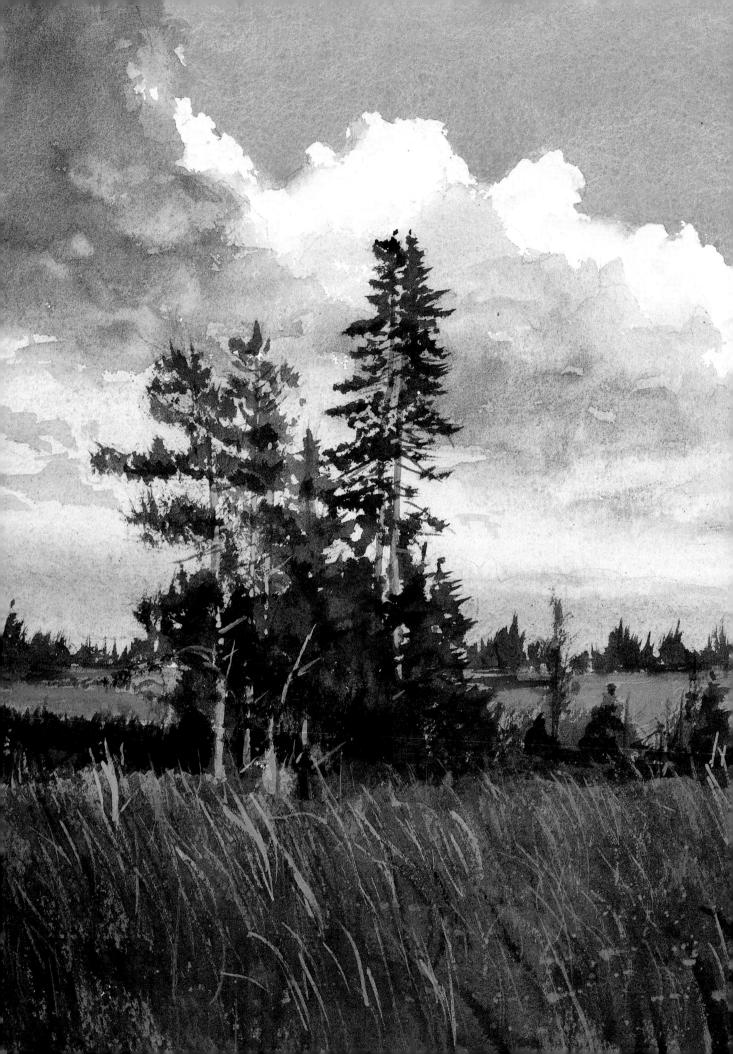

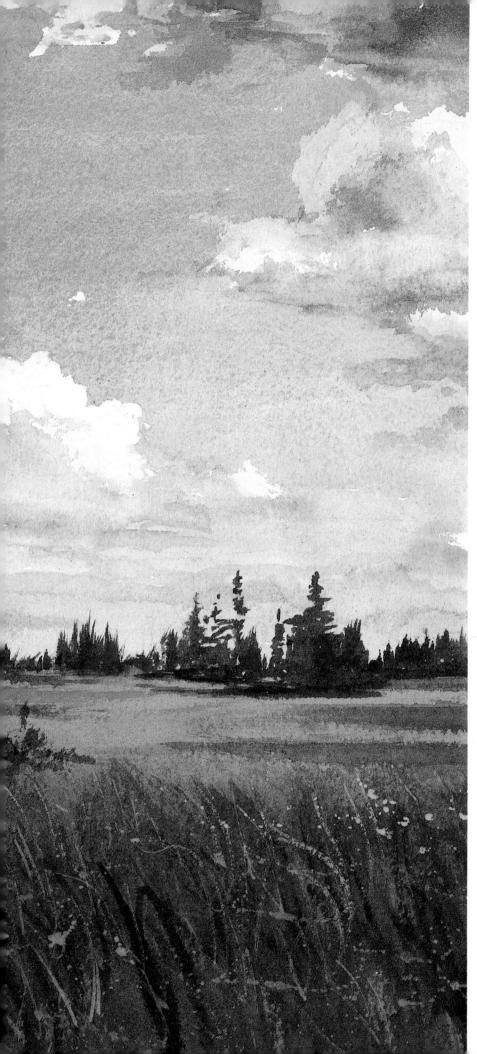

FINISHED PAINTING

For the final step, add detail to the immediate foreground. Pack the area with thin delicate strokes to get across the feel of wind sweeping across the grass. Work with several shades of orange, gold, and brown; finish by spattering a few irregular touches of orange across the grass in the direction that it's moving.

DARK DAYBREAK

Capturing the Stormy Colors of Dawn

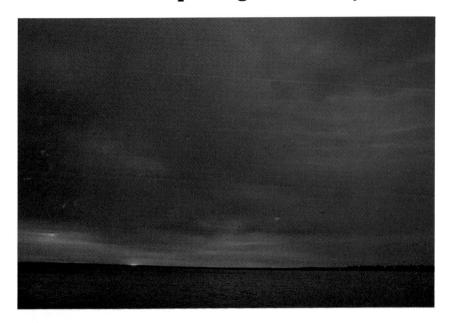

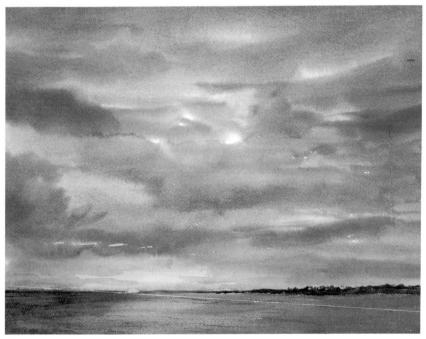

As brooding storm clouds sweep down upon a quiet plain, a sliver of brilliant sky signals the approaching dawn.

PROBLEM

Both the sky and the foreground are an almost unrelieved shade of cool, dark, purplish blue. Unless it's carefully controlled, the thin reddish band breaking through the dark will look forced and out of place.

SOLUTION

Lay in the brightest, lightest, warmest colors first. Don't limit them to just the obvious area above the horizon. Instead, analyze how the red in the sky is reflected on the plain below. After you apply the warm reddish underpainting, gradually add the darker, cooler tones.

Begin by sketching the horizon and the low-lying hills that run along it; then using cadmium orange, new gamboge, and alizarin crimson, begin to paint the sky. To keep the horizon line crisp, work on dry paper. Concentrate most of the color around the spot where the sun is rising, but remember to extend your wash down into the foreground. Now let the paper dry.

Next tackle the clouds. Using a large brush, wet the top of the paper with clear water. When you begin to drop in pigment, work quickly, keeping your color light. You can always go back and make the color more intense, but it's hard to lighten once it's been laid down. Apply the paint loosely, following the patterns formed by the clouds. Keep the sky wet as you drop in darker tones. When you're satisfied with the effect you've achieved, let the paper dry. Here a mixture of ultramarine blue and alizarin crimson capture the color of the storm clouds.

Before you begin the foreground, decide how to capture the shimmering quality created by the reflected light. Here the reddish underpainting is allowed to show through the dark bluish paint, which is laid in more intensely toward the sides of the paper.

To deepen the blue, add a little Payne's gray and sepia. As a final step, paint the trees that lie along the horizon. Then, add texture to the foreground by running a brush moistened just slightly with dark blue paint across the paper.

Little irregularities like those here enliven the finished painting, so don't try to control your strokes too rigidly. Note, too, how tiny areas of the paper are totally free of paint; the speckles of white lighten the dark sky.

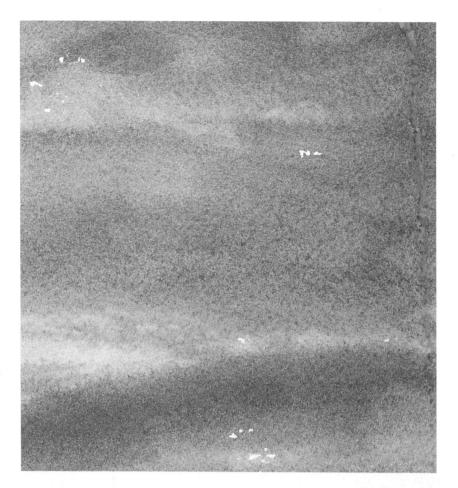

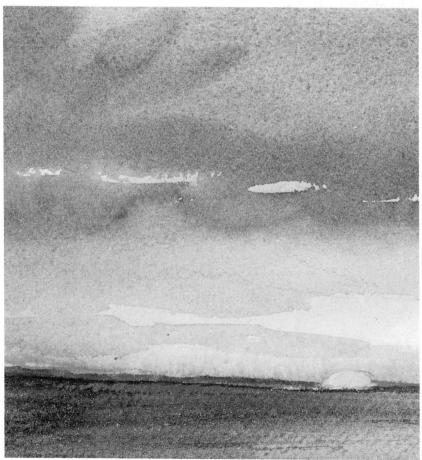

DETAIL

The colors that flicker along the horizon are warm and bright, yet not so strong that they appear garish. When you are working with brilliant oranges, reds, or yellows, use some restraint. Those hues are incredibly vibrant—a little goes a long way.

Learning to Work with Reflected Light

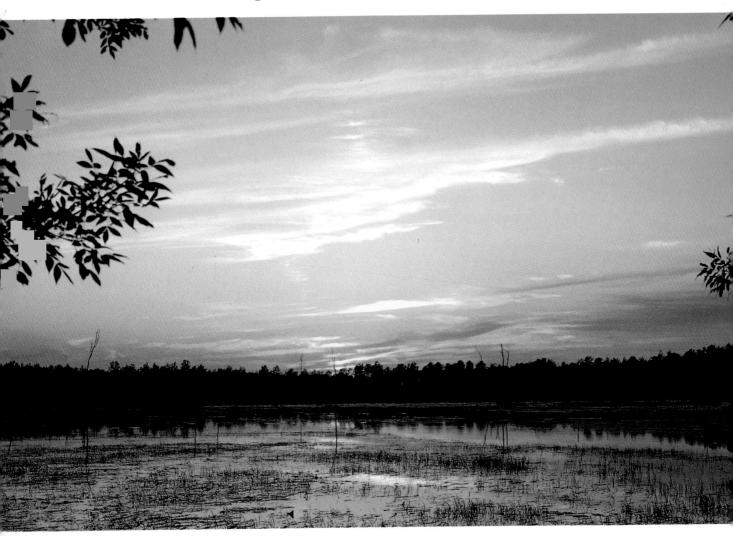

PROBLEM

The warm golden light that patterns the sky and the water is broken up by slashes of cool blues and purples. The entire scene should be drenched with light, but you'll want to emphasize the cool colors, too.

SOLUTION

Cover the paper with a light, warm underpainting; then gradually build up both the bright and the cool colors. Every part of the finished painting will have hints of golden orange.

At dawn, a sun-streaked sky is reflected in the still waters of a grassy pond.

STEP ONE

Sketch in the horizon line and the tree on the left. Then lay in a graded wash of alizarin crimson, cadmium orange, and cadmium red. Work over the entire paper, keeping the brightest tones right at the horizon line where the sun is breaking through. To capture the shimmering colors that float above the horizon, drop in a touch of mauve. Now let the paper dry.

STEP TWO

Using pale washes of cerulean blue and ultramarine, begin streaking the sky with cool tones. Be sure not to cover all of the orange underpainting. Once the pale washes have been applied, add slightly darker values of mauve at the horizon and a strong brilliant orange mixed from alizarin crimson and new gamboge along the horizon and in the water. When the paper has dried, paint the trees in the background and the branches and leaves in the foreground on the left. Now, work the reflections of the trees into the top of the pond.

STEP THREE

All that remains to be done are the details in the foreground. Here the blue washes are a little weak; by strengthening them, you can make the foreground move out toward the viewer while everything else falls back into space. Next add the grasses that break through the water. Use a drybrush technique to capture their scraggly appearance and apply the paint with a light hand. If any detail gets too strong, it will pull attention away from the sky.

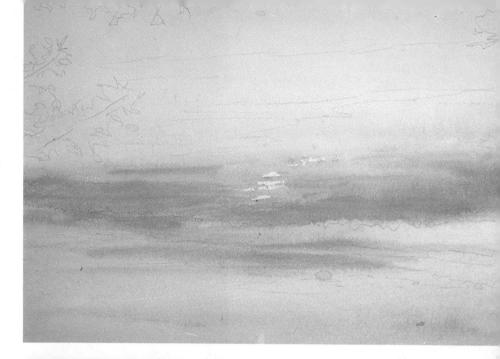

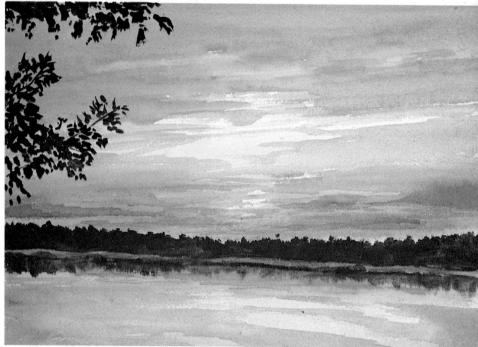

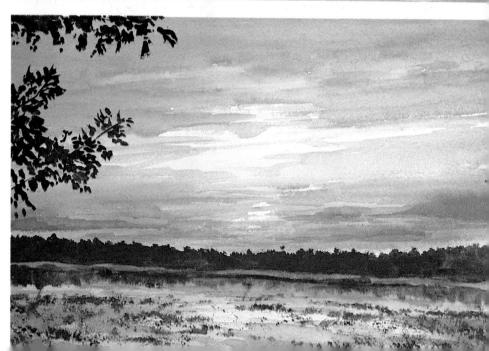

FINISHED PAINTING

The finished painting captures the glorious colors of sunrise; every inch of it is suffused with a golden orange glow. The cool blues and purples flicker across the scene naturally, and the sun's reflections are gracefully captured in the water.

A warm underpainting dominates the painting. The streaks of blue and purple float above the reddish orange wash but never steal attention from the sun-filled sky. Part of the reason the cool colors work is due to the care with which they are applied. Also, they are pale enough and transparent enough to reveal the underpainting.

The same warm color pervades the water, but the dark tones are stronger here. While the underpainting unites the sky and water, the dark patches of grass and the deep bluish purple passages pull the foreground forward.

DEEP BLUE SKY

Depicting a Monochromatic Sky

PROBLEM

So little is happening here that it's hard to know where to begin. The sky is a flat, even tone of blue and the foreground doesn't have much detail.

SOLUTION

Concentrate on the unusual. It's rare that the sky is the darkest area of a painting, so keep the blue strong, diluting it as little as possible.

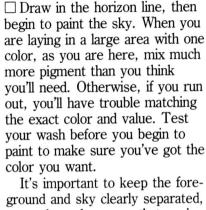

It's important to keep the foreground and sky clearly separated, so work on dry paper that you've turned upside down and propped up at a slight angle. That way, the paint won't run down into the foreground, leaving you free to work without worry. Here cerulean blue and ultramarine are mixed together to create a strong, dense blue. Apply the paint with a large brush to keep your strokes from getting too labored.

After the paint has dried, turn the paper around and start on the foreground. Keep it sparse, simple, and light enough to stand out clearly against the deep blue. Begin by applying a light yellow ocher wash over the entire foreground. When the wash dries, use quick, sure brushstrokes to put down the crisscrossing bands of olive green and mauve. Don't cover up all of the yellow underpainting—that's what makes the foreground warm and lively. Finally, paint in the stand of trees along the horizon.

As a storm approaches, rolling fields lie beneath a still, deep blue sky.

SWEEPING RAIN CLOUD

Learning How to Distinguish Warm and Cool Blues

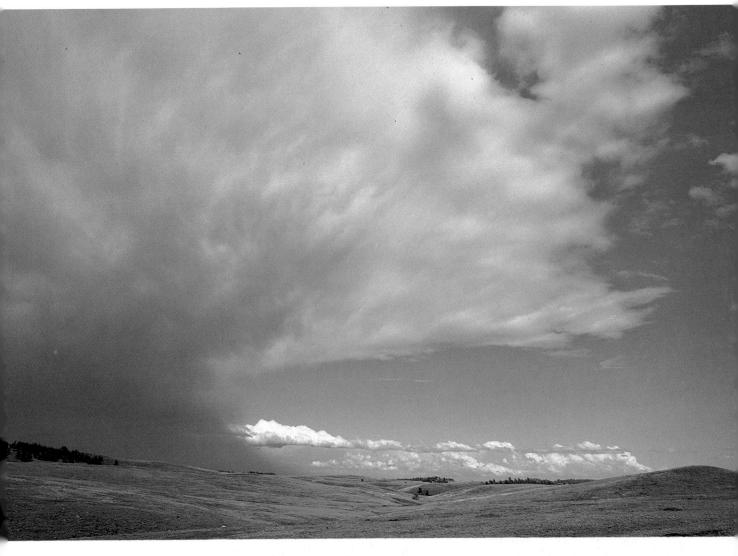

PROBLEM

The rain cloud that sweeps across the left side of this scene has very little definite shape or structure. It will be hard to keep it separate from the blue sky that lies beyond.

SOLUTION

Use color and value to pull the sky and the cloud apart. Paint the cloud first, in a cool shade of blue; then add the sky. To make the sky distinct, you can adjust its value and its warmth.

Far in the distance, an early summer rainstorm beats down upon a fresh green prairie.

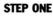

Gently sketch in the rain cloud and the horizon; then, using a natural sponge, wet the entire sky. For the cloud, you'll want cold, steely bluish gray tones. Both ultramarine and cerulean blue are too strong and warm. Instead, start with Payne's gray, tempered with a bit of yellow ocher. Drop the two colors onto the wet paper to indicate the lightest areas of the cloud. Working quickly now, add the darker portions of the cloud before the paper dries. Here Antwerp blue and alizarin crimson form an interesting cool shade. Because the paper is still damp, the light and dark areas run together naturally.

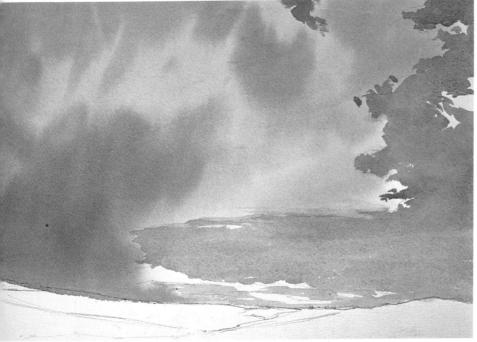

STEP TWO

The sky is blue too, but it's much warmer and more vibrant than the cloud mass, especially toward the top of the paper. Begin there, laying in a mixture of ultramarine and cerulean blue; work around the storm cloud and the clouds near the horizon. As you approach the center of the paper, mix a little yellow ocher with your cerulean blue. Near the horizon line, use just cerulean blue and alizarin crimson. If the edge around the cloud seems too sharp, soften it using a clean, wet brush.

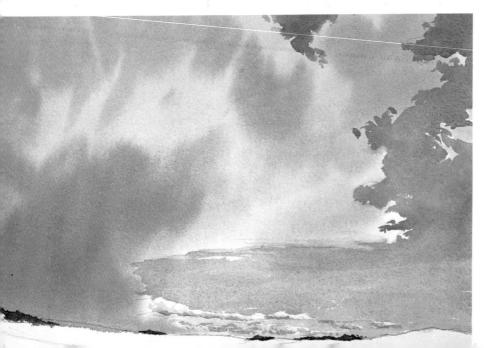

STEP THREE

Add shadows to the long clouds that hover above the horizon. Work with a small brush for control, and make sure that the value you apply isn't darker than the dark part of the storm cloud. Leave the top of the clouds white—the white paper showing through adds a crisp dash to the painting. Now lay in the dark clumps of trees in the background.

FINISHED PAINTING

With new gamboge, Hooker's green, burnt sienna, and sepia, lay in the foreground. Use broad, sweeping strokes applied in a rhythmic fashion to capture the gradations of the hills. Don't let the greens get too flat; you want some variety in your brushwork.

ASSIGNMENT

One of the many challenges a painter faces is to interpret the color of a sky. Understandably, mostly beginners think in terms of blue. But even the bluest sky can be built up of different tones.

Throughout this book, you'll find many references to yellow ocher and alizarin crimson—colors that seem unlikely choices for mixing blues. Get acquainted with how they work.

Begin with a damp piece of paper. You'll need Payne's gray, ultramarine, cerulean blue, yellow ocher, and alizarin crimson. At the top of the paper, lay in a wash composed of Payne's gray and ultramarine. While the paint is still wet, lay in a band of ultramarine and cerulean blue directly below the first band. Make sure the two areas blend together thoroughly. Now eliminate the ultramarine from your palette. Take cerulean blue, add just a touch of yellow ocher, and lay in a third band. For the final band, near the bottom of the paper, mix cerulean blue with alizarin crimson. Again, you'll need just a drop of the second color (red).

Do several of these graded washes, varying the amounts of gray, ocher, and crimson you use. Soon you'll discover how much color you need to just slightly change the blues that form the basis of your palette.

CIRRUS CLOUDS

Exploring Lively, Distinct Cloud Patterns

PROBLEM

Three different situations come into play here: the clouds in the background are soft and indistinct, the smaller ones in the middle ground have sharp edges, and the large mass in the foreground is soft, billowy and tinged with yellow.

SOLUTION

Work out the soft foreground clouds first. To capture their texture, you'll need to work on wet paper. Later go back and rub out the clouds in the background; then define the sharp-edged cloud formations in the center with opaque gouache.

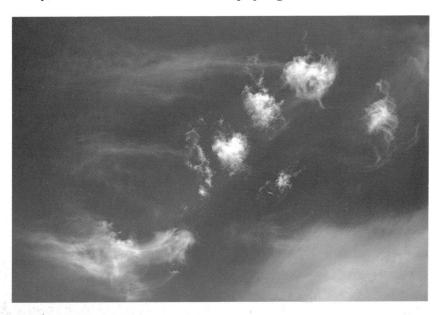

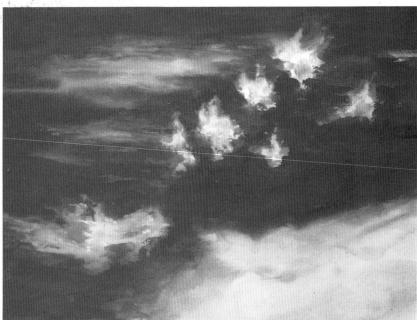

Start by sketching the shapes of the major clouds, then wet the entire paper using a natural sponge. It won't abrade the surface of the paper the way a synthetic one will. Once the paper is wet, begin working on the light clouds in the foreground. (First analyze their color: only when the sun shines directly on clouds are they really white. In this painting, a mixture of vellow ocher and Pavne's grav gets across the feel of the large cloud mass.) With a large brush, work in the color loosely; what you're trying to capture is the soft, hazy way the shapes float against the

Next take ultramarine and cerulean blue and mix a deep, rich tone. Lay in the sky quickly, while the paper is still wet. The blue will run into the cloud mass in the foreground, softening its contours. Before the paint dries, quickly take a piece of paper toweling or a small natural sponge and wipe out the small clouds in the upper left quarter of the painting. Next drop in opaque white to define the crisp clouds in the center. Work the paint rapidly into the still damp blue.

DETAIL

The techniques used in rendering these clouds create very different effects. The cloud on the left was wiped out with a piece of toweling; it looks hazy and indistinct. Those on the right were created by dropping opaque paint into the damp blue sky; they look sharp and clearly defined. The clouds on the right are much more dynamic and forceful than those on the left, which seem to float back into space.

In autumn, thick cirrus clouds whirl across a dark blue sky.

ALTOCUMULUS CLOUDS

Depicting a Complex Overall Cloud Pattern

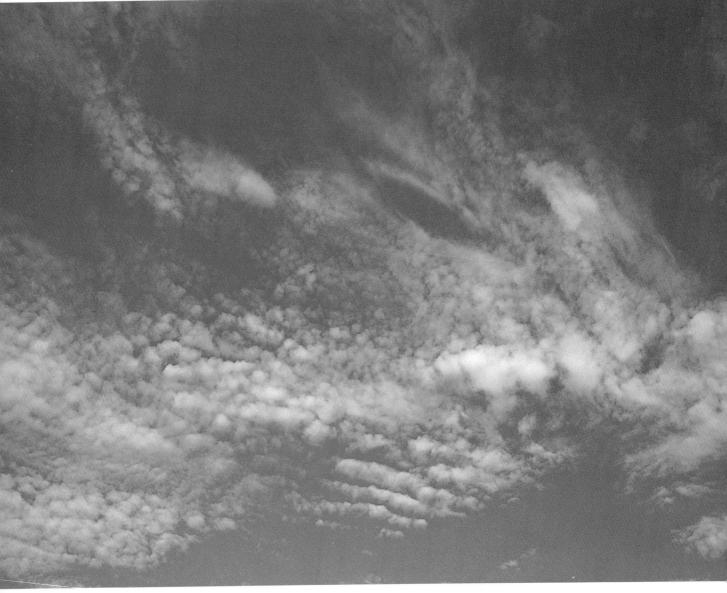

PROBLEM

When a pattern is as strong as the one you see here, to make sense out of it is difficult. The challenge is even greater when you're dealing with soft-edged masses.

SOLUTION

First simplify the pattern as much as possible; then lay down a deep-blue graded wash. To achieve a soft effect, drop in opaque white while the paper is still damp. Don't try to paint around the clouds; their edges will look hard and brittle.

□ When the clouds are as complex as the ones you see here, don't bother sketching them. Instead, begin by analyzing the blue of the sky. Although it looks uniform at first, it is actually darker toward the top. Mix a wash of cerulean and ultramarine blue and apply it quickly to the paper. When you are laying in broad areas like this, use a large, soft brush. Toward the top of the paper, add a little Payne's gray to darken the blue.

Masses of altocumulus clouds float across the sky, forming a rich, dense pattern of white on blue.

While the paint is still damp, begin dropping in the white paint. Blend it gently with the blue underpainting. Keep your eye on the overall pattern the clouds form and don't get stuck in any one spot. When you are happy with the pattern, stop.

You can see an almost pure white passage near the center of the painting. Almost everywhere else, the white paint has blended with the blue. This variation adds sparkle to a painting.

ASSIGNMENT

Don't wait until you're working on a painting to learn how to tackle cloud patterns. Begin at home with several wet-in-wet techniques.

First, prepare a big puddle of blue wash and apply it to three sheets of paper. While one is very wet, drop in opaque white. Explore how it mixes with the blue and how to control it with your brush.

Next, turn to the second sheet; it should be slightly damp. Again, put down opaque white. Note how the paint handles differently when the paper is just damp.

Finally, turn to the third sheet. It should be almost dry. Moisten the cloud areas with clear water. Run your brush over lightly to loosen some of the blue pigment. Now add the white paint.

Don't stop here—endless variations are possible.

CLOUD MASSES

Learning to Simplify Dramatic Cloud Formations

PROBLEM

This composition is deceptively simple. Even though there is only one tree and the prairie seems straightforward, strong, bright colors and complex patterns fill both the sky and prairie.

SOLUTION

Decrease the strong blue in the sky and downplay the clouds behind the tree. You don't always have to paint exactly what you see. Instead, think through the overall composition before you begin to work, and decide what needs to be changed to make an effective painting.

☐ Do a preliminary sketch and then mask out the tree. It's going to be hard to get the tree to stand out against the dramatic sky, so save it for last.

Next tackle one of the hardest parts of the painting—the sky. Begin by laying in a graded wash; the sky is darkest at the top and gradually shifts to a middle tone at the horizon. Don't try to match the brilliant blue you see. There is enough strong color in the foreground, so make the blue a little

While clouds mass together overhead, a lone tree stands in a prairie filled with scraggly grass.

duller and grayer.

While the paint is still wet, start to indicate the large white clouds. Drop opaque gouache onto the paper, letting it mix slightly with the blue underpainting. Once you're satisfied with the pattern you've formed and with the contrast between the clouds and the sky, let the paper dry.

Now develop the foreground. First put down a wash of warm yellow ocher near the horizon line. As you move toward the bottom of the paper, add sepia and burnt sienna using vertical strokes to get across the feeling of tall grass. Next add texture and detail to the foreground. Using opaque paint and a fine brush, highlight a few clumps of grass. Then, to animate the field, spatter paint over it. Finally, remove the masking solution and paint the tree.

Discovering How to Depict Rays of Light

PROBLEM

When the sun lies almost hidden by a mass of clouds, you have to pay attention to three elements: the pattern of the clouds, the sky, and the rays of light. So much is going on that to capture a coherent image is difficult.

SOLUTION

When you approach a complicated subject like this one, it's especially important to plan a method of attack. Visualize the finished painting before you begin; then analyze how to achieve the effect you want. Here the rays of light are dealt with last—they are rubbed out with an eraser.

Storm clouds crowd together over an Arizona desert, masking the sun and allowing only a handful of its rays to break through.

STEP ONE

Draw in the horizon line and the hills and roughly indicate the shape of the storm clouds. Then decide where to start. Since the sky is a much larger part of the scene than the cloud mass, render it first. Work with a variety of blues—ultramarine, cerulean, and Antwerp—warmed with a little vellow ocher. Don't try to make your sky wash too even; a little variety in the surface helps to capture a stormy feel. Right near the horizon, add a touch of alizarin crimson to convey a sense of distance.

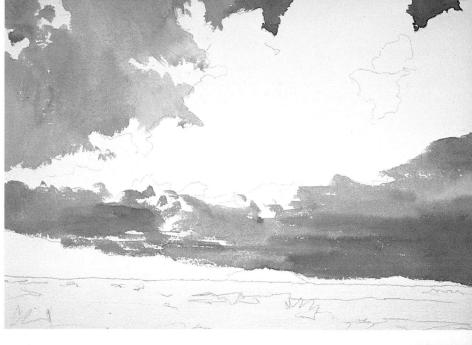

STEP TWO

Now move in on the clouds. You'll want to leave a white border around them to indicate the sun; keep that white shape irregular and full of movement. Use the same blues for the clouds as you used for the sky, but darken the tones with a little Payne's gray and alizarin crimson. Don't work with one flat tone because it's even more important here than in the sky to create a rich surface. Lay in some blue wash, and then add touches of gray and crimson right onto the wet paper, mixing the colors as you work.

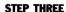

The white border around the storm clouds looks stark, so ease in touches of pale blue to break it up. Don't fill the white area or overpower it; simply pattern what could be a dead, empty space. Now paint in the hills along the horizon. Render them with the cool blues you've already used, to make them harmonize with the sky. Now add the foreground. Here the ground is a wash of yellow ocher and burnt sienna. While it's still wet, drop in dashes of mauve and Antwerp blue toward the immediate foreground.

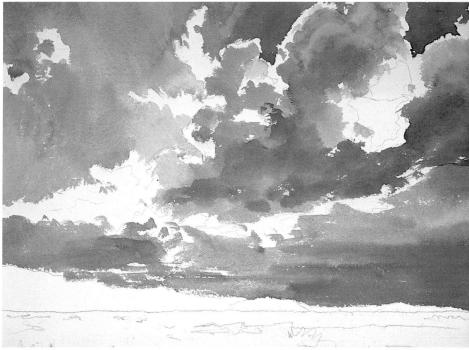

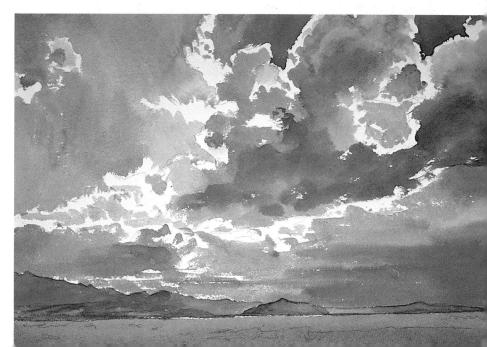

FINISHED PAINTING

Using restraint, enrich the foreground of the painting with new gamboge, Hooker's green, and burnt sienna. Don't add too much detail or it will pull attention away from the sky. Finish the foreground by spattering a dash of sepia over it.

Finally, when the paper is absolutely dry, take a soft eraser and pull out the rays of light that break through the clouds. Work gently; don't force the eraser across the surface or you may rip the paper. Keep the erased lines straight and even, and be sure to have them all radiate from one point. To achieve a dramatic effect, work with assurance.

ASSIGNMENT

It takes practice to use an eraser effectively on a watercolor painting. This exercise will help you understand how it's done.

Begin by preparing several small sheets of paper with a graded wash. Let the papers dry thoroughly; if they're even slightly moist, you'll end up with smeared (and ruined) works.

Take three erasers—an ink eraser, a kneaded one, and a regular soft pencil eraser-and experiment with all three. You'll soon discover that the ink eraser is the most abrasive. It'll pull at the surface of the paper, destroying the texture. The pencil eraser is your best bet; it may pull up the color more slowly, but the result will be much less harsh. Finally, the kneaded eraser is a handy tool for softening lines vou've picked up with the pencil eraser. It's great, too, for cleaning up bits of paper and paint that remain after you've used the pencil eraser.

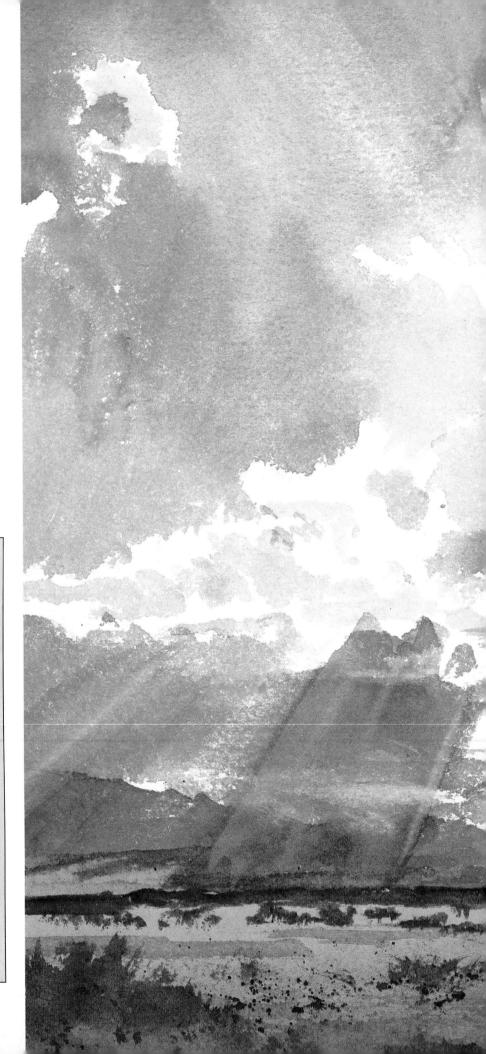

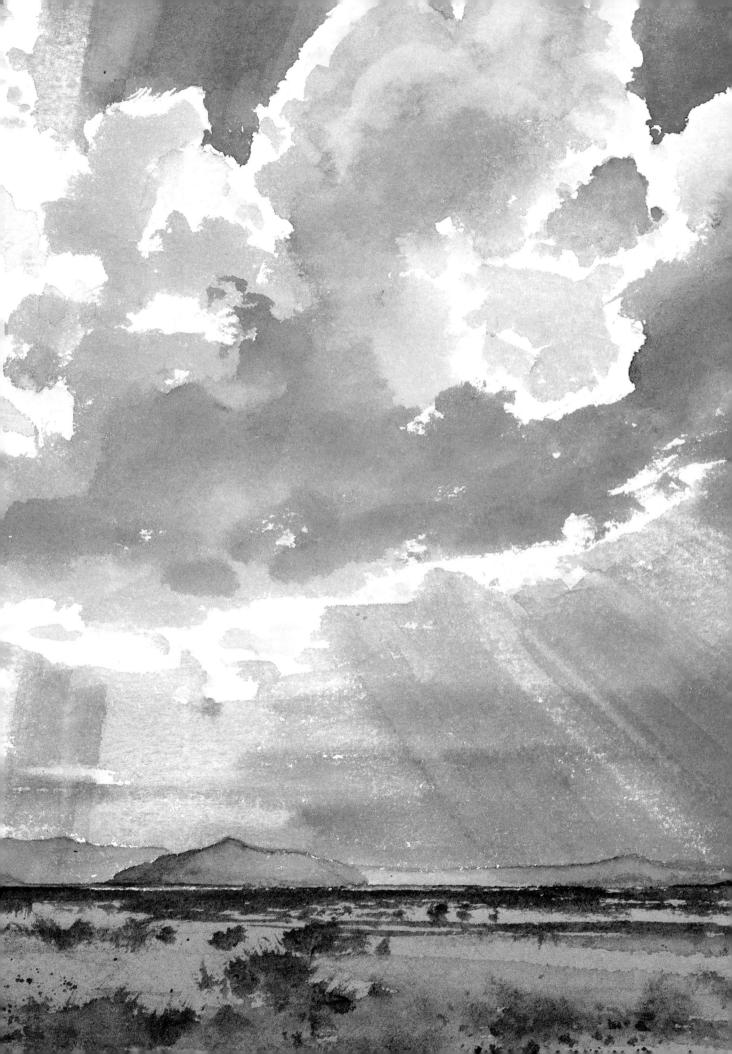

EARLY MORNING

Capturing a Strong Silhouette Against an Early Morning Sky

DOOD! EM

The strong silhouettes of the deer and the tree make the sky almost incidental to the scene. Yet the sky sets the time of day and makes what could be a stiff and unnatural composition come alive. You've got to make the sky interesting and full of color, but not so lively that it pulls attention away from the foreground.

SOLUTION

Paint the sky first, working over the entire paper. The dark foreground will cover up whatever color you lay in, and you'll be able to work more freely if you're not trying to stay in just one area.

Early on a summer morning, as the sun streaks the sky with color, a mule deer pauses briefly before it disappears into the woods.

STEP ONE

Execute a careful sketch; then plan the sky. Keep your washes light; after you mix each color, paint a test swatch to make sure the color isn't too intense. It's easier to lay in blue over pink than vice versa, so start with a pale wash of alizarin crimson. When it's dry, begin laying in the blues. Toward the top, work in Antwerp blue and toward the horizon, cerulean blue. Don't make the sky too regular—the bands of color should have interesting, slightly irregular contours.

Now intensify the blue bands in the sky. Follow the pattern you observe in nature as you begin, and don't cover up all of the pink underpainting. Here, cerulean blue bands are applied in the middle of the sky. At the bottom, cerulean is mixed with ultramarine, and at the top, cool bands of Antwerp blue and alizarin float across the paper.

STEP THREE

Let the paper dry before you move in to paint the deer and the tree. While you're waiting, decide what colors to use. In a silhouette situation like this, any dark color-even straight black-could probably be used. But the effect is much more interesting if you include one or two of the colors used elsewhere in the composition. For the tree, use ultramarine darkened with Pavne's gray and sepia. Render the deer with the same mixture, but add a drop of burnt sienna to bring out the color of the animal's coat.

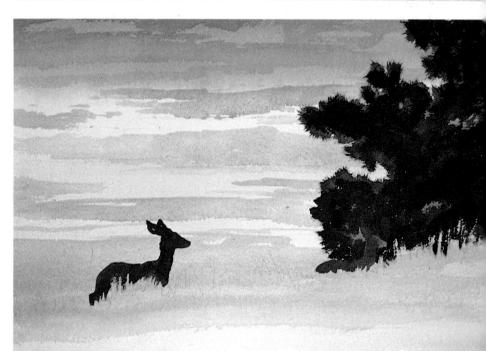

FINISHED PAINTING

Now add the foreground. First apply a wash mixed from yellow ocher, burnt sienna, sepia, and Payne's gray; then, while the paint is still wet, scratch out some of the tall grasses. To do this, simply use the tip of a brush handle. Finally, add a little punch to the foreground by spattering sepia over the grass.

ASSIGNMENT

Momentary scenes like this one, with an animal paused for just a second, have to be captured quickly. One of the most practical ways to do that is to work with a camera. Most artists rely on photography in one way or another, and for artists interested in skies, it can be invaluable. Many of the shifting patterns that clouds form are ephemeral-before you can begin to get down the image you want, the entire pattern may change. Try carrying a camera with you when you go scouting for new painting situations, and record any sky formation that interests you.

Once your film has been developed, organize a file of your pictures. Separate them according to time of day and season. Later on, when you are working on a painting and need to have a specific image—say, a late afternoon sky in autumn—you'll be able to turn to your file and find a suitable sky.

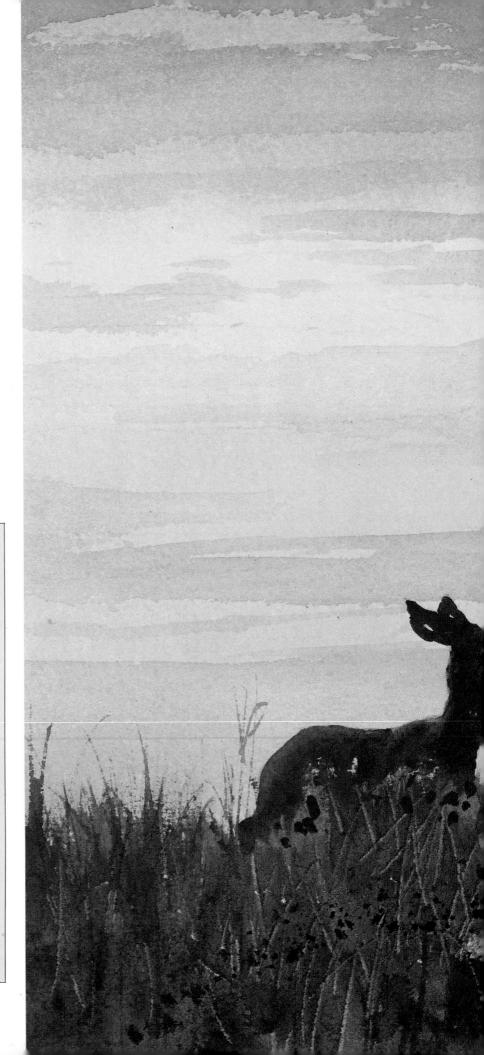

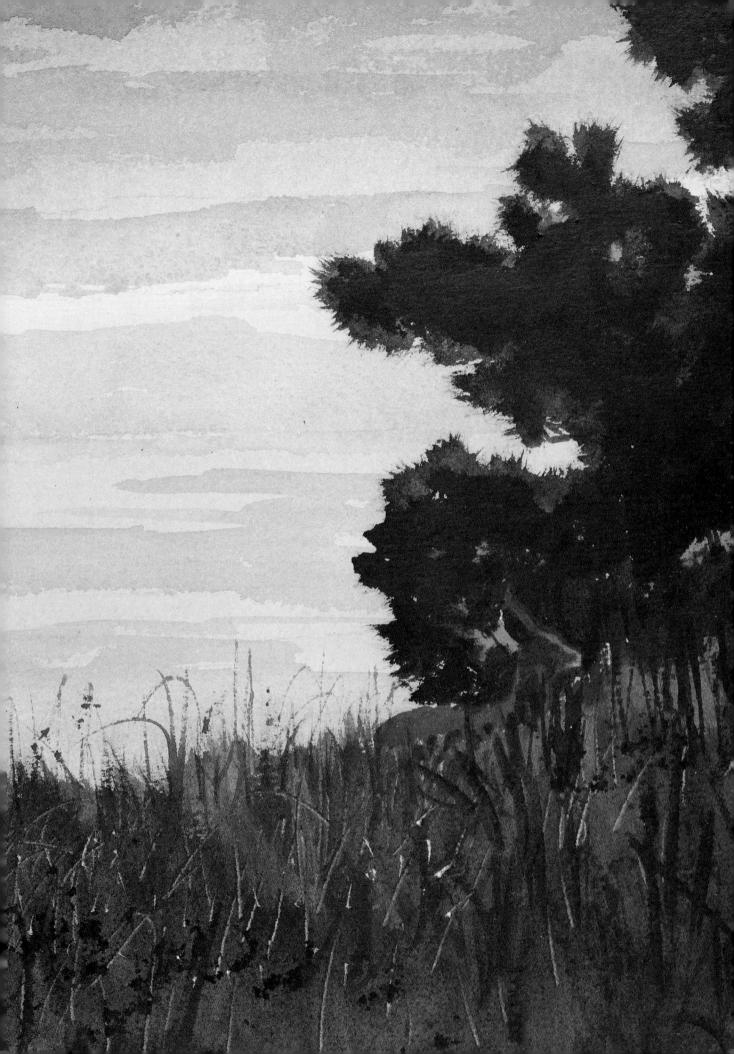

STRATUS CLOUDS

Using a Wet-in-Wet Technique to Depict Cloud Masses

PROBLEM

When you're dealing with nebulous clouds like these, there isn't much to hang on to. Their edges aren't well defined and they run into one another. Finally, in some places, subtle patches of light break through.

SOLUTION

Don't be too literal in your approach. To get the soft feel of this kind of sky, work with a wet-in-wet technique; follow the overall cloud patterns and let the light shine through.

☐ Wet the entire paper with clear water. Then quickly drop ultramarine onto the right and left sides of the paper. Keep the blue light and as you work, follow the patterns created by the clouds. Temper the blue with touches of alizarin crimson and burnt sienna. Next move to the center of the paper. Using the same colors, begin to depict the central clouds.

To convey the feeling of rays of light, lift the paper up and let

As massive stratus clouds bear down upon the land, snow threatens.

the paint run down. Move the paper up and down and back and forth. As you work, try to control the flow of the paint—you don't want to completely cover up the light, white areas. If you lose control, wash the paint off with a wet sponge and start all over again. As soon as you've captured a strong pattern, set the paper down and let the paint dry.

For the foreground, mix sepia with a touch of ultramarine, and

then lay in the rolling hills and the tree trunks. Let the paint dry. Finally, use a pale sepia wash to suggest the masses of branches that radiate from the trunks.

The soft, wet, lush clouds result from careful control of the paint flow. The color runs effortlessly into the white areas, breaking up the white with gentle, raylike streaks.

Balancing a Dramatic Cloud Formation and a Plain Gray Sky

PROBLEM

Most of the scene is taken up by the plain bluish gray sky. The focal point—the cloud formation must blend in with the gray sky yet have enough drama to lend interest to the painting.

SOLUTION

Develop the light, cloud-filled area near the horizon first, then carefully shift to a graded wash for the bluish gray sky above. Make the transition between the two areas as soft as possible.

While the paint is still wet, tackle the clouds. First depict the dark, shadowy areas with a mixture of yellow ocher, alizarin crimson, and Payne's gray. Next mix opaque white with a dash of yellow ocher and drop in the soft white portions of the clouds. Don't let their edges get too sharp. If necessary, drop in a bit of clear water to soften any harsh lines.

Most beginning painters make their clouds almost pure white, but clouds are rarely white. They reflect the color of the light that fills the sky and may be grayish, reddish, or—as they are here—tinged with yellow. Don't be afraid to experiment with unlikely colors when you approach cloudfilled skies. You'll find your paintings will become much more vital and realistic if you move beyond the expected.

To finish the painting, indicate the hillside that runs across the bottom of the picture. Try a pale mauve wash—the cool purplish tone is great for conveying a feeling of distance. When it's dry, lay in the trees in the foreground with Hooker's green. Add detail and texture to the trees with sepia using a drybrush technique.

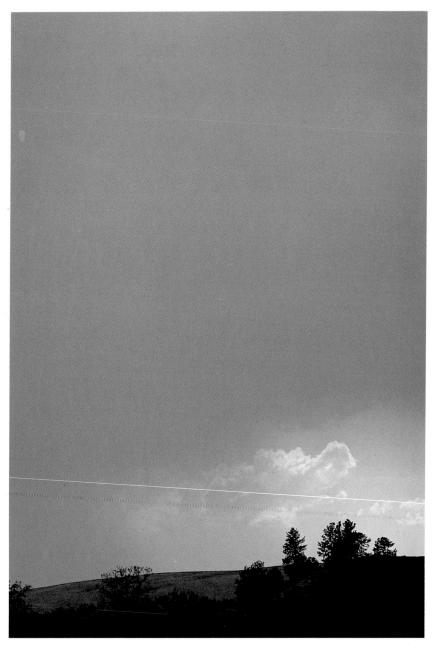

During a rainstorm, low-lying clouds press close to the ground.

CLOUD SPIRAL

Using a Clean, Sharp Edge to Hold the Shape of a Cloud

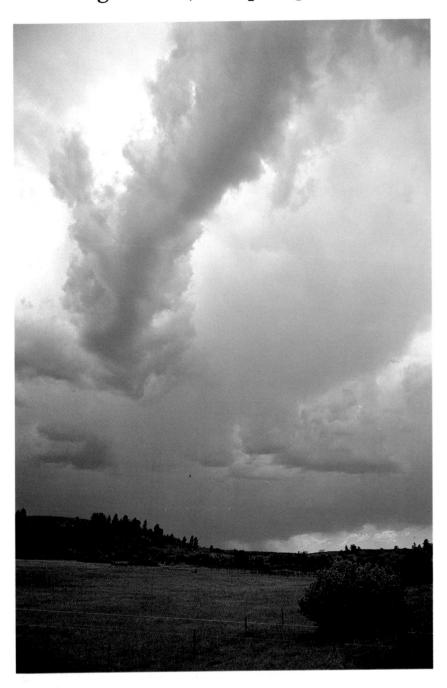

Dark storm clouds spiral down toward a soft green summer landscape.

PROBLEM

Even though the dark vertical cloud is what you notice first, soft diffuse cloud formations actually fill the whole sky. You'll need to capture two atmospheric effects.

SOLUTION

Work wet-in-wet first, rendering the soft clouds that occupy most of the sky. Let the paper dry thoroughly, and then lay in the darker cloud. Because you'll be working on dry paper, you'll be able to keep the cloud's contours clean and sharp.

STEP ONE

After you sketch in the foreground, wet the sky with a sponge. Now lay in a cool gray wash over the whole sky; here the gray is mixed from Payne's gray and yellow ocher. While the wash is still wet, drop in darker colors with a large round brush to indicate the brooding clouds that eddy out near the horizon and at the top of the paper. Use cerulean blue and ultramarine for the basic shapes, and add a small touch of alizarin crimson and burnt sienna near the horizon. Let the paper dry—if it's even a little damp, you'll have trouble with the next step.

STEP TWO

Begin to execute the dark cloud that shoots down through the sky. Try a mixture of Payne's gray, yellow ocher, and cerulean blue. By keeping your brush fairly dry, you'll be able to take advantage of the paper's texture. The paint will cling to the raised portions but won't fill up the depressions. Also, because the paper is dry you'll achieve a crisp, clear line.

Now, while the freshly applied paint is damp, drop in the darkest area of the cloud and the smoky clouds that run along the horizon. For this, mix cerulean blue with ultramarine and alizarin crimson. Finally, with a light wash of cerulean blue and yellow ocher, add the splash of bright sky that breaks through the clouds along the horizon.

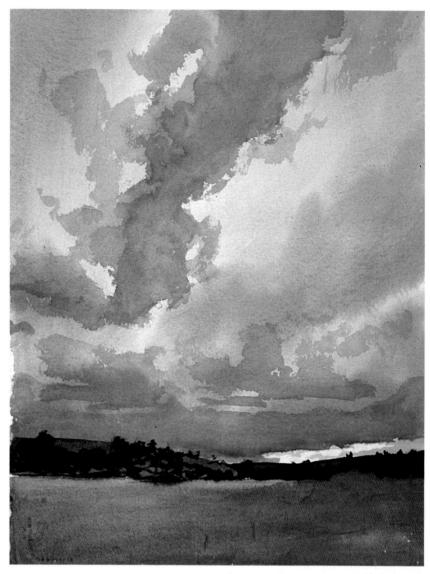

STEP THREE

When you approach the foreground, think in terms of value. The grassy field will be the lightest value, and the trees and hills will be rendered in two darker values of green. Beginning with the distant hills and trees, put down a middle-tone mixture of Hooker's green and burnt sienna. Now accentuate the dark portions of the trees with Hooker's green, sepia, and Payne's gray. When everything is dry, lay in the foreground with a blend of Hooker's green, yellow ocher, burnt sienna, and just a touch of cool mauve.

FINISHED PAINTING (OVERLEAF)

Let the field dry. Then, using the same colors you used in step three, paint the shrub in the lower right corner. You'll want to bring a little life to the foreground now: first lay in washes of green over the grass, and then add some brownish strokes at the very bottom of the paper. The brown strokes move out from the shrub at a sharp angle, adding a definite sense of perspective to the scene and leading the viewer's eye into the painting.

RAINBOW

Capturing the Beauty of a Rainbow

PROBLEM

A rainbow is extremely difficult to capture in paint. It is light and ephemeral yet made up of definite colors. If it doesn't blend in naturally with the sky, it will look garish and seem pasted onto the paper.

SOLUTION

Lay in the blue sky first; then carefully wipe out the area where the rainbow will go. Don't mask the area out—the transition between the sky and the rainbow will be too harsh if you do.

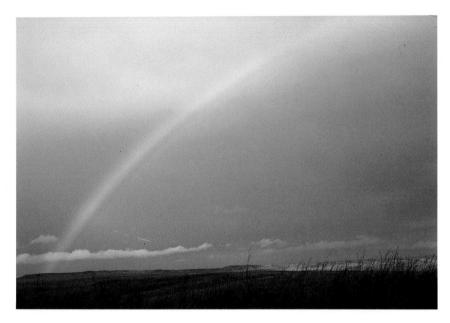

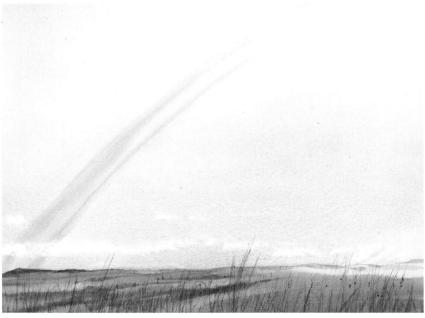

A rainbow springs across a pale blue sky, animating the prairie below.

☐ Although at first the sky seems to be a single shade of blue, it's actually darker toward the horizon. To capture the subtle shift of color, apply a graded wash to wet paper. Here cerulean blue and vellow ocher are mixed with a touch of ultramarine. Since it's easier to control a wash if you don't have to worry about the paint running into the foreground, turn your paper upside down. As soon as vou've laid in the wash, and while the paper is still wet, use a paper towel or dry sponge to wipe up the paint where the clouds and the rainbow will be. Move quickly now. The paper should be slightly damp when you put down the rainbow.

The colors in the rainbow are mauve, ultramarine, alizarin crimson, cadmium orange, new gamboge, lemon yellow, Hooker's green, and cerulean blue. Keep your values very light and let each color blend into the ones surrounding it. Getting the right colors and values as well as a soft, natural feel is difficult — you may need several attempts.

To show the clouds that break through the bottom of the rainbow, again take a piece of toweling or a sponge and pick up the paint. Now put down the foreground. Begin with a wash of new gamboge; then add mauve and sepia for the shadowy areas and the details. When everything is dry, evaluate your painting. (Here the rainbow was too bright toward the top. To soften it, a kneaded eraser was used to gently pick up touches of paint.)

DETAIL (OVERLEAF)

Here you can see what happens when you wipe up wet paint. First, note the soft edges of the rainbow. Then look at the clouds that cut through the arcs. They don't seem harsh but float gently in front of the rainbow.

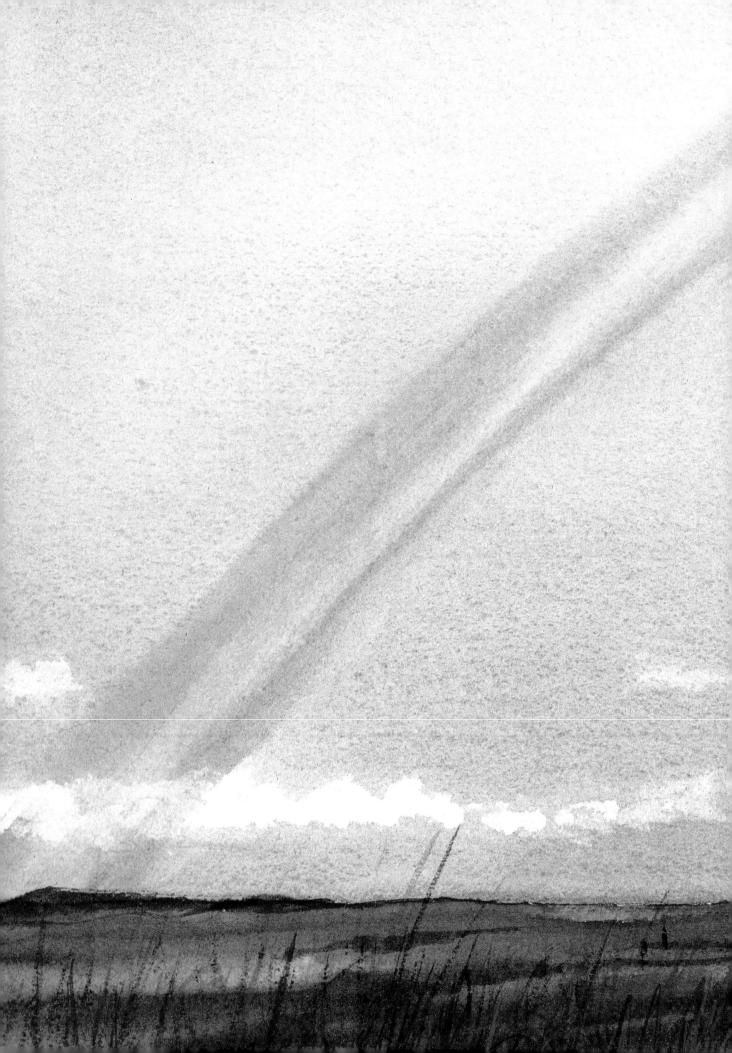

BILLOWY CLOUDS

Discovering How to Work with Late Afternoon Light

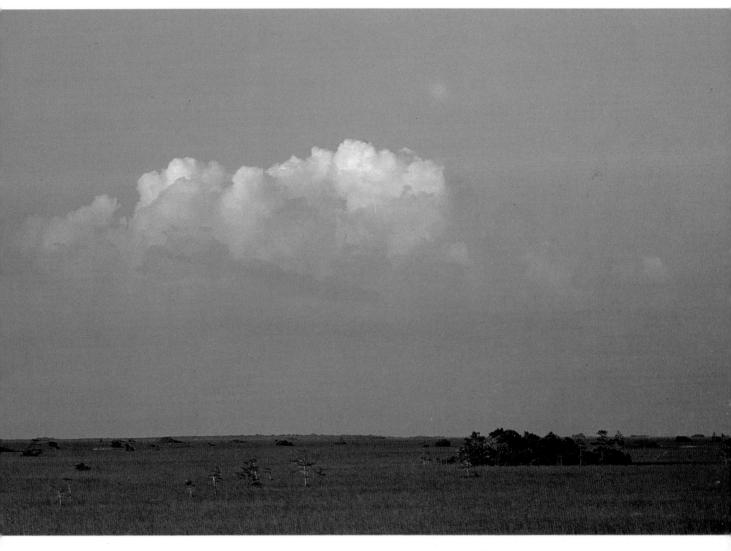

PROBLEM

These clouds are suffused with a warm pink tone—in fact, the whole scene has a pinkish yellow cast. You have to inject your painting with a pinkish tone without overstating it.

SOLUTION

Instead of adding red and gold to all of your colors, first do a flat underpainting with alizarin crimson and new gamboge. The underpainting will shine through all of the colors you put on top, and so unify the entire scene. □ Cover the paper with a pale wash of alizarin crimson and new gamboge; let the paint dry. Now lay in the sky, starting with cerulean blue. Work around the large cloud formation, chiseling out its shape. Toward the top of the paper, deepen the cerulean blue with ultramarine, and near the horizon, drop in a little alizarin crimson.

Using pale washes mixed from your blues and alizarin, paint in

the shadowy areas along the undersides of the clouds. Keep your values light or the clouds will blend in with the medium-value sky. Now lay in the foreground. Start with a wash of new gamboge, and then use burnt sienna and olive green to depict the grasses, shadows, and trees. As a final accent, paint the hills that sprawl along the horizon using mauve.

Soft, billowy clouds float lazily above the Everglades, in a late afternoon sky.

ASSIGNMENT

In the late afternoon, the sky is often cast with a pinkish tone. During other times of the day, the atmosphere is also characterized by a particular hint of color. Try to figure out what colors you see in the early morning, at noon, in the late afternoon, or at twilight. For example, in the summer the sky at dawn may seem suffused with pale yellow; in the dead of winter the sky is often a cold, steely gray. Once you've isolated those basic colors, prepare your watercolor paper ahead of time: lay in a wash over several sheets before you go outdoors to paint.

The underpainting of alizarin crimson and new gamboge—warms the white paper and acts as a base for the colors you add later. The shadows are pale and melt into one another; they're mixed from various densities of ultramarine and cerulean blue, plus a touch of alizarin crimson.

The blue of the sky near the foreground is tempered with uneven touches of alizarin crimson. The purplish blue that results creates a powerful sense of distance.

Horizontal brushstrokes add an expansive feel to the foreground, making it seem to rush outward, beyond the limits of the paper. The warm, rich colors fit in perfectly with the warmth of the brilliant sky.

STORM CLOUDS

Working with Dense Cloud Masses

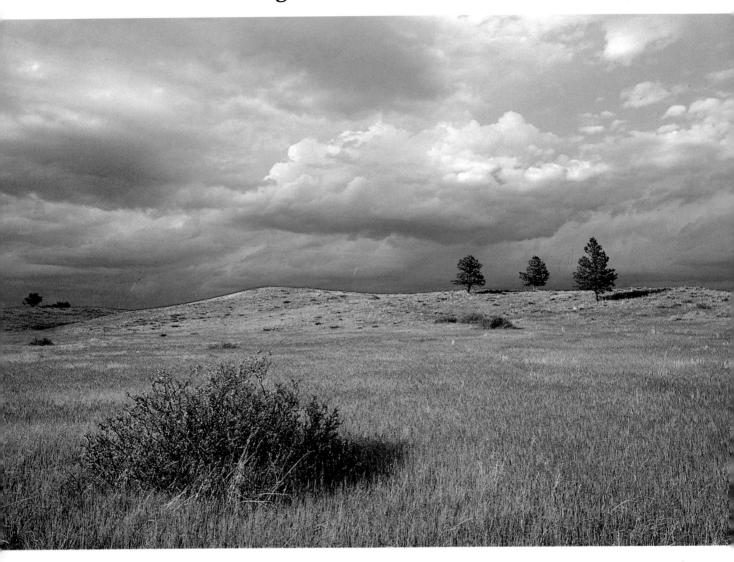

PROBLEM

This scene is packed with richly textured clouds—so many that none of the sky shows through. Furthermore, there's no strong contrast between darks and lights. The clouds aren't your only problem; you'll also want to capture the radiant light that bathes the entire scene.

SOLUTION

Forget about showing all of the surface details that fill the clouds. Instead, simplify them, following whatever pattern you see. Then accentuate the bright green hills that roll across the foreground to suggest the radiance of the sky.

Thick storm clouds press down on a brightly lit prairie.

STEP ONE

Do a preliminary drawing; then wet the sky with a sponge or a flat brush, 1½" to 2" wide. Mix a cool wash of Payne's gray, cerulean blue, and yellow ocher, and drop it onto the top right and left corners of the paper. Let the water on the paper carry the pigment loosely, down and outward. You'll want a darker, warmer tone for the clouds that float above the horizon—try mixing ultramarine, Payne's gray, yellow ocher, and a touch of alizarin crimson. Drop the paint in and again let the water carry it. If you start to lose the pattern you see, use a small round brush to direct the flow of the paint.

Up until now, you've worked wetin-wet, establishing the basic underlying areas of bluish gray. Now, to add structure to the sky, you'll have to add sharper, clearer passages of paint. Before you begin, analyze the scene: look for the most definite patterns of darks. Mix ultramarine and cerulean blue with Payne's gray, and then start to paint. Leave some edges crisp; soften others with a brush dipped in clear water.

STEP THREE

If the foreground gets too dark and heavy, you'll lose the radiant light that washes across the whole scene. What you want is a rich, verdant green that pulsates with warmth. Start laying in the foreground with a graded wash: at the horizon use pure yellow ocher—the gold will make the sun seem to break through the clouds, hitting the distant mountains; as you move forward, introduce Hooker's green and then burnt sienna and sepia. While the paint dries, use a small brush moistened with clear water to wash out the three trees in the distance.

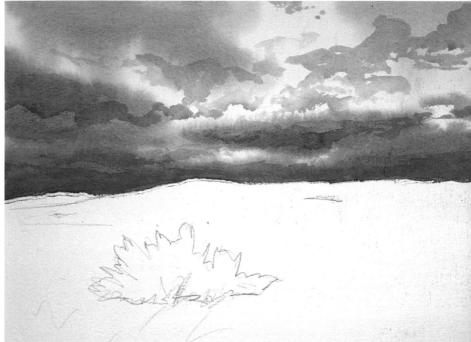

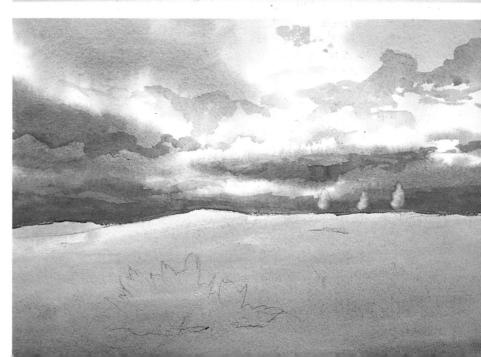

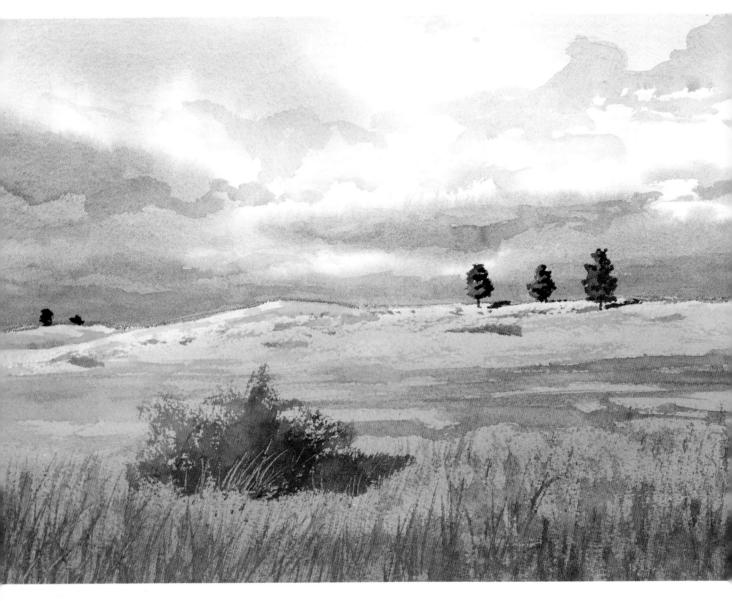

FINISHED PAINTING

Add light, sweeping washes over the graded wash in the foreground; here, Hooker's green, yellow ocher, burnt sienna, and sepia are used. Next add the dark trees along the horizon and the shrub in the foreground. Finally, use a drybrush technique to render the tall grasses visible in the immediate foreground.

DETAIL

Here you can see the two techniques used to render the sky. In the background, a soft, hazy bluish gray runs into the white paper—the paint is applied while the paper is wet. After the paper has dried, the darker, sharper passages that hover over the indistinct background are added.

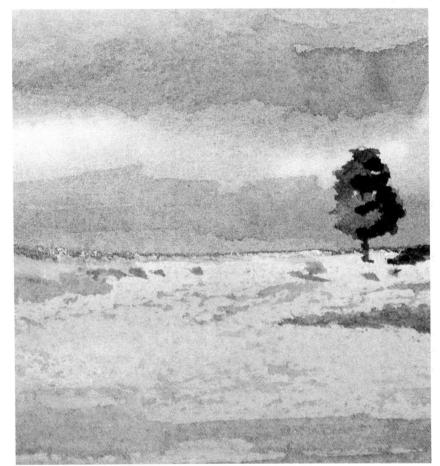

DETAIL

The deep blue sky along the horizon contrasts neatly with the golden green hills. Gradually, toward the bottom of the paper, the ground becomes deeper and richer.

CUMULUS CLOUDS

Using Opaque Gouache to Render Thick, Heavy Clouds

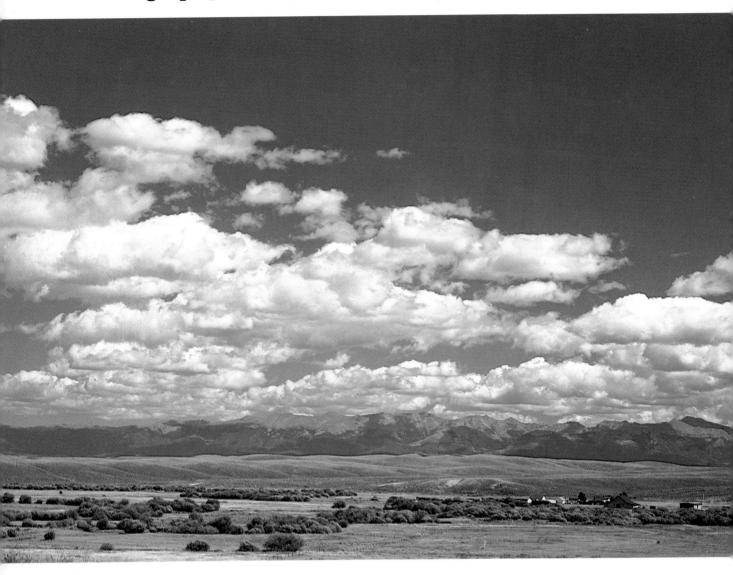

PROBLEM

These cumulus clouds contrast sharply with the rich blue sky and the shift from deep blue to bright white gives the scene much of its power. But the clouds aren't just white—their shadows are grayish gold, and if you make the shadows too dark, you'll lose a lot of the contrast on which your painting depends.

SOLUTION

Begin with the sky, laying in a rich blue graded wash. Then paint the clouds with gouache. First establish their shapes with white, and then gently work in their shadows, constantly balancing the value of the shadowy areas with the value of the sky behind them.

On an autumn afternoon, thick cumulus clouds fill the sky, sweeping back over the rolling Wyoming ranch land.

STEP ONE

Sketch the scene; then begin to paint the sky. In your graded wash, you'll want to work light to dark, beginning along the horizon. (Turn your paper upside down so you won't have to worry about paint running into the foreground.) Along the horizon, put down cerulean blue and yellow ocher, then gradually shift to a mixture of cerulean blue and ultramarine. Next work in pure ultramarine, and then deepen it with a touch of Payne's gray. Let the paint dry.

STEP TWO

Keeping your eye on the patterns formed by the clouds, start painting the clouds closest to you. Lay in their basic shapes using white gouache. For the little clouds that float high in the sky, apply the paint with a drybrush technique. The broken strokes will let the blue of the sky show through, making the clouds seem far away.

Now turn to the shadows. Mix white gouache with Payne's gray and yellow ocher, but keep the color lighter than you think it should be. Carefully work the paint into the clouds, using soft, gentle strokes—you don't want any harsh edges.

STEP THREE

Now it's time to finish the clouds. Add the masses that drift above the horizon, first with pure white and then with the same shadow colors vou used before. To achieve a sense of perspective, make the shadows slightly darker on these low-lying clouds; that will push them back into the distance. Once the clouds are done. you may have to increase the value of the sky that lies just above the mountains. (Here, for example, the darkish shadows made the sky seem too light.) Next paint the mountains using yellow ocher, burnt sienna, and ultramarine.

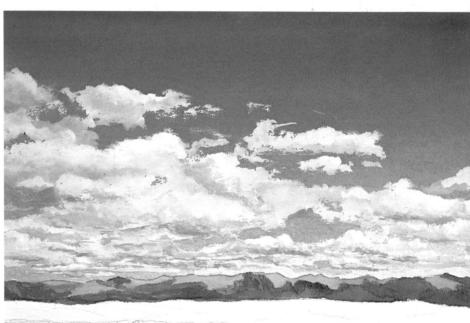

FINISHED PAINTING

To balance the activity in the sky, you'll want a rich variety of greens to spill out across the plain. All the greens you see here are mixed from new gamboge, ultramarine, Hooker's green, yellow ocher, and burnt sienna. Keep the play of lights and darks lively, and finish your painting by adding a little texture to the lower left corner.

ASSIGNMENT

Learn how to control the value of shadows before you attempt to paint a rich cloud formation that's full of lights and darks. You'll be working with gouache, applying it to a prepared surface.

Start by laying in a mediumblue graded wash over an entire sheet of watercolor paper. Let the paint dry. Next use pure white gouache to depict some basic cloud shapes, working either from nature or from a photograph. Keep the contours lively and interesting—you don't want the clouds to look like cotton balls pasted onto a backdrop.

Now mix white with a small amount of gray and yellow. What you need is a very pale shade, just one value darker than pure white. Paint in some of the shadows, using loose strokes. Now make your mixture of white, gray, and yellow one value darker. Lay in more of the shadows. You should immediately see the difference in value between the white and the two light gray tones.

If you make shadows any darker, they may look like holes punched through the clouds. Keep them lighter than the blue sky behind them.

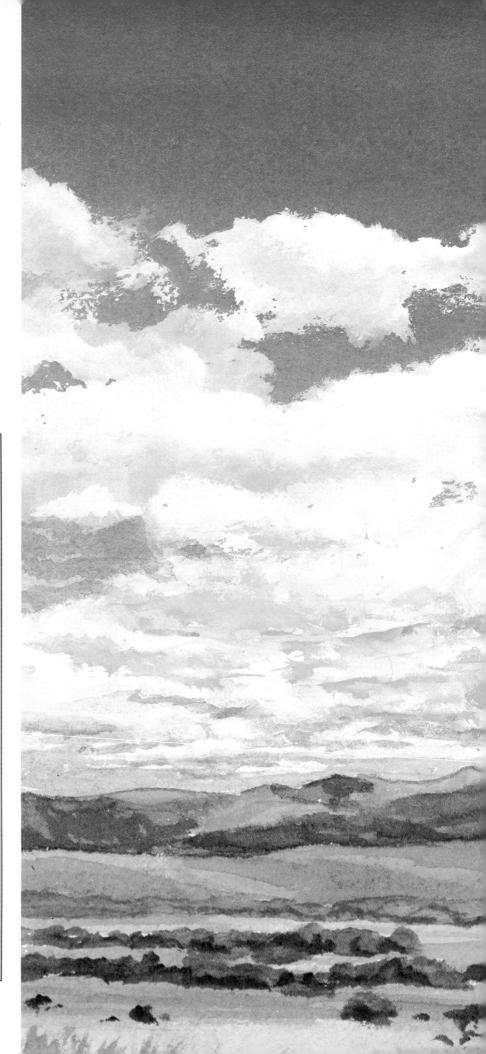

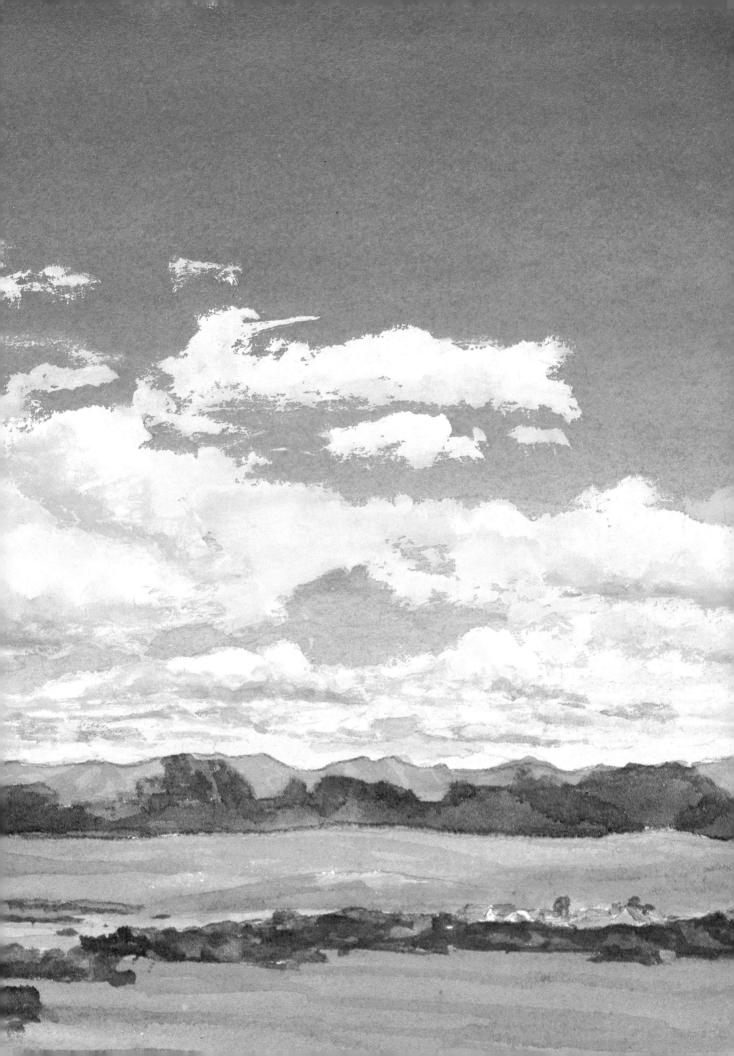

DESERT MOUNTAIN SKY

Learning How to Handle Complex Patterns

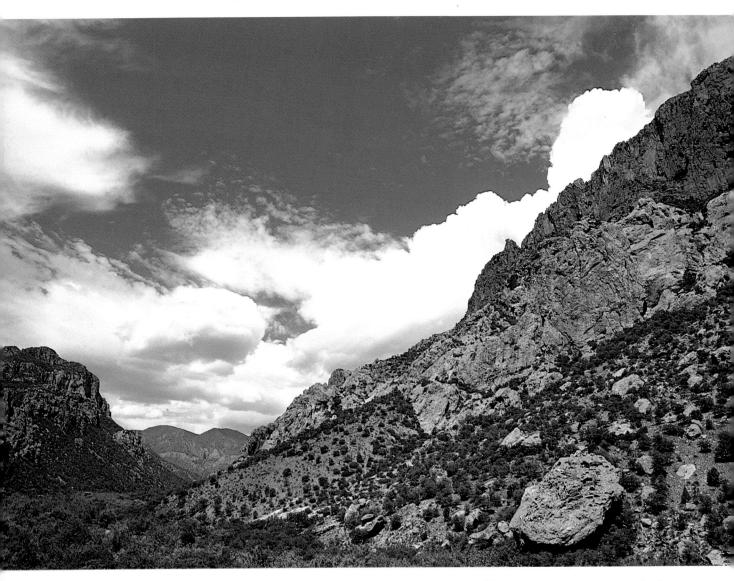

DOOR! EN

So much drama is crowded into this scene that you could easily lose your way when painting it. The clouds and the rich blue sky compete for attention with the rocky mountains.

SOLUTION

Use the cloud masses to separate the deep blue sky from the mountains. Crisply define the edges of the clouds and use a strong blue to depict the sky. ☐ Sketch rocky foreground; then begin the sky. Whenever a painting relies strongly—as this one does—on the effect you create with the sky, paint that first. Then, if you don't capture the feeling you want at first, you can always start over again.

Working on dry paper, take a big brush and a wash of deep ultramarine and lay in the clear patch of sky. In the center, keep the edge fairly well defined. Let

In Arizona, the craggy slopes of the Chiricahua Mountains stand against a cloud-streaked sky.

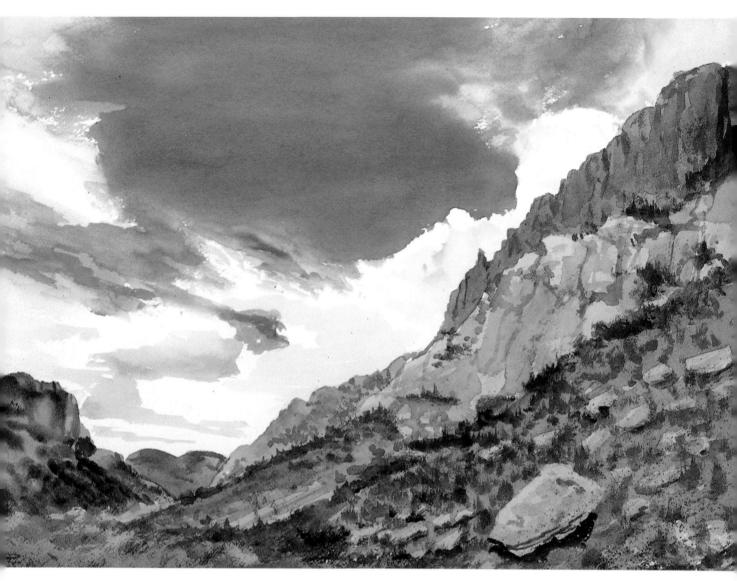

the paper dry. Then work in the lighter areas toward the sides of the paper, adding a little water to dilute your blue. Finally, use a pale wash of blue and mauve to depict the clouds that lie just above the mountains. Let the paper dry again.

The dark sky and the clouds seem to sweep across the paper. Note how the ultramarine wash has been applied unevenly: in some places the color is strong, in others, light; in some areas the edges are sharp, in others, soft. This variety makes the sky charged with excitement.

The foreground is fairly complex, so before you start to paint it analyze the values of the different rock masses. Lay in the most distant mountain with mauve and sepia, and then begin the rocky slopes. Start by applying a flat wash of yellow ocher over the entire foreground. Next define

each mass with darker washes mixed from yellow ocher and sepia. When you are satisfied with the values in each area, add texture and detail using yellow ocher, sepia, and Hooker's green. Don't get carried away—simplify the patterns formed by the rocks and the grass, and balance them against the strongly patterned sky.

CLOUD MASSES

Rendering the Shape and Structure of Clouds

PROBLEM

Soft clouds like these are a challenge to paint. All too often, they end up looking like pasted-on cotton balls. Only the shadows define their structure, and even the shadows are light and unfocused.

SOLUTION

Concentrate on the shadowy portions of the clouds and keep them light. If the shadows get too dark, they will look like holes punctured in the clouds.

☐ Sketch the cliff in the foreground and the outline of the cloud formation. Then lay in the sky with ultramarine and cerulean blue, carefully picking out the shape of the cloud. While the paint dries, study the shadows on the clouds.

For the shadows, you'll want to use washes mixed from cerulean blue, alizarin crimson, and Payne's gray. Keep the washes light and do a few test swatches before you begin to paint. Follow the patterns formed by the shadows, at first using a very light

Masses of soft, puffy clouds crowd together, creating an abstract pattern against a flat patch of dark blue sky.

tone. Once you've established the shape of the clouds, darken the upper edges of some of the shadows; right away, soften the bottom edges of your strokes with a brush dipped into clear water. Keep the pattern lively and don't concentrate the dark shadows in any one area.

Now turn to the foreground. Keep it simple—add just enough detail to make it clear that there is a cliff in the picture. Here a flat wash of mauve is applied first, and then Hooker's green and sepia are used to pick out details.

ASSIGNMENT

Practice painting soft white clouds at home before you tackle them outdoors. Find a picture of a sky that's filled with clouds and work from it. To render the shadows, try using only the three colors used in this lesson: cerulean blue, alizarin crimson, and Payne's gray.

Start by laying in the sky. Then turn to the clouds, looking for the shadows. This isn't always easy, since most people tend to concentrate on the white areas in clouds. You'll be doing just the opposite, painting the darks around the whites.

Keep your washes light. You'll be surprised to see how dark they'll look once they're down on pure white paper. Let your washes overlap, and don't put too many darks in any one area.

FLAT CUMULUS CLOUDS

Achieving a Sense of Perspective

PROBLEM

This is an extremely difficult painting situation. Some of the clouds are far away, and others, close at hand. If you don't convey a sense of receding space, your painting won't make sense. All the clouds will look as if they are stacked on top of one another.

SOLUTION

Develop the shadows in the clouds very carefully. Use them to indicate both the shape and distance of the clouds.

Draw the clouds and the hills that run across the bottom of the picture. Then lay in a graded wash, working carefully around each cloud. You may be tempted to put a wash over the entire sheet of paper and then wipe out the clouds with toweling, but that technique won't work here. If you try it, the clouds will look too soft and undefined. By painting around the clouds, you will be able to

As far as the eye can see, long, flat cumulus clouds drift in a brilliant blue sky.

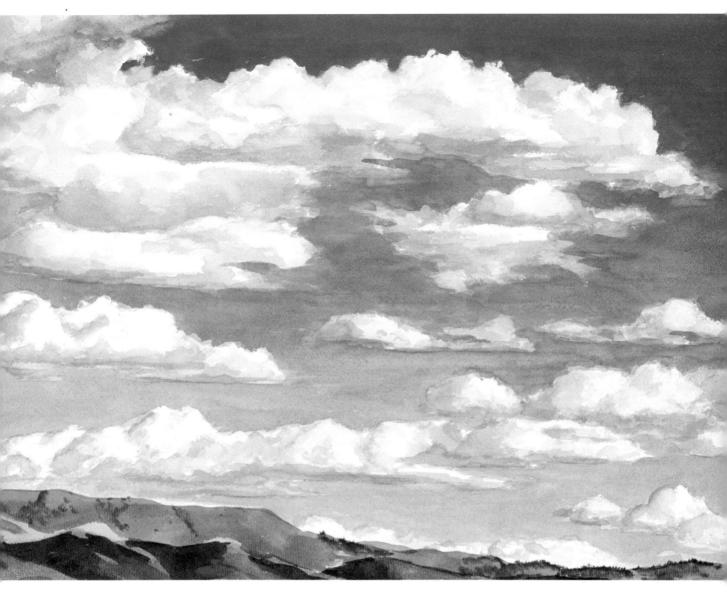

show the distinct shape of each cloud.

Begin the sky at the top with deep ultramarine, and then gradually shift to cerulean blue. Toward the horizon, add a touch of yellow ocher to the cerulean. When the paint is dry, start on the cloud shadows. Here they are rendered mostly with pale tints of ultramarine and alizarin crimson. In a few places, there is a warm touch

of yellow ocher.

The darker tints show the undersides of the clouds; the lighter ones sculpt out the surface detail. As you work, soften the edges of your strokes using another brush that's been dipped into clear water. You don't want any harsh edges—just an easy, flowing rhythm.

Now develop the foreground. In this painting, it's done with

Hooker's green, mauve, sepia, and yellow ocher. Note how the green is a little bolder and brighter in the painting than it is in the photograph. Accentuating the green pulls the hills down and out toward the viewer, and it enhances the sense of perspective already achieved.

CLOUDS AT SUNSET

Experimenting with Bold Color

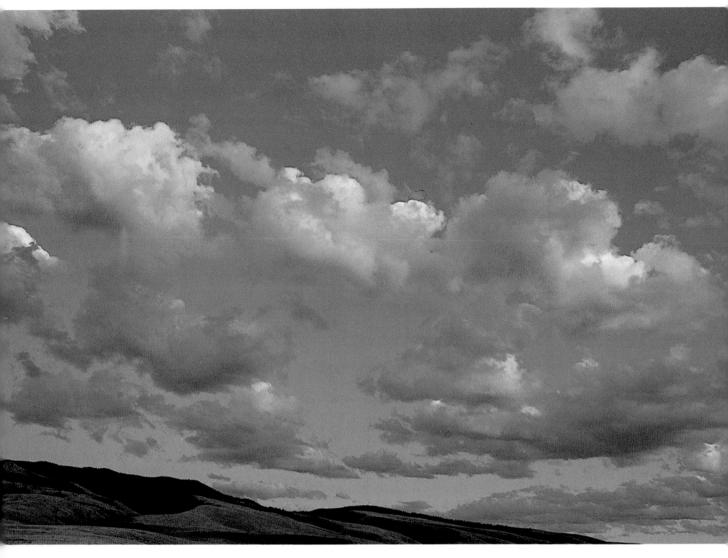

PROBLEM

The warm pink and gold clouds are lighter than the sky. Their shapes are fairly soft and indistinct, so it will be hard to paint around them. If you put them down first, their edges will look too harsh.

SOLUTION

Mask out the brightly colored clouds and you'll be free to develop the rest of the sky as boldly as you like. Lay in a graded wash for the sky; then use gouache for the clouds.

Draw the horizon line and the shapes of the major clouds; then mask out the clouds. Using a big brush, lay in a graded wash. Here strong ultramarine and cerulean blue are applied at the top of the paper. Gradually the wash becomes lighter, and then, near the horizon, touches of alizarin crimson and yellow ocher are added.

Now paint the dark clouds that float right above the horizon. To capture their deep color, mix opaque ultramarine and burnt sienna. Work loosely, with fluid

At twilight, large soft clouds reflect the brilliant gold and pink tones of the setting sun.

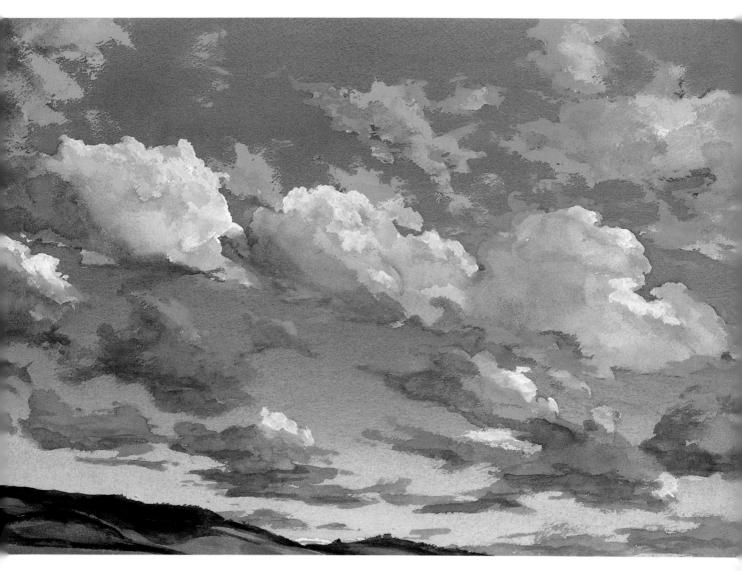

strokes. Toward the top of each cloud, dab on some light, bright tones. Here opaque white, alizarin crimson, and cadmium orange capture the reflection of the sun's rays.

Now peel off the masking solution. Using opaque white, alizarin crimson, and cadmium orange, gently paint the large clouds. Work with soft strokes, gradually blending one color into the next. To establish a sense of perspective, place the lightest colors at the very top of the clouds.

Before you begin the foreground, stop and evaluate the pattern you have created. If any of the clouds seem too weak, continue to sculpt them, using dark hues for their undersides and light hues along the tops.

Make the foreground as plain as possible; you don't want it to pull attention away from the glorious sky. Here two tones of olive green and sepia are applied to create a simple but believable effect.

CLOUDS AT TWILIGHT

Capturing the Play of Light and Dark at Twilight

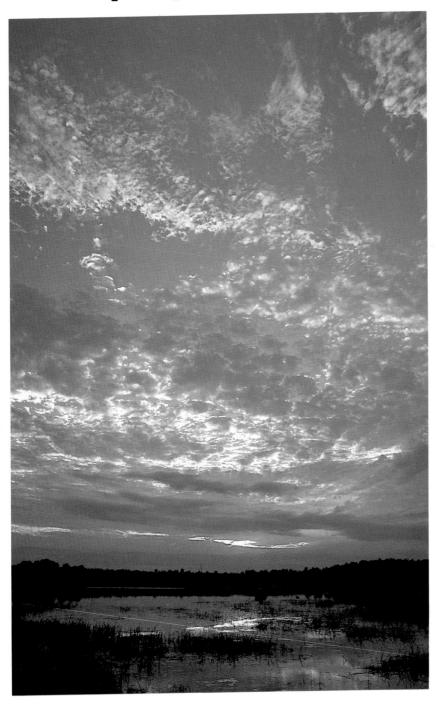

As the sun sets over a pond, dark and light clouds weave back and forth across a rich blue sky.

PROBLEM

The light clouds scattered throughout the sky are the problem here. You can't paint around them because there are too many and their shapes are irregular, and dropping white paint onto a wet blue surface would make them too soft.

SOLUTION

Use opaque gouache for the whites, and paint the light clouds last, after the rest of the painting has been completed. Render them using a drybrush technique to give the white paint an interesting, uneven quality.

STEP ONE

All you need here is a simple sketch showing the horizon and the major shapes in the foreground. Now start to paint. Since you'll be adding the lights with opaque white, you can cover the entire sky with a graded wash. For the rosy, shimmering light that breaks through the clouds near the horizon, you'll want a warm hue. Here alizarin crimson and vellow ocher are laid in above the horizon. Next the color shifts to cerulean blue, and high up in the sky ultramarine comes into play.

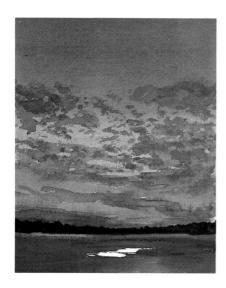

STEP TWO

Once the wash has dried, start building up the dark clouds. Here they are mixed from ultramarine. alizarin crimson, and mauve. Start adding the other darks, too. For the trees that run along the shore, try ultramarine and alizarin crimson deepened with Payne's gray. Now fill in the foreground, laying in the pond with a rich blend of ultramarine, alizarin crimson, and Payne's gray. The deep color will make the pond shoot forward and push the distant trees and clouds back into space. To capture the warm highlights on the water, drop in some alizarin crimson and yellow ocher.

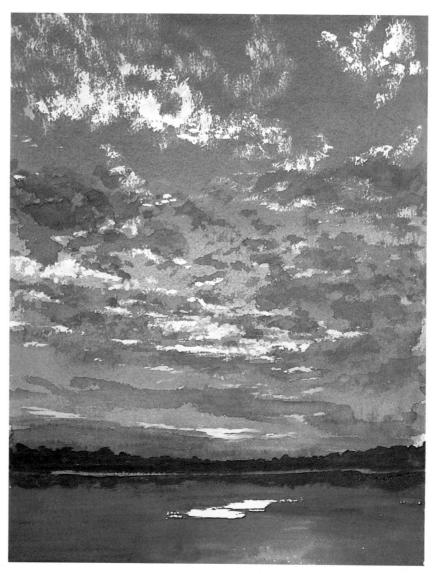

STEP THREE

When you begin adding the light, bright clouds, keep one thought in mind—pattern. It's the way these clouds fill the sky that makes this scene so exciting. Working with opaque paint and a drybrush technique, pull the brush rapidly over the paper. The broken strokes will allow the blue wash to show through, so the whites won't look

too harsh. For the indistinct clouds at the very top of the scene, mix a bit of alizarin crimson with the white; similarly, warm up the whites toward the horizon with a dash of yellow ocher. Finally, using ultramarine and Payne's gray, add the reflections in the water near the horizon.

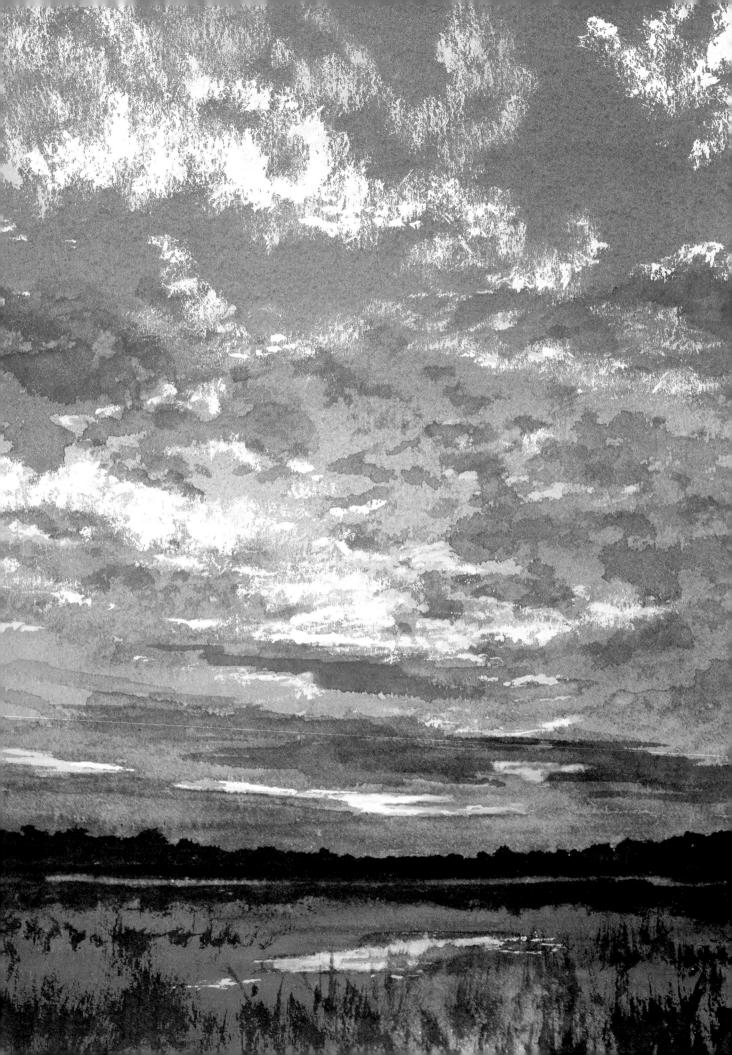

FINISHED PAINTING

The grasses that fill the water are rendered with ultramarine and Payne's gray. They are laid in with a dry brush and, once again, with careful attention to pattern.

DETAIL

All the colors that come into play in the process of painting stand out when you move in on a detail. The lights contain not just white but red and yellow, and the blues are tinged with purple and gray. The surface is rich with color, texture, and visual excitement.

Spend some time working with pattern. Take several small sheets of paper—8" by 10" is a good size for the quick studies you'll be executing—and a medium-size brush. On the small paper, the medium-size brushstrokes will seem large.

Go outside at twilight on an evening when there's some drama in the sky. Look first for broad masses of color and lay them down; then narrow in on smaller areas. Forget about how your finished paintings will look—just go after the abstract patterns you see in front of you. Work loosely and quickly, spending no more than five or ten minutes on any painting. What you are striving for is the ability to see patterns and a way to render them in paint.

FILTERED TWILIGHT

Using a Light-to-Dark Approach to Show Subtle Value Shifts

At sunset in the Smoky Mountains, soft, hazy light filters through a screen of dark clouds.

PRORI FM

Scenes like this one are straightforward: the shapes are simple, there's not too much action in the sky, and only a few colors come into play. To capture the scene's simplicity, you'll have to keep an eye on the values you use.

SOLUTION

Use a traditional light-to-dark approach; it's the easiest way to control values. Simplify the clouds in the sky slightly, and when the painting is finished, use an eraser to pull out the rays of light that shoot through the clouds.

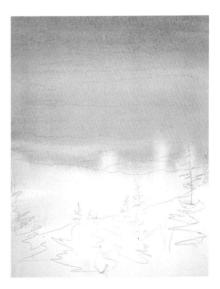

STEP ONE

Get the main lines of the composition down in a quick sketch; then focus on the sky. The light that falls over the entire scene unifies the composition, making the sky harmonize with the mountains. To capture that harmony, start your graded sky wash at the distant mountain range. Begin with alizarin crimson; then, working upward, shift to cadmium orange and cadmium yellow; then, to mauve and cerulean blue. Now take a brush that's been moistened with clear water and pull some of the alizarin crimson down over the mountain ranges in the middle distance.

STEP TWO

Once the wash has dried, develop the cloud formations. Start with the darkest ones near the top of the painting, rendering them with ultramarine, alizarin crimson, and burnt sienna. As you move down toward the mountains, the clouds become lighter. Here they are painted with ultramarine and alizarin crimson. The distant mountains are laid in with cerulean blue and alizarin crimson; the crimson unites them with the sky.

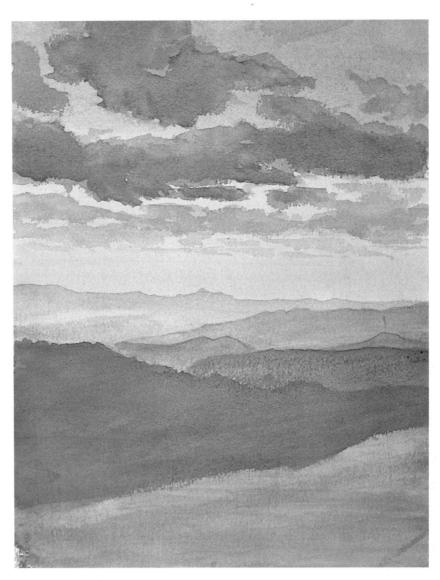

STEP THREE

Working toward the bottom of the painting, finish the mountains in the background. Make each range slightly darker than the one behind it. Be careful to keep the shifts in value subtle; if you make the mountains too dark, you'll lose the softly lit quality that fills the scene. Here the mountains are painted with ultramarine and alizarin crimson.

FINISHED PAINTING (OVERLEAF)

To push the rest of the painting back into space, make the immediate foreground very dark. Use a rich mixture of ultramarine, Payne's gray, and just a touch of yellow ocher. Let the paint dry. Then add the dark trees; here they are mixed from ultramarine, Payne's gray, yellow ocher, Hooker's green, and sepia. Wait until everything is bone dry, and then use an eraser to pull up the rays of light that break through the clouds.

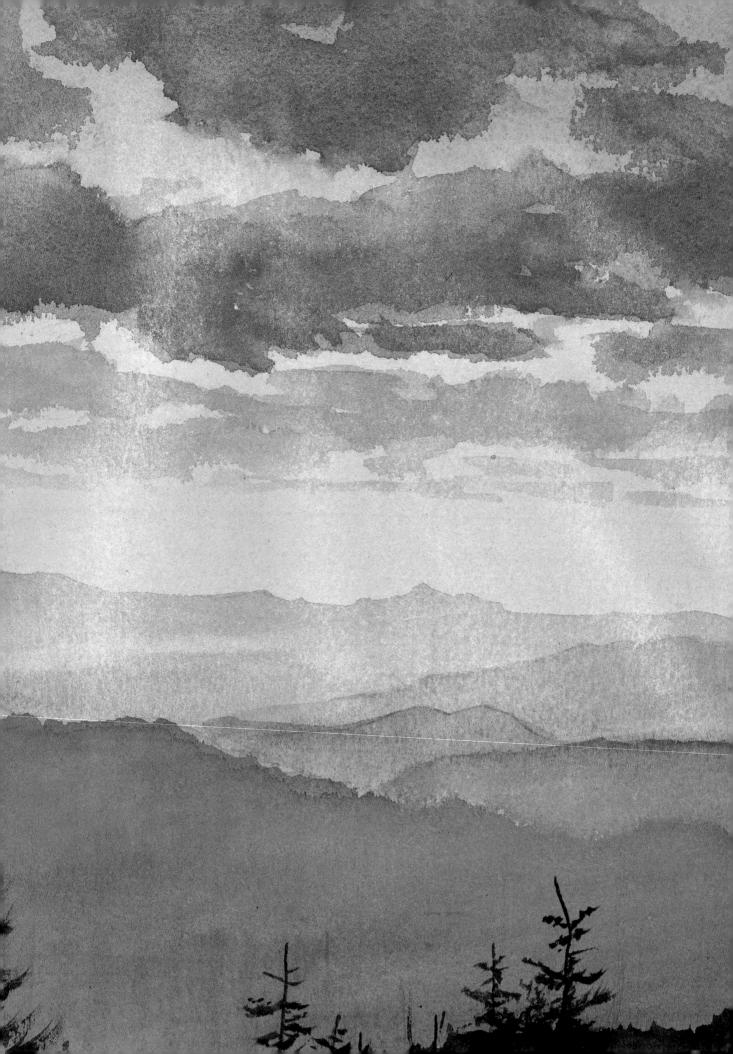

SUNSET

Mastering Complex Atmospheric Effects

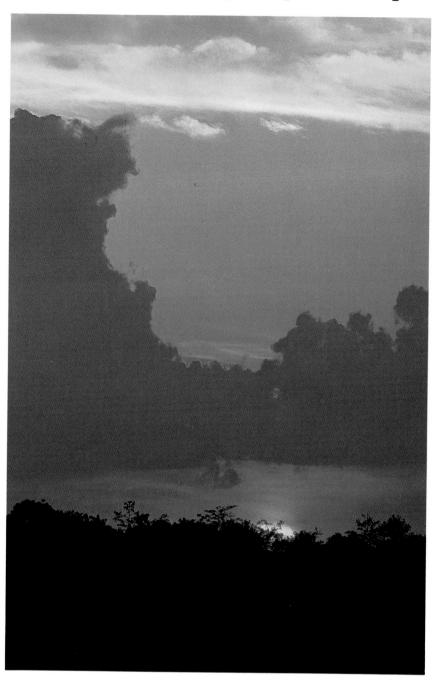

As the sun sets in the Everglades, large clouds sweep upward, some cast in shadow, others catching the last light of day.

PROBLEM

It's hard to figure out where to start. The large cloud formation has a lively, irregular shape; it would be difficult to paint around. And to capture the sensation of the evening sky behind it, you'll want to use bold, loose strokes.

SOLUTION

Begin by tinting the entire paper with a rosy tone to give the scene luminosity. Then go ahead and lay in the brilliant colors above the horizon. While the paint is still wet, wipe out the large cloud formation. You'll paint it last.

☐ Cover the entire sheet of paper with a light tone mixed from new gamboge, yellow ocher, and alizarin crimson. Let the wash dry. Next paint the sun with a strong new gamboge; then put down the warm, bright colors that stretch up from the horizon. Here the sky colors begin with cadmium red and move on to alizarin crimson, cadmium yellow, Davy's gray, and cerulean blue. At the very top, the dark patches are done with cerulean blue and burnt sienna. Now take a paper towel and wipe out the large mass of clouds.

When the sky is dry, turn to the cloud formation. Here it's rendered with ultramarine and burnt sienna. The paint is applied with loose, fluid strokes, with the edges undulating gently.

After you've painted the fore-ground, look at the overall color pattern you've created. Here the area right above the horizon is too garish, so a wash of pale mauve is applied at both sides. The result: a natural yet dramatic sweep of color that captures the interaction of light and atmosphere.

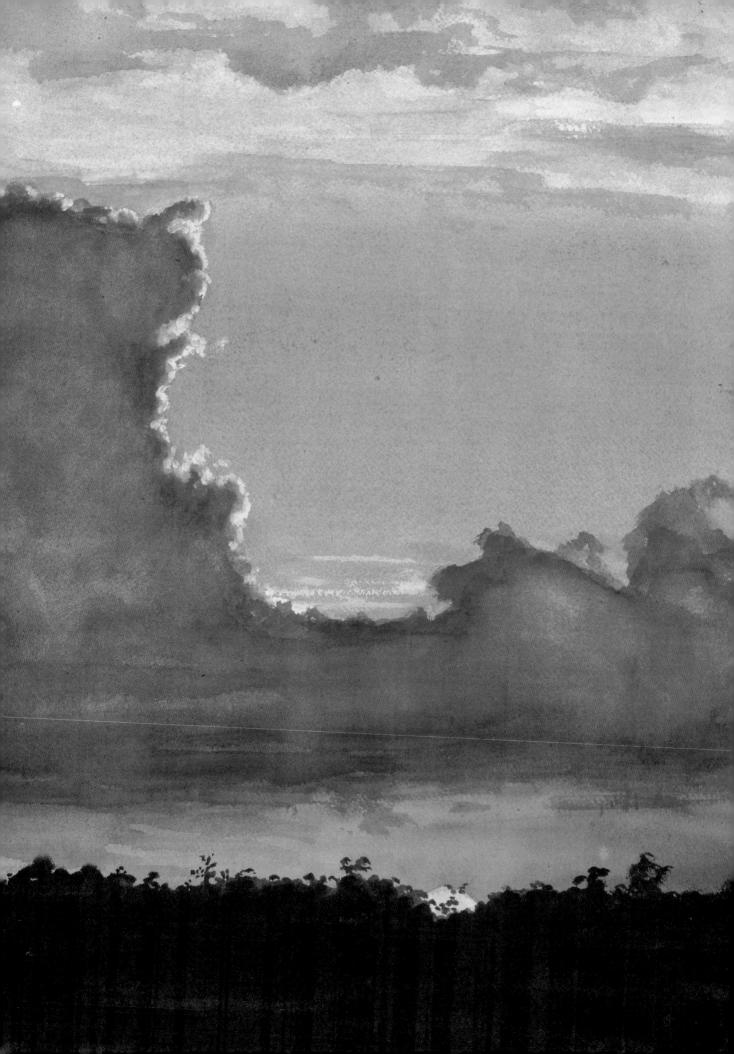

MOON AT SUNSET

Working with Reflected Light

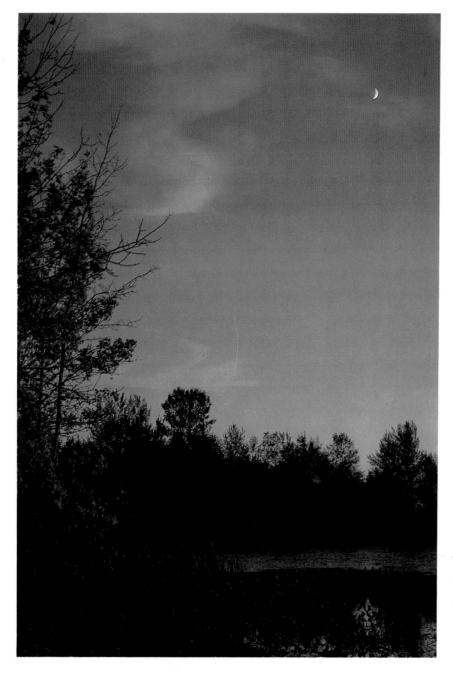

At sunset, a crescent moon stands out against a warm, hazy sky.

Problem

The setting sun casts a strong reddish orange light on the clouds above, and the same color permeates the scene. You'll have to suffuse the painting with a warm rosy tone to capture the feeling of the sunset.

SOLUTION

Execute a reddish orange underpainting; then lay in a graded wash. To capture the strong, exciting color of the clouds, try using opaque gouache.

□ Sketch the scene, and then cover the paper with a pale wash mixed from alizarin crimson and cadmium orange. When the paper is dry, begin the sky. Apply a graded wash starting at the top of the paper. Here the wash is made up of ultramarine, followed by cerulean blue, cadmium orange, and, near the horizon, alizarin crimson.

As soon as the sky is dry, turn to the clouds. Mix opaque white with cadmium red, yellow ocher, cadmium yellow, and alizarin crimson. When you start to paint, keep your brushstrokes loose to suggest the hazy quality of the sky. Don't apply the gouache too thickly—if you do, it will likely crack and flake when it dries. Now paint the crescent moon with opaque white.

The foreground is an important part of this painting. Like the sky, it is permeated with a reddish orange hue. The underpainting has to shine through, or the trees and water will contrast with the sky. Here the trees are rendered with sepia, ultramarine, and Hooker's green, and the water is depicted with cerulean blue. In the lightest passages, and especially in the water, the reddish orange underpainting lends warmth and vibrancy to the scene.

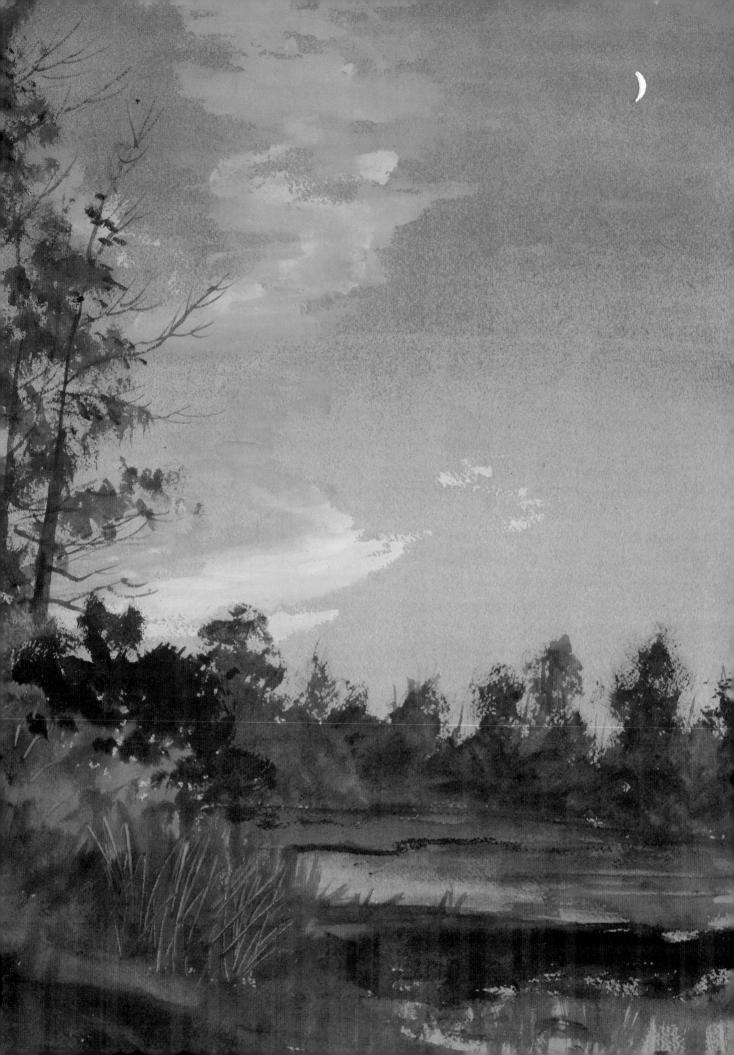

DETAIL (RIGHT)

High in the sky, subtle touches of rose-colored gouache drift across the blue. Applied thinly and with a drybrush technique, the gouache seems almost transparent, not thick and heavy as you might expect. The moon is painted with opaque white.

DETAIL (BELOW)

Even in the darkish foreground the warm underpainting unifies the scene. Here the underpainting is visible in the water and in the sky behind the clouds. Since the clouds are made up of golds and reds, too, they fit into the painting naturally.

Little touches can add interest to a heavy foreground. Note here, for example, how the grasses that have been pulled out of wet paint with the back of a brush handle enliven the scene.

ASSIGNMENT

Gouache handles much like transparent watercolor and the two media work together smoothly. Get acquainted with the opaque paint and discover what it can do for your paintings.

Take a sheet of watercolor paper and cover it with a wash of transparent watercolor. Let the paint dry. Then experiment with gouache. Don't worry about composition; your goal is simply to learn about the properties of gouache.

First apply the paint thickly with a fully loaded brush. Next try a drybrush technique. Now try both diluting the paint and applying it very thickly. You'll find that if you put down too much paint in one spot, it may crack when it dries.

After you've gained some confidence with gouache, try using it in a painting. This medium is ideal for laying in light areas over dark backdrops or even for adding small touches of light, bright paint over a medium-tone ground.

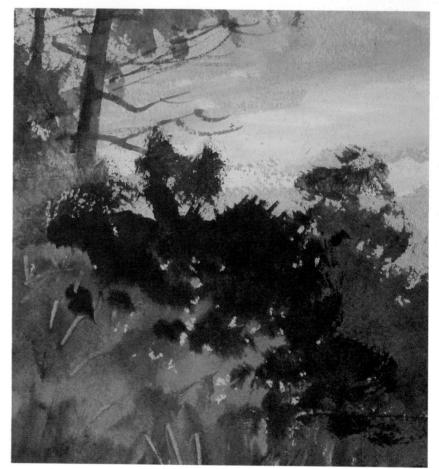

Painting Around Clouds

PROBLEM

Except for the dark trees in the foreground, this scene is a study in pale blue tinged with pink and yellow. Everything has to stay light and fresh if the painting is to capture the feel of dawn.

SOLUTION

Look past the obvious blues in the sky to the underlying colors. Then put down an underpainting of yellow and pink, before you turn to the blues. To keep the sky light, try painting around the clouds; the pale underpainting will subtly color the clouds.

At dawn in autumn, clouds float high above the Wabash River.

STEP ONE

Sketch in the sweep of the river and the trees in the foreground, and then start to paint. Beginning near the horizon, lay in a wash of alizarin crimson. While the paint is still wet, cover the rest of the paper with a pale wash of new gamboge and yellow ocher. You want just a hint of color—almost an ivory tone. Over the wet paint, drop cerulean blue into the water in the foreground.

After the paint has dried, use cerulean blue for the sky. Near the top of the paper, apply a wash of pure color; near the horizon add a little yellow ocher and Payne's gray to dull the color and make the sky seem a little farther away. Paint around the clouds, looking for the pattern of blue that lies behind them. Keep your brush fairly dry so you'll be able to control the flow of the paint.

STEP THREE

Now it's time to work in the darks. Here they are all mixed from a base of sepia and burnt sienna; Hooker's green and Antwerp blue are added to the earth tones to give the color a little punch. Begin by painting the trees that rush backward along the river; then add their reflections in the water. Now start to paint the trees in the immediate foreground. Do the major branches first and then the trunk that's lying in the water.

FINISHED PAINTING

Complete the dark trees with a drybrush technique—broken, scraggly strokes are perfect for depicting foliage. The rich, lively brown you see here is created from a little yellow ocher added to sepia and ultramarine. When all of the dark trees are completed, you may find that the water seems too pale. That happens here, so ultramarine is added to the water in the immediate foreground. The dark blue makes all the other colors fall into place and strengthens the sense of perspective.

The warmth of pure cerulean blue captures the fresh quality of the sky at dawn. Behind it, the pale yellow underpainting subtly enhances the scene's mood.

Toward the horizon, the cerulean blue is a little duller — where yellow ocher and Payne's gray have been added to it. The dull tone makes the sky here seem far away.

The feathery strokes used to render the leaves let patches of sky show through and keep the foreground from appearing too leaden.

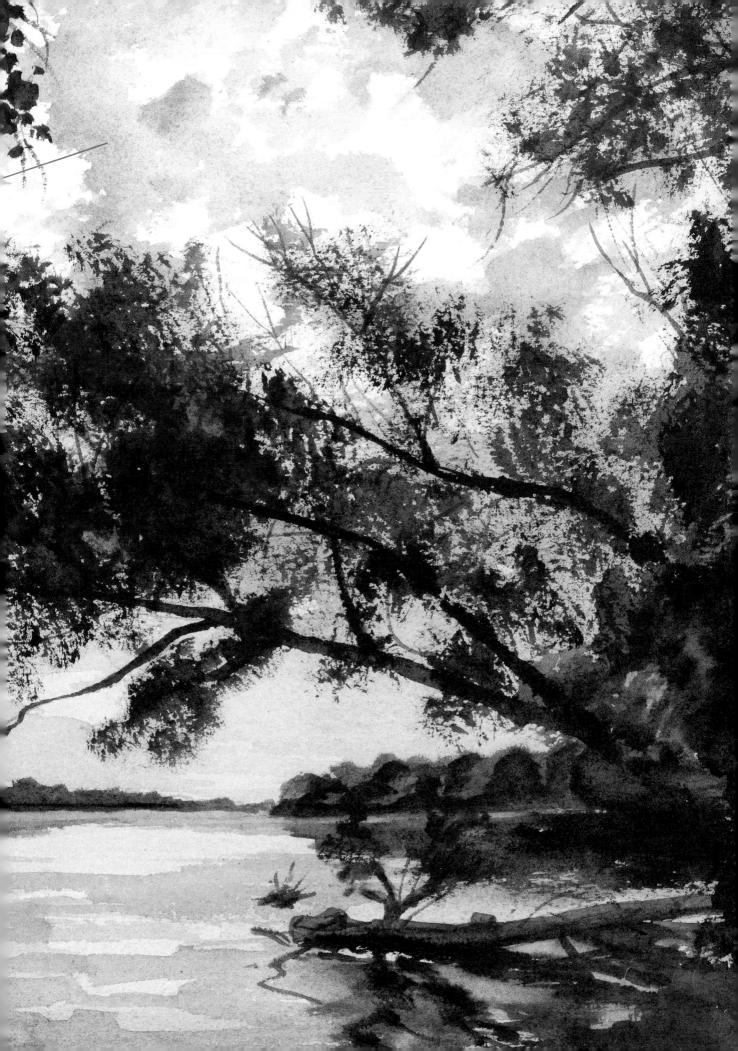

SUN HALO

Capturing the Feeling of an Icy Winter Sky

PROBLEM

The effect created by the freezing-cold, ice-filled air is incredibly subtle. Bands of whitish blue radiate from the sun. You'll have to control your colors and values very carefully to achieve the effect that you want.

SOLUTION

Keep everything soft by working wet-in-wet. To capture the halo effect, use circular strokes. You'll actually be doing a graded wash, but instead of applying it from top to bottom, you'll work outward from one central point.

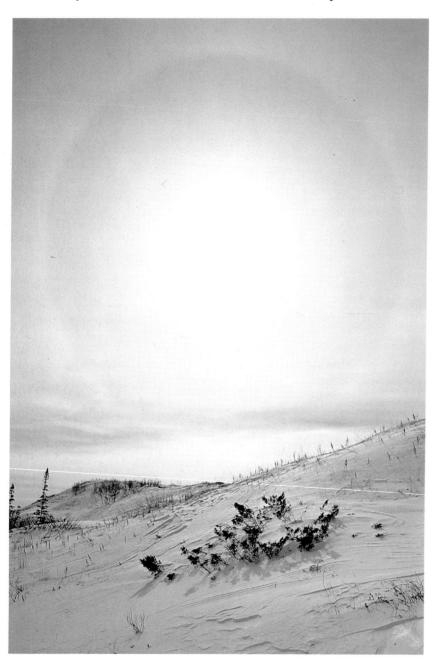

In sub-zero temperatures, the air is laden with icy particles which seem to form a halo around the sun.

☐ Sketch in the foreground, and then moisten the paper with a natural sponge. Control of values will be critical now, so be sure to plan how you are going to attack the scene before you begin to paint. Use cerulean blue to render the sky—it's ideal for capturing the icy feel of midwinter. You'll want to keep it very pale, and in the center of the halo, try adding just a touch of yellow ocher to indicate where the sun lies hidden.

Start to paint at the halo's center; then gradually move outward using circular strokes. Break up the blue with bands of white, but don't let the light-to-dark progression get too monotonous. It's difficult to control a circular graded wash—don't get discouraged by your first attempts. Remember, if the result isn't what you want, you can always wash the paper with clean water and start all over again.

Once you're satisfied with the halo, work on the sky along the horizon. Strong horizontal strokes executed with cerulean blue, Payne's gray, and yellow ocher keep the circular pattern from becoming too studied.

Let the paper dry before you begin the foreground. You'll use the same colors—cerulean blue and yellow ocher—plus you'll add more Payne's gray for the deep shadows. As you start to lay in the foreground, concentrate your color toward the sides of the paper. Keep the center light to indicate the highlight caused by the sun

Finally, add the scraggly clumps of grass that break through the snow. The clumps closest to you should be darker and more defined than those farther away. At the very end, spatter a little brownish gray paint over the snow-covered ground to animate it.

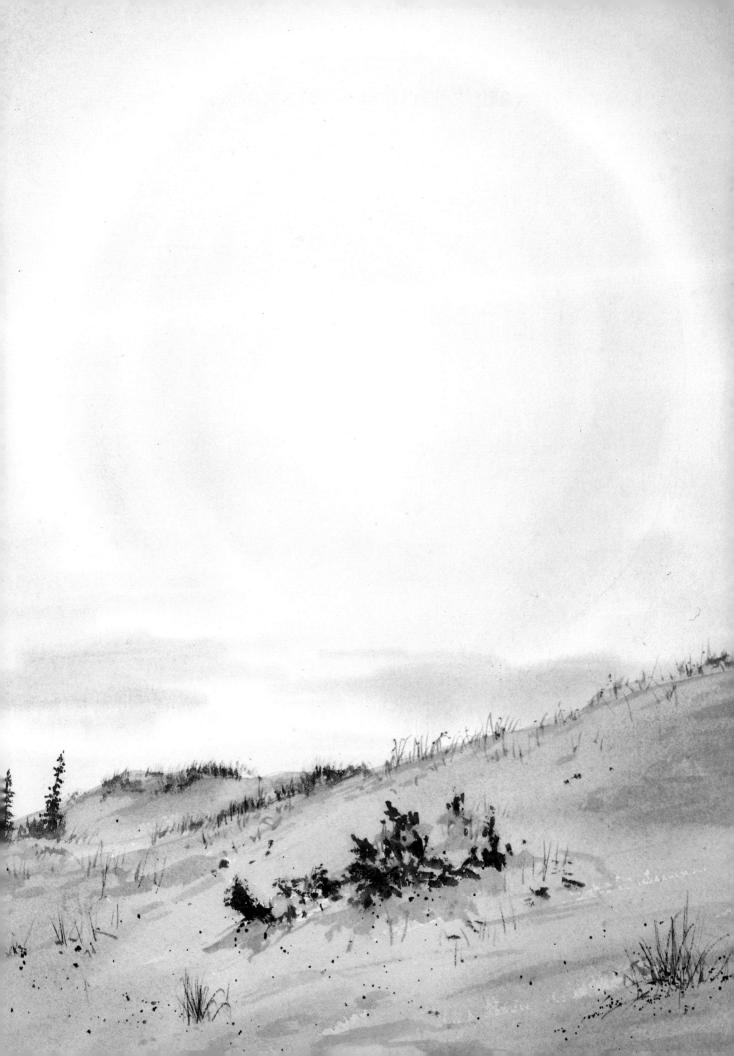

SOFT WINTER SKY

Learning to Control the Contrast Between Snow and Sky

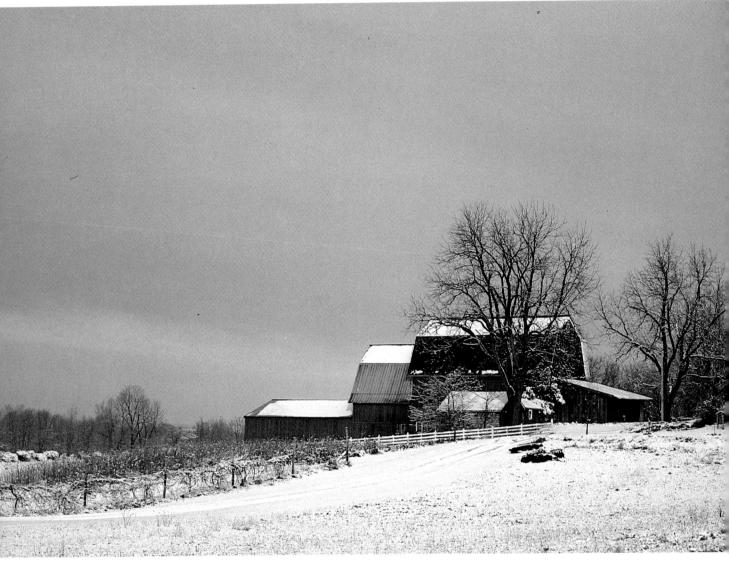

PROBLEM

Here you are confronted with a typical winter landscape. The sky is clear, without much variation, the foreground is blanketed with snow, and except for the barn all the values fall in a light- to middle-tone range.

SOLUTION

Don't go for the dramatics. Follow a traditional light-to-dark approach and keep control of all your values. Be especially careful of the value relationship between sky and snow: don't make the sky too dark or the snow too light. It's easy to disregard what you see and think in clichés. Remember, snow isn't always bright white and the sky isn't always sky blue.

□ Execute a careful drawing—when a scene includes a building, you need to begin by establishing a clear framework. Next paint the sky, working around the barn. First wet the sky area with a sponge; then start to drop in your color—here cerulean blue, Payne's gray, yellow ocher, and, right at the horizon, a touch of alizarin crimson. Don't let the tones get too flat—let an occasional dash of blue stand out. Now let the paper dry.

In the cold, frosty air of a December day, a barn hugs the snow-covered ground.

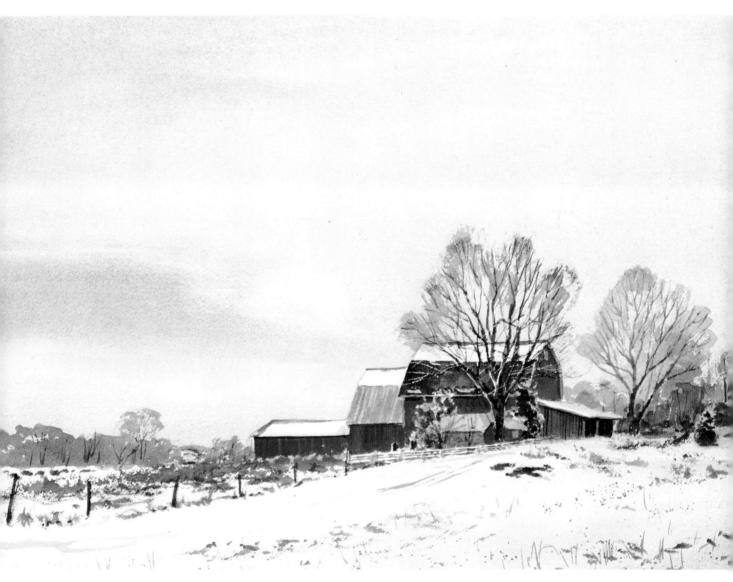

Shift to slightly darker values to lay in the trees and hills in the background. Use very light washes of ultramarine and mauve mixed with burnt sienna. Next, turn to the barn. It's the focus of the scene, so execute it carefully. Work with deliberate vertical strokes and keep the color flat. Add the trees that grow by the barn, and then tackle the foreground.

You may be tempted to leave the foreground pure white, but snow is usually much more complex. It captures the shadows of the clouds passing overhead, as well as those cast by the hills and valleys of the ground itself. Use a very pale wash of blue and gray, and be sure to let some patches of white paper shine through. As a final step, use white gouache to render the roof of the barn, the lightest and brightest area in the painting; then enliven the foreground with bits of grass, the fence posts, and a dash of spattering.

DETAIL (LEFT)

In the cool, hazy grayish sky, a patch of blue breaks through. It not only makes the sky more lively but also helps balance the composition. Without it, all the strong color would be concentrated on the red barn on the right side of the complete painting. Here the cool tones of the purplish trees have just a touch of warm burnt sienna in them. The brownish tone subtly relates the trees to the barn and grasses in the foreground.

DETAIL (BELOW)

A pale bluish gray wash is used to render the foreground. Through the wash, bits of crisp white paper sparkle through. The ocher spattering and bits of grass keep the snow-covered ground from becoming monotonous and flat.

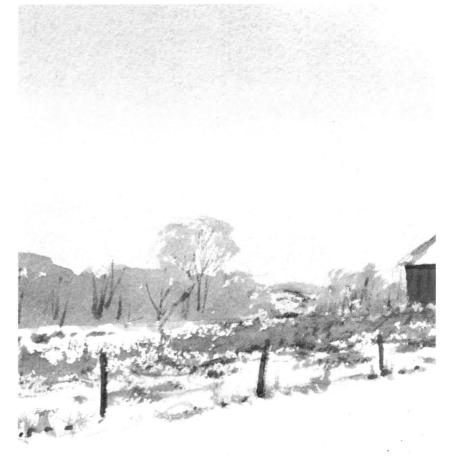

ASSIGNMENT

In winter, the color of the sky can be difficult to capture, especially if the ground is covered with snow. Snow itself presents a challenge because it is almost always tinged with color and is not pure white.

Become sensitive to the colors of winter by making quick watercolor studies on snowy days. Experiment with different grays and blues, and even with touches of alizarin crimson and yellow ocher. Keep the sky clearly separated from the snow: if the two areas are almost the same value. add touches of a stronger blue or gray to portions of the sky. Or try accentuating the shadows that fall onto the snow. You may be surprised to find that sometimes the snowy ground is actually slightly darker than the winter sky.

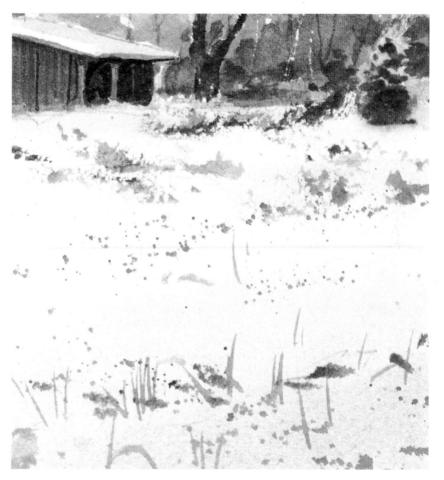

FLAT WINTER SKY

Rendering a Simple Winter Landscape

PROBLEM

The sparseness of a scene like this grips whoever encounters it. The same qualities that make it appealing—it's clean and crisp and light—make it difficult to paint. When a composition is this simple, every stroke has to be just right.

SOLUTION

Use a traditional light-to-dark approach. Understand when you begin that simple situations such as this can be very hard to execute. Pay attention to your technique and concentrate on capturing the colors and patterns you see.

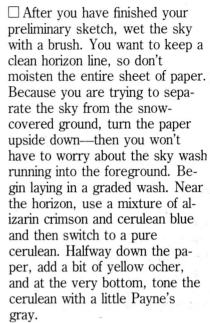

While you are waiting for the paper to dry, look at the foreground. Usually a snowy white plain has at least a touch of color. Here, though, because the contrast between the sky and the ground is so important and the ground occupies such a tiny portion of the scene, you are probably better off leaving it pure white.

When the sky is dry, paint the tree trunks and branches with burnt sienna and sepia. Let them dry, and then with a pale wash mixed from the same two earth tones, indicate the masses of tiny twigs which fill the crowns of the trees.

Finally, controlling the flow of pigment, spatter a tiny bit of brown across the snowy plain. You don't need much—just a touch will add enough color to keep the white paper from becoming dull.

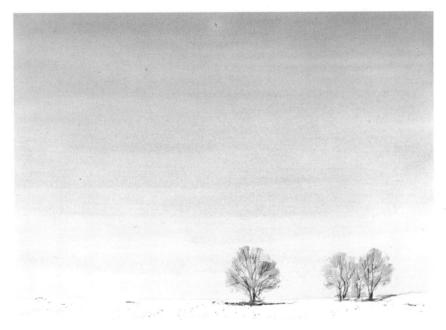

On a late afternoon in March, a cold pale blue sky acts as a backdrop for a cluster of trees.

CLOUD-FILLED DAWN

Experimenting with Dark Clouds and Brilliant Light

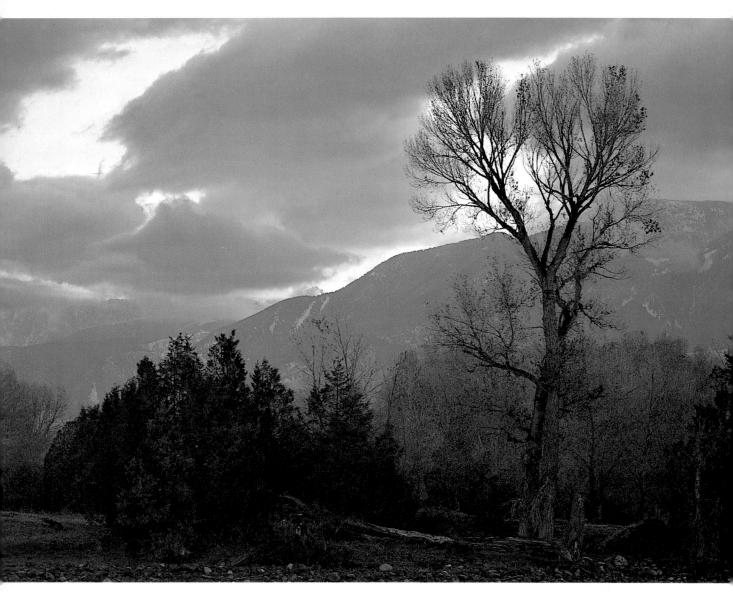

PROBLEM

Most of this scene is dark and brooding, but the light that shines behind the clouds is brilliant and clear. The light patches aren't a uniform color—they range from pale blue to pink and gold.

SOLUTION

A multicolored underpainting will capture the lively play of blues, pinks, and golds. When it's dry, you can paint the dark blue clouds over it.

At dawn in Montana, light breaks over the mountain while dark clouds shoot across the sky.

STEP ONE

Wet the sky with a large brush and then begin to drop in paint. Here cerulean blue, alizarin crimson, and new gamboge are worked into the wet paper. The colors are allowed to run together, creating pale purples and oranges. Before you continue, let the paper dry.

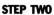

Over the dry underpainting, lay in the dark clouds. Use a mixture of cerulean blue, alizarin crimson, and ultramarine. Don't apply the paint too evenly: soften some edges with water and render other areas with a drybrush technique. You want to indicate all the action that the clouds create. While the clouds are still wet. paint the distant mountain with the same mixture of blues and red. Drop a little water on the wet paint to soften the mountain and to suggest the cloud that's bearing down on it.

STEP THREE

Now turn to the other mountains. Mix together ultramarine, Payne's gray, and cerulean blue; then lay in the paint loosely, making some areas light and other dark. For the trees in the middleground, try a mixture of mauve and burnt sienna blended with a little new gamboge. Use strong vertical strokes to suggest the way they mass together. Finally, render the darker evergreens with Hooker's green, sepia, and ultramarine.

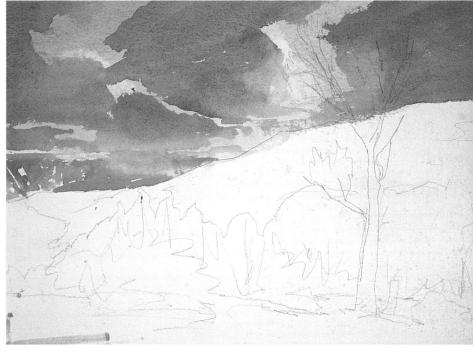

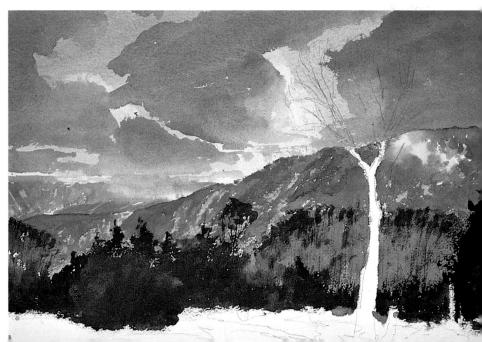

FINISHED PAINTING

Finally, paint the immediate fore-ground and the tall tree on the right using various combinations of yellow ocher, sepia, ultramarine, and Payne's gray. To suggest the twigs that radiate from the branches of the tree, use a pale brown wash applied with a drybrush technique. On the ground, furrow the earth with bands of deep, rich paint and spatter dark pigment over it to break up the flat grayish brown wash.

On some clouds, the edges are sharp and crisply defined. Deep ultramarine stands out clearly against the cerulean blue underpainting. Behind the dark blue clouds, pale blues and pinks float in the sky. The pale colors shift gradually from one hue to the next because they are allowed to bleed together when applied to the damp paper.

Over the distant mountains, a hazy effect is created by dropping water onto the wet blue paint. The water dilutes the blue and spreads upward, giving a soft and diffuse feeling to this section of the painting.

ASSIGNMENT

Prepare several sheets of paper with a multicolored underpainting. Then use the prepared paper the next time you paint a cloudy scene set at dawn or dusk.

The secret to success here is to keep all the colors you drop into the wet paper very pale. If your colors are too strong, they will be conspicuous in your finished paintings. Prepare one sheet of paper using yellows and reds. On another, try cool blues and purples. Do a third sheet with both warm and cool tones.

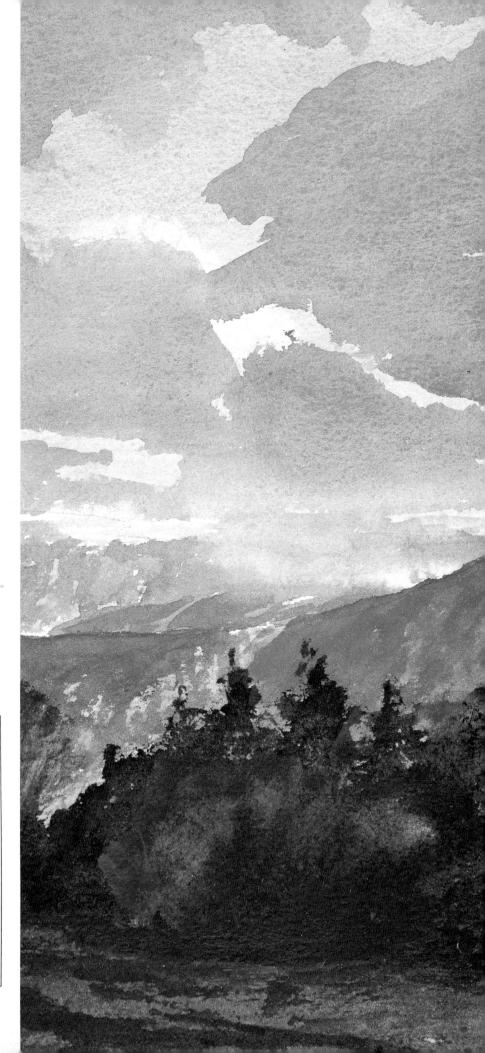

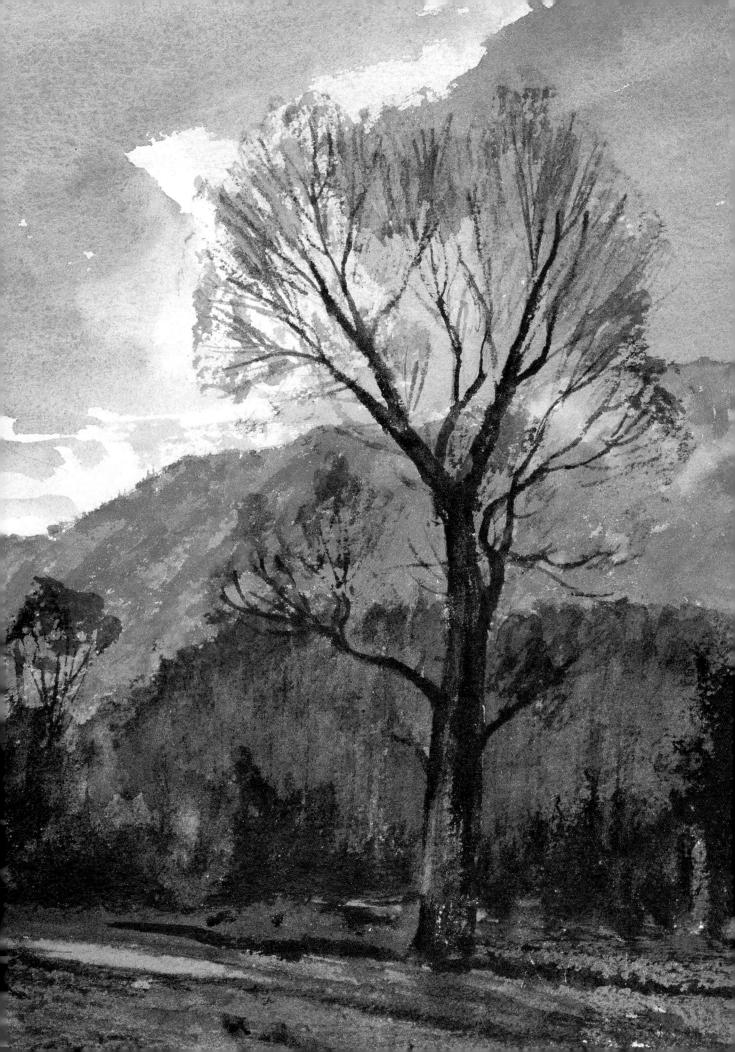

PALE AUTUMN SKY

Laying in a Cloud-Shrouded Sky and a Vivid Foreground

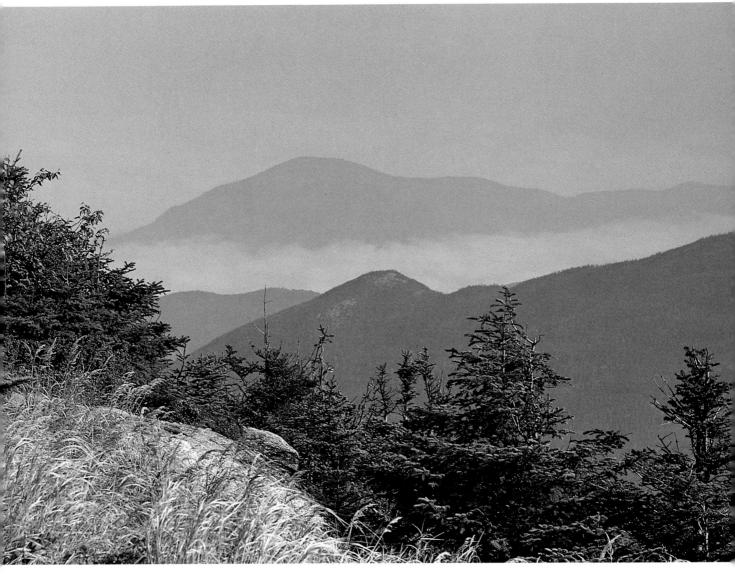

PROBLEM

Everything up close is sharp and clear and loaded with color. But the colors get softer and lighter as you move back toward the mountains. The farthest mountain is even partially obscured by a cloud.

SOLUTION

If you can capture the distant feel of the mountains and the foggy clouds that roll in, the sharp, crisp foreground will fall easily into place. So work light to dark—start with the sky and the mountains.

☐ In your sketch, capture all the major parts of the composition. Then start painting the sky. Use a cool flat wash mixed from cerulean blue and Payne's gray, and lay it in all the way to the dark mountain in the foreground. Then let the paper dry.

Now move in on the mountains. For the one farthest away, mix cerulean blue with a bit of yellow ocher. As you paint, keep in mind the cloud bank that nestles between the two distant peaks; don't cover up all of the

On a clear, brilliant day in autumn, clouds press in across the Adirondacks.

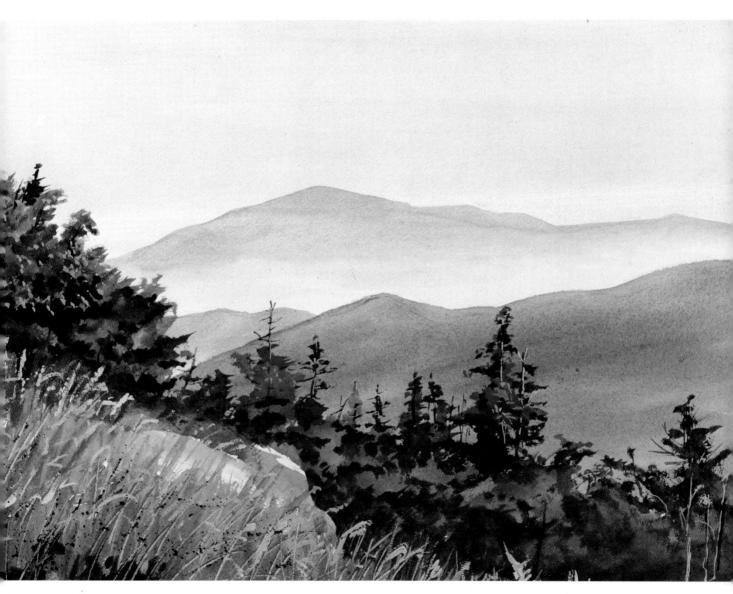

pale wash you applied at the beginning. For the intermediate mountain, add a bit of Payne's gray to your wash. To depict the mountain closest to you, you'll need an even stronger color, so drop some ultramarine into your wash to make it deeper and cooler.

Build your blues up gradually, letting the paper dry between each step. If you rush and change tones while the paper's still moist, the blues will bleed into one another. You'll lose the cool,

controlled look you are trying to achieve. These blues that you've laid in will help achieve a sense of space by receding while the warm colors in the foreground push forward.

Once the backdrop is dry, build up the foreground. A lot of rich earth tones come into play here. The leaves on the left are mixed from burnt sienna, sepia, and cadmium orange. The greens are built up from Hooker's green, burnt sienna, and new gamboge; for the dark accents, splash in a little Payne's gray. The golden grasses that fill the immediate foreground are rendered with yellow ocher, sepia, and burnt sienna. Finally, add detail to the grasses and the trees on the left with opaque paint—yellow ocher mixed with white—and then spatter dark sepia against the lower left corner.

In the finished painting, the warm vibrant vegetation springs forward, clearly separated from the cool mountains that lie in the distance.

Sorting out Abstract Patterns

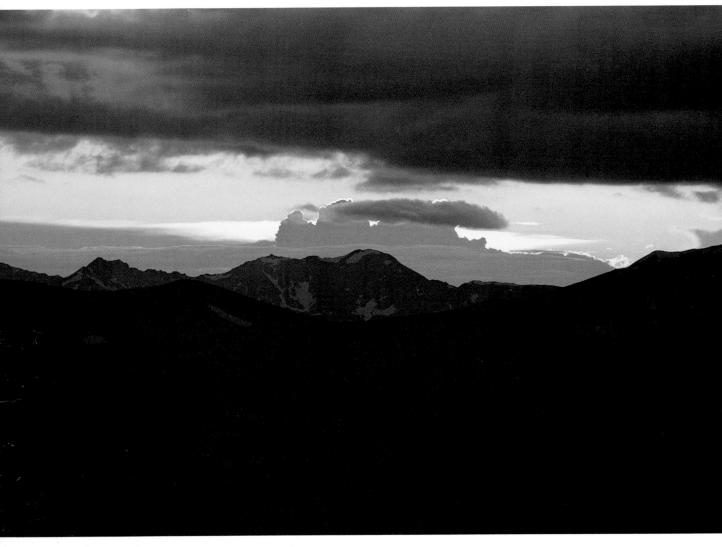

PROBLEM

When you are standing in the middle of a scene like this one, you can feel, hear, and see the drama. When you begin to paint it—probably later and from memory—you'll want to capture that strong mood.

SOLUTION

When a situation is this odd, interpret what you see freely. Sketch the scene on the spot, and make color notes to guide you later. In your painting, you'll start with light colors and gradually build up to the darks.

At sunset, snow, rain, and wind all hurl themselves against the Rockies.

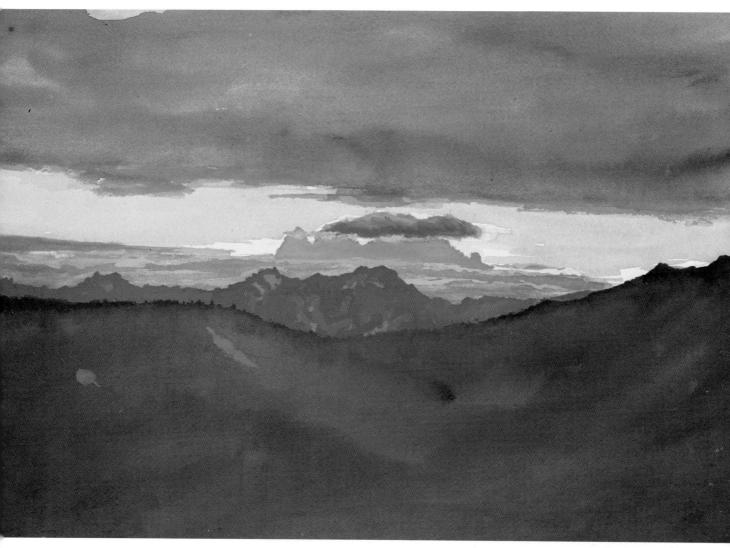

☐ There's not much to draw—just the general shapes in front of you. Sketch them lightly. Now lay a bright yellow wash of new gamboge over the entire paper. Here the color is applied right from the tube, with just enough water added to keep it moist. Beginning with strong yellow matters—it will be one of the brighter, warmer colors in the painting.

In the center of the paper build on the new gamboge foundation. First, take opaque yellow and work in the brightest passages; then, when it's dry, use cadmium orange and mauve to capture the clouds that float beneath the bright yellow sky. Finally, use a deep mixture of mauve and Davy's gray to paint the small dark cloud in the center of the scene.

When you've completed the center of the painting, look for abstract patterns throughout the rest of the scene; the dark shapes may be easier to follow if you think of them that way. Begin at the very top of the paper, use mauve and Davy's gray to render the large dark cloud. Along the lower edge of the cloud, apply cadmium orange.

Next paint the mountain in the background with alizarin crimson, burnt sienna, and cerulean blue. Value is important here—the color should be darker than the cloud but not as dark as the mountain in the foreground. To paint the foreground, use alizarin crimson, ultramarine, and sepia.

When everything is dry, look for spots that need to be highlighted. Here a few touches of opaque white and orange are added in the center of the paper to lighten the area around the sun.

COLORFUL LIGHT

Using Underpainting to Capture Afternoon Light

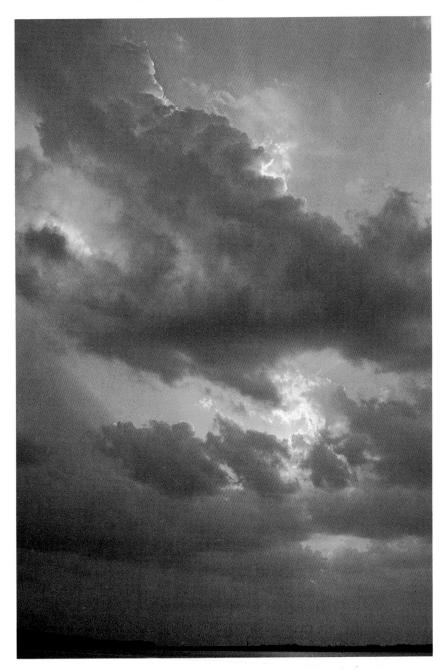

PROBLEM

The dark clouds dominate this scene, but the patches of bright light make it come alive. The light areas have to stand out clearly or your painting will look dull and leaden.

SOLUTION

Lay in a warm underpainting over a whole sheet of paper. When that wash dries, add the darks. This procedure will enable you to control the amount of light that breaks through the clouds.

STEP ONE

With a pencil, lightly indicate the basic shapes of the clouds and draw in the horizon. Now using a large flat brush, cover the entire paper with a pale wash of new gamboge. Add alizarin crimson near the horizon and in the areas where the lightest passages will be.

Late on a summer afternoon, patches of brilliant luminescent sky break through a bank of dark clouds.

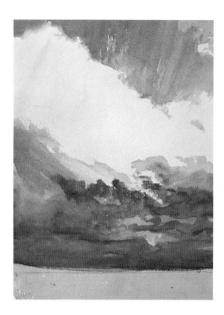

STEP TWO

Add the middle values. Working around the major dark cloud, paint the sky and the smaller clouds. Don't just apply a flat wash—let the colors go down unevenly, and let your brushstrokes suggest movement. All the blues and grays here are mixed from cerulean blue, Davy's gray, yellow ocher, and alizarin crimson.

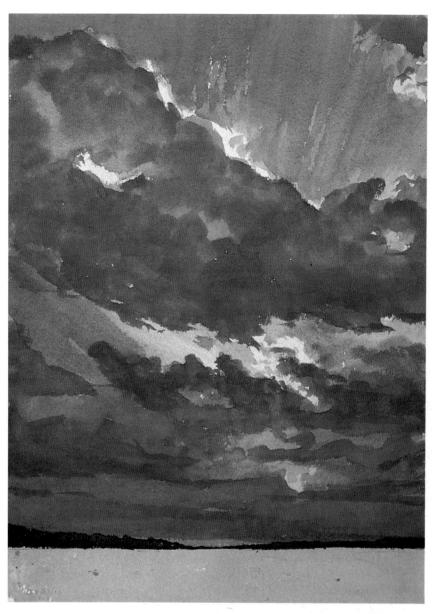

STEP THREE

To paint the large cloud formation, use the same colors as in the previous step. The Davy's gray will help capture the cold, steely atmosphere that runs through the entire scene. Don't cover up all of the underpainting but let bits of it show through. Before you move to the foreground, paint the trees along the horizon.

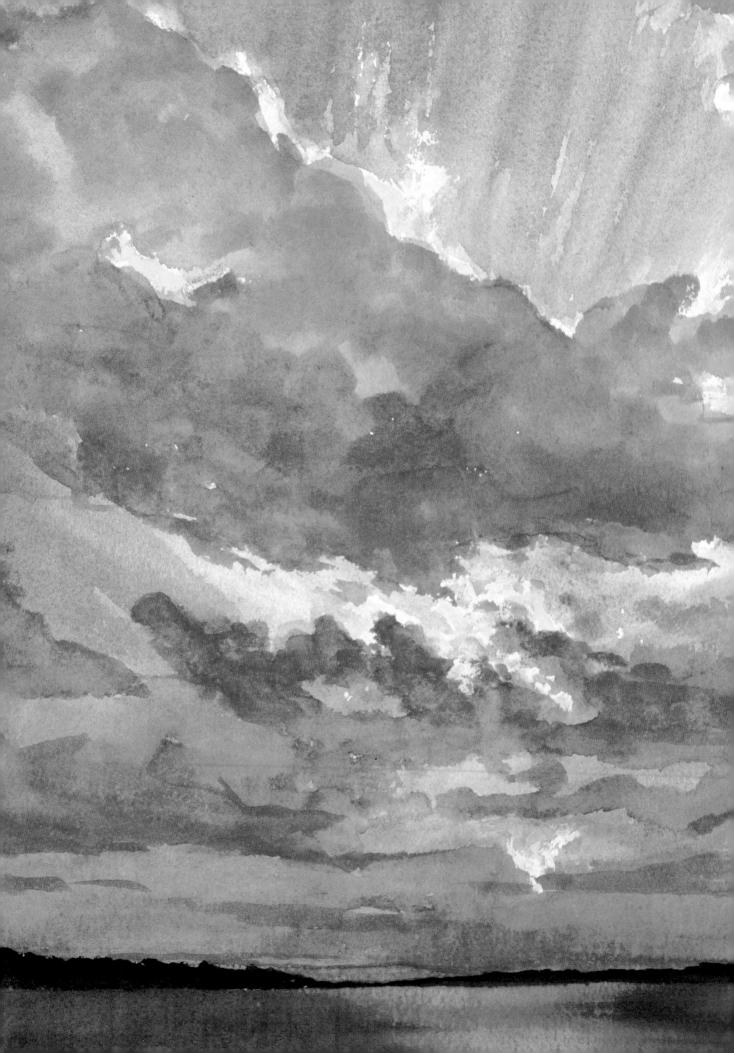

FINISHED PAINTING

About all that's left to paint now is the foreground. First lay in a wash of new gamboge and alizarin crimson. Let the paint dry, and then move on to the dark water. To capture the highlights that play across the water, use a drybrush technique. Mix cerulean blue with Davy's gray; then gently stroke the paint onto the surface. Finally, reinforce the bright areas in the sky with splashes of gold paint.

Here bold brushstrokes clearly suggest a sense of movement. They rush up from the dark gray cloud and seem to continue beyond the edges of the paper. Bands of blue merge with touches of yellow ocher and Davy's gray, creating a rich, dramatic effect.

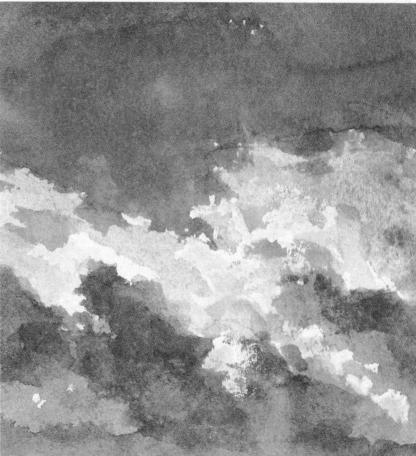

DETAIL

The underpainting of new gamboge and alizarin crimson tints all the light areas and gives them a warm glow. As a final step, these passages are highlighted with dabs of gold paint. The gold seems even brighter than it actually is because of the contrast provided by the deep gray cloud.

SUNSET AND REFLECTION

Painting a Sunset over a Lake

PROBLEM

This complex sky has both hard and soft edges. Some clouds have definite shapes while others are nebulous and undefined.

SOLUTION

Work quickly and try to capture the general feel of the clouds. Lay in the warm colors first; then build up the cooler, darker hues.

For the warm shimmering highlights in the water, put down a wash of cadmium red and cadmium orange. Before you begin to add the blues, allow the paper to dry.

Mix wash of cerulean blue and ultramarine for the sky. Load a big round brush with the color and start painting. Follow the overall pattern you see, working with care around the sun. Be sure to let the underpainting show through the blue. Near the top of the paper, you'll want to suggest the hazy light that falls over the entire scene. Dilute your wash slightly and let the color bleed softly over the paper.

Capturing the ripples in the water calls for short, careful strokes made with a small brush. Here the dark ripples are painted with cerulean blue, alizarin crimson, and burnt sienna. Add only a few strokes to the center of the paper; the underpainting will suggest the light of the setting sun striking the water.

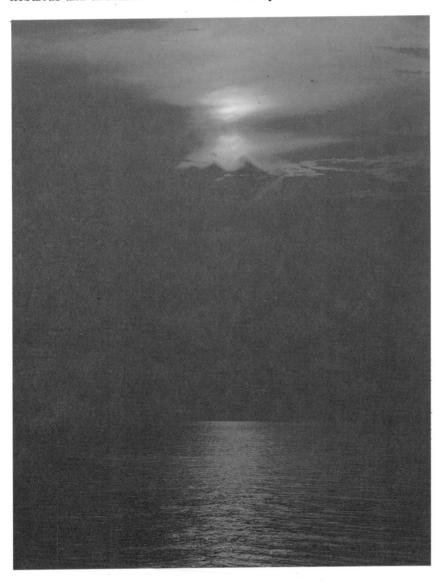

As the sun sets over Lake Michigan, hazy light breaks through the clouds and reflects on the water below.

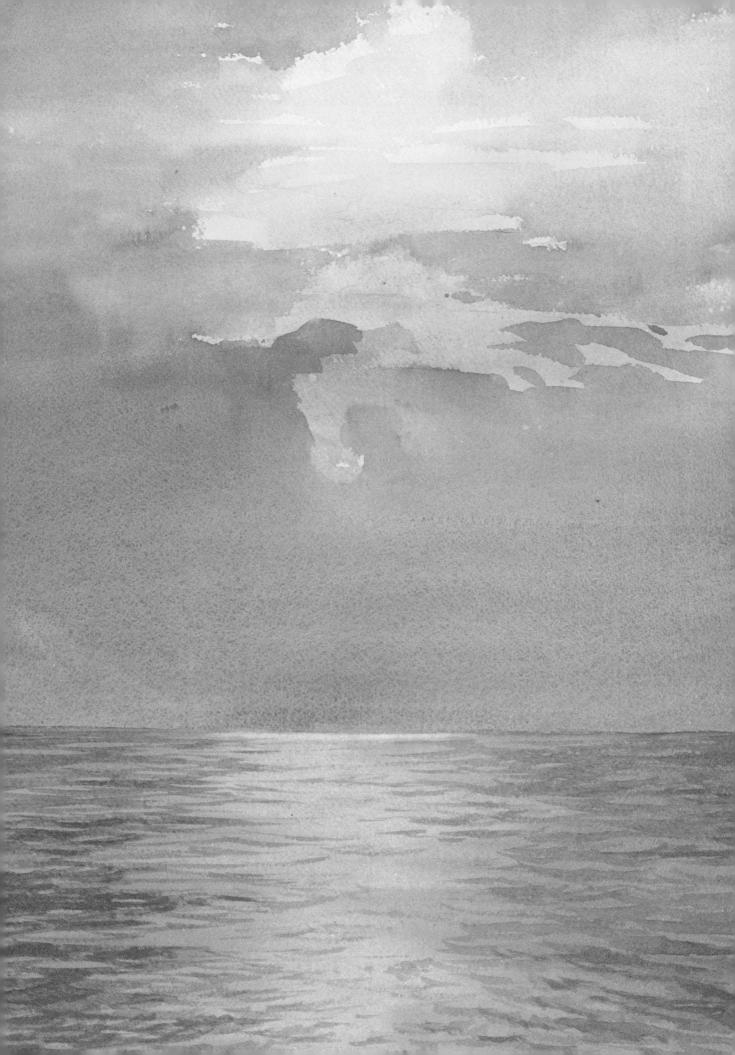

WINTER SUNRISE

Capturing the Feeling of Fog

PROBLEM

Working with fog or hazy light can be extremely difficult. Everything here is so soft and diffuse that there's hardly anything definite to hang on to.

SOLUTION

Work wet-in-wet to capture the hazy atmosphere, and add a little punch to your painting by slightly increasing the strength of the gold. As you develop the scene, keep all the values very light.

☐ Before you start painting, lightly sketch the composition. Block out the sun with a liquid masking solution so can freely paint the sky. Now wet the entire paper with a natural sponge. Begin by laying in a wash around the sun, working with a large oval brush and circular strokes. Lay in the paint all the way down to the horizon. As you move outward from the sun, gradually increase the value of your paint. Farther out, decrease the value; you'll suggest how the sun warms the

area right around it. Here the colors used are yellow ocher, cadmium orange, alizarin crimson, and Davy's gray.

While the paint is still wet, add the general shape of the trees using a very light wash mixed from ultramarine, burnt sienna, and Davy's gray. After the paint has dried, moisten your brush with a slightly darker value; then add a few trunks and branches to give structure to the trees.

Finally, turn to the foreground. For the icy ground, start by laying in a pale flat wash of yellow ocher and cadmium orange. When it's dry, add the grayish shadows that lie across the ground and then the bits of grass that break through the snow.

In the finished painting, the colors are slightly brighter than they appear in nature, which adds a touch of drama to the scene. Because of the wet-in-wet approach, however, the hazy, lyrical feeling of the foggy morning is still captured.

At sunrise in winter, frost fills the air, creating a hazy, foggy, softly lit atmosphere.

MIDWINTER SCENE

Balancing a Cool Foreground and a Warm, Dramatic Sky

PROBLEM

The snow-covered ground is darker and cooler than the late afternoon sky. Both areas require a special treatment. You'll have to balance the shadowy snow against the warm, colorful sky.

SOLUTION

Develop the sky by working wetin-wet. Apply a lot of color, and make some areas very pale but warm—otherwise the sky will look overcast. When you turn to the foreground, keep the hues cool and work on dry paper. ☐ Sketch the tree and then draw in the horizon line. Now start with the most difficult part of the painting, the sky. With a natural sponge, moisten the sky area with clear water all the way down to the ground. Let the water evaporate for a minute or two, and then start to drop color into the damp surface. Right in the center of the paper, lay in some new gamboge and yellow ocher.

While the paint is wet, add a little cadmium orange and cadmium red near the horizon. Once the warm colors have been apIn midwinter, on the frozen shores of Lake Michigan, branches of a tree swept up during an autumn storm lie covered with snow.

plied, start muting them with cool tones. Here ultramarine, cerulean blue, Davy's gray, and a touch of alizarin crimson are worked in around the bright passages. Because the paper is still wet, the darker tones will merge softly with the warm colors. Right above the horizon, there's a sliver of brilliant orange—don't cover it with the darks.

The snowy ground is very different from the sky. Whereas the sky is fluid and full of color, the ground is monochromatic and still. To capture its cold, solid feel,

work on dry paper. Lay in the ground with ultramarine, cerulean blue, and alizarin crimson. Slightly vary the values to show how the snow lies packed in drifts.

When the paint dries, add details with a slightly darker hue; then run touches of burnt sienna across the paper. Finally, paint the tree: first render the dark branches and later go back to add the snow that lies on them.

In the finished painting, an endless expanse of icy ground seems to move slowly toward the distance to meet the afternoon sky.

DETAIL

The sky is made up of soft, effortless shifts from yellow to orange and from orange to blue. This subtle effect results from working wet-in-wet. Note the sliver of orange that floats along the horizon. This detail, though hard to control on wet paper, is well worth the effort—it makes a strong note in the finished painting.

DETAIL

Cool blues applied to dry paper suggest the still, quiet mood of this winter scene. Slight variations in value sculpt out the contours of the snow drifts, and touches of burnt sienna break up the relentless field of blue.

MOUNTAIN DAWN

Working with Subtle Shifts in Color and Value

PROBLEM

Here the quiet beauty of the scene rests on a limited palette. Everything is pinkish and purplish blue. One false note of color will ring out and disrupt your painting.

SOLUTION

When you begin to lay in the sky, keep the area right above the mountains warm; you'll be creating a subtle halo effect. Then, when you turn to the mountains, gradually build up your values.

In the Rockies, an early morning rainstorm bathes the sky and land with a cool, purplish tone.

☐ First sketch the scene. Then begin to paint the sky using light values. Start at the top of the paper with ultramarine, and moving down, shift to cerulean blue. Next turn to mauve; then, alizarin crimson. Carry the crimson to the bottom, making it lighter as you move down. When you add the mountains, the red will spotlight their contours and suggest the rising sun.

For all three mountains, use cerulean blue, ultramarine, and alizarin crimson. Start with the mountain in the distance, using very pale values. Let the paint dry before you move on; this will keep the mountains clearly defined. Next paint the middle slope, increasing the density of your pigments. Again, let the paint dry before you move on.

The mountain in the foreground is the darkest area in the painting. When you work on it, create some texture—use slightly uneven strokes and add some irregular touches on the mountain edge. Unlike the sky and the distant hills, which are flat, the foreground must have enough detail to make it seem close.

Because of the limited palette, the finished painting is a harmonious study of hue and value.

ASSIGNMENT

Try grading a sky primarily with color, not with value. Imagine that the sun is shining in from the left. Begin there with a clear pure yellow. As you move right, across the paper, gradually shift to red and then to blue. Don't let the yellow and the blue mix to form green.

Begin with new gamboge on the far left. Next introduce mauve and then cerulean blue. Practice until you can make the transition between the colors look fresh and spontaneous.

DRAMATIC DAWN

Mastering Strong Contrasts of Lights and Darks

PROBLEM

The church, ground, and trees contrast sharply with the sky. Most of the sky is a medium purple, but near the horizon it's a bright flash of gold. To give your painting power, you'll want to keep the gold vibrant—it has to stand out against the darks.

SOLUTION

The darker the building and the sky, the brighter the patch of light will appear to be. Keep all the values fairly dark except for the area right along the horizon, and make the sky a little lighter around the church to give it emphasis.

☐ The church, viewed at an interesting angle, should be drawn in carefully before you start to paint. The final silhouette has to make sense, and for that a good drawing is vital.

Paint the sky in stages, starting with the warm tones and later adding the cool blues and purples. Right along the horizon, lav in a strong cadmium orange; then add new gamboge and alizarin crimson. Keep the color strong near the ground and then soften the wash over the entire area of the sky. Grade the sky gently, so no hard edge occurs between the bright colors and the softer ones. When the paint is dry, lay in a graded wash of ultramarine and alizarin crimson all the way to the top of the paper. With the same colors, add a few cloud effects near the horizon. The yellow will look even stronger and brighter once these cool touches have been laid down.

The rest of the painting should be easy. Mix a very dark pool of paint—here Prussian blue, alizarin crimson, and sepia—and then add the darks. As you depict the church and the ground, use careful, even strokes. The trees on the right call for a drybrush technique—wispy strokes will summon up the melancholy mood created by trees standing silhouetted against a dark sky.

DETAIL (TOP)

The sky moves from a medium purple to a light, radiant rose. Right around the top of the church, the sky is fairly light; it seems even lighter than it is because of the strong, dark color of the building.

DETAIL (BOTTOM)

Painted with a barely moistened brush, the texture of these trees is a welcome contrast to the clean, crisp dark tones that dominate the painting. Behind the trees, bright yellows and oranges spill along the horizon. These strong, pure colors work naturally with the rest of the sky, in part because a wash of those colors is carried over the entire sky before the cool tones are introduced. Until the darks are added, the light tones don't seem nearly bright enough—they need contrast to make them work.

At dawn, an old church stands silhouetted against a light-streaked sky.

MOONLIGHT

Staining a Painted Sky with Clear Water to Suggest Clouds

PROBLEM

Moonlight is the only illumination here. The snowy ground catches the moon's dim light, brightening the night air. Get the lighting right here—if you don't, your painting won't capture this time of night or the feeling of winter.

SOLUTION

To make the sky and ground work together, use a limited palette. You can get across the feel of a winter evening by streaking the sky near the horizon with water after you've laid in the blue.

Now begin the sky. Turn the paper upside down; then work from light to dark. Here alizarin crimson and ultramarine are laid in near the horizon. Slowly shift the color to pure ultramarine and then to a mixture of ultramarine and Prussian blue. When the paint is dry, turn the paper right side up.

The snowy foreground seems warm because of the moonlight that illuminates it, so begin by laying in an underpainting of alizarin crimson. After the underpainting has dried, overpaint it with a slightly darker value of ultramarine and alizarin crimson. Leave a few passages of the underpainting uncovered to indicate the snowdrift in front of the windmill.

Even with the carefully graded wash, chances are that the sky will seem too flat. Try breaking up that large area by washing in water near the horizon. This technique, you'll find, gives a soft feel while creating a sharp edge—an interesting combination. At the same time, you'll see that very little shift in color or value is produced.

Start the foreground by laying in whitish blue gouache along the horizon. Now turn to the details. The windmill requires a steady hand and a fine brush—here it's rendered with sepia and Payne's gray. Add the bits of grass that poke through the snow, and the buildings and trees along the horizon. At the very end, add the crescent moon with white gouache.

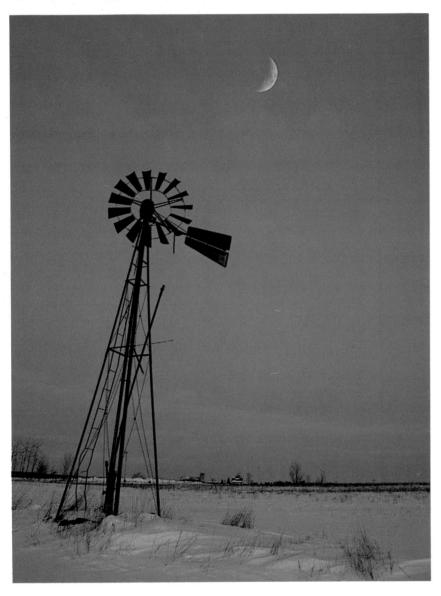

A crescent moon floats above a midwinter landscape, which is punctuated by an old windmill.

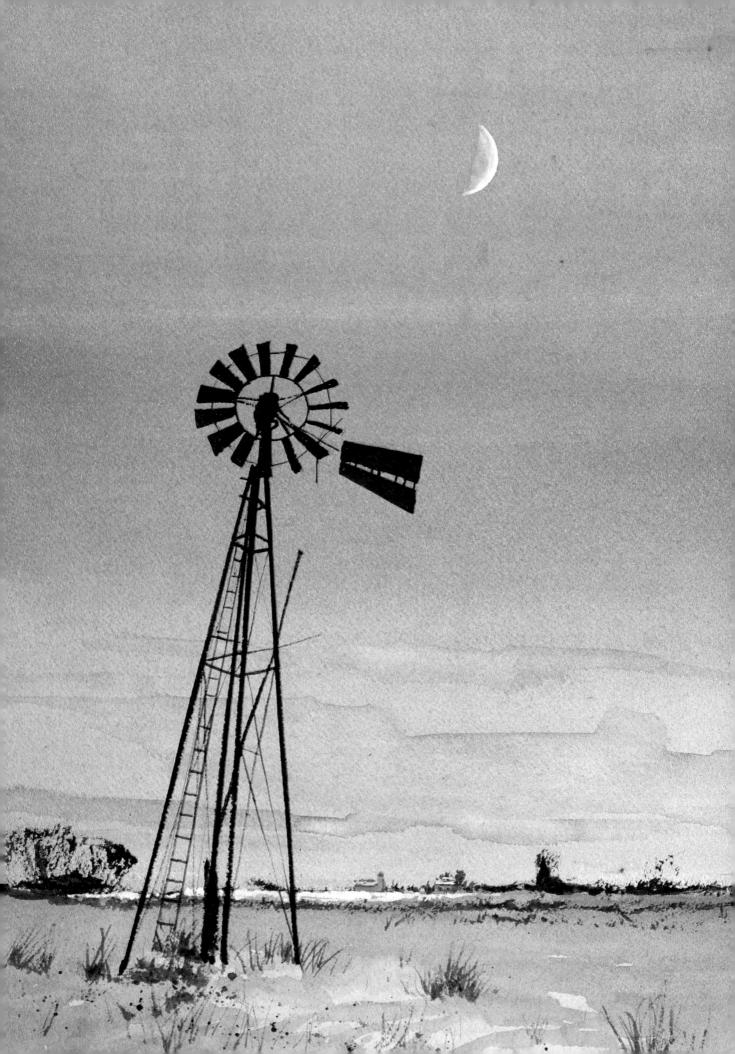

FULL WINTER MOON

Learning to Paint a Moonlit Scene

PROBLEM

Painting a moonlit scene is always a challenge, especially in the winter when there's snow on the ground. The snow catches the light cast by the moon, illuminating the landscape; yet the shift in value between the sky and the ground is very slight.

SOLUTION

Paint the golden moon right away; then after it dries, mask it out. When you start to lay in the sky and the foreground, don't use too dark a shade of blue and don't make the two areas contrast too sharply.

☐ Sketch the scene; then paint the moon with new gamboge and touches of alizarin crimson. As soon as it dries, cover the moon with liquid masking solution. Then turn to the sky. Use a graded wash. Here Prussian blue is mixed with ultramarine. For the foreground, try a cooler blue; here it's a blend of cerulean blue and alizarin crimson.

Let the paper dry. Then tackle the trees, rendering them with sepia and Payne's gray. A variety of techniques come into play here: the trunks are done with a small brush loaded with paint; the spidery branches, with a drybrush technique; finally, the masses of twigs, with a light wash laid in over some of the branches.

Now peel the masking solution away from the moon and add the clouds that hover in front of it. Then moisten some areas right around the moon and wipe out the paint there, to suggest clouds which fill the sky.

Finally, turn to the foreground. Give texture to it with a slightly darker mix of cerulean blue and alizarin crimson; then add a few strokes of sepia to suggest the grasses that break through the snow cover.

In February, a full moon rises over a still, snow-covered landscape.

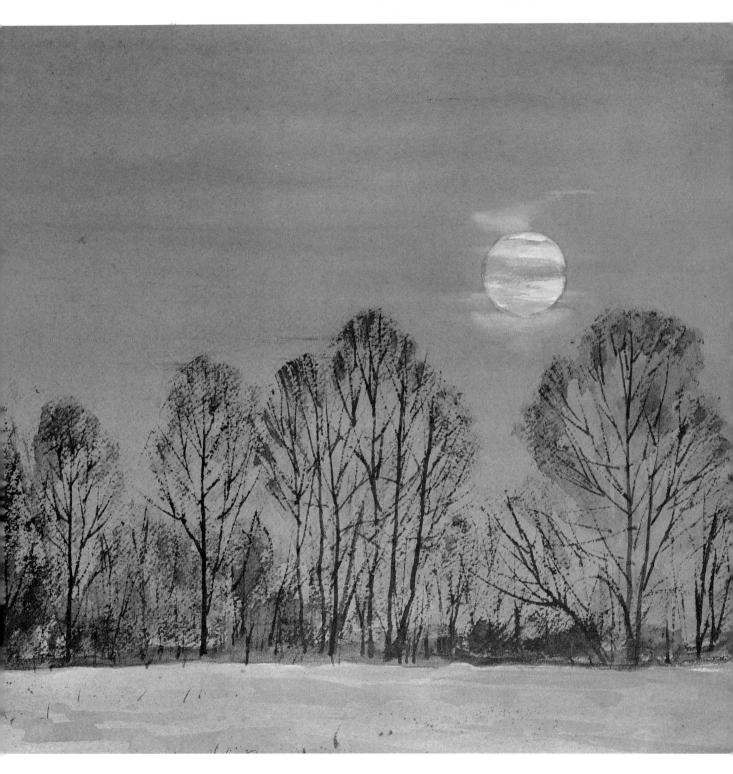

Handling the Contrast Created by a Silhouetted Foreground

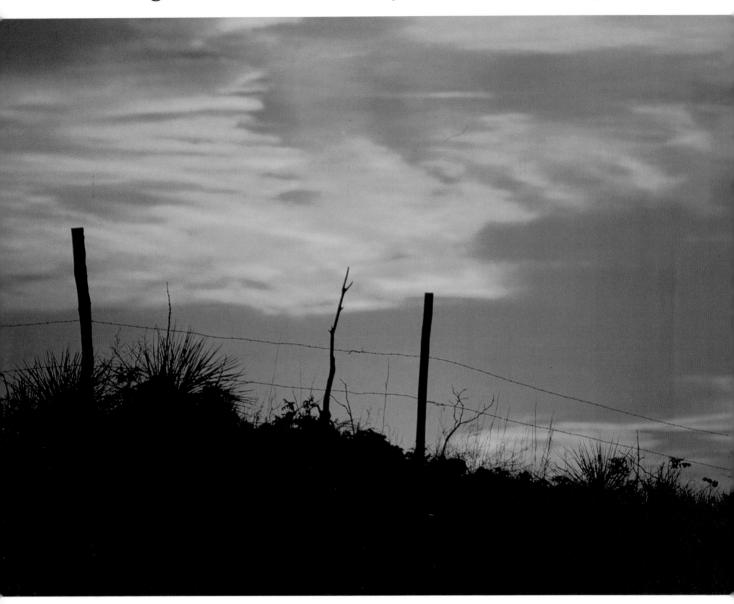

DDOD! FM

When working with extreme contrasts, it's easy to end up with a harsh, forced effect. If the sky is either too flat or too garish, the subtle pattern created by the clouds will be lost and with it the gentle, easy touch that distinguishes this landscape.

SOLUTION

Keep the foreground dark and dramatic. When you begin to paint the sky, try rendering it with layers of overlapping light and dark color. You'll break up the masses of strong orange and create a rich, lively pattern.

☐ Carefully sketch all the detail in the foreground—the grasses, fence posts, and barbed wire. Then turn to the sky. Wet it and then lay in a light tone of new gamboge deepened with cadmium orange and alizarin crimson. Let the paper dry. To create the dark streaks that rush across the sky, use a deeper tone mixed from the same colors plus a touch of

A blazing orange sky filled with soft, layered clouds silhouettes a lonely barbed-wire fence and prairie.

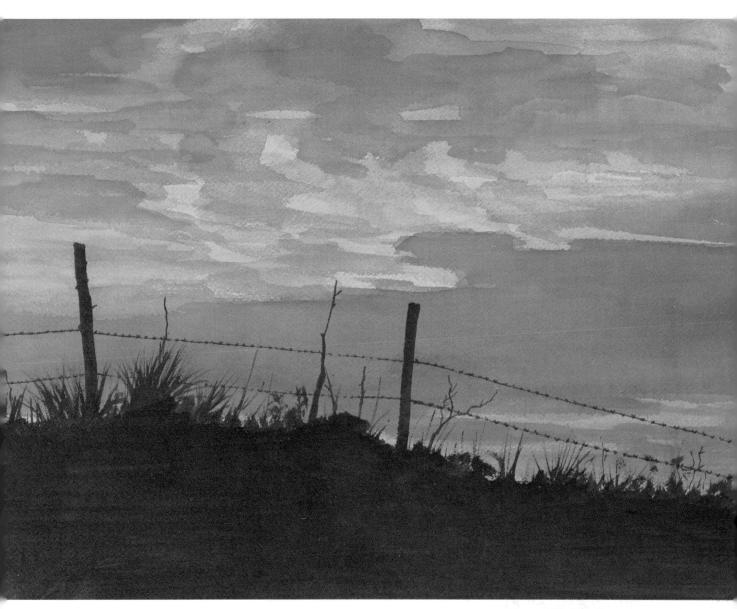

mauve. (Mauve is a good darkening agent for yellow—in small doses, it will change the value of yellow without substantially changing the color.) Work slowly as you add the bands of deep orange. Keep some edges crisp; let others bleed into the adjoining areas of wet paint. Try to follow the general pattern of the clouds. Above the horizon, lay in a bold

area of dark paint; then let the paper dry.

The foreground should be a rich dark hue. Here it's carefully painted with ultramarine and sepia. The dark color sets off the yellow, gold, and orange in the sky, making them seem even brighter and more intense.

Working with Strong yet Subtle Contrasts

PROBLEM

The brilliance of the setting sun warms this sky, but the sky's color is only moderately strong. Toward the horizon, the sky becomes almost pure gray and the foreground is very dark.

SOLUTION

Mask out the sun and paint it last. You'll then be able to adjust its brilliant color to blend harmoniously with the muted sky and deep, dark foreground.

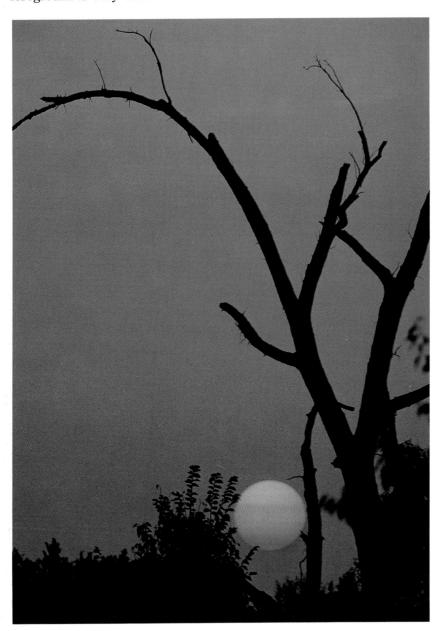

☐ Sketch the shapes in the foreground carefully; then mask out the sun. Next lay in the sky with a graded wash, placing the warmest color at the top of the page and a cool gray at the horizon. The gray will form an effective backdrop for the sun when you paint it. Here a mixture of alizarin crimson and new gamboge is applied at the top of the sheet. Gradually mauve is added to the orange, and then the mauve gives way to a combination of mauve and Davy's grav. Near the horizon, the gray is strong and dark.

To render the foreground, use sepia. The tree is executed with careful, even strokes to keep the silhouette strong and powerful. Elsewhere, however, the brushwork is looser, at times even impressionistic, to soften the contrast between the sky and the ground.

Now pull off the masking solution and paint the sun. Here the strength of new gamboge is broken by a touch of cadmium red. The red mixes with the yellow, forming a warm orange tone that relates the sun to the sky above.

In an early autumn sunset, the skeleton of an old dead elm stands silhouetted against a warm orange sky.

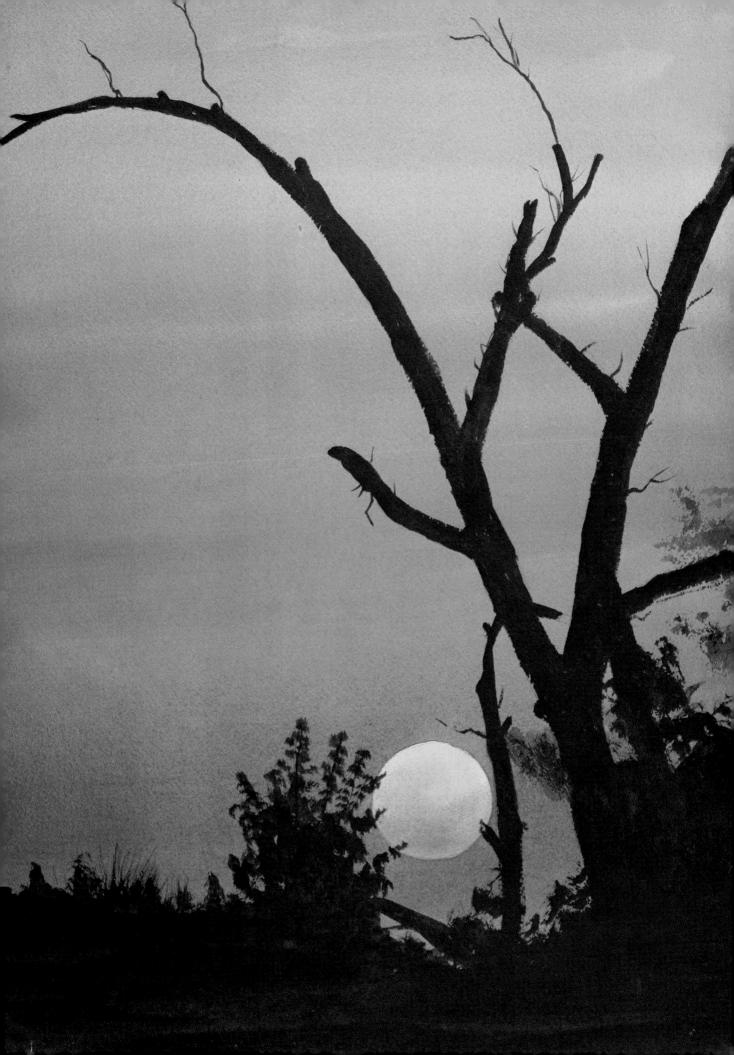

PRAIRIE SUNSET

Capturing the Drama of a Sunset

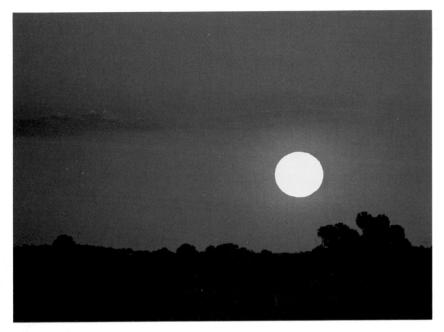

PROBLEM

Taken just at the moment when the still-golden sun was hovering in the sky before setting, this photograph is a study in strong color and contrast. The sun is a special problem: its color is so strong and pure that it could easily look artificial.

SOLUTION

To make the sun fit logically into the picture, show how it lightens the atmosphere immediately around it. Use circular strokes, and as you work outward from the sun, gradually making the sky darker.

☐ Execute a preliminary sketch; then paint the sun with new gamboge. When the paint is dry, cover the sun with masking solution. Now begin the sky.

Here the entire sky is rendered with new gamboge, alizarin crimson, and mauve. The paint is laid down with loose, circular strokes that radiate from the yellow sun. As you move outward, gradually increase the density of the pigment, and never let the color become too regular. Near the edges of the paper, the yellow and red are strongly tinged with mauve.

Before you begin work on the clouds, let the paper dry. While you're waiting, study the patterns the clouds form: they hover right over the sun and then become fainter farther up in the sky.

For the darkest clouds, use mauve mixed with alizarin crimson. Keep the edges soft; if necessary, run a little clear water on them. As you move upward, use a paler wash of color and don't cover all of the sky that you initially laid in.

Next turn to the ground. Mix a good amount of sepia and ultramarine together, making the color dark and intense—the darker the ground, the brighter and more powerful the sky becomes. Lay the paint onto the paper, keeping the edge hitting the sky lively and full of movement. Finally, peel the masking solution off the sun.

Over a prairie, a brilliant yellow sun slowly sets in a vivid sky.

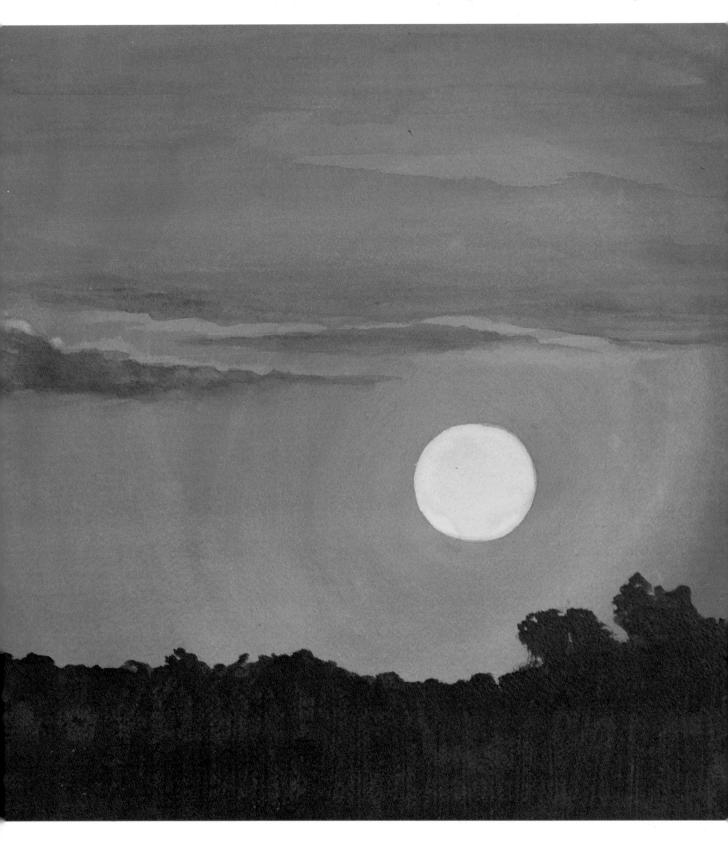

Laying in a Sky Composed of Delicate Slivers of Color and Light

PROBLEM

This sky is richly patterned with bands of color—so much color that it will be hard to keep the different hues from mixing together and becoming muddy.

SOLUTION

Start by toning the center of the paper with a warm yellowish orange wash. After it's dry, turn to the area near the horizon, where the bands of color are strongest. With a small brush, gradually fill that area with overlapping slivers of color.

To lay in the streaks of color that fill the sky, use a small round brush. In some areas, keep the edge of your strokes crisp; in other places, let the bands of color mix together. Be very careful not to let the bands cover all the underpainting—that's what pulls the sky together. Near the horizon, use alizarin crimson, cadmium orange, and mauve. In the center of the sky, add ultramarine. For the rich mottled area high in the sky, try ultramarine, Prussian blue, and Payne's gray.

All that's left now is the foreground and tree; they call for a deep, dark tone. Here it's mixed from ultramarine, Payne's gray, and sepia.

In the finished painting, bands of color shoot across the sky, suggesting the sun's last rays playing upon a cloudy sky.

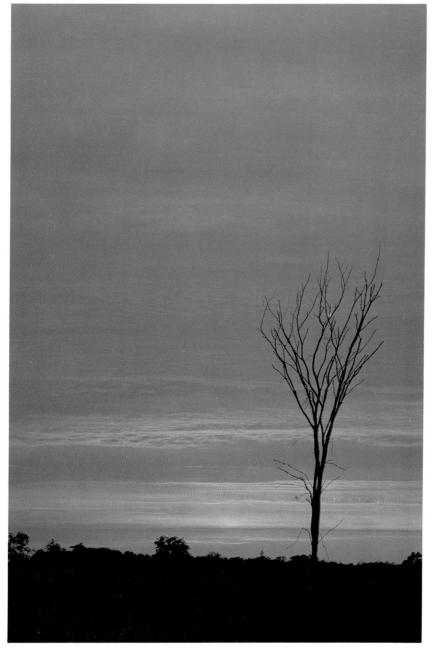

After the sun has set, streaks of red, orange, purple, and blue shift across a cloudy sky.

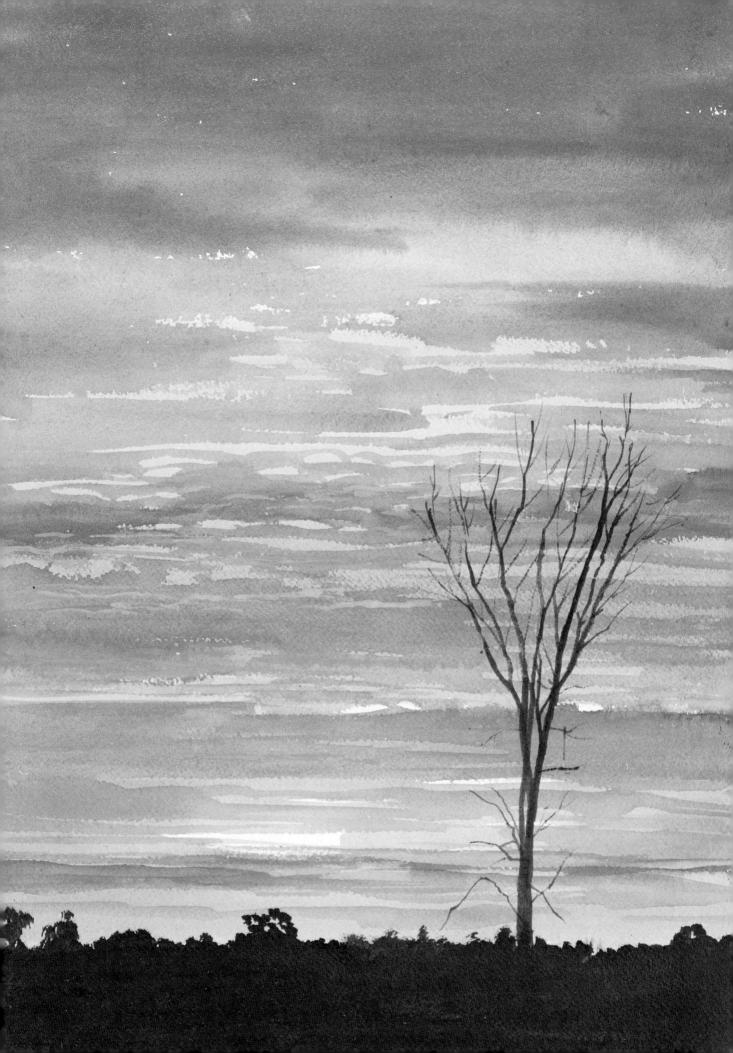

BRILLIANT RAINSTORM

Evoking the Feeling of a Rain-Filled Afternoon Sky

PROBLEM

Thrce interesting conditions occur here, and for a painting that really works, you'll want to capture all of them. First, there's the strongly patterned, cloudy sky; next, a hazy light bathes the distant mountains; finally, rays of light break through the cloud cover.

COLUTION

Use a wet-in-wet technique to lay in the sky, indicating the soft patterns the clouds form. To capture the hazy atmosphere, paint the distant hills in very light values. Finally, when everything is dry, rub out the sunbeams with an eraser.

After your initial sketch, sponge down the entire sky. Now drop in cerulean blue, Payne's gray, burnt sienna, and ultramarine. Next, tilt the paper slightly, letting the colors run together. Be careful—keep some areas pure white. As soon as the paint forms a pattern that pleases you, put the paper down to dry.

Now build up the distant mountains, beginning in the back. As each range dries, move on to the

Dark clouds eddy in a richly patterned sky as rain begins to pour on the mountains.

next. Keep the values very light at first, to indicate the hazy, rainy atmosphere. Here the two distant ranges are rendered with cerulean blue and yellow ocher, and the third with ultramarine and burnt sienna.

Before you turn to the foreground, let the paint dry. Then pull out the rays of sun with an eraser. Remember, the paper has to be absolutely dry or you'll smudge the paint and ruin your painting. As you run the eraser over the dry paper, pick up just enough paint to suggest the rays; don't try to remove all of the pigment. Note how subtle this effect is—at first it's hardly noticeable because just a little of the paint has been removed.

Finally, paint the foreground. As you lay it in, don't let the color get too flat; uneven application of the paint will make the foreground seem close at hand.

APPROACHING STORM

Painting a Dark Sky Set Against a Lush Summer Landscape

PRORI FM

Even though the storm clouds are moving in on the scene, the ground is brightly lit. If the sky is too dark, the flower-filled hillside will look out of place.

SOLUTION

Paint most of the sky with dark, dramatic blues and grays, but leave the area right behind the trees pure white. It will not only make the dark clouds seem to press in on a clear sky, but it will also spotlight the pine trees and make the brilliance of the foreground seem natural.

Tall pine trees separate a moody blue sky from a hillside covered with fresh summer wildflowers.

STEP ONE

Sketch the basic lines of the composition. Then paint the sky quickly, all in one step. The look you want is fresh, soft, and exciting—something you can only capture if you work rapidly. Wet the sky with a natural sponge, and then drop in ultramarine, burnt sienna, cerulean blue, and yellow ocher. Let the colors bleed together, but be sure to leave some areas pure white. Now let the paper dry.

STEP TWO

Turn to the trees. Begin with their trunks and some of the dark branches on the right using a dark mix of cerulean blue and sepia. Next lay in the branches and needles. Start with a light value of green; you'll add the rest of the dark, shadowy areas later. Here the light green is mixed from new gamboge and cerulean blue. Dab the paint onto the paper, keeping your strokes lively and uneven.

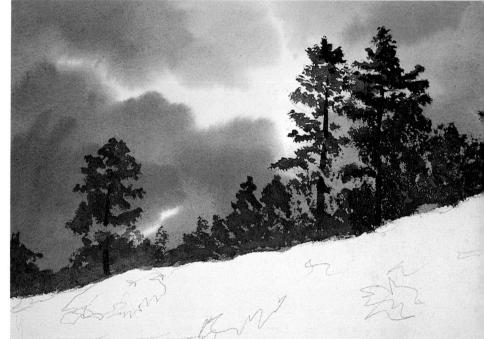

STEP THREE

Now finish the dark shadows on the trees, again using a mixture of cerulean blue and sepia. What's left now is the warm, lush foreground. Start by laying in a wash mixed from Hooker's green, sepia, and yellow ocher. Don't try to get the color too even; it will be much more interesting if it shifts from light to dark green.

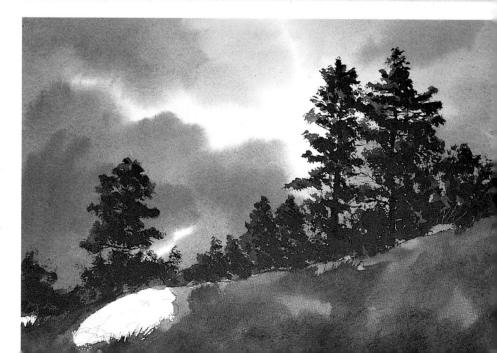

FINISHED PAINTING

Once the foreground dries, spatter bright yellow gouache over it to depict the wildflowers. Finally, paint the rock on the far left using Payne's gray, mauve, and yellow ocher.

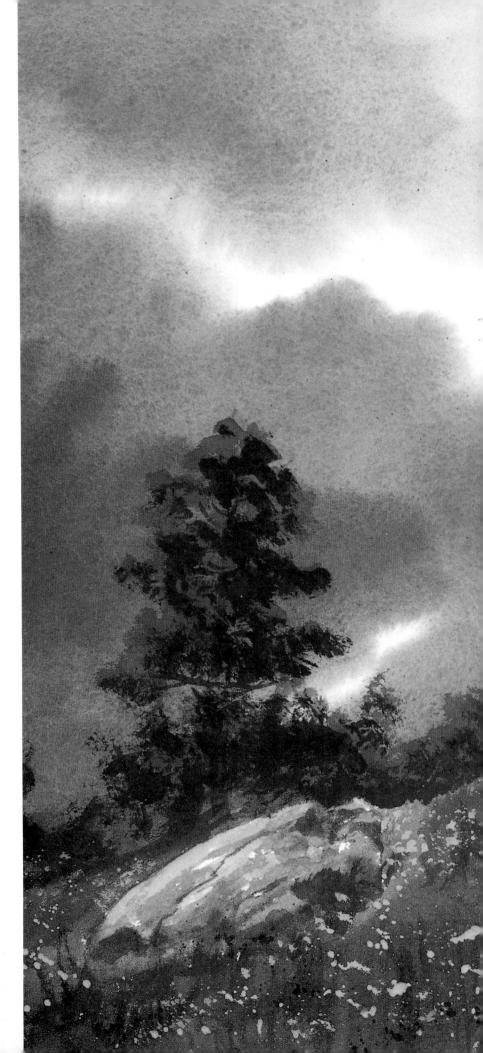

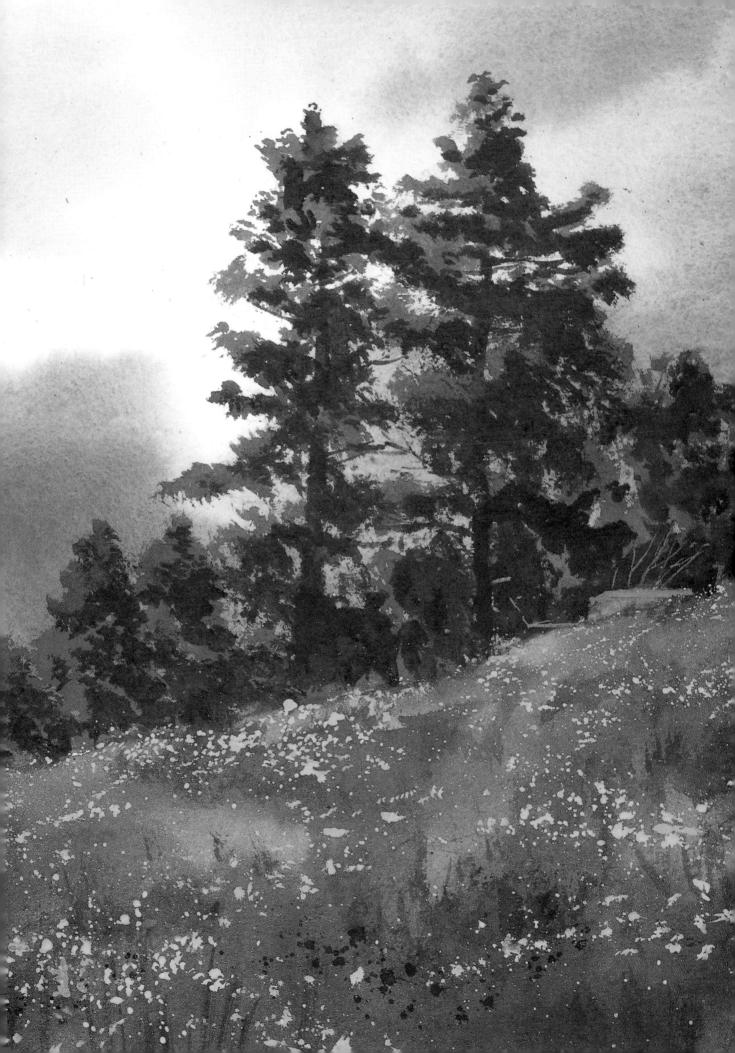

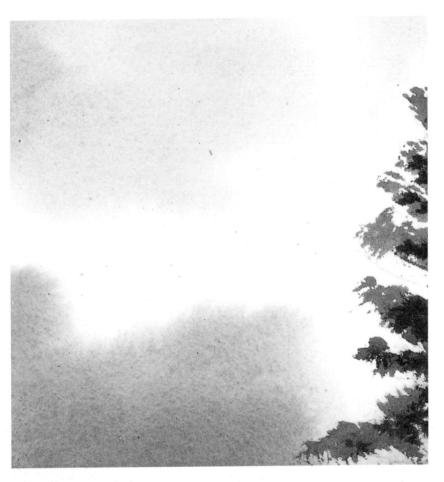

DETAIL

The patch of white sky behind the pines not only breaks up the dark blues and grays that fill the sky but also directs the eye to the pines which dominate the hillside. The white area has a soft, undulating feel, created because the blues which are laid onto the wet paper bleed into the white.

DETAIL

An uneven wash of Hooker's green, sepia, and yellow ocher is the backbone of this foreground. Sometimes dark, sometimes light, the colors suggest sunlight playing on a grassy hillside. The dense gold spattering seems to fill the grass with brilliant wildflowers.

BRIGHT SUMMER SKY

Narrowing in on the Foreground

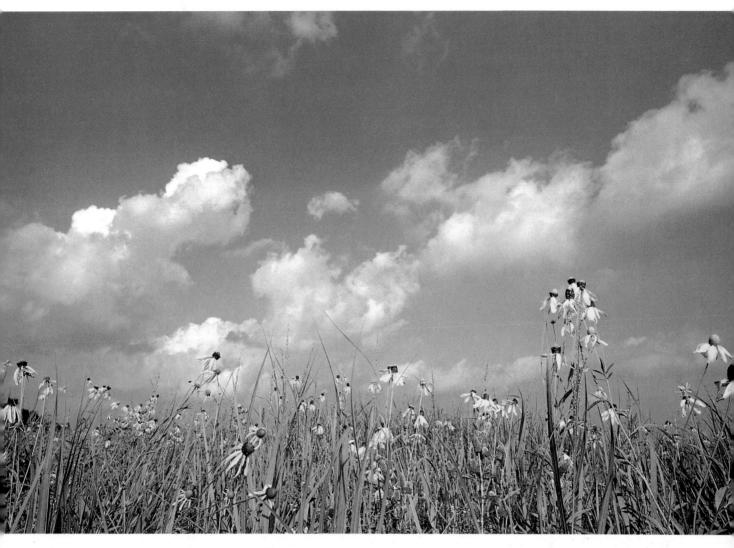

PROBLEM

The field is really the subject here, but the sky is so strongly patterned that it competes for attention. You'll have to balance the two areas.

SOLUTION

Go ahead and treat the sky boldly—if you want, you can even accentuate its drama. Paint the flowers and grass as a final step, with gouache. Because gouache is opaque, you'll be able to work over the sky area and easily adjust the strength of the bright yellows and greens.

A brilliant blue sky forms the backdrop for a field of summer wildflowers.

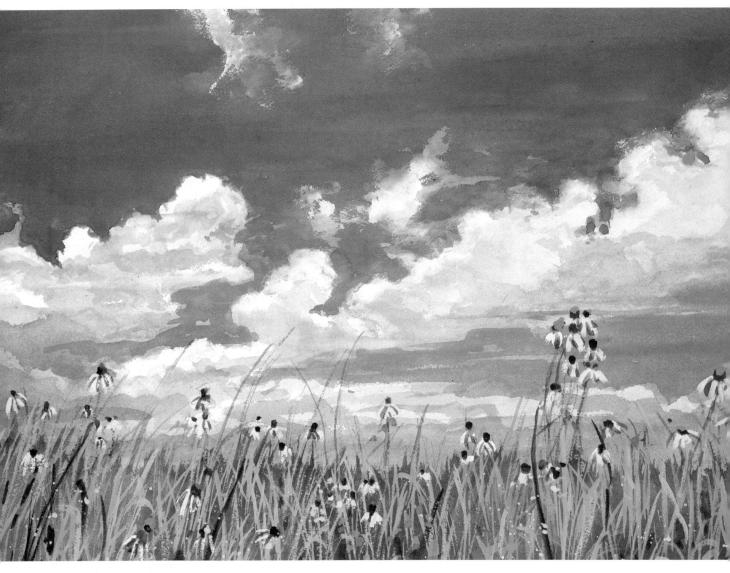

□ With a rich mixture of ultramarine and cerulean blue, start to lay in the dark blue sky. At the very top of the paper, drop in a few touches of white gouache and let the drops melt into the blue paint. When you reach the clouds and start to paint around them, shift to cerulean blue and yellow ocher. While the paint is wet, soften some of the edges you've created with clean water. Next, lay in the shadowy undersides of

the clouds with a pale mixture of ultramarine, alizarin crimson, Payne's gray, and yellow ocher. Again, soften the edges with clear water as you work.

After the sky has dried, lay in the dark grass with Hooker's green, new gamboge, and Payne's gray. For the light grass and flowers, use gouache; here Hooker's green and new gamboge are blended to form a lively

spring green. With dabs of

mauve, add the little purple blossoms that grow among the grasses; then spatter touches of yellow over the foreground.

At the very end, the clouds here seem too dark. To make them appear lighter, the top of the sky is darkened with pure ultramarine. One shift in value—for example, darkening this sky—can often bring a whole painting into focus.

DETAIL

The shapes of the clouds are etched out by the blue paint; later the blue, gray, and purple shadows that play along their undersides are worked in. The white you see here is the untouched watercolor paper.

DETAIL

Tall, thin green brushstrokes weave in and out, creating a richly patterned field of grass. The little spatters of yellow added at the very end help pull the foreground forward, animating it at the same time. Touches of mauve further break up the greens and relate the ground to the purple patches of sky near the horizon.

WATER

WATERFALL

Capturing the Power of a Waterfall

PROBLEM

The surging power of the waterfall will be difficult to capture. What makes this scene even more challenging is the hard, rough rock formations that lie behind the falls.

SOLUTION

Working from light to dark is the standard method of working in watercolor, but scenes like this one call for a different approach. Since the rough rocks are packed with textural detail, develop them first. When you've completed them, turn to the light, cascading water.

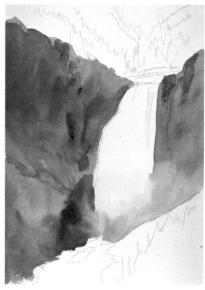

STEP ONE

Sketch the major lines of the composition—the waterfall, the rocks, and even the trees; then begin to lay in color. Start with middle-tone washes. Here both warm and cool colors come into play: yellow ocher, burnt sienna, mauve, cerulean blue, and sepia.

On the Yellowstone River, a waterfall pulses over dark sheets of jagged rock.

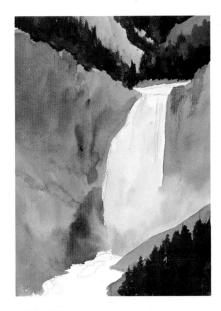

STEP TWO

Continue developing the middle tones; then begin to work on the darkest values, moving from the top of the paper down. First, paint the distant rock formations with washes of burnt sienna, yellow ocher, and mauve. Now strike in the dark greens with Hooker's green light, burnt sienna, mauve, and Payne's gray.

Turn from the trees to the waterfall. Moisten the area of the fall with clear water; then drop in very light touches of new gamboge, cadmium red, and cerulean blue.

Develop the foreground rocks and trees with the same techniques that were used for the distant formations.

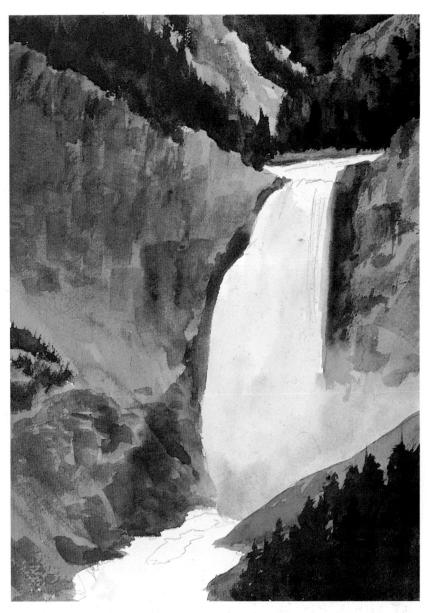

STEP THREE

Gradually add texture to the rocks. In this step, your palette will consist mostly of mauve, burnt sienna, and ultramarine blue. Dilute each color to a medium tone; then scumble the color onto the paper. To do this moisten your brush with diluted colors, shake out most of the moisture, and then pull the brush over the surface. As you work, keep your eye on the dark, shadowy portions of the rocks. They are what you are out to capture.

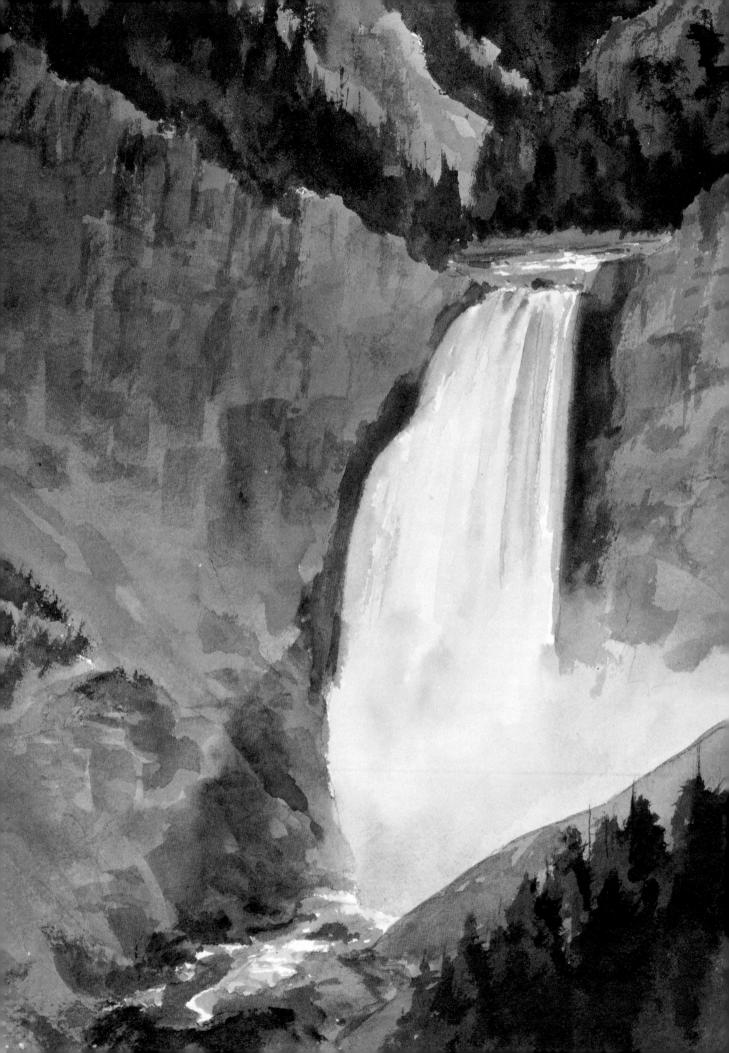

FINISHED PAINTING

All that's left to execute now is the water in the foreground. As soon as you've laid it in, examine the entire painting, looking for areas that seem weak and underdeveloped. Here the colors of the waterfall were too faint; adding stronger touches of red, yellow, and blue brought it clearly into focus.

The transparent delicacy of the waterfall is captured as touches of color are dropped onto moistened paper. When you use this approach, add the color sparingly and don't let the yellow run into the blue; if you do, you'll end up with a muddy—and unrealistic—shade of green.

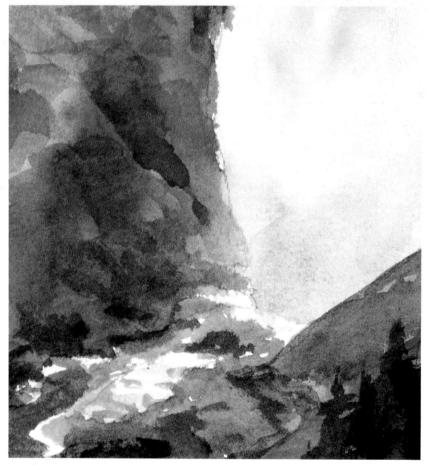

DETAIL

The water in the foreground was executed quickly and impressionistically. A dab of bright green paint lies surrounded with darker, blue passages, suggesting the rush of water without detracting from the power of the waterfall.

MOUNTAIN LAKE

Working with Strong, Clear Blues

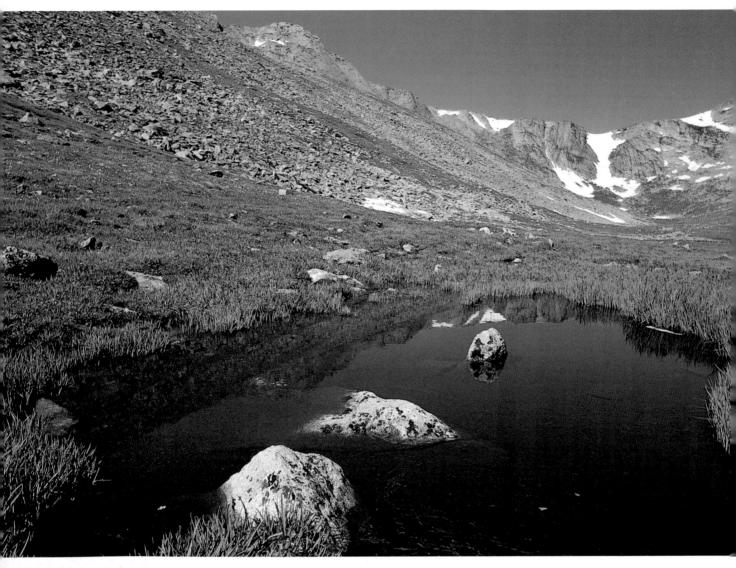

PROBLEM

When water is this brilliant, this clear, and this still, it becomes the center of any painting. You can't play down the power of the blue—it has to be strong.

SOLUTION

To emphasize the dynamic feel of the mountain lake, paint the deepblue areas first. Once you've captured exactly what you want, move on to the rest of the composition.

The deep blue water of a quiet lake stands out against an alpine meadow.

STEP ONE

Quickly sketch the overall scene; then begin to develop the lake. Dip a soft brush into clear water and, working around the rocks, moisten the paper. Next, drop ultramarine blue onto the damp paper. Starting at the top of the lake, gently coax the paint over the paper. As you near the bottom of the lake, darken the blue with mauve and burnt sienna. Now lay in the sky with washes of ultramarine and cerulean blue.

STEP TWO

Build up the rest of the composition. Start with the distant mountains, quickly washing them in with a medium-tone mixture of burnt sienna and mauve. For the grass, use a base of Hooker's green light enlivened with a little yellow ocher and new gamboge. Don't let the grass become too flat; keep your eye on lights and darks.

STEP THREE

In Step One, you laid in the bright blue portions of the lake and the shadowy areas toward the bottom of the paper. Now concentrate on the shadows that lie on the left and on the reflections that play upon the water. Make ultramarine your base color—it will relate these dark areas to the brightest passages. Subdue the bright blue slightly with burnt sienna and sepia.

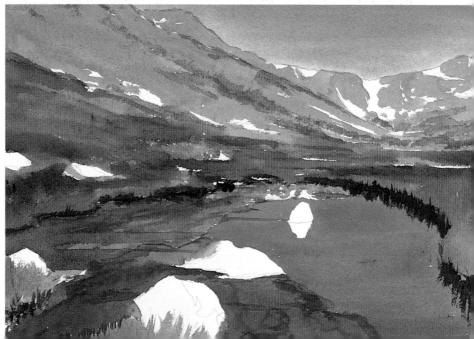

FINISHED PAINTING

Now add detail. Start with the rocks lying in the lake and strewn on the hillside. First render them with a pale wash of yellow ocher; then sculpt out each surface with blue and sepia. Add interest to the hillside on the left by spattering sepia onto the paper. Finally, take a small brush and articulate the grasses around the lake.

In the finished painting, the brilliantly blue lake is just as you intended it: a focal point that pulls the composition together.

Cool, pale mauve dominates the mountains. Mauve is a perfect hue to use when you want to suggest a = vast expanse of space. It mimics the way the atmosphere softens and cools forms in the distance.

The top of the lake is rendered with pure ultramarine. Toward the bottom, the blue gives way to mauve and burnt sienna.

ASSIGNMENT

Water isn't always blue. It can be dark, murky brown; brilliant green; or pale gray. As this lesson has shown, even in paintings where blues dominate, other colors come into play.

Experiment with your blues. First take a sheet of watercolor paper and draw a series of squares on it, each of them about 2 inches by 2 inches. Now lay in a wash of ultramarine over the top half of a square. Quickly add a wash of burnt sienna to the bottom of the square, coax it upward, and see what happens when the two colors combine.

In the next square, use a darker wash of burnt sienna and discover what the resulting hue looks like. Continue this experiment with a number of graying agents—Payne's gray, Davy's gray, raw umber, sepia, and any other color you wish. After you complete each square, label it with the colors and their percentages. Later, when you need a particular blue, you can use this sheet as a guide.

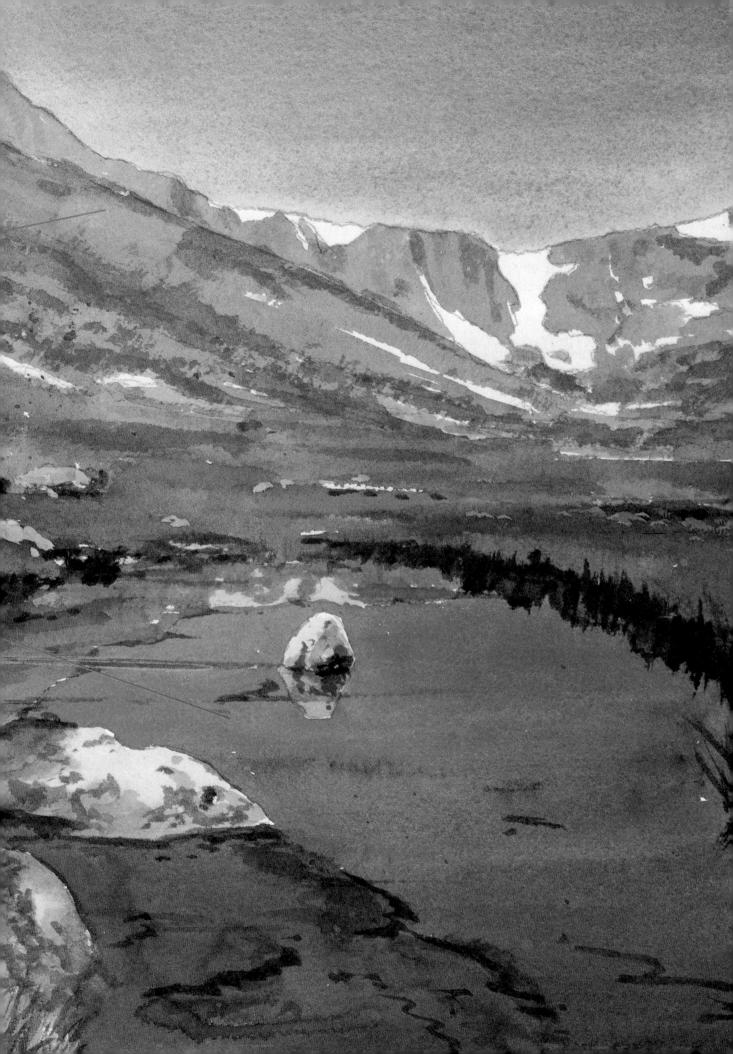

Learning to Handle Closely Related Values

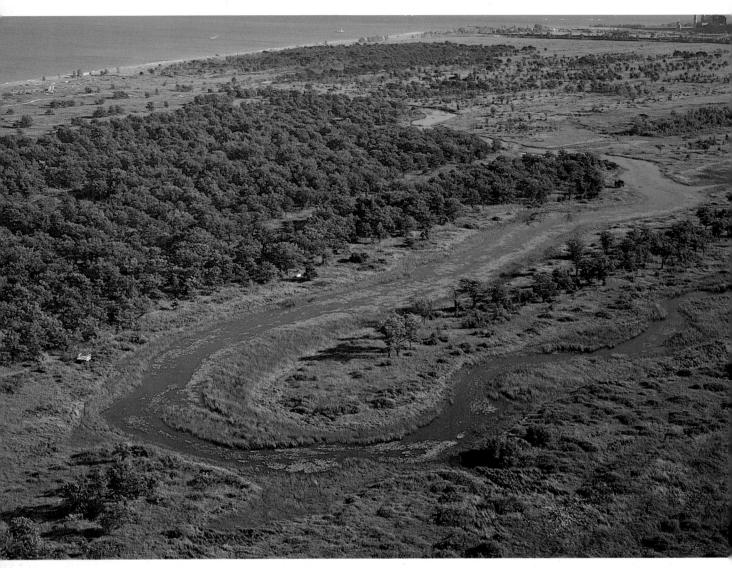

PROBLEM

The blues and greens that dominate this scene are very closely related in value. The values have to be controlled carefully if the river is to stand out against the rich carpet of trees.

SOLUTION

Paint the land first. Once you've established its value scheme, it will be easier to gauge the value of blue that you need to accentuate the river.

Viewed from a hillside, the undulating contours of a river etch out a gentle, rhythmic pattern.

STEP ONE

Keep your drawing simple: sketch in the horizon and the pattern that the river forms. Next, analyze the colors that make up the land. At first, the land may simply seem green. Viewed closely, though, you'll see that it contains warm reds and yellows, too. Here it is rendered with washes of Hooker's green light, yellow ocher, mauve, alizarin crimson, and cadmium orange.

STEP TWO

Add definition to what you've begun. Paint the distant trees with ultramarine and burnt sienna. As you move forward in the picture plane, shift to washes made up of Hooker's green light, cerulean blue, and yellow ocher. In this step you are not only defining the shapes of the trees, you are also adjusting the value scheme of the painting.

STEP THREE

Working with the same three colors, further develop the composition as you add the darkest portions of the trees. As you work, don't concentrate too much on any one area; instead keep an eye on the overall pattern you are creating. When you have finished building up the greens, you're ready to tackle the water.

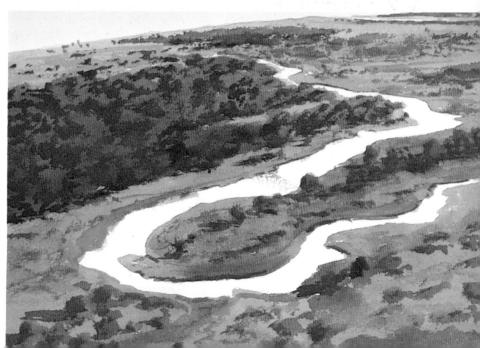

FINISHED PAINTING

Starting at the top of the paper, lay in a graded wash consisting of cerulean blue, yellow ocher, and ultramarine. Continue using the same colors as you turn to the river. In the distance, keep your color fairly light; as you move forward, gradually darken it.

In the finished painting, small passages of white paper shine through the blue of the river. This kind of crisp accent is important in a painting made up of so many dark values.

The strong blue water in the distance is painted with cerulean blue, ultramarine, and yellow ocher. The same hues are used to depict the river

What seems at first just green is actually composed of many colors—yellow ocher, mauve, cerulean blue, ultramarine, alizarin crimson, and cadmium orange, as well as Hooker's green light.

ASSIGNMENT

Discover how to control values before you attempt to paint a scene filled with rich lights and darks. Work with ultramarine and alizarin crimson, or just one of these hues. Prepare three large puddles of wash, one of them very dark, one a medium tone, and one very light. Now study your subject.

Working from light to dark, begin to lay in the lightest areas of the composition. Let the paper dry, then add the medium tones. Finally, add the darks. Don't try to depict subtle value shitts. By pushing each value to the limit you can learn much more about the importance of values in general. What you are executing is a value study, not a finished painting.

When the darks are down, study what you've done. Have you captured the patterns formed by the lights and darks, and does your painting make sense? If it's hard to read, the chances are that you've overemphasized one of the values.

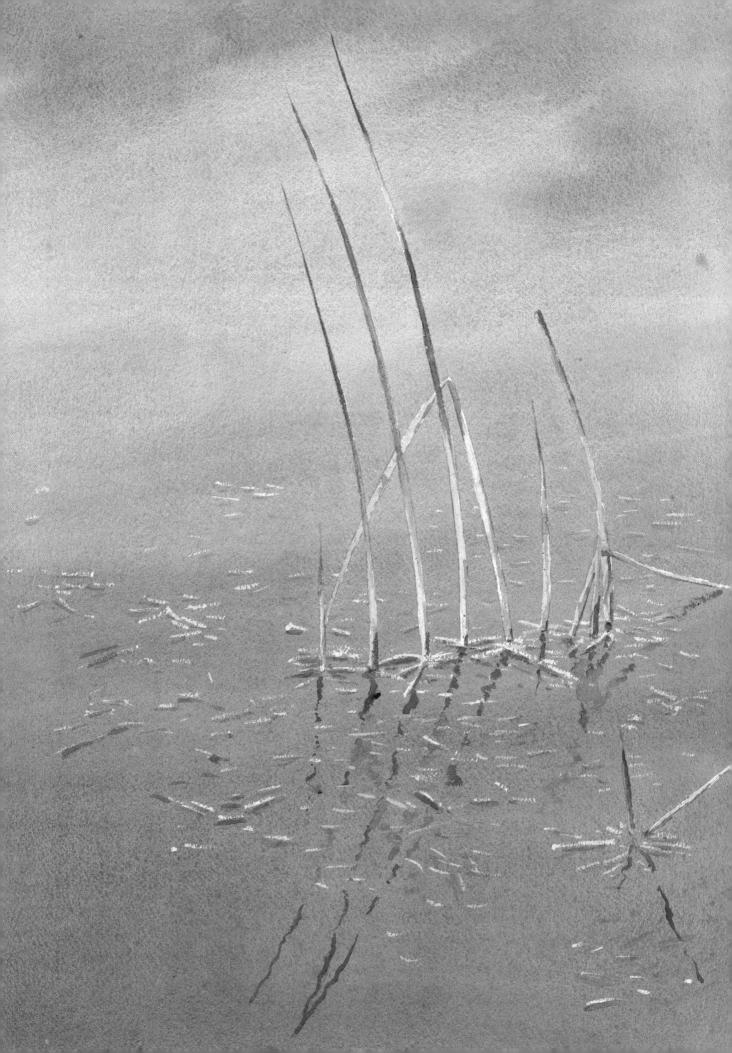

STILL LAKE

Using Brushstrokes to Separate Sky and Water

PROBLEM

It is almost impossible to tell where the water ends and the sky begins. Unless you separate them clearly, your painting will be difficult to understand.

SOLUTION

Let your brushstrokes pull apart the water and the sky. Use circular strokes around the sun. Then, when you reach the water, begin to lay in strong horizontal strokes.

☐ Sketch the reeds, then cover the lightest area—the sun—with masking tape. Next, wet the entire sheet of paper with a sponge. Starting near the sun, lay in a pale wash of new gamboge and yellow ocher with sweeping, circular strokes. As you move outward, slowly introduce mauve and alizarin crimson.

When you reach the water, begin to use broad, horizontal brushstrokes. At this point, continue to use new gamboge, yellow ocher, alizarin crimson, and mauve. When you near the very bottom of the paper, add ultramarine. Now let the paper dry.

For the reeds you'll need a strong, rich, dark hue—sepia is perfect. Paint the reeds with a small, pointed brush; then turn to the reflections in the water. To render them, shake most of the pigment from your brush and use fine, squiggly lines to mimic the slight movement that runs through the water. Finally, peel the masking tape from the sun.

The soft, gentle light of early morning washes over a lake.

CIRCLES

Rendering Soft, Concentric Ripples

PROBLEM

Although the water is basically still and smooth, movement beneath the surface sends out circles of ripples. To paint the scene convincingly, you'll have to get across the feel of still water and motion simultaneously.

SOLUTION

A classic wet-in-wet approach is your best bet in situations like this one. Using it, you can gradually build up the subtle ripples that break through the still surface of the water.

As the sun rises, a lone egret wades warily into the water.

☐ Execute a simple preliminary drawing; then stop and evaluate the scene. When you are trying to depict subtle motion in water, you often have to exaggerate what you see. That's the case here. If your approach is too literal, the chances are that you won't get across the way the water eddies outward. Right from the start, plan on accentuating the ripples.

Begin by laying in a graded wash. Start at the top with chrome yellow; in the middle shift to yellow ocher; when you near the bottom turn to new gamboge. Move quickly now. While the surface is still wet, begin to work Davy's gray onto the paper to indicate the concentric ripples. Since the paper is still wet, you can create a soft, unstudied effect. When you approach the bottom of the paper, add a little cerulean blue to the gray to make the foreground spring forward.

Let the paper dry thoroughly. While you are waiting, choose the colors you'll use to paint the bird. You want a dark hue, but one that's lively. The easiest way to achieve a lively, dark color is to mix two dark tones together; here the egret is painted with sepia and burnt sienna. The same colors are used to paint the bird's reflected image.

When you have completed the bird, you may find that it seems too harsh against the soft, yellow backdrop. If so, try this: Take a fine brush, dip it into a bright hue (here cadmium orange), and lay in a very fine line of color around the egret. This thin band of bright orange pulls the egret away from the water and suggests the way the light falls on the scene.

SUMMER FOG

Conveying How Fog Affects Water

PROBLEM

Two distinctly different forces are at play here. The sun rises brightly over the horizon, but the fog dulls its brilliance and makes the entire scene soft, dull, and diffused.

SOLUTION

Concentrate on either the fog or the sunrise. Here it's the sunrise that is emphasized. To capture its warmth, accentuate the yellows that run through the entire scene. The end effect will be quite different from the actual scene in front of you, but your painting will be focused and dynamic.

In late summer, fog settles down over a lake just as the sun begins its ascent into the sky.

STEP ONE

After you have completed your preliminary drawing, tear off a piece of masking tape and cover the sun and the sun's reflection in the water. Now paint the background rapidly, in one step. Run a wet sponge over the paper and immediately begin to drop in color. Working from the sun outward, apply new gamboge, alizarin crimson, mauve, and then cerulean blue. At the bottom of the paper, drop in ultramarine and work it gently across the surface. Now let the paper dry.

STEP TWO

Once you've established the sky and lake areas, begin to add details. Start by adding the soft trees that lie along the horizon. Here they are rendered with a pale wash of ultramarine and burnt sienna. To separate the trees from their reflections in the water, use a paper towel to blot up the wet paint in that area.

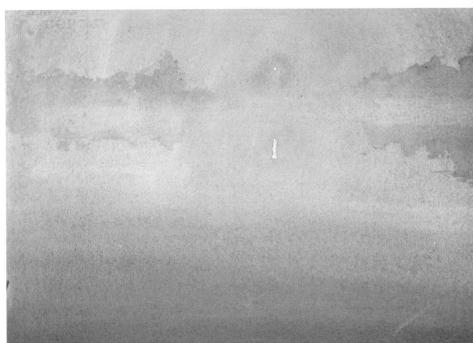

STEP THREE

Working with the same colors, move forward. First lay in the dark trees that lie on the left side of the scene; then begin work on the grasses. Use a drybrush approach, and start with the grasses in the middle ground. Here they are painted with a dark mixture of sepia and ultramarine.

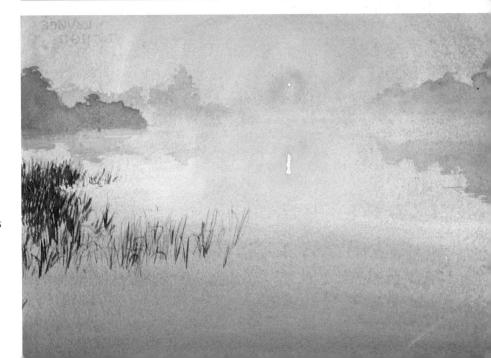

FINISHED PAINTING

Complete your painting by adding the grasses in the foreground.

The colors of the rising sun are laid in with new gamboge, alizarin crimson, mauve, and cerulean blue. The sun and the lightest part of its reflection are masked out before the painting is begun.

The trees along the horizon are rendered with several layers of pale ultramarine and burnt sienna.

ASSIGNMENT

In step one, you worked wet-inwet, quickly establishing the entire background. This technique is basic—one that every watercolor artist should feel comfortable with. Take the time to experiment with it.

First, run a wet sponge over a sheet of watercolor paper. Don't drench the paper; just make it evenly moist. Now drop in the colors that were used in Step One: new gamboge, alizarin crimson, mauve, cerulean blue, and ultramarine. Start at the top of the paper and gradually work down. As you paint, don't let the blue bleed into the yellow.

Do this part of the assignment several times, until you feel confident of your ability to execute a smooth, graded wash. Then proceed to further experiments.

Try manipulating the color while it is still wet. First, take a paper towel and wipe out sections of the wash with long horizontal motions. Next, wad up a piece of toweling and blot up bits of color.

Finally, let the paper dry; then moisten a portion of it with clear water, and blot up some of the paint with a piece of toweling. Next, moisten another area of the dried paper and drop color onto it.

As you experiment, try working on very wet paper, damp paper, and paper that is almost dry. You'll be amazed at the variety of effects you can achieve—effects that you can put to good use in your watercolors.

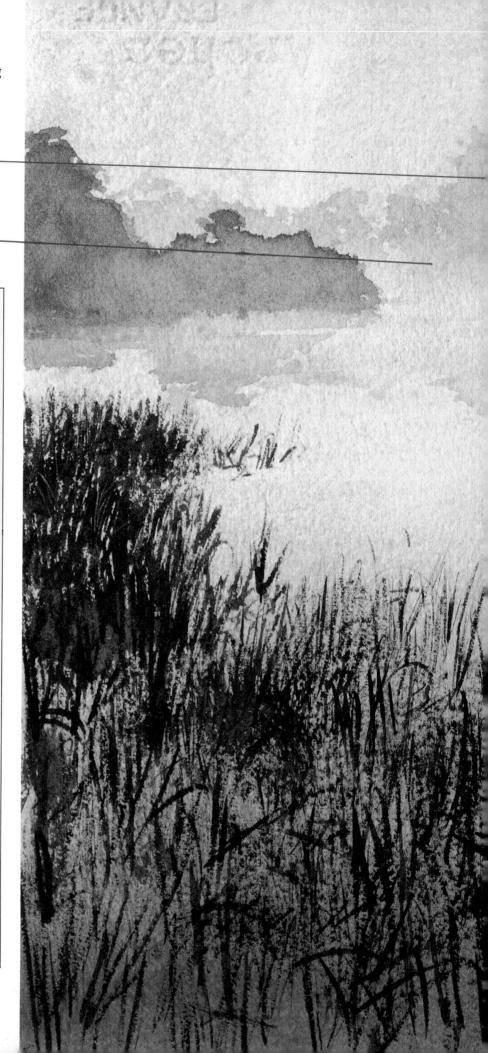

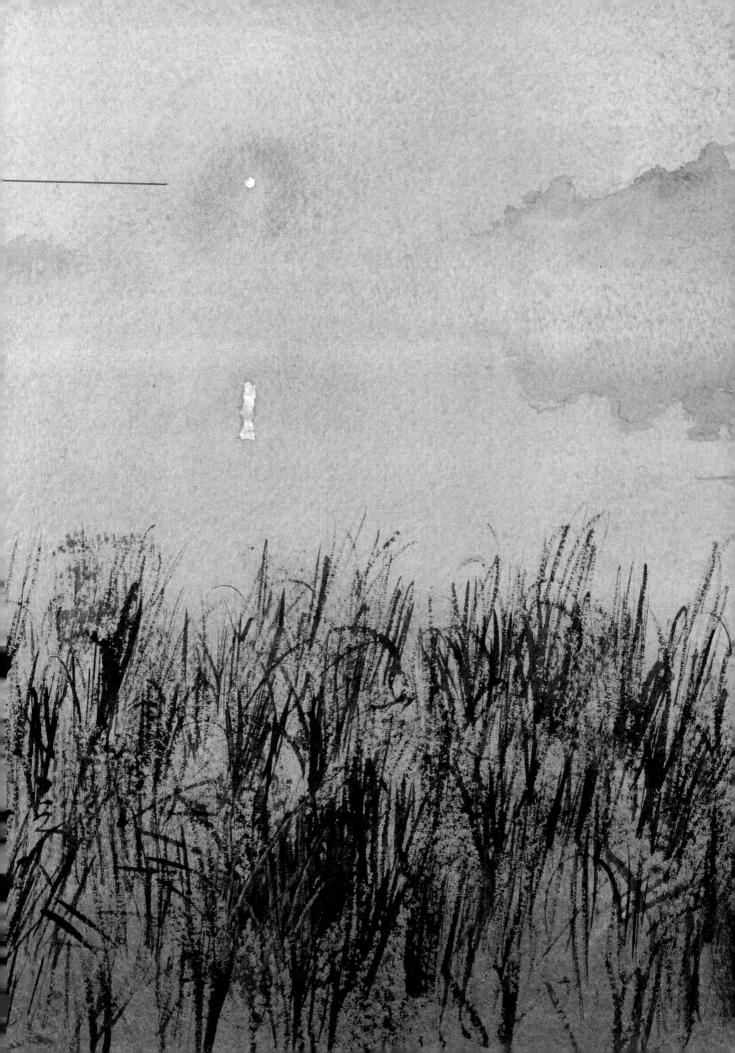

LATE AFTERNOON LAKE

Controlling the Brilliance of Sunset over Water

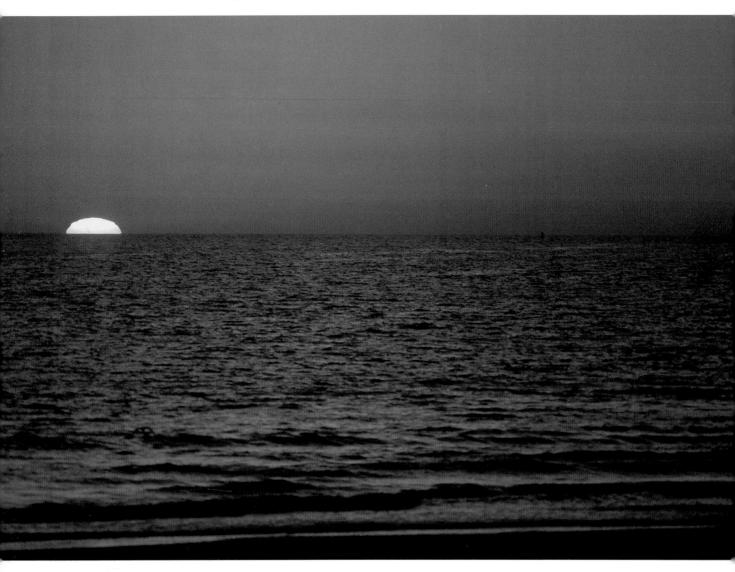

PROBLEM

It would be easy to make the water too light and too bright. To capture the feeling of sunset, you have to suggest how darkness is stealing over the scene.

SOLUTION

Cover the entire paper with a warm, rich underpainting; then add the dark waves.

☐ Sketch the horizon line and the sun; then mask the sun out with liquid frisket or a piece of masking tape. Next, lay in a graded wash. Use a large brush, and don't bother wetting the paper first—the wash doesn't have to be perfectly smooth. Start at the top of the paper, using mauve, alizarin crimson, cadmium red, and cadmium orange.

When you approach the water, eliminate mauve from your pal-

As the sun sets over a lake, its brilliance floods the sky and tinges the water below a deep, dramatic orange.

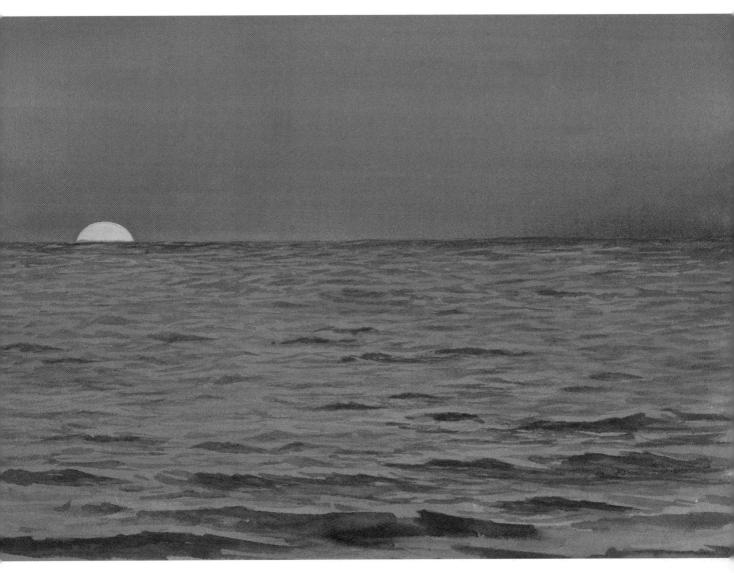

ette; you want the water to be slightly lighter than the sky, since you'll soon be adding the dark waves. To render the waves, use a middle-value mixture of ultramarine and burnt sienna. Along the horizon and in the immediate foreground, add a touch of alizarin crimson and Payne's gray. Render the waves with short, choppy, horizontal strokes to indicate a feeling of movement.

Even in simple scenes like this

one, perspective matters. The waves in the distance should be much smaller than those in the middle ground. Those in the foreground should be fairly large. As you work, keep your eye on the overall pattern you are forming and don't let your brushstrokes become too regular. As a final touch, remove the mask from the sun, and paint in the sun with new gamboge.

REFLECTED CITY LIGHTS

Experimenting with Neon Reflections

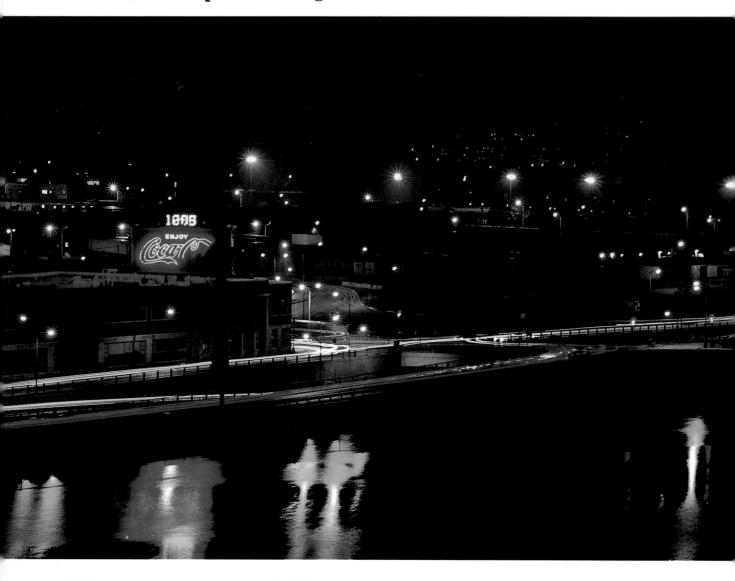

PROBLEM

A scene as dark as this one is extremely difficult to paint in watercolor. Yet its power and drama are tremendously appealing—appealing enough to overcome whatever problems lie ahead.

SOLUTION

Mask out the brightest, lightest passages; then make the rest of the composition really dark. Before you begin to lay in the darks, develop any areas that have even a hint of color.

The raucous, busy nightlife of a city is mirrored in the river that runs through it.

STEP ONE

Carefully sketch the scene; then paint in all the bright lights with liquid frisket. Masking these areas out is important. You must first develop all the subtle touches of color that run through the composition, and then establish all the darks, before you can peel the frisket off and paint the very brightest passages.

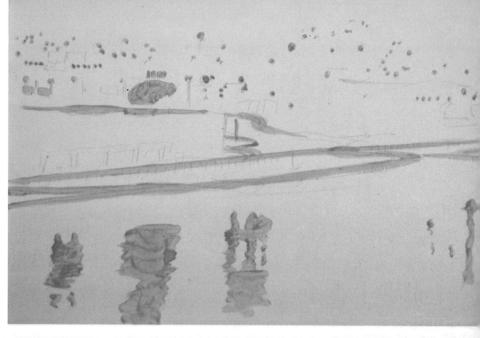

STEP TWO

Now turn to those portions of the scene that have some color, but not the brilliance of the areas you masked out. Before you start to paint, study the composition. Search for every spot that *isn't* dark—any spot that even a subdued color runs through. Now lay those colors in.

STEP THREE

Using Payne's gray, ultramarine, and alizarin crimson, lay in the dark background, making it as dark as possible. In the center of the scene, where you've carefully developed your underpainting, make your darks a little lighter: You want the color you've already established to show through.

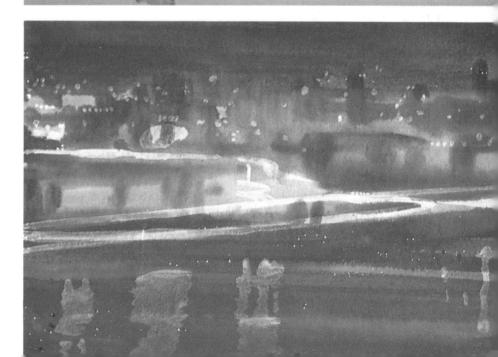

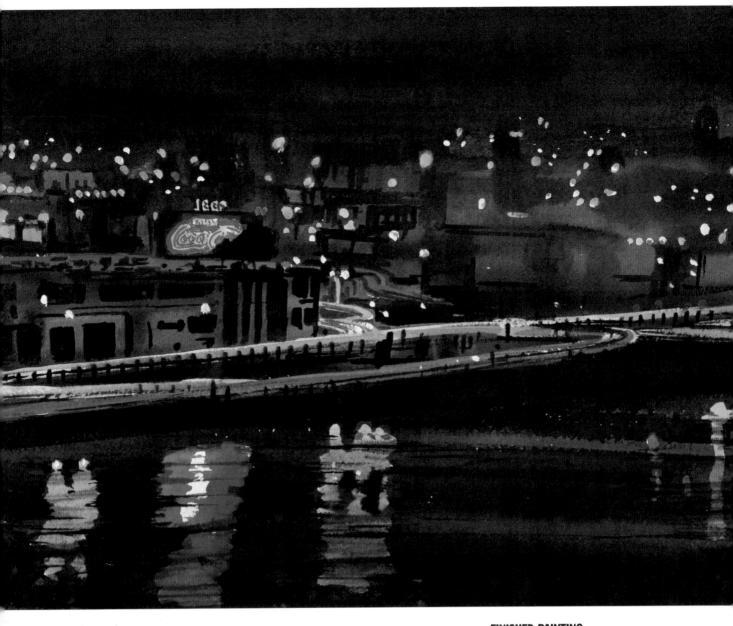

FINISHED PAINTING

In scenes like this one, the most important touches come at the very end. It's now that you'll drop in all the bright, vibrant colors that will give your painting life.

First, peel off the frisket. Next, prepare your palette with strong, vivid yellows, oranges, and reds, plus bright blues and greens. Dilute the pigments slightly; then go to work.

Use strong, fluid brushstrokes as you lay in these brights; you want to capture the immediacy of the scene, and if your strokes are too tentative, the gutsy feeling that drew you to this spot in the first place will all be lost.

DETAIL

The brilliant neon lights and their reflections were masked out in Step One and were executed only after the rest of the painting had been developed. They aren't the only touches of color, though. Note the dull greens that shine through the darks of the buildings and the subdued orange glow beneath the bright red reflection in the water.

There's a lot more to watercolor painting than brushes and paint. All around your home you can find miscellaneous tools that will enhance your work.

Start with simple table salt. Lay in a wash of color on a piece of paper, then sprinkle a little salt randomly over the surface. Watch what happens: As the paint dries, the salt will pull the water and pigment toward it, creating an interesting, mottled effect.

Now experiment with paper towels. Lay in a wash, and then use toweling to blot up some of the pigment. When the background paper is still very wet, you'll find that you can pick up most of the color; as the paper dries, more and more of the pigment adheres to it, so that less color can be removed.

Finally, experiment with an eraser. Lay in a wash and let the surface dry completely. When it's dry, carefully pull the eraser over the paper. You'll discover that—pulled hard enough—the eraser can pick up a good amount of color.

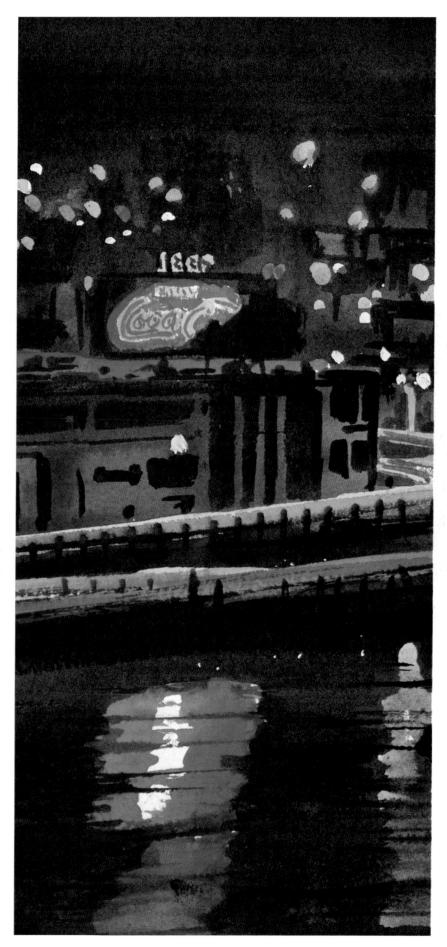

QUIET STREAM

Animating a Dark, Still Stream

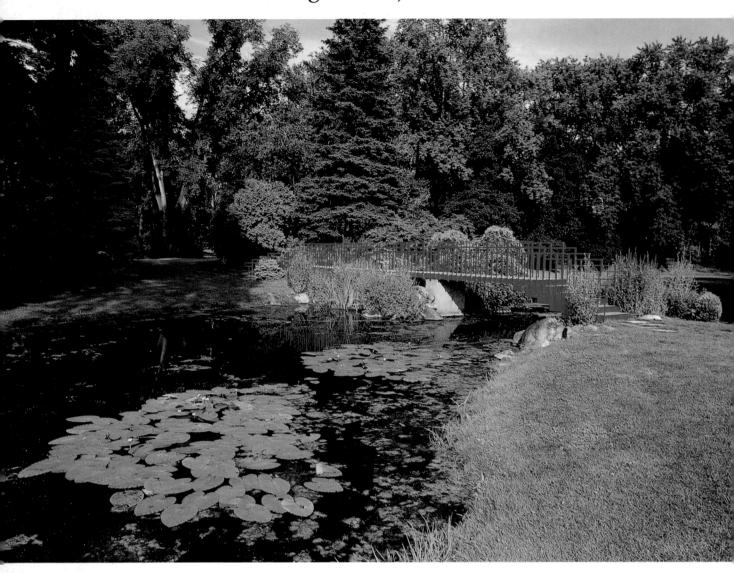

PROBLEM

This scene is filled with brilliant color—the red of the bridge and the green of the lilies and foliage. In fact, everything except the water is bright, interesting, and full of life.

SOLUTION

Exaggerate the reflections that spill into the water; this will make the stream come alive. Work in a traditional light-to-dark manner to control the value scheme.

A brilliant red bridge spans a quiet lily-covered stream.

STEP ONE

Execute a preliminary drawing; then lay in the sky with a pale wash of cerulean blue. As soon as it's down, turn to the trees in the background. Simplify them: Render them loosely, working with three values—one light, one medium tone, and one dark. Here they are made up of Hooker's green light, Payne's gray, cerulean blue, ultramarine, and new gamboge.

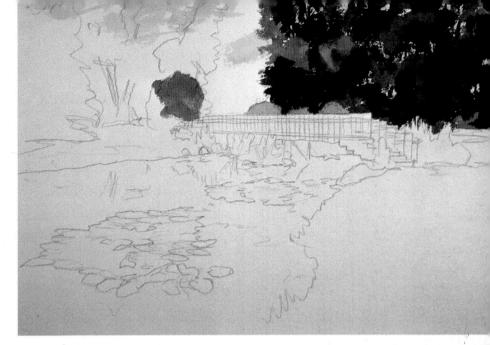

STEP TWO

Finish the background. Continue working with the same colors and continue simplifying what you see. The point is to have close control of the value scheme and to have the background hang together as a unit. Before you move in on the water, lay in the swatch of green in the lower-right corner.

STEP THREE

Stop and analyze the water. It's made up of three distinct values: the light lilies, the dark water, and the middle-tone reflections and vegetation. Start with the middle tone. Render the reflections and vegetation with a mixture of yellow ocher, burnt sienna, and sepia. Next, lay in the water. You want a dark, steely hue: Try using sepia, ultramarine, and Payne's gray.

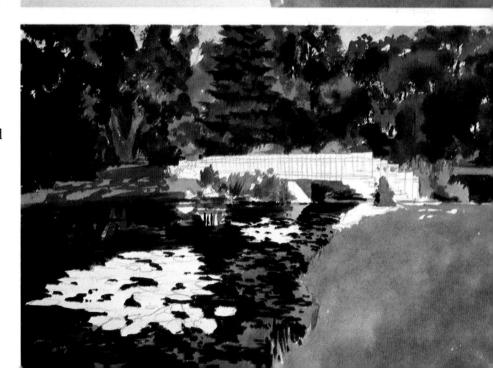

FINISHED PAINTING

Two important elements still have to be added: the bright green water lilies and the brilliant red bridge. They are what make this scene so special. Use a bright, vivid green for the lily pads; here a mixture of Hooker's green light and new gamboge is used. As you paint, vary the strength of the green and the yellow to create a lively, variegated effect.

Finally, turn to the bridge. If you make it as bright and strong as it really is, it will destroy your painting's unity. Instead, use a medium-tone wash of cadmium red; even diluted, the red will be strong enough to spring out against the rest of the elements.

The masses of trees that line the background are simplified and are developed by using three distinct values. This simplified approact puts emphasis on what's really important, the bridge and the water.

The dark water comes alive as reflections and floating vegetation break up its surface.

ASSIGNMENT

To paint effective landscapes, you needn't travel far. Search your neighborhood for an interesting site; a lake shore, pond, or stream is perfect. Study the site over a period of months.

Paint the site at dawn, midday, and dusk, and as the seasons change. If you begin work in the spring, your paintings will trace the progress of trees bursting into leaf and the effect the vegetation has on the water.

Try working from different angles, too, and at different distances. The familiarity you gain as you explore your site can enrichen your paintings.

Early on, you'll solve basic compositional problems, and you will have the freedom to concentrate on issues that are more important—the movement of the water, the feel that steals over the scene at certain times of day, and the way the site is transformed as seasons change.

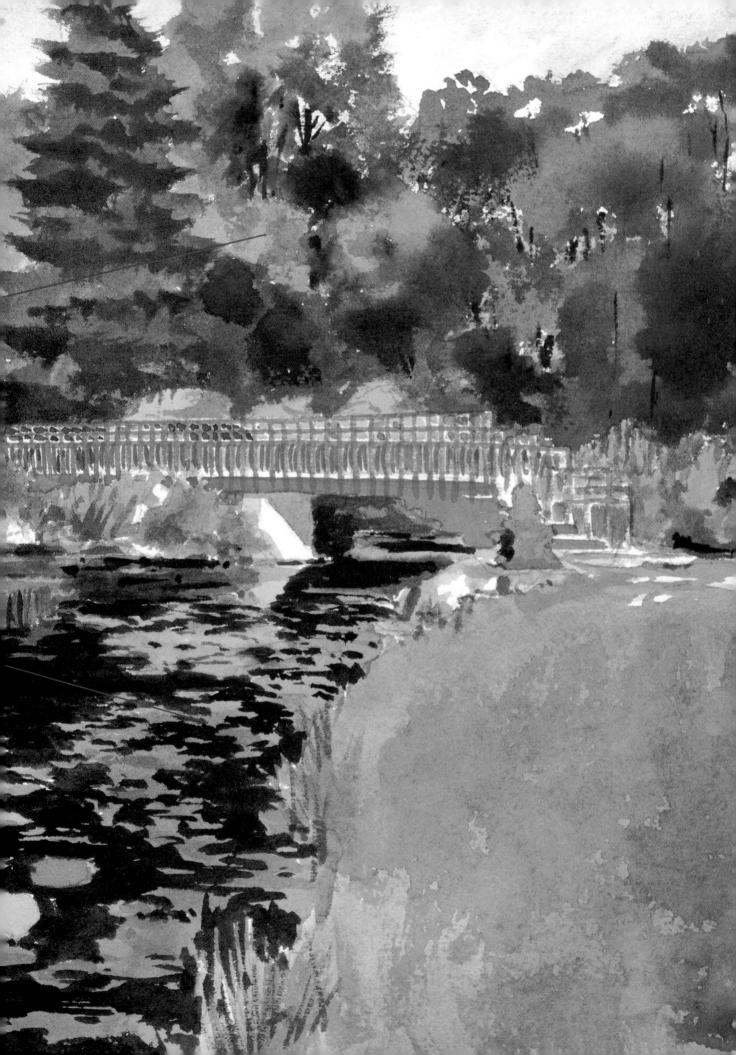

LEAVES ON A POND

Picking out the Patterns Formed by Floating Vegetation

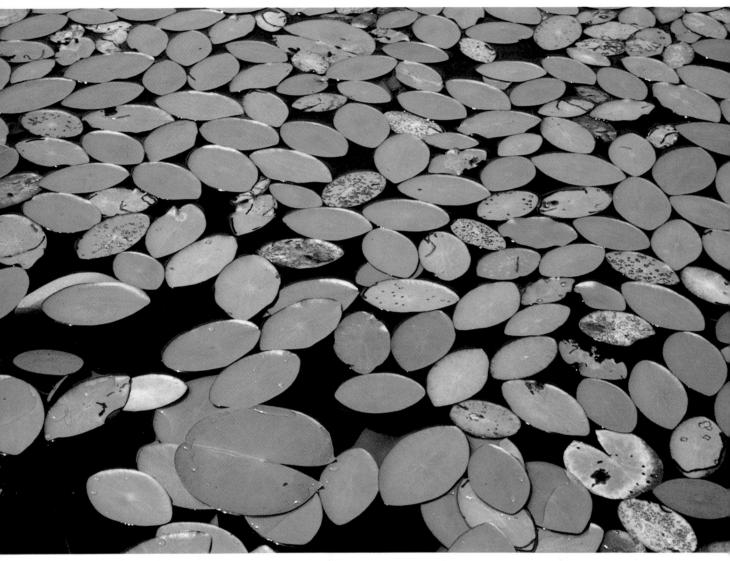

PROBLEM

Here the water is so dark that it really becomes unimportant; it simply serves as a backdrop for the rich pattern of leaves. Pulling the leaves into focus and making them work presents the challenge.

SOLUTION

Execute a careful, detailed sketch; then lay in all of the dark areas first. Once they are down, concentrate on making the leaves varied and interesting.

☐ After you have sketched the scene, begin to lay in the darks. Here they are rendered with Payne's gray and ultramarine blue. Let the surface dry thoroughly; then turn to the leaves.

Figure out your plan of attack before you begin. Aim for an overall sense of design—a lively interplay between warm and cool tones and lights and darks. Start with all the leaves that aren't green—those that are orange, yellow, or even mauve. Once they are down, turn to the greens.

Rich green leaves lie massed together on the dark, still water of a pond.

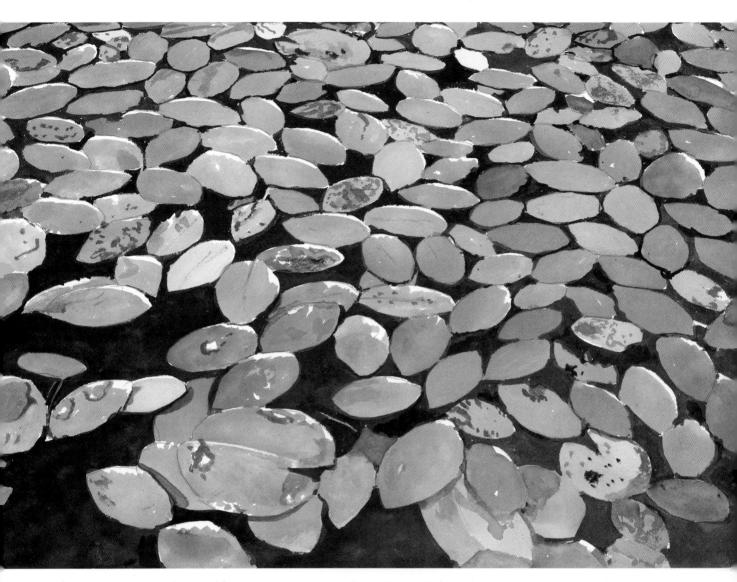

In a scene as complex as this one, try to work in an orderly fashion; if you don't, the chances are that you'll get lost in detail. Begin in the upper-left corner and slowly work across the surface of the paper and then down. As you work, concentrate on variety: Make some leaves warm and some cool; make some bright and some grayed down. From time to time, let the white of the paper stand for the highlights that flicker on the edges of the leaves.

Here Hooker's green light and

new gamboge form the basis for most of the leaves. The hues and values are varied, though, with touches of cerulean blue, ultramarine, mauve, and even chrome yellow.

When you've completed all of the leaves, look at your painting critically. You'll probably want to add texture to some of the leaves. Note here how the golden leaves are tempered with touches of brown, and how some of the green leaves are broken up with touches of darker, denser color.

RAINDROPS

Mastering a Complex Close-up

PROBLEM

This is an incredibly complex subject, one that will be difficult to paint. Three layers are involved: the vegetation, the web, and then the water.

SOLUTION

Develop the underlying layers first; then use opaque gouache to render the raindrops.

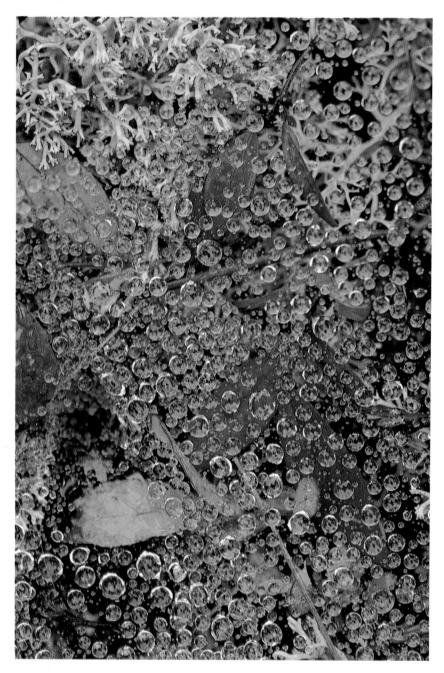

☐ In your drawing, concentrate on the brightly colored areas in the background, and keep the shapes simple. When the drawing is done, lay in the entire background. Begin with the brightest elements, the seaweeds and leaves. Here the greens and browns are made up of new gamboge, ultramarine, Payne's gray, and a touch of burnt umber. The red leaves are painted with cadmium red, alizarin crimson, and mauve.

Allow the bright areas to dry; then concentrate on the dusky areas that surround them. Use dark colors—Payne's gray, ultramarine, mauve, sepia, and burn sienna—and paint loosely. Don't get caught up in too much detail.

Now it's time to paint the most difficult element, the raindrops. Dilute a good amount of white gouache with water; you are aiming for a translucent look. If the gouache is too thick, it will cover the background, which you want to shine through the white paint.

As you begin work, follow your subject carefully. You can't paint every drop, but you should try to capture the pattern the drops form on the web. First lay in vague, circular shapes. When they are all down, go back and reinforce their edges with touches of thicker gouache.

At the very end, dab small touches of pure white gouache onto the paper; here you can see them at the bottom of the painting. These small splashes of brilliant white clearly pull the raindrops away from the dark background and accentuate the spatial relationships that you have set up.

Raindrops hover on a delicately woven spider's web suspended above seaweeds and fallen leaves.

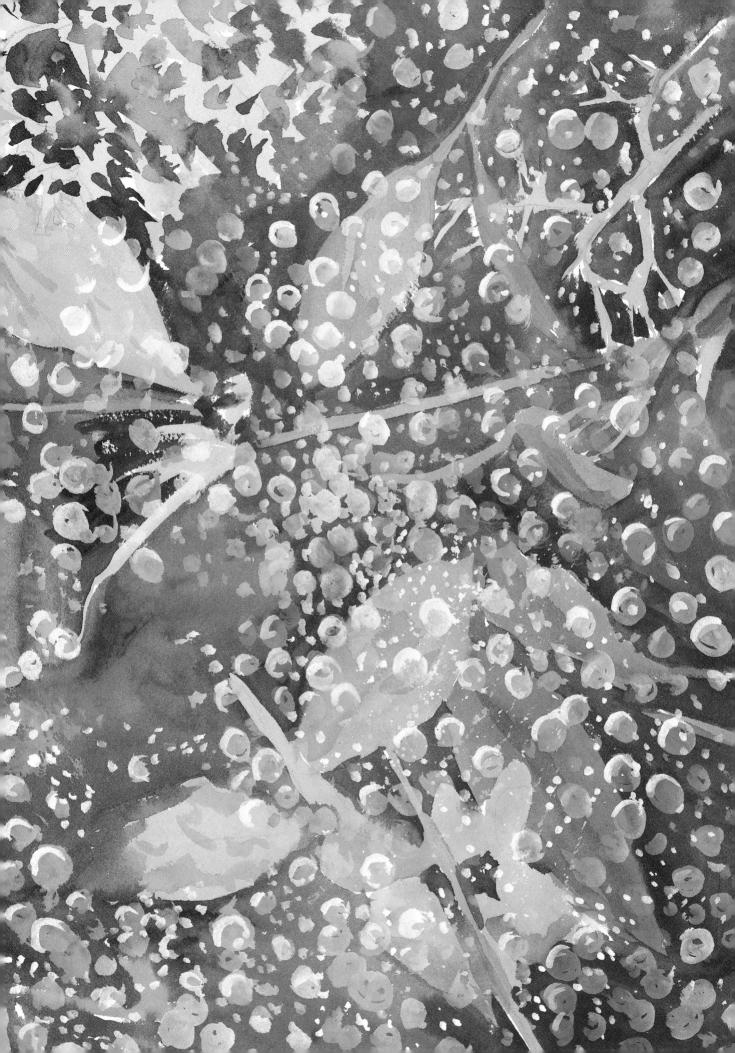

PATTERNED ICE

Balancing Strong and Subtle Elements

PROBLEM

Two quite different elements are at play in this composition—the crisp, colorful grasses and the subtly patterned ice. Both have to be painted convincingly.

SOLUTION

Start out with the most difficult area, the ice. To capture its complex surface, wipe out bits of the wet paint with a rag.

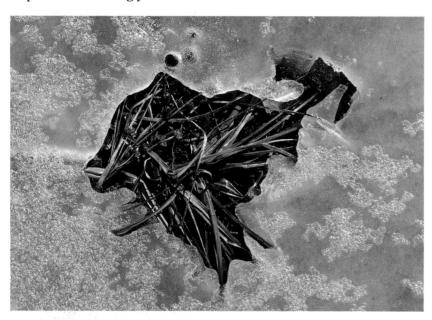

☐ Sketch the scene; then lay in the ice with a middle tone made up of Payne's gray, cerulean blue, and yellow ocher. Concentrate on the portions of the ice that are decorated with crystals, and while the paint is still wet, take a rag and blot up some of the gray tone, to lighten the crystallized areas. Then reinforce the dark areas by adding a touch of alizarin crimson to your mixture of gray, ocher, and blue, and scumbling the paint over the paper.

Let the paper dry thoroughly; then turn to the grasses in the center of the composition. First, render the green blades with new gamboge and Hooker's green light. For the brown blades, use rich earth tones—yellow ocher and burnt sienna.

In the finished painting, the ice and the grasses sit comfortably together. Their spatial relationship is obvious and the sharp, crisp feel of the vegetation balances the soft, diffused look of the ice.

In March, as the days become balmier, grasses that have lain hidden for months break through a thick crust of ice.

MOTTLED ICE

Analyzing the Color, Value, and Texture of Ice

PROBLEM

It is the ice, not what lies on top of it, that presents a challenge to the painter. The rich, complex surface is marked by subtle shifts in color and value.

SOLUTION

Pretend it is the ice alone that you are out to capture. When you are completely satisfied with it, move on to the leaves and twigs.

☐ Execute a simple preliminary drawing; then cover the entire paper with a light-gray tone made up of Payne's gray, yellow ocher, and cerulean blue. While the surface is still wet, spatter darker grays all over the paper; then blot up bits of the dark paint with a paper towel.

Repeatedly spatter and blot, trying a variety of approaches. To produce a fine spray of paint, use a toothbrush. Dip it in your color; then run your thumb along the bristles. Next, use a medium-size brush and splash larger drops of color onto the paper. Let the paper dry.

Before rendering the leaves and twigs, prepare your palette with yellow ocher, burnt sienna, sepia, cadmium orange, Hooker's green light, and lemon yellow. Now take a medium-size brush and lay in the greens and browns.

At the very end, go back to your gray-based mixture and accentuate some of the dark, shadowy portions of the ice. Here, for example, the cracks and depressions that break up the surface of the ice were added last.

An interesting assortment of dead twigs and green leaves rests on a richly, mottled sheet of ice.

LACY CRYSTALS

Simplifying Difficult Patterns

PROBLEM

It is the complexity of this subject that will make it difficult to render. Each crystal is made up of many fine details, and together the details seem to be almost overwhelming.

SOLUTION

Simplify the subject as much as possible. Paint all the darks first; then go back and add the medium tones. To capture the lights, scratch them out with a razor.

☐ Sketch the major lines of the composition; then mix a wash of deep blue, using ultramarine and Payne's gray.

With a medium-size brush, begin stroking the dark paint onto the paper. Move all over the composition, keeping your eye on the largest, boldest patches of dark blue.

Now turn to the middle values. Mix a big puddle of medium-tone wash, using ultramarine and cerulean blue. With a large brush, lay the wash over the entire

Magnification reveals the intricacy and elegance of frost crystals captured on a sheet of glass.

paper. You'll find that it softens the darks you've already established and also unifies the composition.

Before you move on to the lights, the paper has to dry completely. If it's even slightly damp, the razor will shred the paper, and your painting will be lost. When you begin to pick out the lights with the razor, you'll discover that it skips over the rough watercolor paper, creating the interesting, jagged effect you see here.

FOREST SNOW

Sorting Out a Maze of Snow-Covered Branches

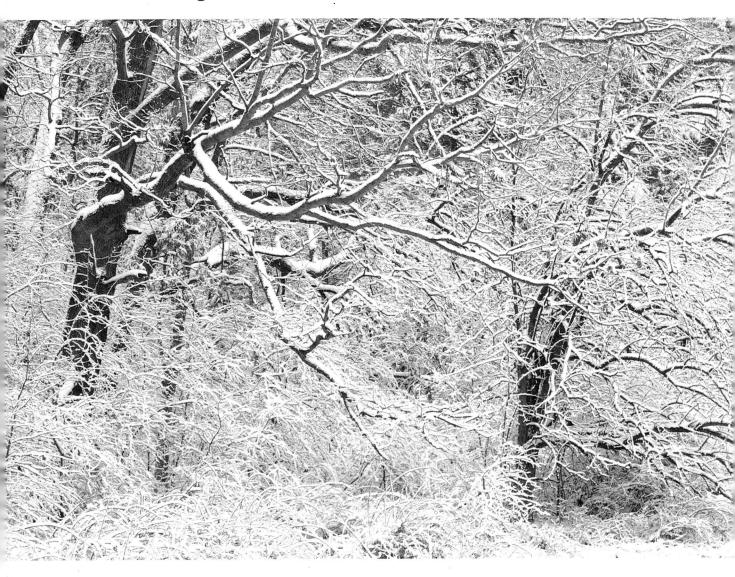

PROBLEM

When virtually everything in a scene is light, it becomes difficult to see the very whitest passages. Yet they are what give a composition like this one punch.

SOLUTION

Lay in the darkest values first—here the major tree trunks—then slowly build your painting up by working from light to dark. From the start, let the white of the paper represent the most important lights.

Deep in a forest, snow and ice cling to the trees, creating a subtle pattern of whites.

STEP ONE

In your preliminary drawing, concentrate on the two large trees that dominate the composition. Get down on paper the way their branches twist and bend, and lightly indicate the lines of the dark tree trunk in the background. Now loosely paint in the dark trees with burnt sienna and sepia. Be careful—right from the start, work around the whites.

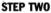

Continue working around the lights as you lay in the background. Here it's made up of cerulean blue and Davy's gray. Use a fairly light hue; there will be plenty of time to add darker accents. Let the paper dry; then add swatches of a slightly darker gray to suggest shadowy areas. Finally, loosely stroke on a touch of burnt sienna and yellow ocher to indicate the leaves that cling to the tree in the foreground.

STEP THREE

Mix several pools made up of cerulean blue and Davy's gray, making each pool that you prepare slightly darker than the previous one. Your washes prepared, go to work on the background. Search the scene for shadows and slight shifts in value as you develop the flickering pattern of darks and lights formed by the snow and ice. With your darkest wash, begin to suggest the trunks and branches in the distance.

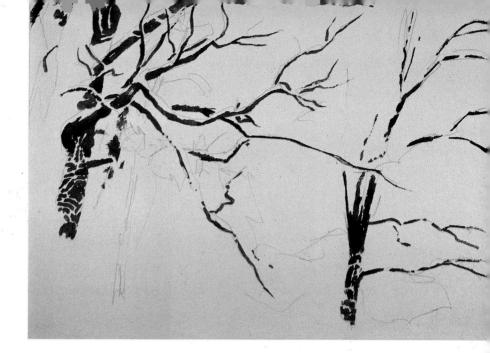

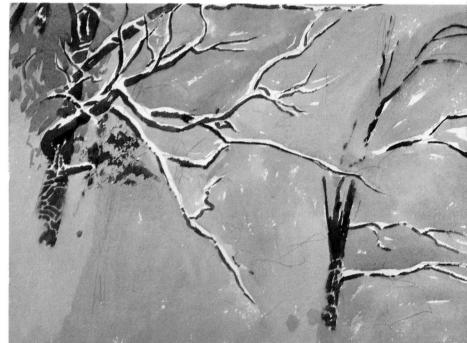

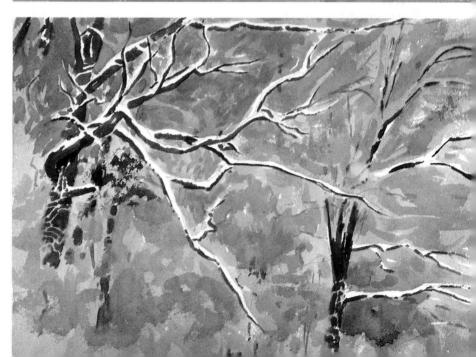

FINISHED PAINTING

At this point, what the painting needs is focus. Working with a small, rounded brush, gently stroke paint onto the paper, searching for minor branches that will give additional structure to the scene. Even now, be careful not to intrude on the bright whites that you established when you first began; they're the real key to making a painting like this one work.

In the finished painting, the cold, icy feel of the scene is definitely captured, yet without an overload of detail. In fact, the work looks much more detailed than it actually is because of the subtle shifts between lights and darks.

Painted first, with burnt sienna and sepia, the main trees and branches make up the darkest value in the painting. They were rendered carefully, by working around the whites.

Overlapping layers of cerulean blue and Davy's gray make up the tangle of lights and darks that fill the background. Although very few details are included, in the finished painting these layers of color suggest a maze of trees.

The white of the watercolor paper is preserved throughout the entire ____ painting process. In the final painting, the whites stand out boldly against the blues, browns, and grays.

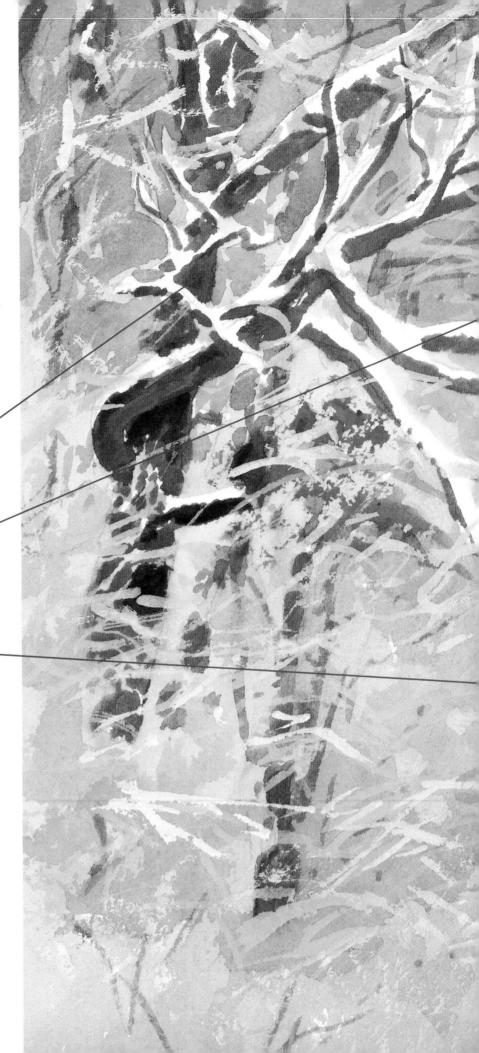

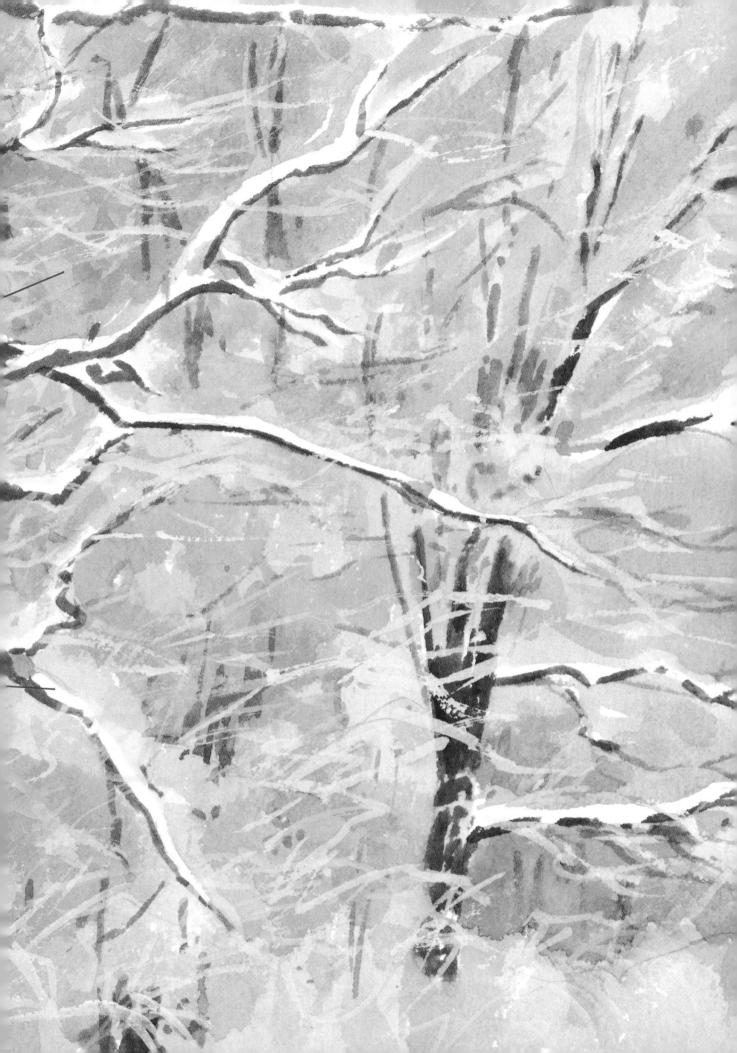

FROST-TIPPED GRASSES

Using Opaque Gouache to Render Frost

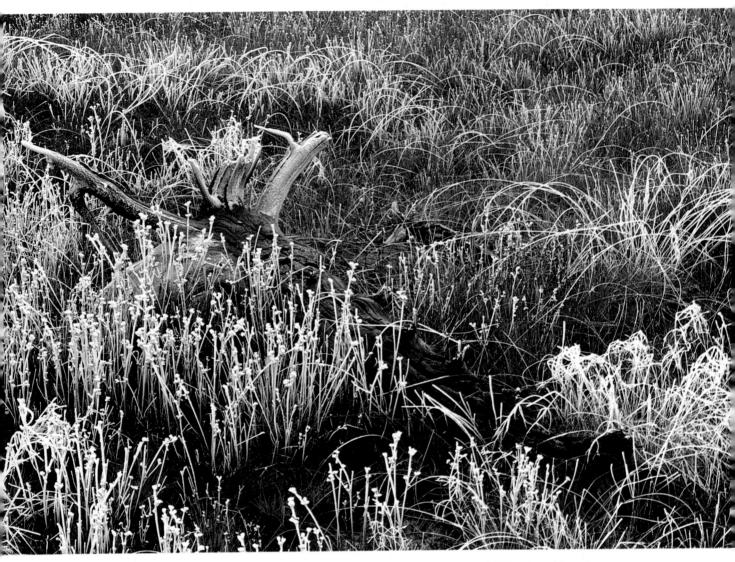

PROBLEM

Capturing a white pattern when it's set against a middle-tone background is difficult, especially when the pattern is this rich.

SOLUTION

Don't try to paint around the whites or even to mask them out. Instead, develop the rest of the composition first; then add the frost-tipped grasses with opaque gouache.

☐ In sketching the scene, concentrate on the fallen tree trunk. Then begin work on the brownish background color. Prepare your palette with two basic earth tones—yellow ocher and burnt sienna—and with mauve. You'll find mauve invaluable for rendering the shadowy areas in the composition.

Now, working around the fallen tree trunk, lay in the field of grass. Use several values of brown made from the yellow ocher and burnt sienna, and use a good-size brush. Don't let your work become too flat. As you apply the paint to the paper, look

Coated with frost, an ordinary field of grass is transformed into an intricate, beautiful interplay of white and brown.

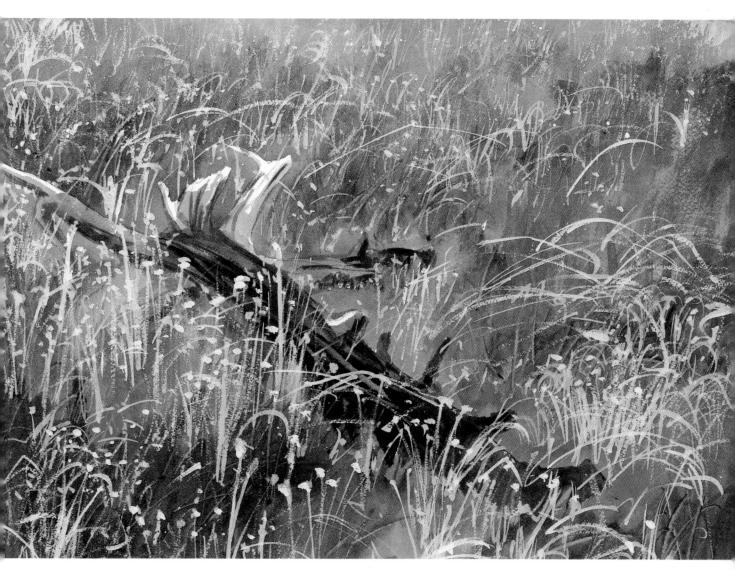

for little variations in value to break up the field. Next add mauve to the ocher and sienna and concentrate on the shadow areas of the grass.

The tree trunk is the next step. Here it is rendered with yellow ocher, Payne's gray, and ultramarine. Let the white of the paper stand for the highlights that fall on the wood.

Before you add the frost, let the paper dry completely. Purewhite gouache will be too bright; temper it with a touch of yellow ocher. The yellow ocher will not only tone down the white, it will also relate the frosty passages to the ocher-based background.

Working with a small, rounded brush, quickly add the frost. As you paint, search for the overall pattern that the frost forms. Use soft, thin strokes in the background and stronger, more definite ones in the foreground. This technique will help you establish movement into space. The stronger strokes will pull the foreground out toward the viewer; the softer ones in the background will make the distant grasses seem farther back in the picture plane.

Finally, add small dabs of white to suggest how the frost clings to the top of the grass.

LIGHT FOG

Establishing Mood Through Underpainting

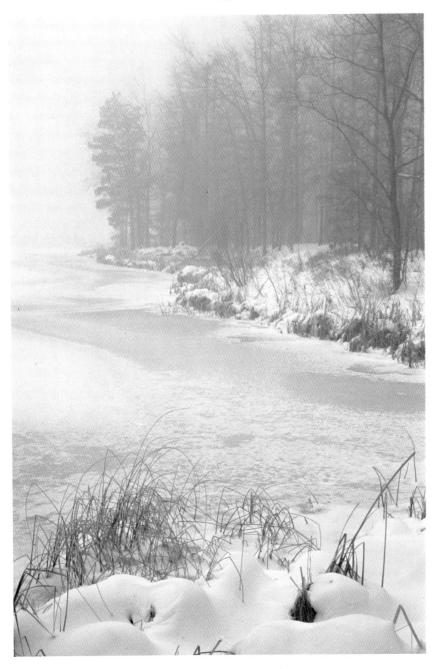

PROBLEM

Fog transforms color and softens shapes. On a clear day, this scene would be filled with crisp whites and definite edges. Under fog, it is grayed down and all the forms are soft and diffused.

SOLUTION

To capture the soft, grayness that dominates this scene, lay in a preliminary grayish wash over the entire paper. When you begin to build up your painting, keep all the values very light, except for those in the foreground.

STEP ONE

Begin with a light drawing indicating the shape of the shoreline and the basic lines of the trees in the background. Next, mix a light-tone wash of Payne's gray and yellow ocher, plus a touch of alizarin crimson, and cover the entire paper with it. Let this underpainting dry.

On an early morning in December, a light fog envelopes a lake shore.

STEP TWO

Execute the background with two basic washes. Mix one from cerulean blue and Payne's gray and the other from cadmium orange and burnt sienna. The grayish-blue wash is great for rendering the most distant trees; the orange one breaks up what could become a solid wall of gray.

Use stronger color to depict the middle-ground grasses that hug the distant shore. Here they are painted with sepia, yellow ocher, and burnt sienna.

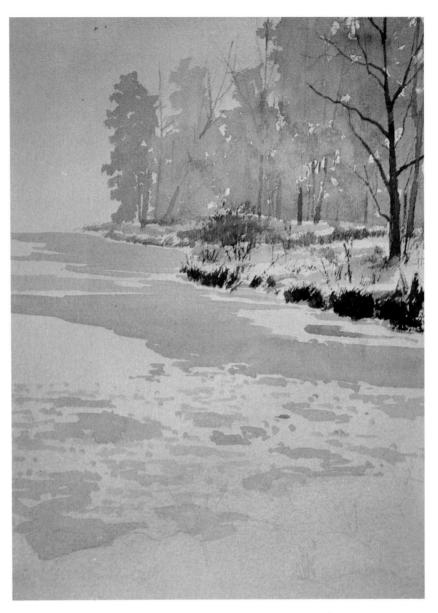

STEP THREE

When you approach the icy lake, look for large areas of dark and light. If you add too much detail, you'll lose the softening effect of the fog. Here three colors come into play: Payne's gray, cerulean blue, and yellow ocher. In the background and middle ground, pull out large flat areas. In the foreground, use small strokes to indicate the texture of the lake.

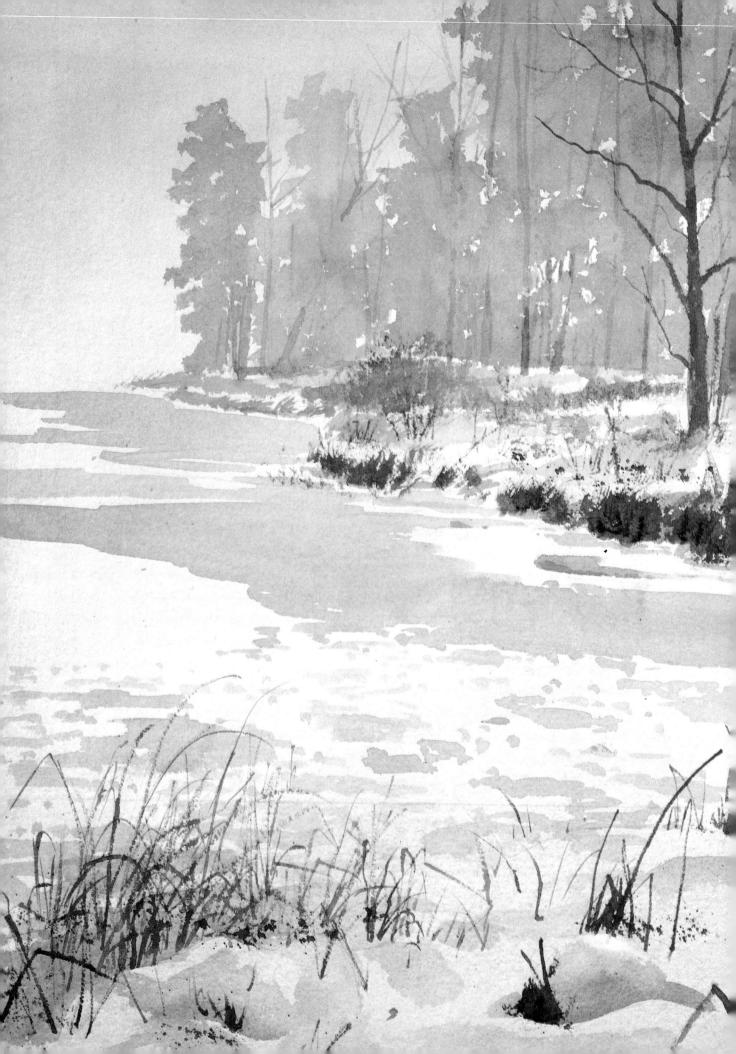

FINISHED PAINTING

Continue using a gray-based wash to complete the ice and snow in the foreground; then turn to the grasses. Paint them with strong, definite colors—sepia, burnt sienna, and yellow ocher—using a drybrush technique. As a final step, spatter bits of your darkbrown colors around the base of the grasses to anchor them in the snow.

DETAIL

Painted with soft washes of color, the distant trees seem muffled by the fog. The passages painted with cadmium orange and burnt sienna not only break up the grays, they also help pull the trees in the middle ground away from those in the distance.

DETAIL

In the immediate foreground, the ice and snow are rendered mostly with cerulean blue. The blue pushes the foreground forward, away from the grayer passages farther back. The blue passages are also painted more boldly than those in the middle ground and background, to further accentuate what lies at the very front of the picture plane.

REFLECTIONS ON WATER

Painting Water on an Overcast Day

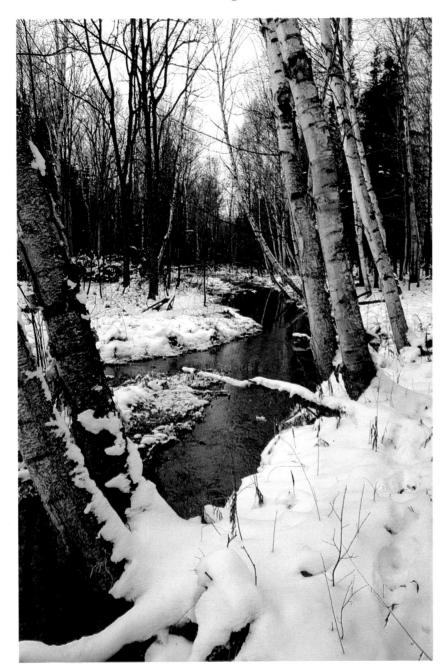

PROBLEM

On overcast days, water often seems dark—so dark, in fact, that it may be difficult to see the reflections cast in it and the ripples that run through it. But if they are ignored, your painting will seem flat and dull, and the stream will look unrealistic.

SOLUTION

Simplify the trees in the background and make the snow and the water the focus of your painting. Lay the water in before you develop the foreground, and exaggerate the reflections.

STEP ONE

When a scene is packed with detail, a careful, detailed drawing is a must. Sketch what you see carefully; then cover the paper with a wash of color, one that will set the painting's color mood. Wet the paper with clear water; then, starting at the top, drop in a wash of ultramarine blue. As you near the horizon, lighten the tone and gradually add a touch of alizarin crimson.

In late afternoon on a dark, overcast December day, a stream courses through a snow-covered woods.

STEP TWO

Let the paper dry; then begin work on the background. The tree tops in the distance are rendered with light tones of Hooker's green light, Payne's gray, and new gamboge. The darker trees are made up of the same hues plus alizarin crimson. To suggest the scraggly branches that fill the scene, use a drybrush technique.

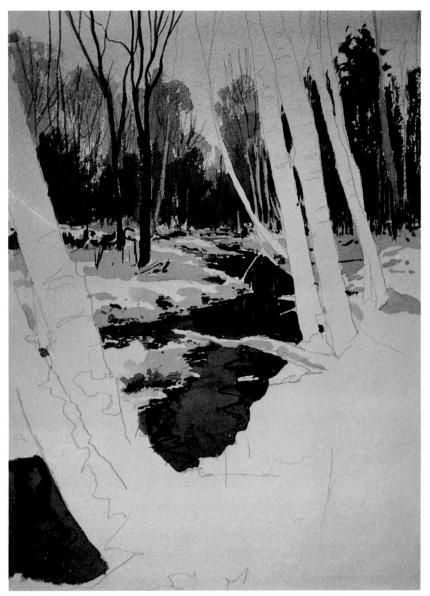

STEP THREE

Before you turn to the fore-ground, lay in the water. It forms the darkest value in the painting, so once it's down, it will be easy to adjust the rest of the value scheme. Using a dark mixture of ultramarine and Payne's gray, carefully stroke the color onto the paper. Let the paper dry slightly; then add the reflections, exaggerating them slightly. When the water is done, add gray shadows to the snow in the middle ground.

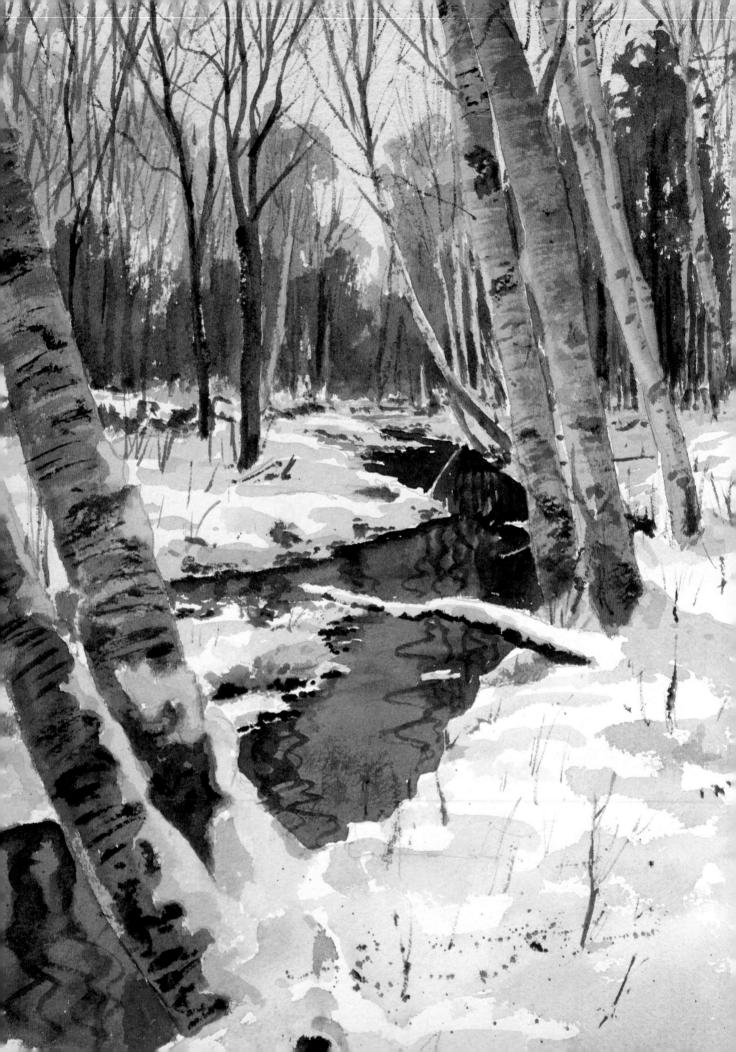

To capture the rosy tinge that colors the trees on the right, paint them with alizarin crimson, ultramarine, and burnt sienna. The cooler trees in the immediate foreground are rendered with alizarin crimson, ultramarine, Payne's gray, and Hooker's green.

Now lay in the shadows that spill over the snowy foreground, using a wash of alizarin crimson and ultramarine. As a final touch, use burnt sienna to suggest the growth that shoots out from the snow; then spatter touches of brown onto the foreground.

DETAIL

Deep, rich, and dramatic when set against the white snow, the blue of the stream is composed of ultramarine and Payne's gray. The reflections are rendered with an even darker hue. To capture a sense of how the water moves, exaggerate the reflections as you lay them in.

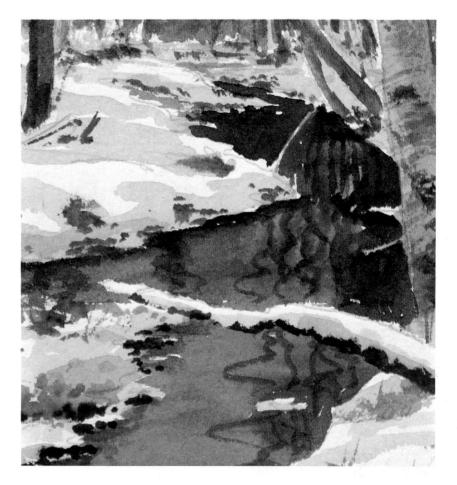

DETAIL

Before the painting was begun, the paper was toned with a very pale wash of ultramarine and alizarin crimson. The blue adds a cool, subdued feel to the snow, while the alizarin crimson suggests the light of the late afternoon sun.

Exaggerating the Contrast Between Lights and Darks

PROBLEM

Seen up close, these ice-coated blades of grass take on a strange, bizarre look. To capture the look realistically, you'll have to show how the ice clings to the grass.

SOLUTION

Exaggerate the contrast between the foreground and the background. If the thick blue coat of ice in the background is dark enough, the ice-coated grass will spring into focus.

Use all four hues as you lay in a modulated wash over the upper half of the paper. Be sure to work around the ice-coated blades of grass. Let the paper dry slightly; then go back and lay in the dark ridges and bumps that texture the background's icy surface.

When you have finished the dark background, turn to the brown and green grasses—the ones that aren't covered with ice. To paint them, use Hooker's green, yellow ocher, burnt sienna, sepia, and mauve.

With all the darks and medium tones down, you can concentrate on the focus of the painting, the ice-covered grass. To capture the cool feel of ice, choose ultramarine and cerulean blue, plus a dab of alizarin crimson. Start with a very pale wash of color, and remember to leave the top edges of the blades pure white. Let the paper dry and then add the shadows that play over the ice, using darker values of your wash.

Only one element is missing now—the green blades that are caught inside the ice. With a small, rounded brush, carefully paint the sharp-edged blades of grass with Hooker's green and vellow ocher.

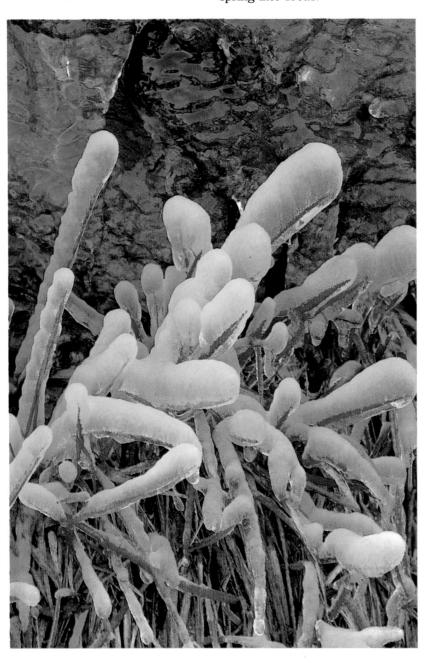

A thick coat of ice transforms slender blades of grass into swollen, fingerlike projections.

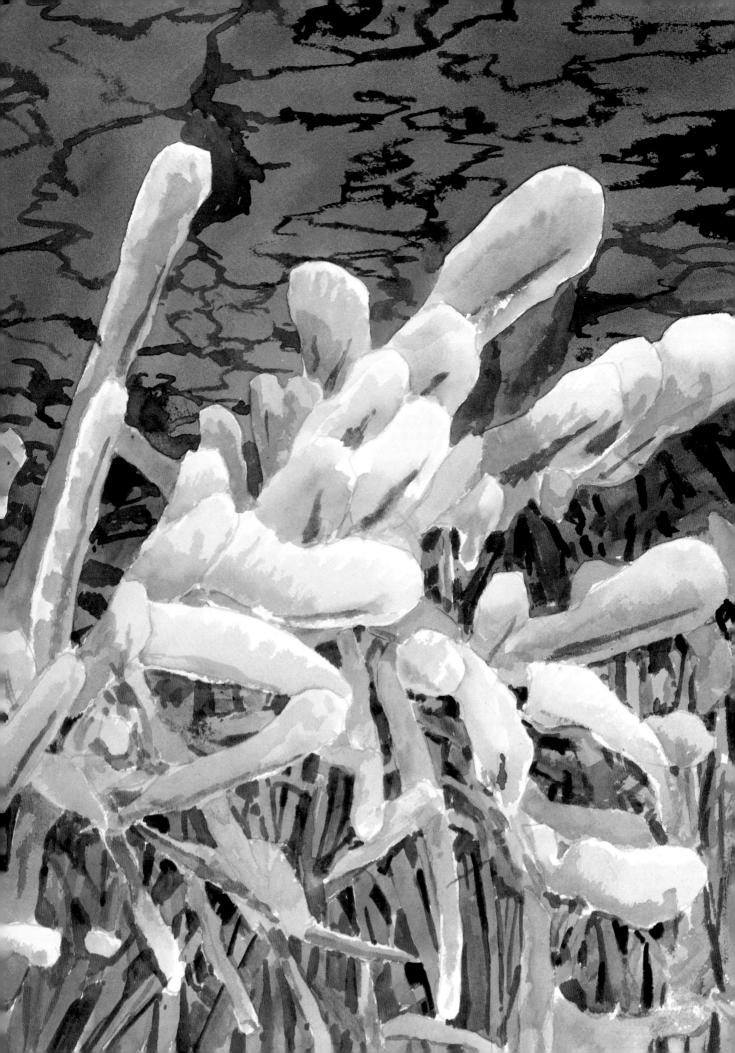

MIRRORLIKE REFLECTIONS

Depicting Dramatic Reflections Cast on a Lake

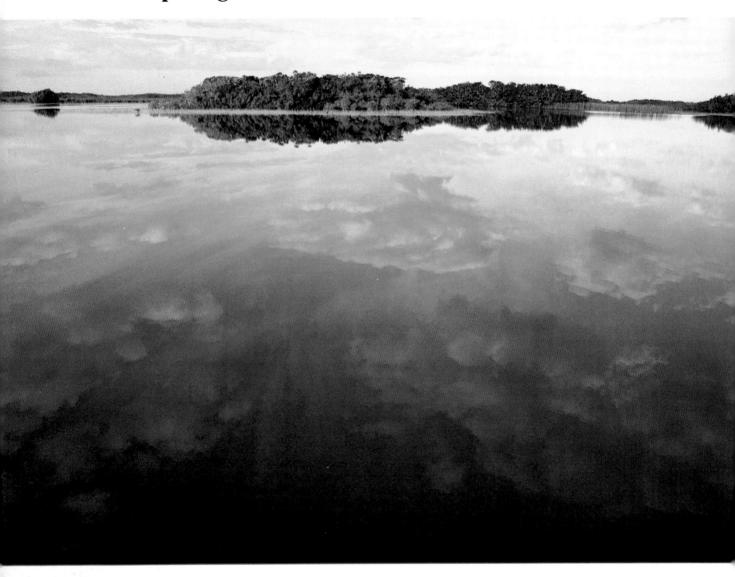

PROBLEM

Few scenes rival this one in its power. Quiet, mirrorlike, deepblue water reflects a dramatic, cloud-filled sky. Depicting the white clouds realistically can be difficult, especially when they are reflected in such dark-blue water.

SOLUTION

Opaque gouache is your best bet here. Using it, you'll be able to develop the scene in a traditional light-to-dark fashion and then, at the last moment, render the reflected cloud formations.

Magnificent cloud formations are reflected on the tranquil surface of a lake.

STEP ONE

Sketch the island in the middle of the lake and add the horizon line. Now lay in the sky with a pale wash of cerulean blue, indicating the underside of the clouds with a light mixture of cerulean blue and ultramarine.

Next paint the water with a mixture of cerulean blue, ultramarine, and yellow ocher. Note how the lake is pale near the horizon line, and how it quickly becomes much darker. As you shift to darker color, work around the reflection of the large cloud right beneath the island.

STEP TWO

Strike in the dark-green trees and their green reflections now; once they are down, you'll be able to adjust the rest of your values. Here they are rendered with Hooker's green and Payne's gray; the sandy shore is painted with yellow ocher.

Right away you'll notice how much lighter the sky and water look when set against the dark green. Now, with a wash of ultramarine and alizarin crimson, increase the strength of the cloud formations in the sky and begin to paint the dark portions of the clouds that are reflected in the water.

STEP THREE

To capture the pale streaks of light that radiate outward in the water, dip a brush into clear water, stroke it over the entire lake, and use a clean rag to pull some of the color from the lake's surface. While the paper is still damp, drop in ultramarine and alizarin crimson to indicate the darkest portions of the reflected clouds.

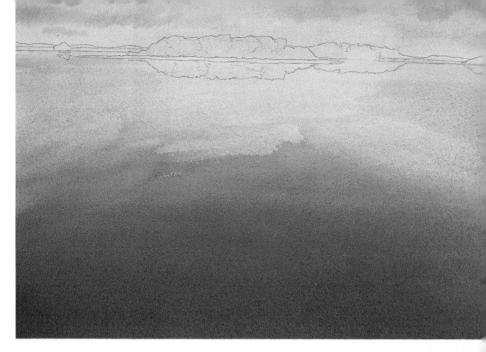

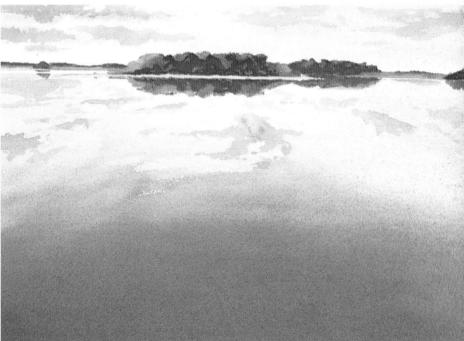

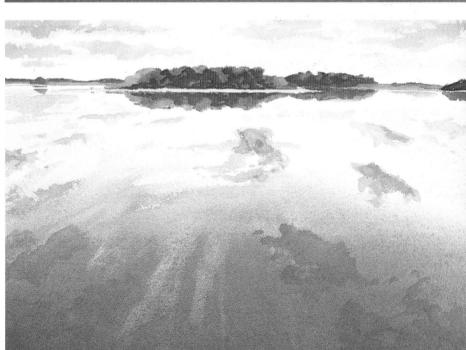

All that's left now are the whites of the reflected clouds. Don't make them too bright; add just a touch of yellow ocher to the white gouache to tone it down, and dilute the gouache slightly to make it less powerful. Carefully paint the clouds; then let the paper dry.

To soften the effect of the opaque paint, try this: Take a large brush, dip it into clear water, and then run it over the passages that you've painted with gouache. Right away they will become softer and less distinct—perfect for capturing the gentle feel of clouds.

The clouds that streak the sky are painted in two steps. First they are laid in with a very pale wash. Once that's dry, they are reinforced with a slightly deeper hue.

The trees and their reflections are painted with just two colors, Hooker's green and Payne's gray. Rendered simply, without much detail, they fit easily into the picture.

The reflected clouds are built up gradually, from light to dark. The brightest areas, however, are painted last, with white gouache that has been tempered with a touch of yellow ocher.

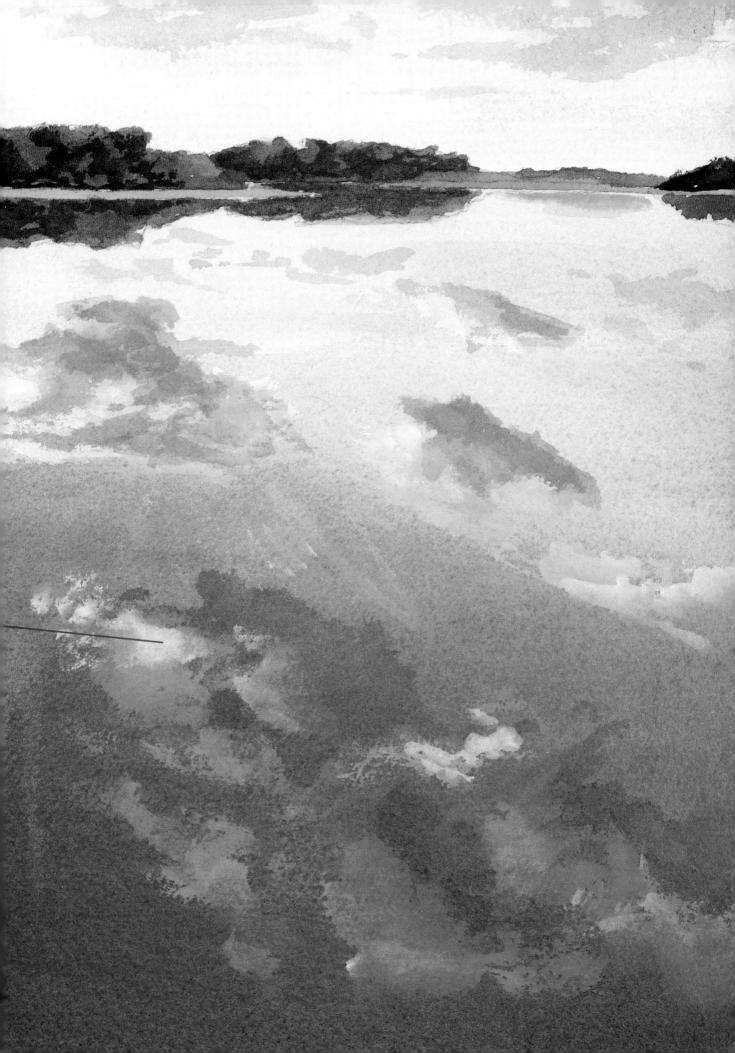

CROWDED RIVER

Manipulating Color and Light

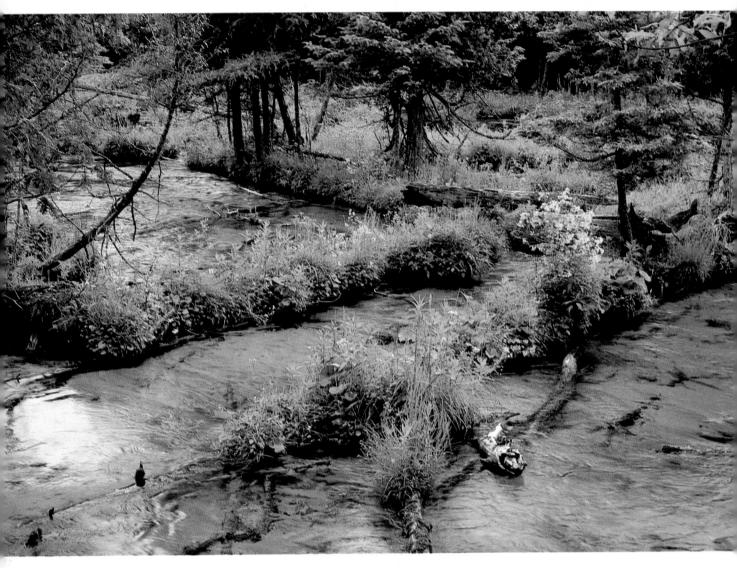

PROBLEM

This scene is extraordinarily complicated. It's packed with greens that are closely related in value. What's more, the river itself is dark and tinged with green.

SOLUTION

Emphasize the light that strikes the water and make the water bluer than it actually is. By doing this, you'll break up the wall of greens and give your painting a few crisp accents.

Fallen logs, thick with vegetation, lie across a shallow, swiftly moving river.

STEP ONE

Loosely sketch the scene; then figure out your plan of attack. Since the scene is so complicated, start with the most difficult area first—the water. If you run into trouble, you can always start over.

Working with yellow ocher and sepia, paint the shadows that run along the bottom of the logs. Next, lay in the shadowy portions of the water with the same two hues. Finally, paint the ripples in the water with cerulean blue.

STEP TWO

Start to build up the greens. Working from the top of the paper down, lay in the trees and grasses with a variety of flat green washes. Here they are made up of Hooker's green light, Payne's gray, and new gamboge. Once these areas are established, develop the dark, shadowy areas of green with the same colors plus alizarin crimson. Before you move on, add the dark tree trunks with Payne's gray and sepia.

STEP THREE

Finish the greens that lie in the foreground, again beginning with flat washes of color. Let the washes dry; then put down the dark shadows and details that articulate the vegetation on the logs.

In the final stages of this painting, it became clear that the water was too bright and was broken into too many areas. To pull the water together, and to tone it down by one-half of a value, a light wash of ultramarine blue was pulled over most of the water. As a finishing touch, additional reflections were added with dark ultramarine, and dabs of bright yellow were laid in to suggest the flowers growing on the logs.

To simplify this overly complicated scene, the trees were laid in with simple, flat washes of greens. Once the washes dried, darker greens were worked into them to depict their shadowy undersides.

Yellow ocher and and sepia may seem unlikely colors for water, but they work perfectly here. In the final, stages of the painting, a pale wash of ultramarine was pulled over these areas, uniting them with the blue areas that surround them.

The ripples that play upon the surface of the water are strongly horizontal and balance all the strong verticals formed by the trees. The soft, diffuse ripples were worked wet-in-wet.

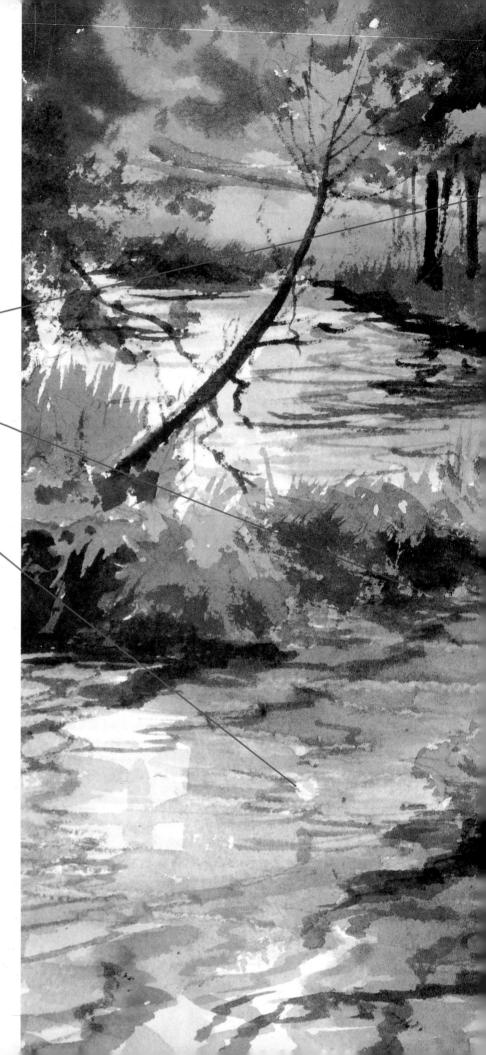

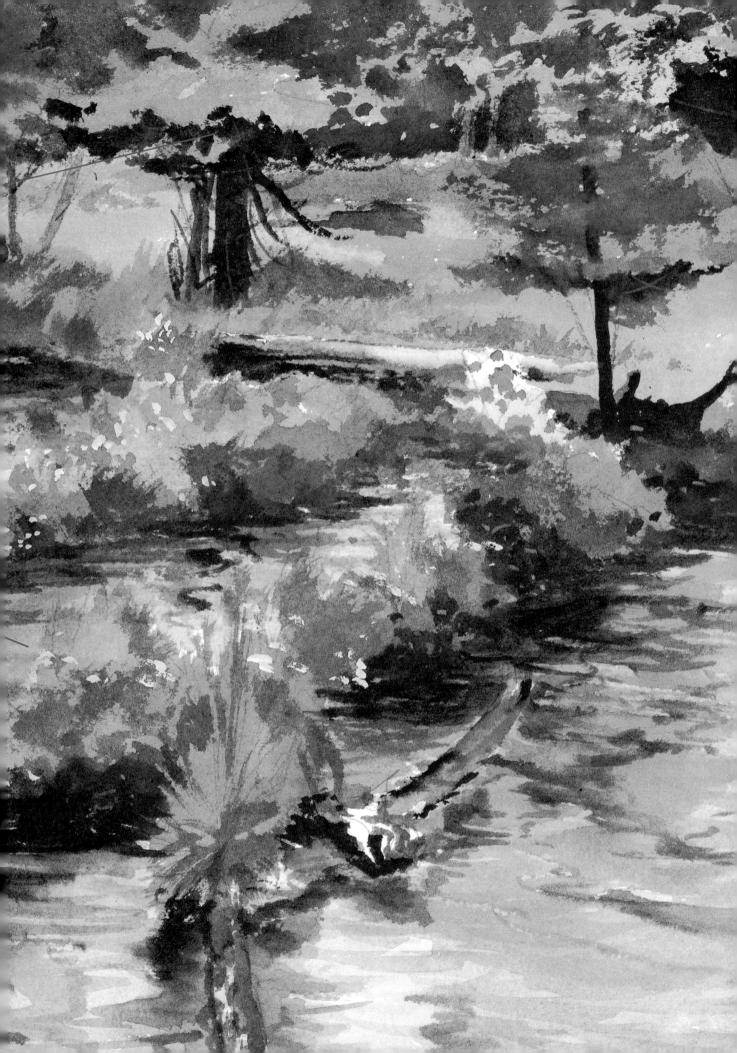

WHITE WATER

Highlighting a Quickly Moving Stream

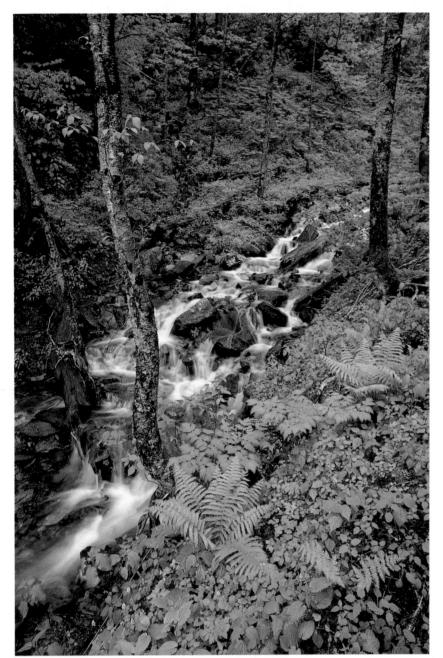

PROBLEM

The rocky stream is a complex jangle of forms and colors, and the trees and ferns form an intricate maze. It will be difficult sorting out what you see.

SOLUTION

To make the stream stand out clearly in your painting, simplify it and make it lighter than it actually is. To capture just the right value, paint it last, after all the greens are down.

STEP ONE

Start simplifying the scene in your preliminary sketch; don't get involved in details. Immediately begin to lay in the background with Hooker's green, new gamboge, and Payne's gray. At this stage keep the greens fairly light so that you can come in later and add details with a darker hue. To set up your value scheme, paint a few of the darks that lie in the immediate foreground.

In the Smoky Mountains, surging white water rushes over a rocky bed.

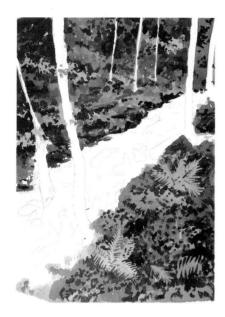

STEP TWO

For the shadowy areas, you'll need burnt sienna, sepia, and mauve. Working all over the surface of the paper, lay in these very dark touches. When they are dry, work back over the surface with an intermediate-value green. At this point all of the greens should be down.

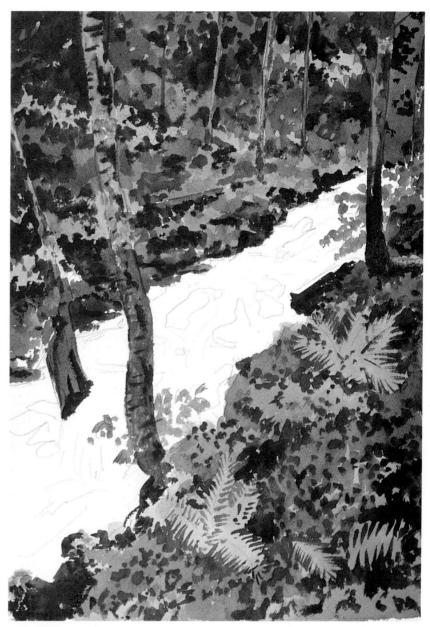

STEP THREE

Paint the trees, keeping them fairly dark; if they are too light, they'll stand out sharply against the greens and steal attention from the stream. Render them with sepia, burnt sienna, and Payne's gray. Finally, add the touches of vegetation that grow around the tree trunks.

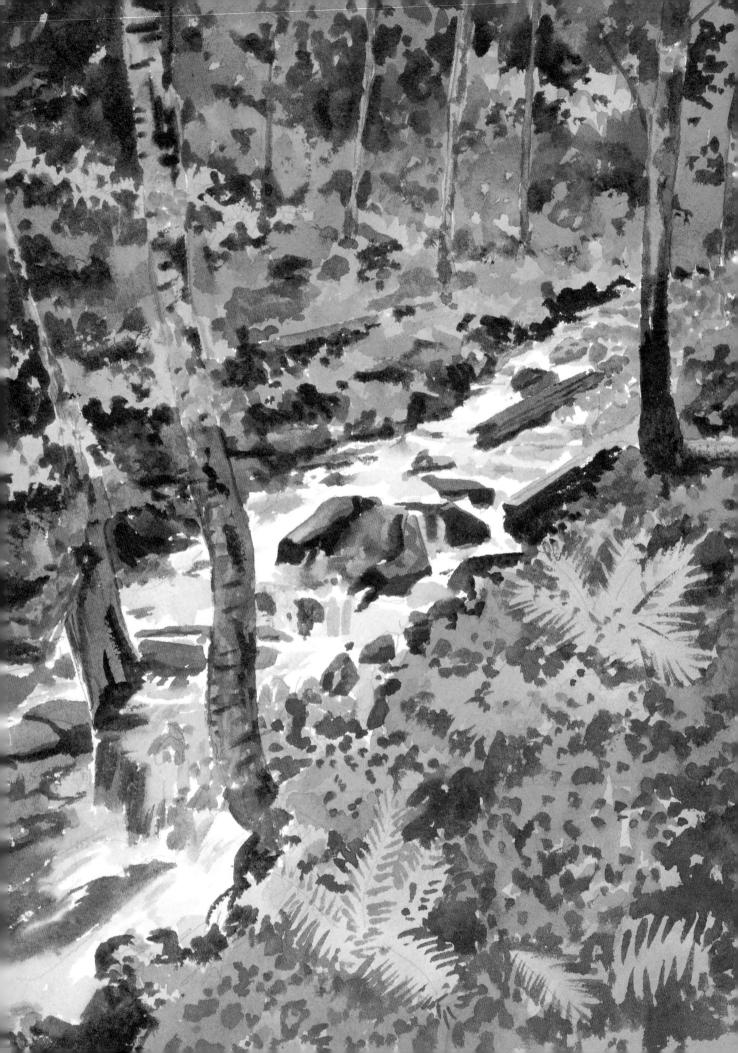

All that remains now is the rocky stream. Using sepia, burnt sienna, yellow ocher, and cerulean blue, paint the rocks. Simplicity is the key to success here; don't paint every rock you see, and simplify the ones you do paint.

While the paper is drying, select the colors you'll use for the water. Here cerulean blue is the basic hue; touches of yellow ocher and sepia tone the blue down and give it a steely cast.

Now paint the water with short, choppy strokes. Most important, work around the lightest, brightest passages; the crisp white of the watercolor paper will form the highlights.

DETAIL

The quickly moving water stands out clearly against the wall of vegetation. Note how the stream is bordered by a band of deep, dark brown, further separating it from the greens.

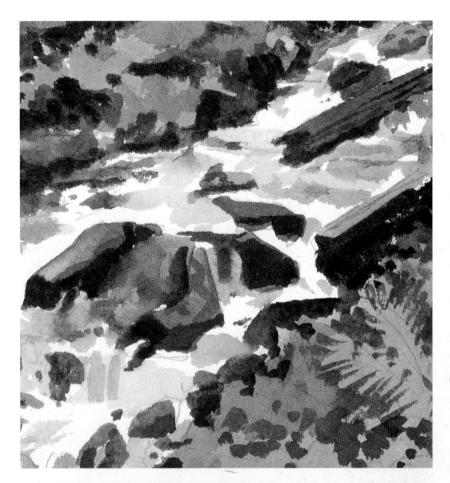

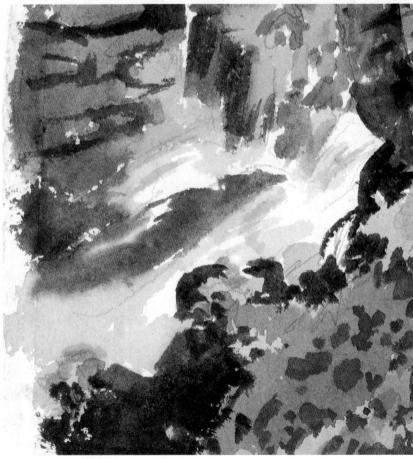

DETAIL

The water is rendered with short, quick strokes. Made up of cerulean blue, yellow ocher, and sepia, it is cool enough—and toned down enough—to fit in easily among all the strong greens.

SPARKLING WATER

Exploring Reflections and Light

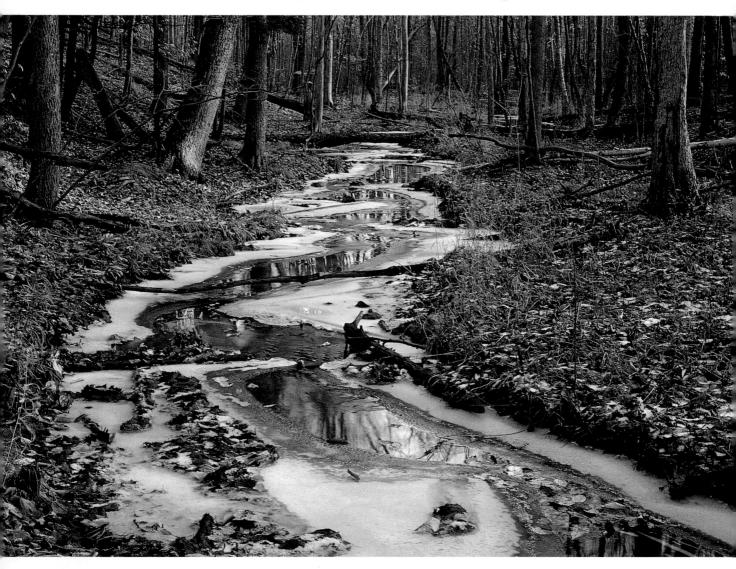

PROBLEM

One thing makes this scene special: the transparent, sparkling water set against the opaqueness of the ice. You have to capture the play of light on the newly formed ice and the flickering reflections that dance through the water.

SOLUTION

Develop the background before you tackle the water. When you turn to the stream, exaggerate the ice, the highlights, and the shimmering reflections of the trees.

Deep within a forest, ice begins to form on a shallow, meandering stream.

STEP ONE

In your preliminary drawing, sketch the major trees and the contours of the stream and ice. Begin to develop the background, working with mauve, yellow ocher, Hooker's green, burnt sienna, and cadmium orange. Use mauve to depict the most distant trees; you'll find that the purple creates a strong sense of distance. As you move forward, switch to the warmer hues.

Just as soon as the background dries, put in the trees. Before you start to paint, though, note how the light falls on the right side of each trunk; keep these areas light. Browns and grays are dominant here—mixed from sepia, Payne's gray, and burnt sienna, with a touch of Hooker's green. Let the trees dry; then add the grass and the leaves, using a drybrush technique and the same colors you used to build up the trees.

STEP THREE

Gradually introduce color into the icy edges of the stream. Cerulean blue and ultramarine make up the shadowy areas of ice; the white of the paper is left as highlights. Sepia and burnt sienna furnish just the right color note for the fallen leaves and twigs. Don't go overboard painting the leaves, though. Add just a few of them—if you depict too many, you'll make it more difficult to complete your painting.

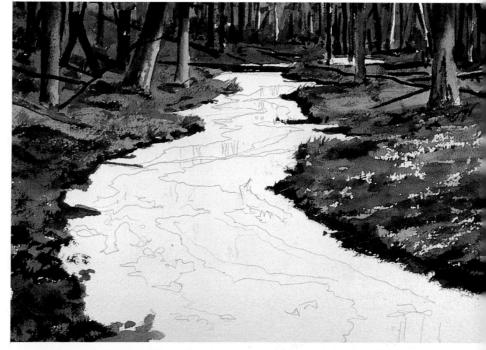

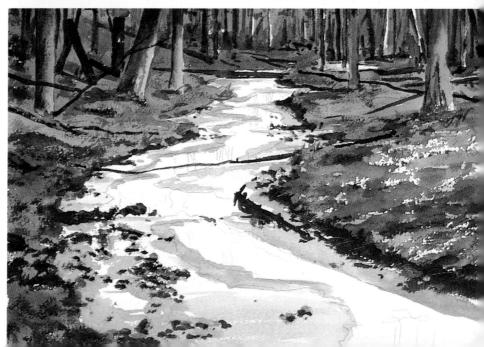

Until now, you've worked fairly cautiously, developing the setting with a traditional light-to-dark approach. Now, as you turn to the transparent water, it's time for drama.

Exaggerate what you see. Working with cerulean blue, ultramarine, Payne's gray, and sepia, make the reflections darker than they actually are, and make them more lively, too. Begin toward the back of the stream with long, slightly undulating strokes. As you move forward, use darker paint and more dynamic, calligraphic brushwork.

In the finished painting, the stream clearly dominates the scene. Packed with color and movement, it stands out boldly against the golden-brown forest floor and the dull brownish-gray trees.

The trees in the background are rich with color, yet understated enough to act as a backdrop for the stream. The following colors make up the trees: mauve, yellow ocher, burnt sienna, cadmium orange, Payne's gray, and Hooker's green.

In the finished painting, the water is clearly the focal point. Crisp white ice gives way to dark blue water, where lively reflections sparkle.

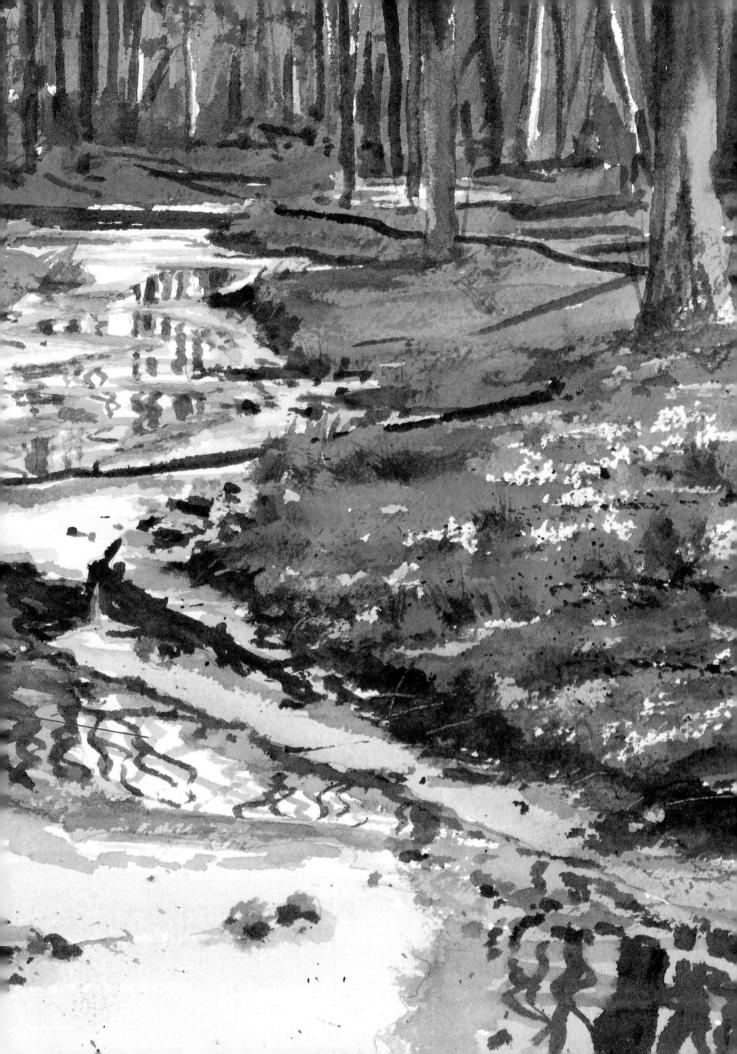

RUSHING STREAM

Painting Rapidly Flowing Water

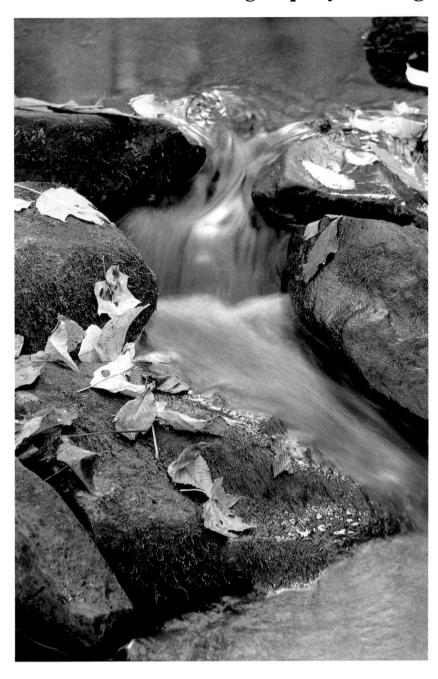

In autumn, a stream of water eddies rapidly over moss-covered rocks.

PROBLEM

The real subject here is the nature of flowing water. At the top of the scene, the water is still and green; as it rushes over the rocks, it becomes soft and unfocused; at the bottom, it is filled with subtle ripples.

SOLUTION

Concentrate on the most dramatic part of the composition, the point where the water spills over the rocks. Paint the water first, and if you fail to capture its mood, start over.

STEP ONE

Sketch the rocks and the leaves, then begin to lay in the water. You'll want it to be infused with a soft feel, so work wet-in-wet. First "paint" the stream with clear water; then begin to drop in color. Here the rich green area is made up of olive green, yellow ocher, and burnt sienna. Note how the reflections are exaggerated to break up what could become a dull expanse of dark color. For the rushing water, try using cerulean blue and ultramarine mixed with just a touch of yellow ocher.

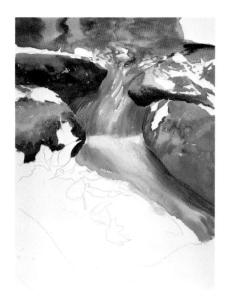

STEP TWO

Next execute the rocks that surround the rushing water, but work around the fallen leaves that lie on top of them. These rocks form the darkest value in the composition, so once they are down, you can tune the rest of your painting to work harmoniously with them. Render them with ultramarine, cerulean blue, Payne's gray, sepia, and Hooker's green light. To hold the soft feel established earlier, continue to work wet-inwet.

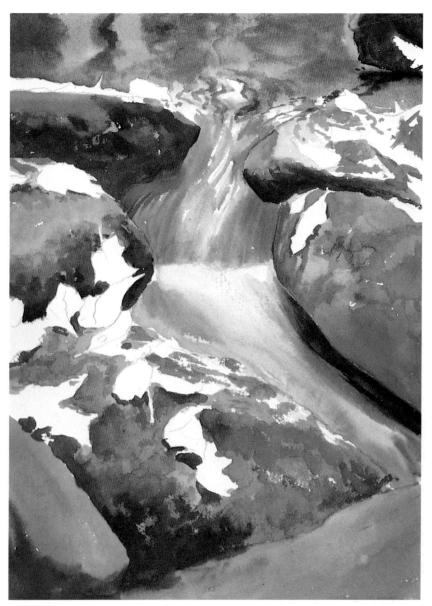

STEP THREE

Working with the same colors, complete the rocks; then lay in the water at the bottom of the scene. Now go back and add textural details to the rocks.

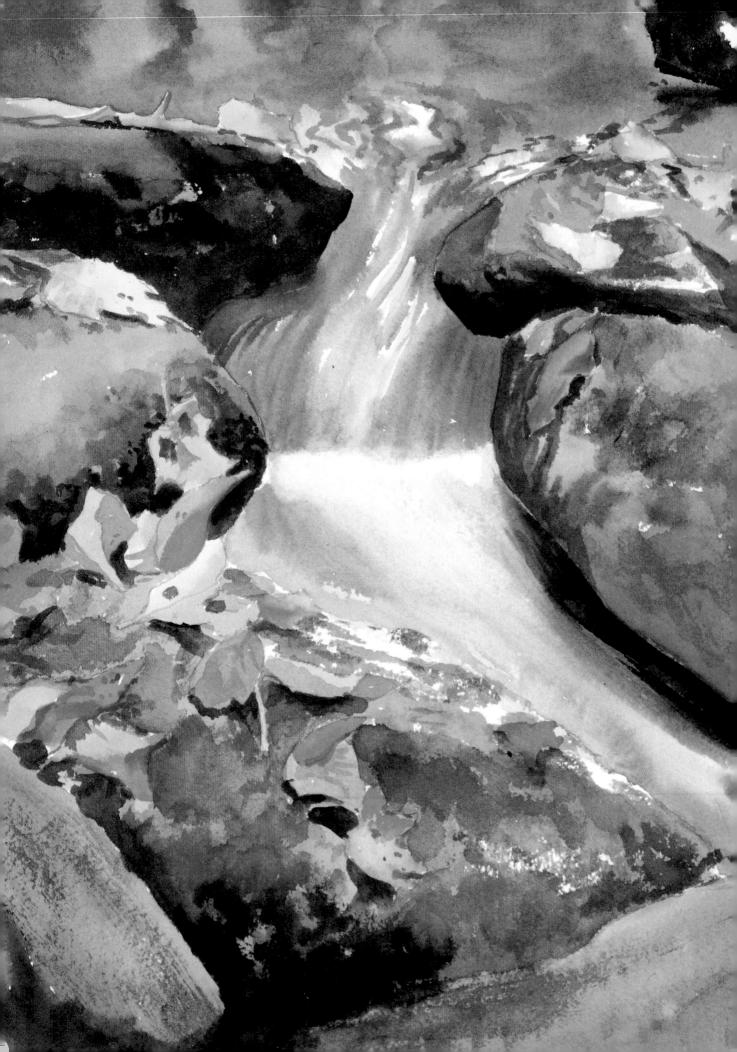

The brightly colored autumn leaves could easily detract from the focal point of your painting, the water. Tone down their brilliance by using pale washes of color; you'll find that thin, transparent color also helps build up a soft overall feel. Lay the leaves in with a variety of hues—cadmium orange, cadmium red, new gamboge, mauve, cadmium yellow, alizarin crimson, and Hooker's green light. To render each leaf, lay in a flat wash, then go back and emphasize its structure.

DETAIL

Painted wet-in-wet, the still green water looks soft and unfocused. To break up the surface of the water, the reflections are exaggerated. Note the small calligraphic strokes that connect the green water to the rushing blue water that cascades over the rocks; they act as a visual bridge between the two areas.

DETAIL

The leaf-covered rocks surrounding the stream are rendered with ultramarine, cerulean blue, Payne's gray, sepia, and Hooker's green light. Like the water, they are worked wet-in-wet to maintain the painting's soft feel. The leaves are laid in with pale washes of color. Were they painted with stronger hues, they would pull attention away from the rushing water.

DRIPPING RAIN

Moving In on Detail

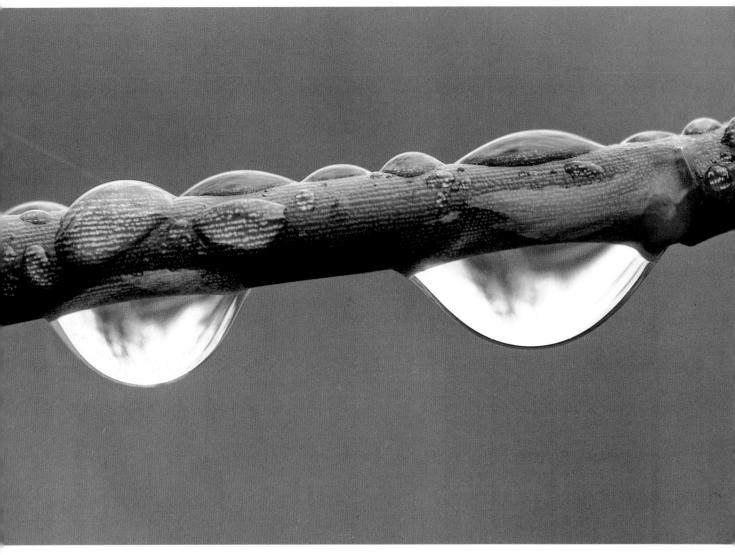

PROBLEM

What at first may seem simple in this composition is really fairly complex. If you can capture the minute details as well as all of the color notes found in the raindrops, you will build an exciting and unusual still life.

SOLUTION

To make the drops of water stand out clearly, paint the background with a rich, dark tone. That done, concentrate on detail. ☐ Execute a careful preliminary drawing first. Then moisten the background area with clear water so that you can lay in a soft middle-tone. At the top, work with ultramarine, cerulean blue, and burnt sienna. Toward the bottom, add a hint of alizarin crimson.

Paint the basic colorations of the twig next, working around each drop of water. Here the washes are made up of alizarin

A fascinating world filled with color and detail lies hidden in a few simple drops of rain.

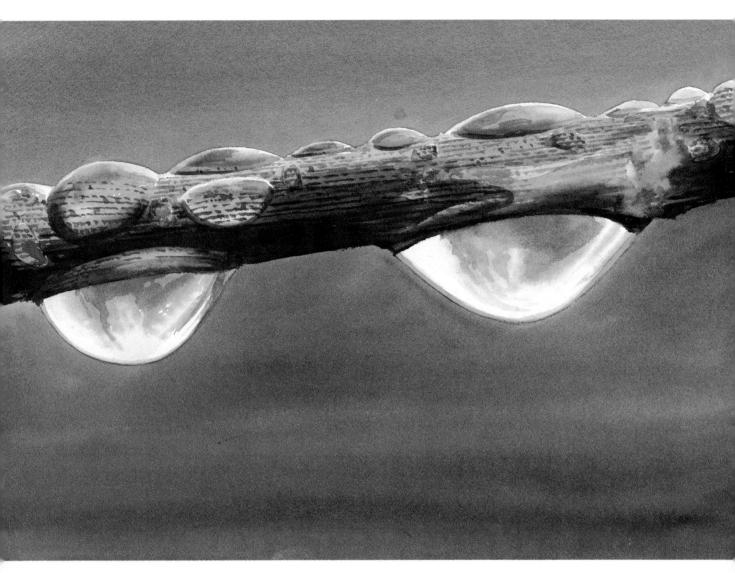

crimson, ultramarine, Hooker's green, sepia, and cerulean blue. When the paper is dry, add the thin lines that run down over the twig.

For the raindrops, use the same basic hues, but add cadmium yellow. First moisten the paper with water; then apply your colors, mixing the rainbowlike hues right on the paper. At the very end, go back and add the details of the striated lines.

Learning How to Paint Transparent Drops of Water

PROBLEM

Shimmering, transparent water can be difficult to paint, especially when it's set against a vivid backdrop. Capturing the three-dimensionality of the raindrops presents a special challenge.

SOLUTION

Let a strong drawing set up the structure of the leaf and the position of the raindrops. When you begin to paint, concentrate on the highlights that brighten the drops of water.

☐ Sketch each drop of water and each vein in the leaf; then stain the paper with a solid wash of cadmium orange and new gamboge. Let the paper dry.

Using cadmium red and cadmium orange, lay in the deep reddish-orange portions of the leaf. As you paint, work around the veins and the highlights. Once the paper is dry, go back and soften the veins by adding touches of the reddish wash to them. If any passages of gold seem too strong, work clear water over them to lighten the color.

Now paint the shadows under the raindrops with cadmium red, alizarin crimson, and mauve. On the side opposite the shadow, introduce a lighter tone of the same wash. As a final step, wet the bottom of each raindrop and wipe up some of the color; then add the shimmering highlights with touches of opaque white gouache.

Crystal-clear raindrops hover on a golden-orange aspen leaf.

BRIGHT DROPLETS

Masking Out Highlights

PROBLEM

It's the crisp, bright drops of water that make this subject sparkle. You'll have to emphasize them to create a lively, interesting painting.

SOLUTION

Mask out the raindrops with liquid frisket, and you'll be able to hold your whites. More than that, the frisket will give you the freedom you need to execute the background boldly.

☐ Draw the leaves and the raindrops; then carefully mask each drop of water out with liquid frisket. Lay Hooker's green light, Payne's gray, and new gamboge on your palette; mix a wash and then begin to lay in the darkest leaves. Once they are down, paint the rest of the leaves with lighter washes, varying their tones slightly. Here they are rendered with Hooker's green light and new gamboge.

Let the paper dry; then working with a wash one value darker

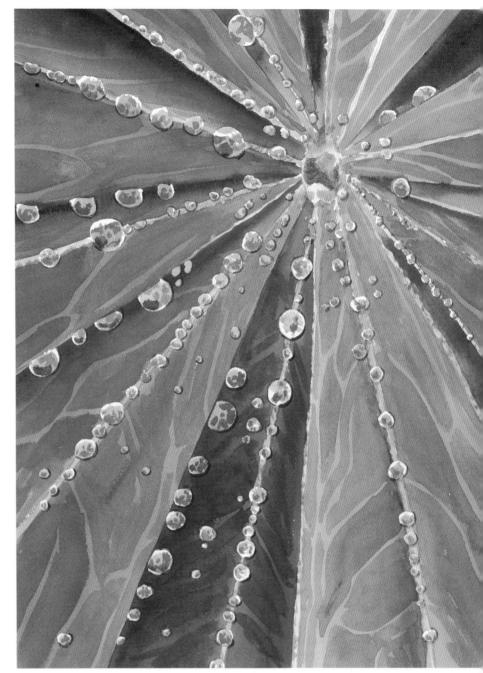

than the underlying washes overlay the leaves so that the lighter values delineate the radiating veins.

Now peel off the frisket and begin to paint the raindrops with Hooker's green light, new gamboge, and cerulean blue. To make them pop out, leave a narrow rim of white around most of the drops.

Clear, brilliant drops of water shimmer atop the leaves of a lupine.

COLORS IN A LAKE

Maintaining a Flat, Decorative Look

PROBLEM

The beauty of this autumn scene rests in its flat, decorative feel. Maintaining a decorative, almost abstract look, is essential.

SOLUTION

Look beyond the obvious vertical bands of color and stress the horizontals that run through the water. The interplay between the verticals and horizontals will capture the decorative look you are after. ☐ Prepare your palette with strong, vivid hues: new gamboge, cadmium yellow, cadmium orange, cadmium red, and Hooker's green. Now mix a wash of new gamboge and cadmium orange and lay the color in over the entire sheet of paper. While this wash is still wet, stroke in vertical bands of cadmium red, cadmium orange, and Hooker's green, using a 1½-inch brush and horizontal strokes. Let the paper dry.

The brilliant colors of autumn foliage lie reflected in a quiet lake.

Next begin to work with a small, round brush as you lay in the ripples that run through the water. Two values of Hooker's green make up these ripples; the ripples are bold at the bottom of the paper, and gradually become finer and softer toward the top.

Make sure the paper is thoroughly dry before you move on to the reeds; any moisture will soften your strokes and break up the decorative pattern you want. With a small, fine brush, carefully render the reeds with sepia and Hooker's green. Finally, lay in a few rapid, calligraphic strokes to suggest how the reeds are reflected in the water.

In the finished painting, the horizontal brushstrokes and ripples are poised against the vertical bands of color. Together these elements provide a simple but colorful backdrop for the graceful patterns of the reeds.

SHIELDED STREAM

Mastering Soft, Unfocused Reflections

PROBLEM

A canopy of leaves shields this stream from direct sunlight, softening and blurring the reflections cast in it. And while the water is unfocused, the trees themselves are clearly and crisply defined.

SOLUTION

When you encounter soft, hazy, reflections, use a wet-in-wet approach. The strokes you lay down on damp paper will bleed outward, creating the effect you want. For the trees, work on dry paper and keep the edges sharp.

☐ Sketch the scene carefully; then lay in the upper portion of the painting. First stroke a wash of new gamboge over the top of the paper, extending down to the shoreline, and let the paper dry. Next paint the greens that fill the background. Use Hooker's green, cerulean blue, and new gamboge; since the underpainting will brighten up your green, don't use too much new gamboge.

To render the dark ground, try using sepia and ultramarine blue; for the patch of sunlight that spills through the trees, use cadmium orange. Finally, paint the trees with sepia.

It's now that the fun starts. Wet the entire lower half of the paper and drop color onto all but the very bottom of the moistened surface. To unify your painting, use the same hues that you employed in the upper portion of vour composition—new gamboge, cadmium orange, and Hooker's green. Let the colors swirl about: then, at the bottom of the paper, drop in touches of cerulean blue to suggest the sky. Beneath the shoreline, add sepia and ultramarine to the wet paper. Keep the blue away from the new gamboge, or you'll end up with a muddy green.

Working quickly, moisten a small brush with sepia and run the brush up and down over the paper to depict the reflections of the tree trunks. Because the paper is still damp, the paint will bleed softly outward.

In the finished painting, the reflections are soft and muted, yet still made up of strong color. The thin band of white that separates the cerulean blue from the other colors in the water adds a crisp accent note. Without this band of white, the water could easily become dark and oppressive.

Tall tree trunks, golden foliage, and patches of pale blue sky are mirrored in a dark, still stream.

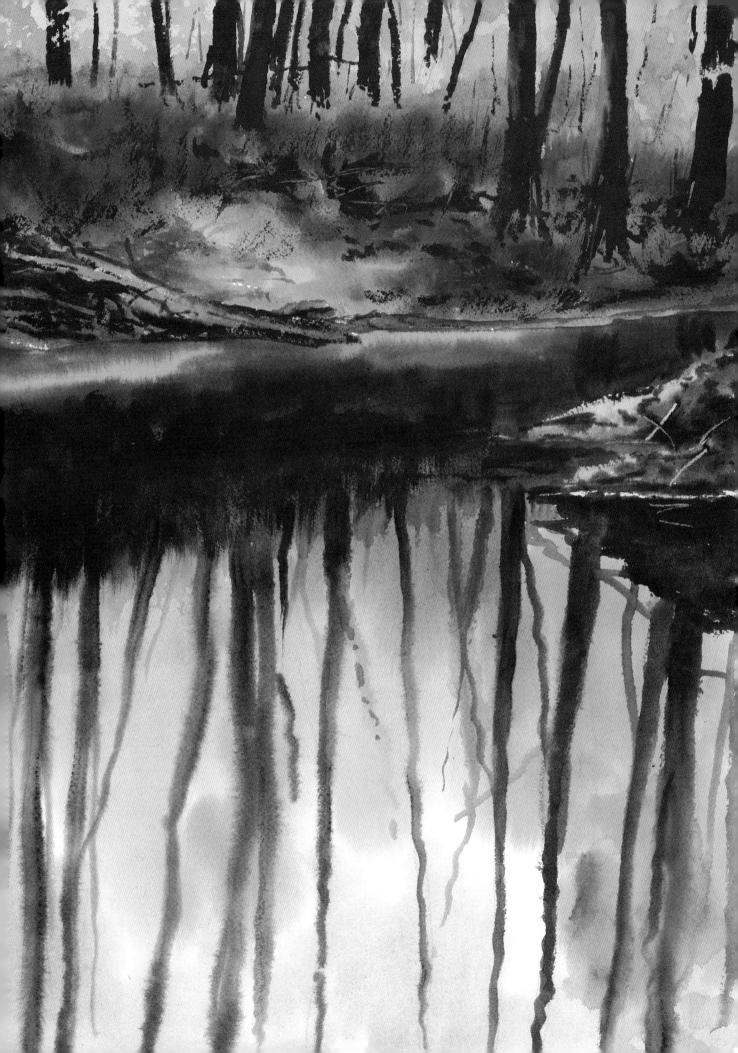

DRAMATIC WATER

Rendering Bold, Brilliant Reflections

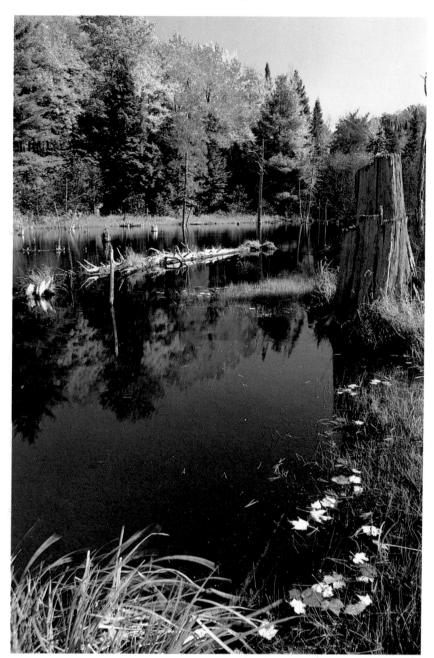

PROBLEM

When you render a dazzling scene like this one, it's easy to make colors too strong and too bright. Water dulls reflected color significantly; if your reflections are too vivid, your painting will look artificial.

SOLUTION

Paint the actual foliage first and use it as a key in balancing the strength of the reflections. Paint the reflections and the deep blue water in one step, to assure that they will work together.

STEP ONE

Quickly sketch the scene; then lay in the sky with a pale wash of cerulean blue. Now turn to the foliage. Begin with flat washes of Hooker's green, cadmium red, cadmium orange, and new gamboge; then let the paper dry. Next, render the shadowy portions of the trees, adding mauve, cadmium red, and alizarin crimson to your palette.

The deep blue water of a lake takes on the strong, brilliant golds and reds of autumn.

STEP TWO

Now it's time to establish the most difficult portion of the painting, the water. Begin by wetting the surface; then drop in the colors that make up the reflections—using the same hues that you relied upon in Step One.

While the paper is drying, mix a big pool of ultramarine. With a large brush, sweep a pale wash of the blue over the reflections, using strong horizontal strokes. Finally, paint in the clear blue water, making the color increasingly darker as you near the bottom of the paper.

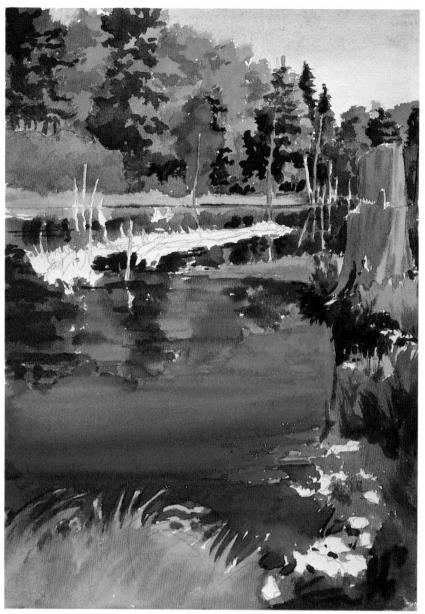

STEP THREE

Develop the foreground with warm, rich color—yellow ocher, Hooker's green light, mauve, cadmium red, and cadmium orange. Work around the leaves that are floating in the water; you'll add them later. Next, render the tree trunks and twigs, working with Payne's gray, sepia, and Hooker's green light.

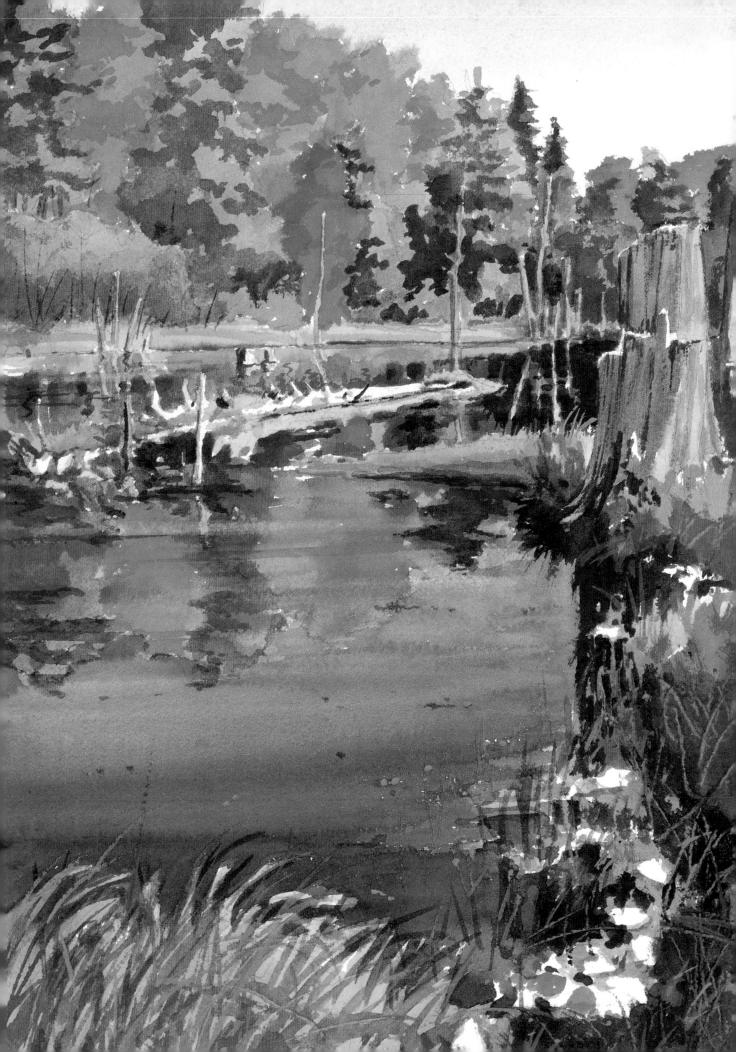

FINISHED PAINTING

At this point you are ready to fine-tune your painting. Start in the immediate foreground by enlivening the grasses with darker strokes of green. Next, lay in a few of the brightly colored leaves and break up the water with small touches of green. Finally, paint the grass-covered log midstream.

Now evaluate your painting. Here the water was too flat and too bright a blue. To break it up, try this: Take a medium-size brush, dip it into clear water, and then run the brush over the water with strong, horizontal strokes. Next, take a piece of paper toweling and gently run it over the moistened area. You'll find that this treatment removes just a trace of the color and suggests how light reflects off the water.

DETAIL

To subdue the reflections, a pale wash of ultramarine blue was swept over the paper as soon as the reflections had dried.

DETAIL

Strong, bold blue makes the foreground spring into focus. The horizontal strokes that break up the blue were added last. Clear water was applied horizontally to the blue water, then paper toweling was run gently over the surface, picking up bits of color. The end result: a lively variation in value that animates the entire foreground.

WATER JETS

Using Diluted Gouache to Depict Translucent Water

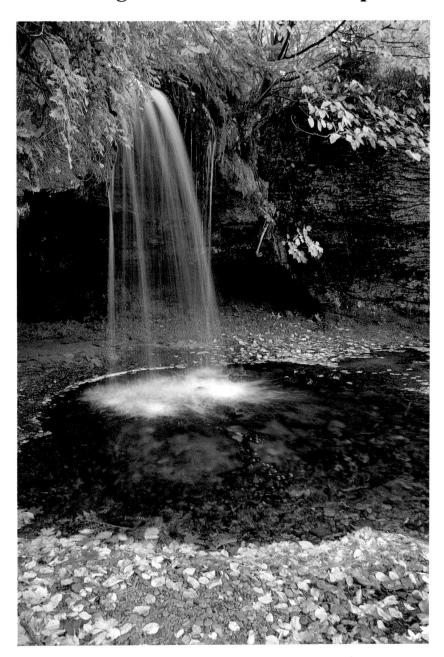

PROBLEM

Some of the dark rocks and green vegetation that make up the background shine through the soft jets of water. Your challenge lies in depicting the translucent nature of the water.

SOLUTION

Diluted gouache is perfect in situations like this one. You can develop the background as freely as you like before you go back and define the waterfall with the opaque paint.

STEP ONE

Sketch the scene; then begin work on the background of rocks and vegetation. Don't bother working around the waterfall; instead, lay it in with a dull wash of grayish-green. Later you can add darks and lights to pick out its structure. Here the background is painted with cadmium orange, cadmium red, Hooker's green light, Payne's gray, and mauve.

In early autumn, jets of water spray over the rocks and fall gently into a still pond.

STEP TWO

Working around the bright white spot where the falling water hits the pond, paint the foreground. Use dark, dull colors—Payne's gray, sepia, and ultramarine-for the pool of water, and break the water up with short, jagged strokes that radiate outward from the center of the pool. To render the leaf-covered ground in the immediate foreground, lay in a soft wash of cadmium red and orange darkened with a touch of mauve. Keep this area simple so that it won't detract from the waterfall.

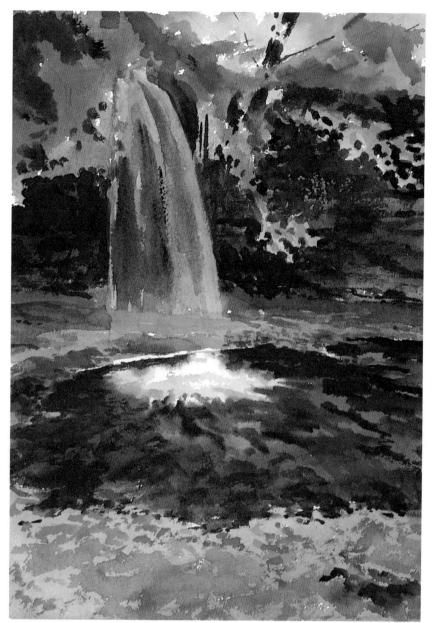

STEP THREE

Now break up the surface of the waterfall with long strokes of Payne's gray and Hooker's green light; you need these dark touches to make the lights stand out clearly against the rock. Next, with a thin wash of mauve, add touches of color to the white area of the pool. Then animate the foreground with dashes of cadmium red and orange.

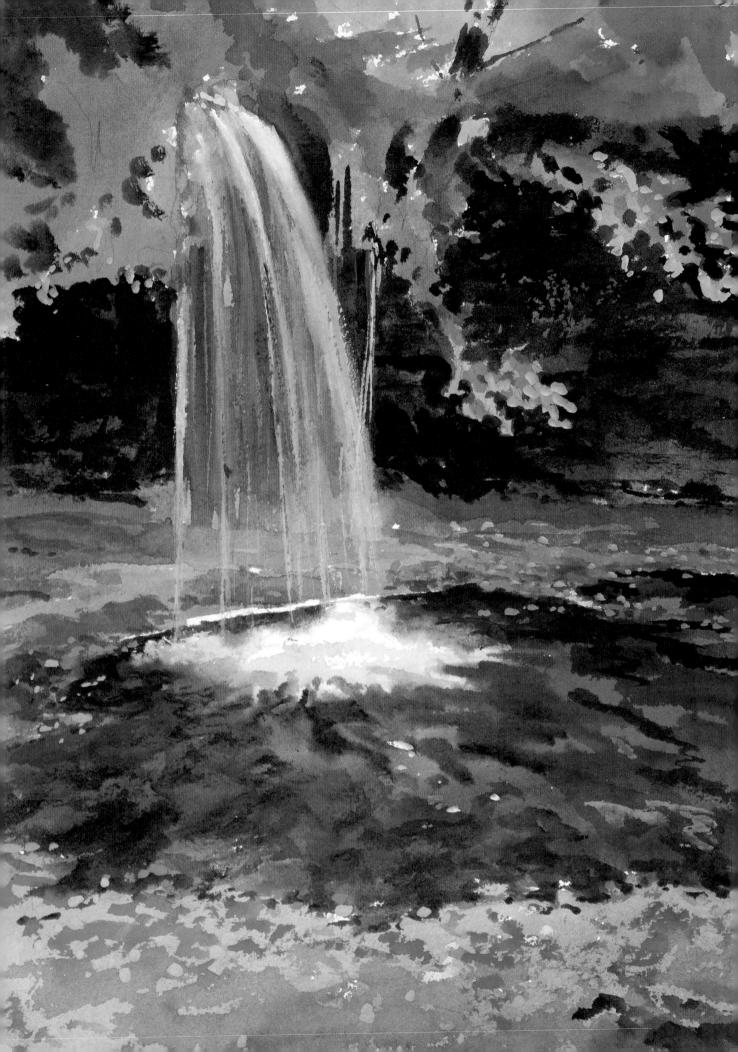

FINISHED PAINTING

The shift that occurs in the final stages of this work is subtle, but it makes a big difference in the final painting. First mix together opaque white with a touch of mauve and accentuate the lightest areas in the waterfall. Once the white is down, go back and soften it with a brush that has been dipped in clear water. As a final step, dab bits of golden gouache around the edges of the pool to suggest the leaves that litter the ground.

DETAIL

The waterfall is built up gradually. First a medium-value wash of greenish-gray is laid in to form its base. Next streaks of dark greenish-gray paint are added to break up the solid curtain of color. To accentuate the white jets of water, opaque gouache—in a mixture of white and mauve—is applied to the brightest areas. Finally, the gouache is softened with clear water.

DETAIL

The bright white of the water-color paper gets across the feeling of surging water perfectly. Touches of pale mauve suggest the shadows formed as the falling water meets the pond. All around this bright white area, dark strokes of color radiate outward.

WATER WALL

Working with Soft, Diffuse Patterns

PROBLEM

This subject is extremely difficult to paint. The wall of water is so soft and so light that there isn't much to hold on to.

SOLUTION

Lay in the rocks that lie behind the waterfall first; then wipe out some of the color to suggest the jets of water. If you start with too dark a tone and can't wipe up enough of the color, start over again with a paler hue.

Next, take a natural sponge, dip it into clear water, and wipe out the vertical bands that make up the curtain of water. Pull the sponge over the paper with strong, definite strokes, and clean it in clear water repeatedly as you work. Use the same technique to pull out the pale diagonal area where the falling water meets the water below. Now evaluate what you've accomplished. If your colors and values satisfy you, move on to the foreground.

Here the foreground is made up of cerulean blue, Payne's gray, and burnt sienna. The color is applied with large, abstract strokes that mimic the dark patterns formed by the rushing water. In the immediate foreground, the color is strong and bold; this dark passage leads the viewer into the painting and toward the center of attention, the waterfall.

At the very end, you may want to go back and add touches of opaque white to the waterfall. If you do, proceed cautiously; soften the opaque paint with clear water, or it may stand out too sharply, destroying the subtle balance of color that you have achieved.

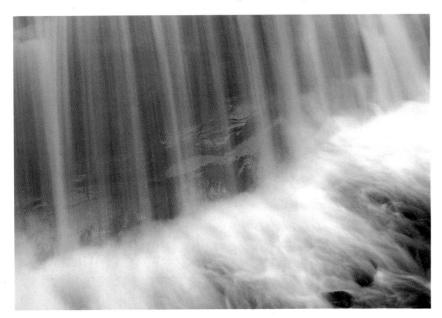

The base of a torrential waterfall pounds against the rocks, forming a solid curtain of cool blue.

FOGGY STREAM

Controlling Color and Value

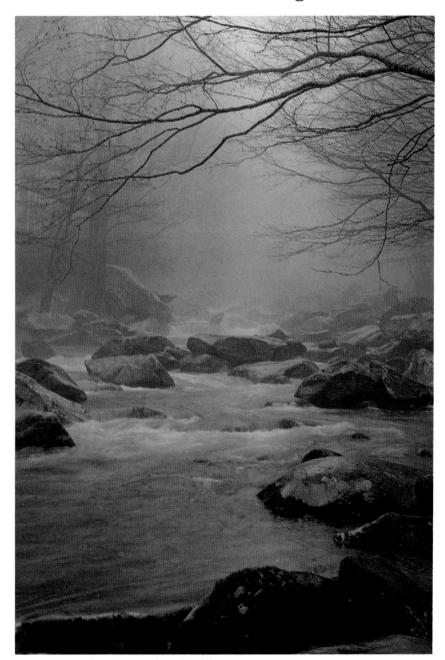

PROBLEM

The fog is so thick and so heavy that it muffles color and value. What's more, it makes even the sharp rocks in the background soft and unfocused.

SOLUTION

To control color and value, build your painting up slowly, using a traditional light-to-dark approach. And don't follow exactly what you see; make the water bluer than it actually is, to add a little life to your work.

STEP ONE

Execute a careful preliminary sketch; then begin to develop the background. Lay in a light wash made up of cerulean blue, alizarin crimson, yellow ocher, and Payne's gray, and make the wash lightest in the center of the paper. While the paper is still slightly wet, lay in a wash of Payne's gray and yellow ocher to indicate the trees in the background. Now let the paper dry.

In early winter, thick gray fog presses down over a rocky stream.

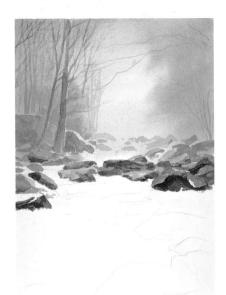

STEP TWO

Working with cool grayed-down hues, build up the background and middle ground. Here the trees are rendered with a very light mixture of Payne's gray, burnt sienna, and ultramarine blue. Using the same colors, paint the rocks; note how those in the background are much lighter than those in the middle ground.

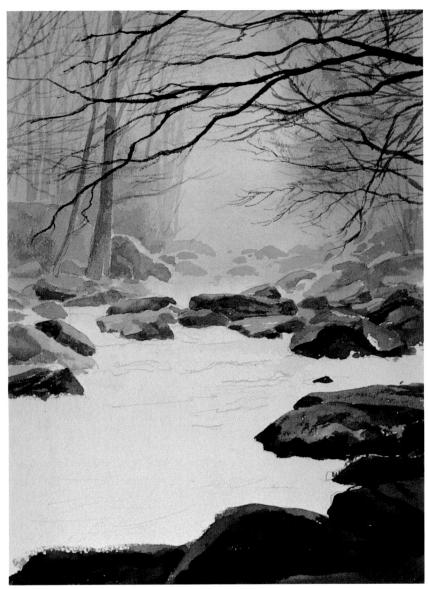

STEP THREE

Before you tackle the water, finish the rest of the rocks and the trees. The rocks that lie in the immediate foreground should be rich with dark hues. Try painting them with sepia, burnt sienna, yellow ocher, and ultramarine blue. Use the same colors to depict the scraggly tree branches that stretch across the stream.

FINISHED PAINTING

Study your painting before you move on. Even though it looks muted and filled with a variety of grays, you know that it is packed with understated color—yellow, red, blue, and brown as well as gray. Treat the water in the same fashion, rendering it with cerulean blue and vellow ocher. The vellow ocher warms the blue and makes it more lively and interesting. First lay in a very pale wash of color; then slowly introduce darker tones. Let the white of the paper stand for the surging water in the middle ground. As a final step, add long, fluid horizontal brushstrokes to the water in the foreground.

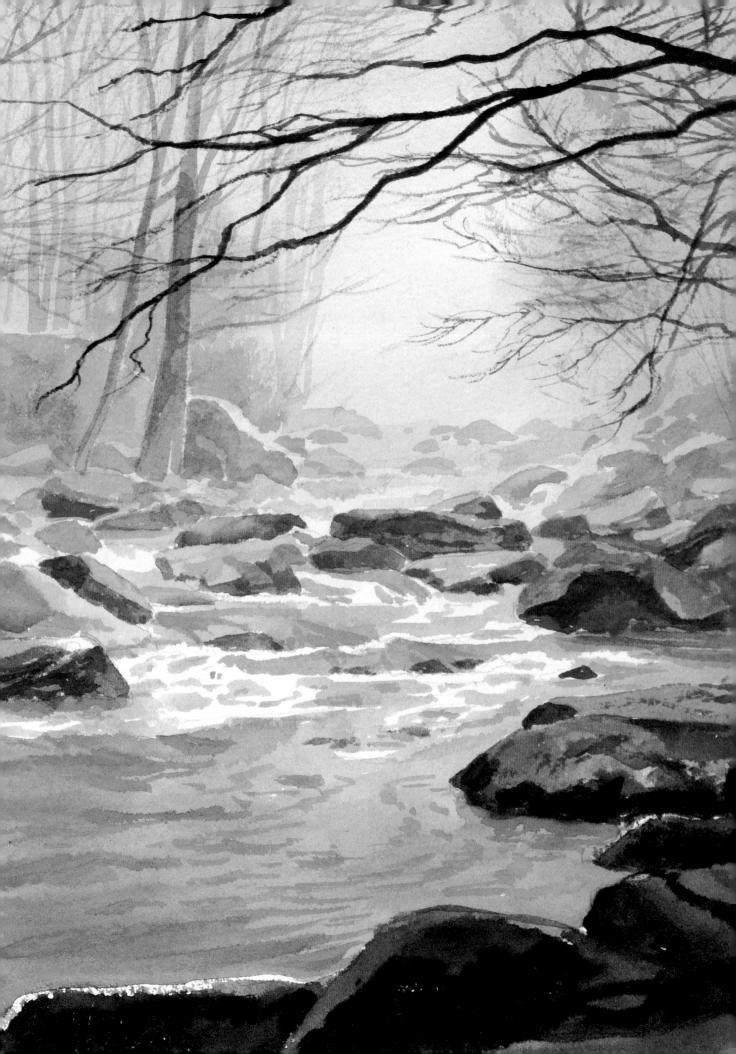

ROCKY SHORELINE

Handling Transparent Water and Reflections Simultaneously

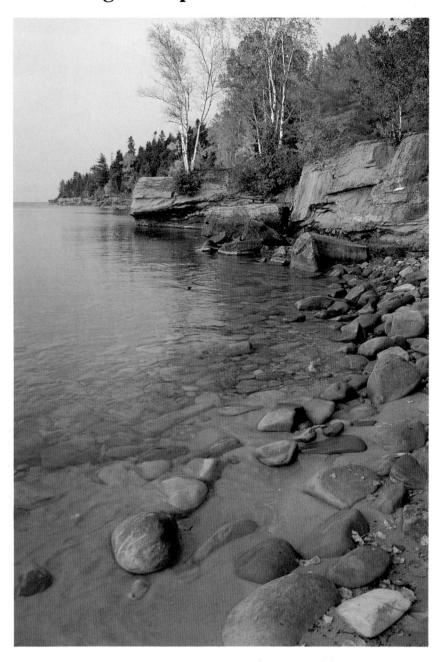

Colorful autumn foliage and craggy brown rocks act as a backdrop for the still waters of Lake Superior.

PROBLEM

In the foreground, the water is transparent; farther back it is deeper and mirrors the trees that line the shore. Both effects are important and have to be captured.

SOLUTION

Paint the sky and the water in one quick step; then build up the rest of the painting around them. Right from the start you can deal with the reflections; gradually add the rocks as your painting progresses.

STEP ONE

Sketch the scene; then lay in the sky and the water, working from top to bottom. For the sky, lay in a light wash of cerulean blue with some alizarin crimson. As you approach the horizon, make the wash lighter. To paint the water darken the wash with ultramarine. While the wash is still wet, drop in touches of burnt sienna to render the shadows cast by the trees and to suggest the rocks that are under the water.

STEP TWO

The rocky cliffs that support the trees merge into the rocks that line the shore. Capture this sweep of color by painting the cliffs and the rocky foreground in one quick step. Mix together a wash of alizarin crimson, cadmium orange, and burnt sienna; then lay it in.

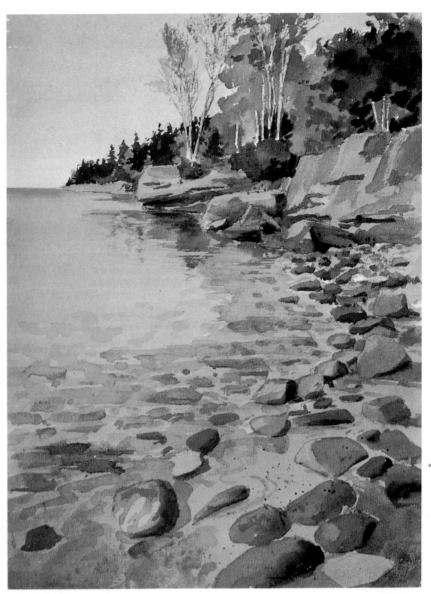

STEP THREE

Add the bright trees in the background with Hooker's green, yellow ocher, burnt sienna, cadmium red, and cadmium orange. Now turn to the cliffs and rocks. First add texture and shadows to the cliffs with a middle-value hue mixed from ultramarine, burnt sienna, Payne's gray, and yellow ocher. The cliffs done, develop the rocks with the same colors. Paint their darkest, shadowy areas first; then go back and wash in the color of each rock. Apply quick dabs of color to the water in the foreground to suggest the rocks farthest from the shore that are covered by water.

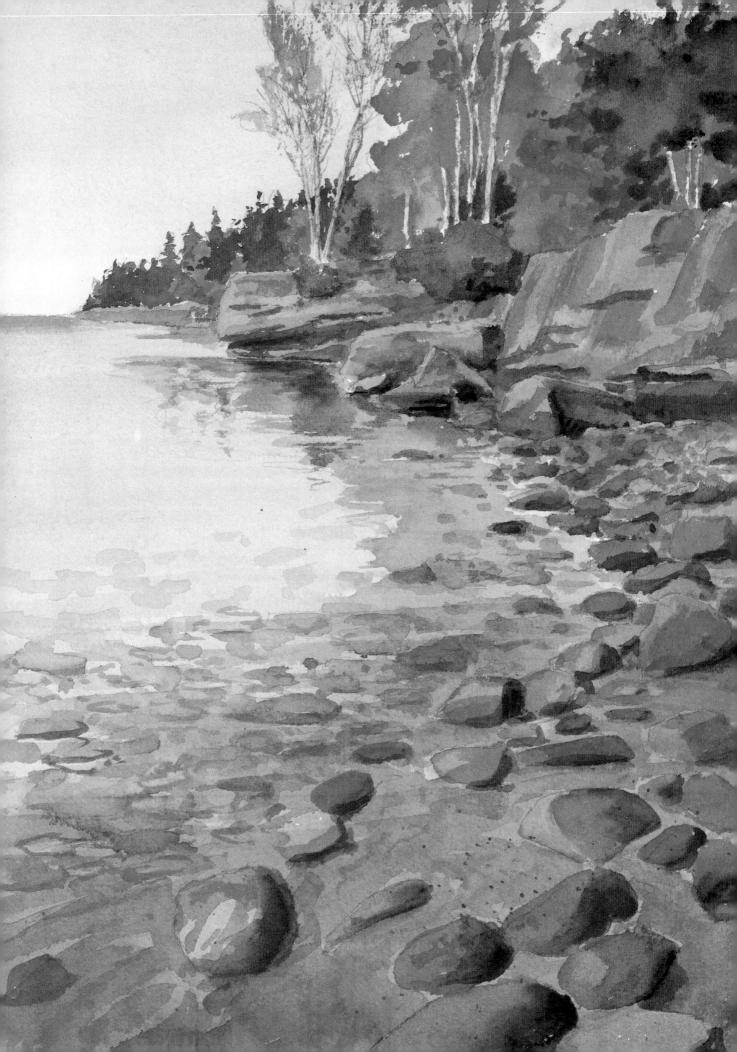

FINISHED PAINTING

Very little remains to be done. Examine the rocks in the foreground and add any details you think necessary; then turn to the rocks that lie a little farther back. If they seem too harsh, try this: Mix a very light wash of ultramarine and quickly run it over the water-covered rocks. You'll soften their contours and make them seem more realistic all in one step.

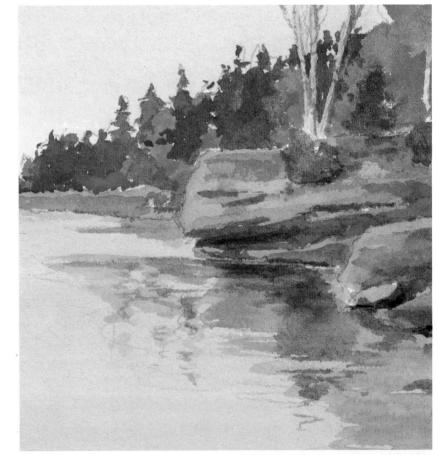

DETAIL

The reflections of the trees and rocks were painted wet-in-wet. Because the paper was slightly damp, the reflections blur and run into one another realistically.

DETAIL

The rocks were developed gradually, built up with successive layers of wash. Only in the final stages of the painting were their shadows and contours etched out. At the very end, a pale wash of ultramarine was pulled over the rocks that lie in the water to soften their edges and to relate the water to the rest of the lake.

TRANSPARENT WATER

Depicting the Abstract Beauty of Water in Motion

PROBLEM

The transparency of water is in itself difficult to paint. Here the situation is made even more difficult because the water is moving rapidly. Finally, the sandy shore that shines through the water is packed with pattern.

SOLUTION

Develop the painting freely, concentrating on abstract pattern. At the very end, add the brights with opaque gouache.

While the paper is still wet, introduce the darker values. Because the paper is damp, no harsh edges will intrude on the pattern you are creating. Next use dark washes of color to suggest the shapes of some of the stones.

Once the paper is dry, flood a wash of cerulean blue and ultramarine diagonally over the center of the composition to show the contour of the incoming water. Finally add the whites, using white gouache mixed with a touch of cerulean blue and yellow ocher. As you dab the paint onto the paper, follow the pattern formed by the highlights that flicker over the water's surface.

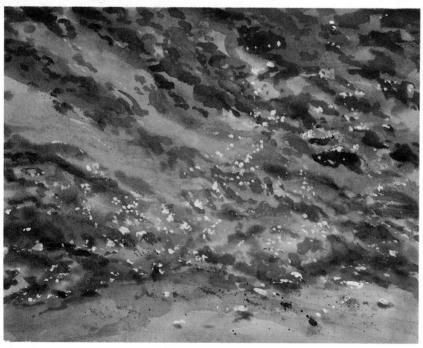

Clear, cold water rushes onto a sandy shore then quickly turns back, retreating toward the ocean.

DETAIL

The initial blue, gray, and brown washes merge together effortlessly because they were applied simultaneously and then allowed to mix together. The slightly darker tones were also laid onto damp paper to soften and blur their edges. A final wash of cerulean blue and ultramarine shows the directional flow of the water, while dashes of opaque white add highlights that break up the darker tones.

ASSIGNMENT

If you are attracted to abstract paintings, but need a point of departure before you can begin work, use water or ice as your starting point. Select a subject that has interesting patterns or shadows—a frost-covered pane of glass, a sheet of ice, or even a mound of snow.

Execute a sketch by concentrating on the entire subject, without focusing on any particular detail. As you draw, don't glance at the paper—try to coordinate your hand and your eye without thinking. Once the basic shapes are down, repeat the process, this time working with thin washes of color. Gradually increase the density of the pigment until you have a fully developed watercolor.

Your first efforts might seem clumsy—but don't be discouraged. With practice you'll find that you can create dynamic abstract paintings that are unified and coherent because you began with something real.

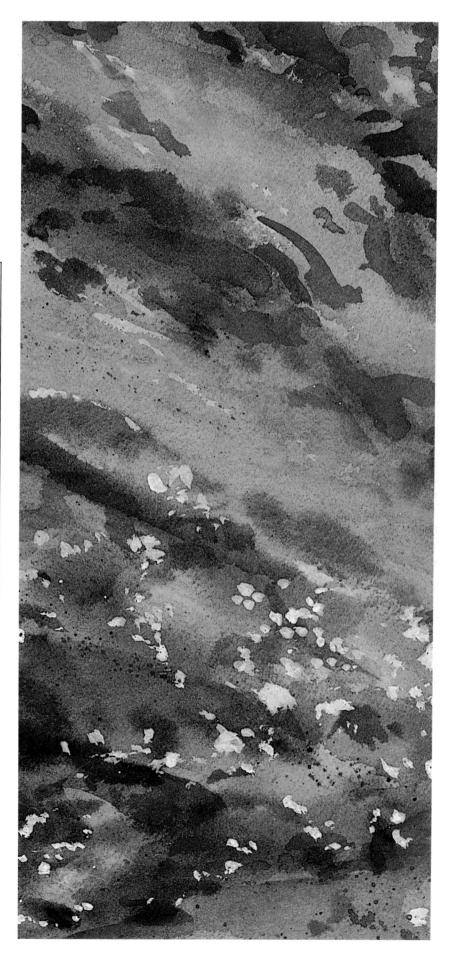

GLITTERING WATER

Pulling Out Highlights with a Razor

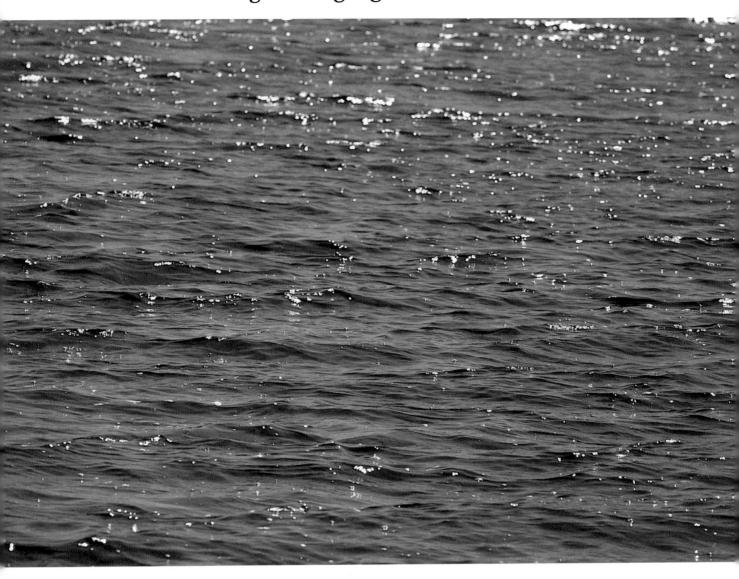

PROBLEM

Capturing the highlights that race across the surface of the lake is the problem here. You can't mask them all out, and painting around them would be almost impossible.

SOLUTION

Pull out the highlights at the end, after you've painted the lake, using a razor. You'll find that a razor is ideal for capturing the jagged, rough feel of the waves.

☐ Whenever you intend to use a razor to pull out highlights, choose heavy, sturdy paper. A 300-pound sheet is thick enough to stand up to the action of a razor or a knife.

Cover the entire surface of the paper with a wash made up of cerulean blue, ultramarine, and Payne's gray. While the wash is still wet, lay in streaks of darker blue to indicate the larger waves that break across the surface of the lake. Because the paper is damp, their edges will be soft.

Let the paper dry; then paint the smaller waves. To achieve a sense of perspective, make them

Dashes of light streak across the deep-blue surface of a lake.

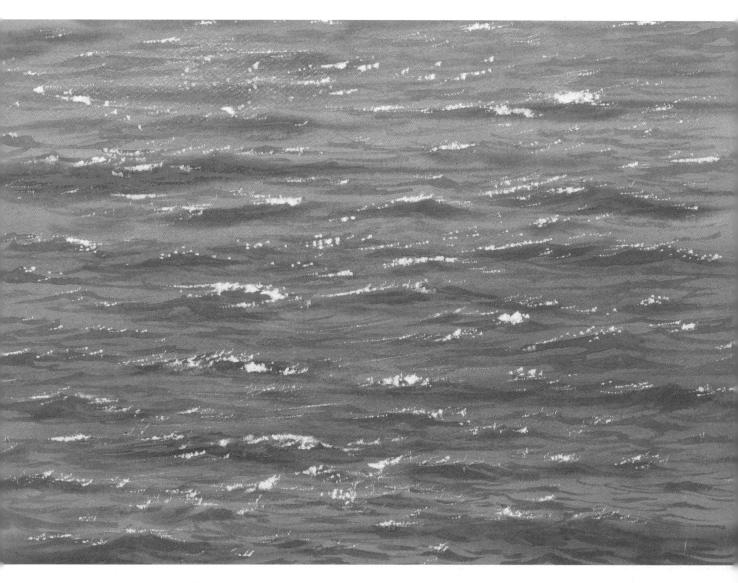

larger near the bottom of the paper and smaller and less distinct as they move back in space.

All that remains now is the scratching out of highlights. Be careful: If the paper is even slightly damp, it will shred and pull apart. While you wait for the paper to dry, note how the highlights flicker on top of the major waves; that's where you'll want them in your painting.

Pull the razor carefully over the paper, never letting it tear through. Concentrate the highlights in the foreground; pull out fewer as you move back toward the top of the paper.

ASSIGNMENT

You'll feel more comfortable working with a razor in the field if you practice the technique at home. Lay in a flat wash on a sheet of 300-pound paper. While the surface is still damp, try scraping the razor across it. As you watch the paper shred and tear, you'll quickly discover the importance of working on an absolutely dry surface.

Now let the paper dry. Experiment by pulling the entire blade across the paper, picking up broad swatches of color. Next, try working with just the corner edge of the razor. Finally, try combining broad strokes with finer ones. Throughout, give your strokes a definite sense of direction.

Separating Sky from Water

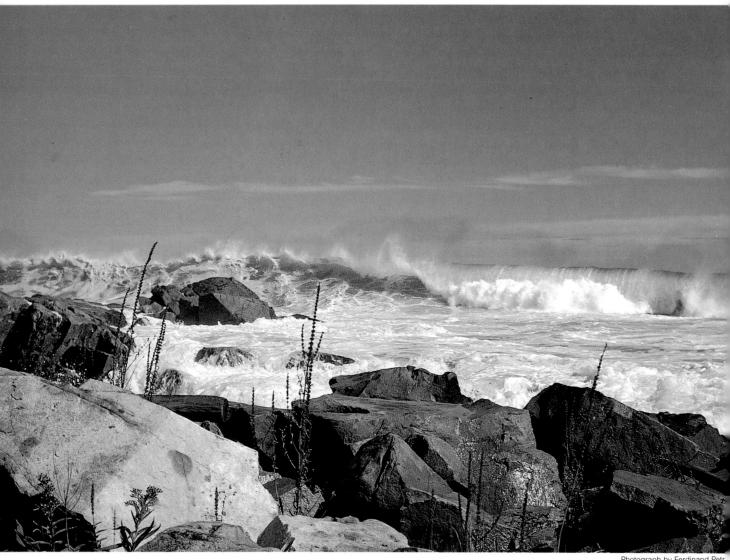

Photograph by Ferdinand F

PROBLEM

When the sky is as bright and blue as this one is, there is always a chance that it will steal attention from the real subject of the painting, the powerful wave that breaks across the central rock.

SOLUTION

Make the most of the cloud that streaks across the sky. Use it to separate the sky from the water.

On a clear spring day, heavy surf pounds against a rocky New England shore.

STEP ONE

Sketch the scene; then lay in the sky. Since you are working with deep blue, turn the paper upside down; if the paint runs, it won't dribble down into the wave. First wet the edge of the wave where it breaks against the sky; this will keep the edge soft and smooth. Then paint the sky with ultramarine, cerulean blue, and alizarin crimson, with paler washes toward the horizon. Be sure to leave some white for the cloud in the lower sky.

Now turn the paper right-side up and start to execute the wave. As you paint, let patches of the white paper break through to indicate the brilliant whites of the pounding surf. Here the bluish portions of the wave are rendered with cerulean blue and alizarin crimson. Once these areas are dry, add the greenish wall of water on the right with Hooker's green light and new gamboge. Finally, add splashes of green and blue to suggest the breaking wave on the left.

STEP THREE

Now lay in the foamy water that washes across the foreground, again working with cerulean blue, ultramarine, alizarin crimson, Hooker's green light, and new gamboge. Use short, horizontal strokes to make the water look flat.

Once the water is done, render the rocks with burnt sienna, alizarin crimson, and cadmium orange. At first lay them in with flat washes of color; once the washes are dry, go back and add the shadowy portions.

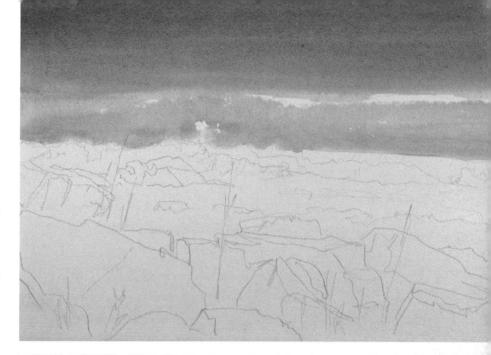

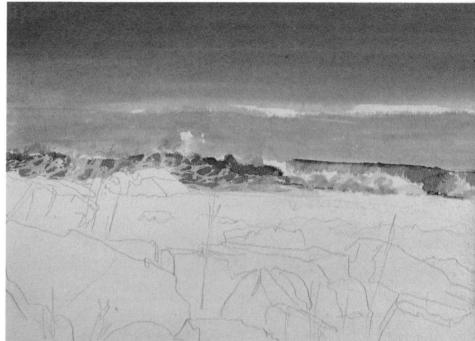

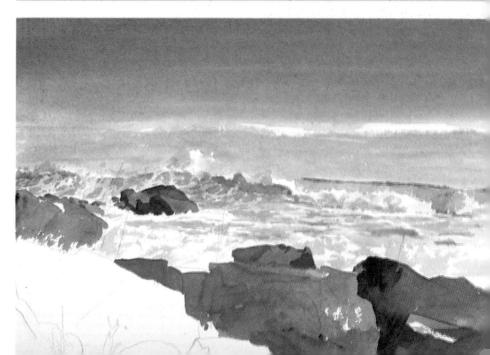

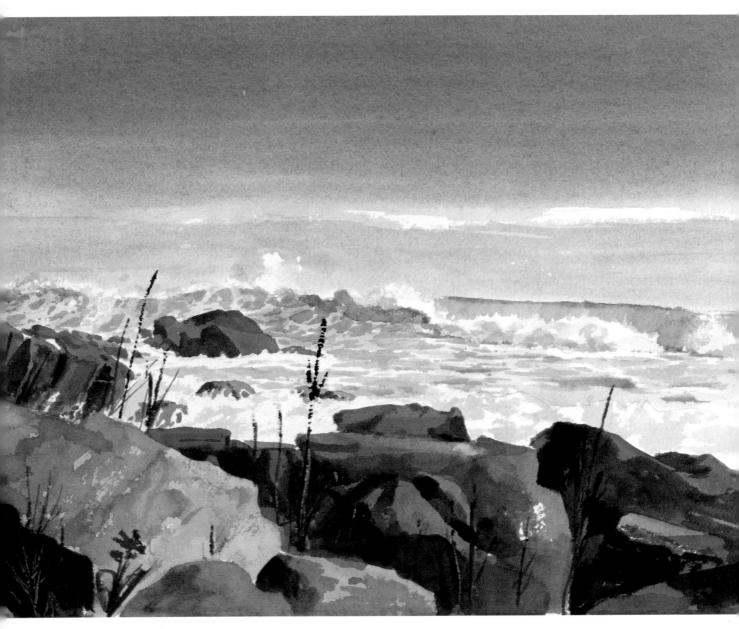

FINISHED PAINTING

When you begin to execute the rocky foreground, use strong, bold color, and pattern the rocks with very dark tones. The stronger and darker these rocks are, the more the water and waves will seem to recede. As a final touch, drybrush in the tall grasses that grow amidst the boulders; and, if necessary, go back to the water and pull out additional white highlights with a razor blade.

ASSIGNMENT

Waves present a special challenge to the landscape artist. They last for but a second, and in that time there is a great deal of visual information that must be rendered if you are to capture the power and drama of pounding surf. The easiest way to become familiar with waves is to sketch them often—and quickly.

Go to the shore on a day when the surf is heavy; bring along a pad of newsprint paper, charcoal, and pencils. Go to work immediately. Keeping your eyes on the water, begin to execute loose, gestural drawings. Use your whole arm to catch the sweeping power of the waves.

Concentrate first on the swells in the distance—they are low and rhythmic undulations. Next, sketch the waves that are closer to shore; note how, as they crest, they rise and begin to topple over. Then sketch the waves as they begin to break. Explore how they turn over and begin to explode in spray. Finally, draw the waves as they crash down onto the water that is lapping toward the shore.

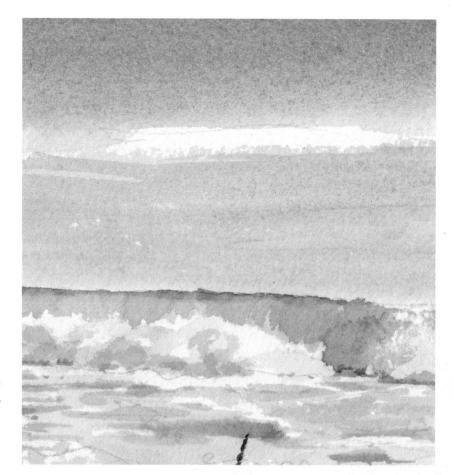

DETAIL

The cloud that streaks across the paper separates the sky from the water below. Without it, the strong blue of the sky would diminish the power of the breaking wave. Green, not blue, makes up the pounding surf. This shift in color further separates the water from the sky. The brilliant white of the paper stands for the tips of the powerful waves.

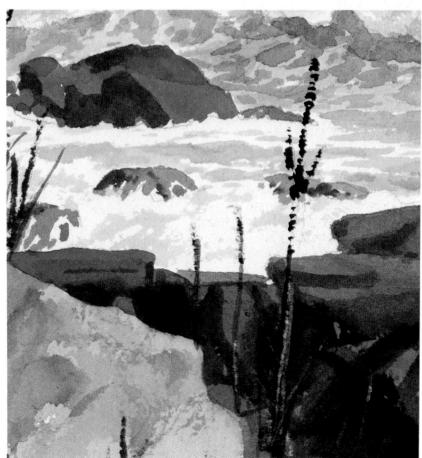

DETAIL

The large rocks in the foreground establish a sense of scale. Because they are painted with strong, dark color, they also make the waves and water recede.

CRASHING WAVES

Emphasizing a Light-Streaked Wave

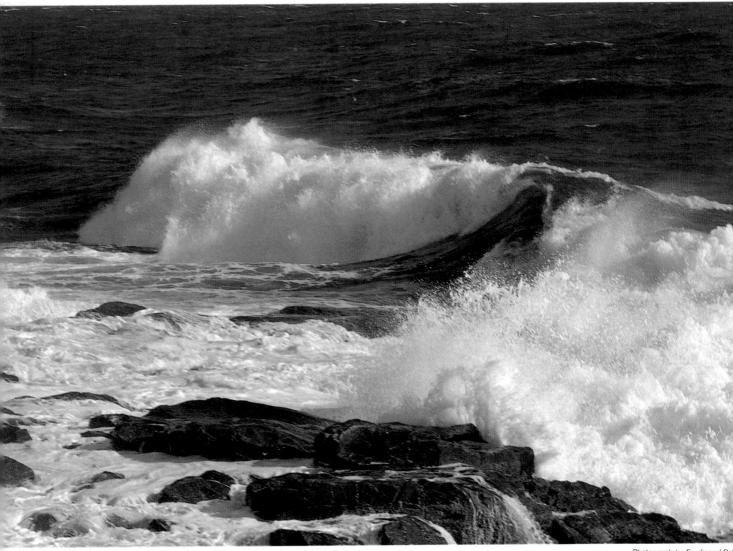

Photograph by Ferdinand Pet

Compared to the dark water and rocks, the wave is very light in value. Unless it is handled carefully, it may not stand out clearly in the finished painting.

SOLUTION

Paint the dark-blue water and the rocks in the foreground first. Once they are down, you'll be able to adjust the value of the wave.

On a cold autumn day, a breaking wave surges against the rocks.

STEP ONE

Sketch the scene; then lay in the sky with a medium-value wash of cerulean blue and ultramarine. Next sweep a very dark wash, made up of the same two blues, over the water. When you reach the wave, use a drybrush technique to render its edge.

STEP TWO

The water done, turn to the rocks. First paint their shadowy portions with sepia, ultramarine, and burnt sienna. As soon as the shadows are dry, lay in the rest of the rocks with a warmer wash. Here it is composed of burnt sienna and yellow ocher.

Before you turn to the wave, paint the sweep of water that rushes up to meet it. Instead of using a straight blue, try working with some green. It will help separate the foreground from the dark-blue backdrop. Use Hooker's green, cerulean blue, ultramarine, and Payne's gray.

STEP THREE

When you begin to work on the wave, use a light hand: The white of the paper is just as important as any color you lay in. Analyze the wave, searching for the shadows that sculpt it out. Paint these areas carefully, using cerulean blue, ultramarine, Hooker's green, yellow ocher, and Payne's gray. With the same hues, lay in the water that eddies around the rocks in the foreground.

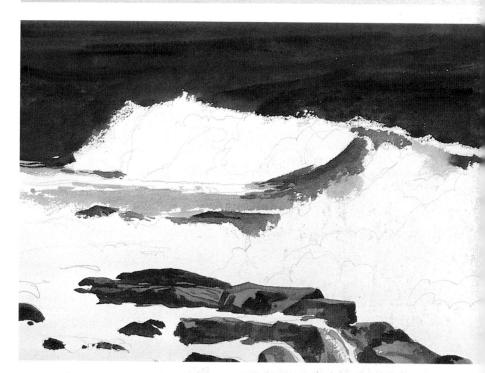

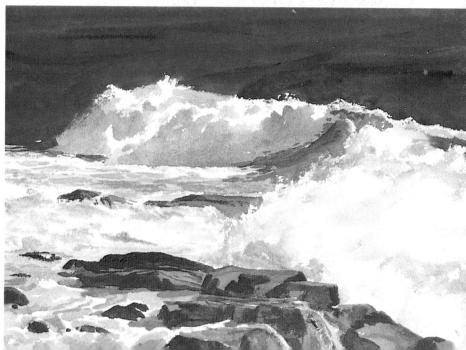

FINISHED PAINTING

At this point, the dark-blue water in the background dominates the composition. Tone it down by adding small waves with opaque ultramarine. When the waves are dry, drybrush in touches of opaque white to suggest how the light glistens over the water. Finally, moisten a small brush with opaque white and add dabs of the paint to the top of the breaking wave.

The dark waves added at the very end break up the heavy expanse of deep blue. Rendered with horizontal strokes, they also flatten out the water and direct attention to the focal point of the painting, the breaking wave.

It's the white of the paper that makes the water sparkle and glisten. The washes of color are applied sparingly to make the most of the watercolor paper.

Painted mostly with Hooker's green, the surging water stands out clearly against the wave and the water in the background. Touches of Hooker's green also run along the edge of the wave, again separating it from the large expanse of dark blue.

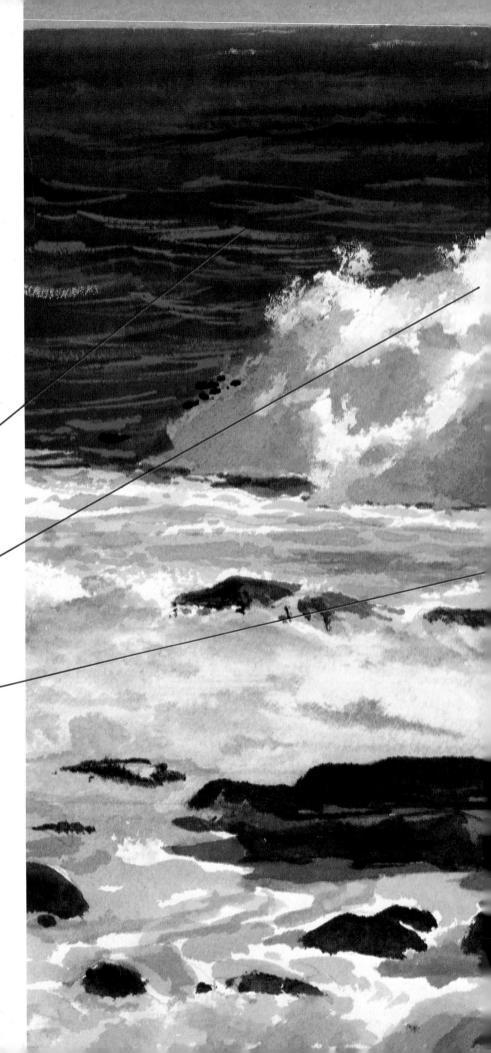

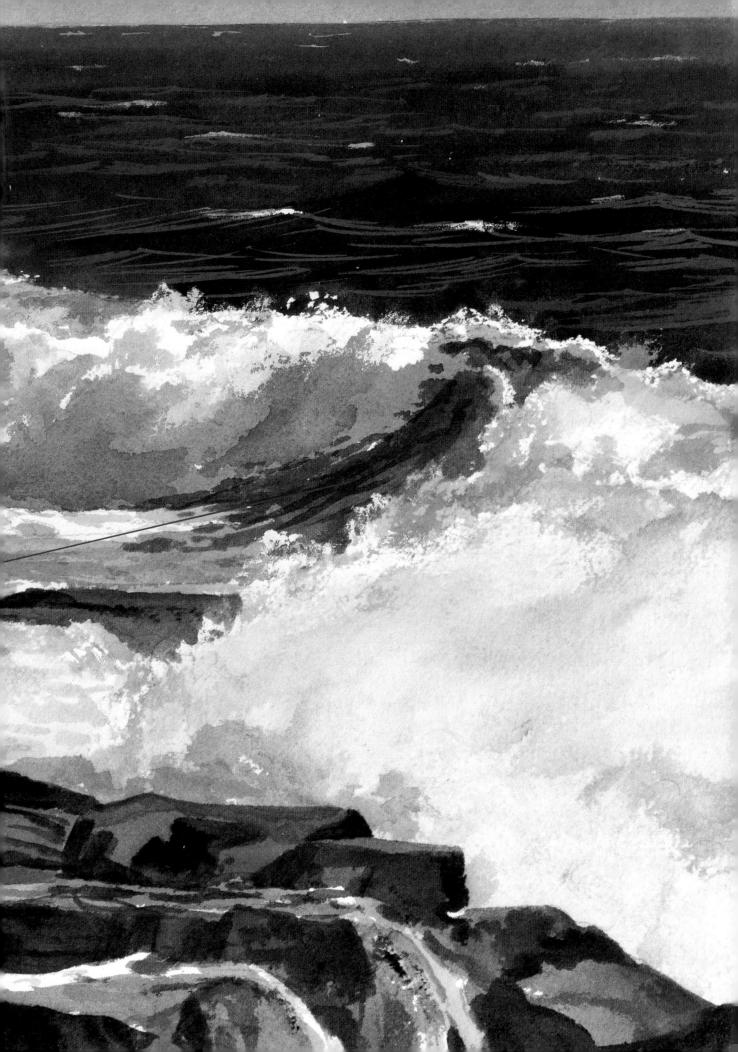

OCEAN SPRAYS

Capturing Soft, Glistening Spray

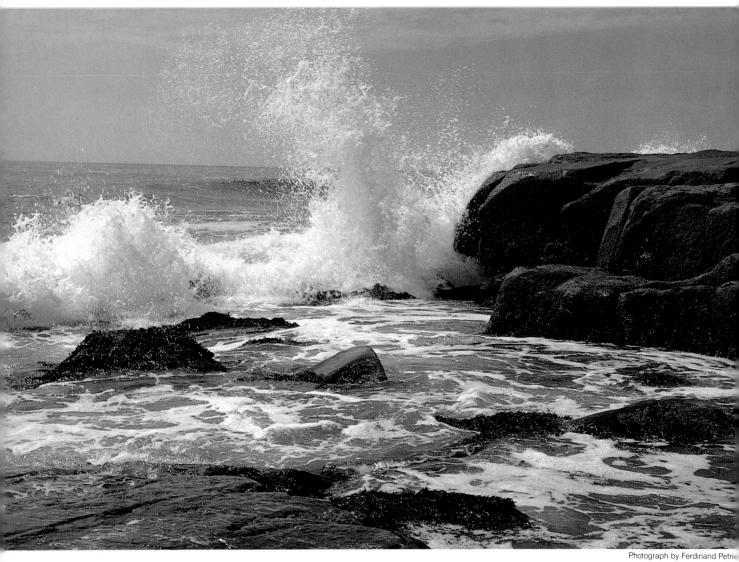

PROBLEM

This scene is dramatic, but it's gentle, too. The spray that shoots into the air and the glistening water that spills over the foreground are soft and filled with light.

SOLUTION

To keep the wave soft and fluid, use a wet-in-wet approach. Let the white of the paper stand for the most brilliant bits of spray and water.

☐ After you have sketched the scene, turn the paper upside down. Wet the sky and the wave's spray with clear water; then lay in a very light wash of alizarin crimson. Don't let the crimson bleed into the spray. While the paper is still wet, drop in cerulean blue and ultramarine, again avoiding the white spray. Now let the paper dry.

Turn the paper right-side up and begin work on the water that lies behind the wave. Here it is rendered with cerulean blue,

Glistening spray shoots into the air as a massive wave hurls itself against a rock.

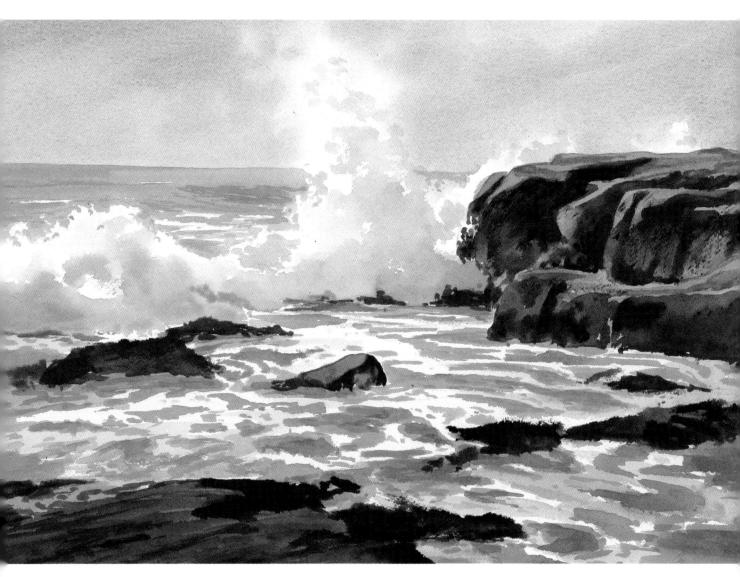

ultramarine, and Payne's gray. Where the contours of the spray meet the water, leave a hard edge to pull the two areas apart.

Before you turn to the wave and the water in the foreground, execute the dark rocks with burnt sienna, sepia, and Payne's gray. When they are dry, wash the top of each rock with cerulean blue to suggest how they reflect the sky.

The stage is now set for the wave. Prepare a wash made up of ultramarine, cerulean blue, and alizarin crimson; then gently

stroke the wash onto the paper. Work slowly—don't cover up all of the white paper. You want a band of white to surround the wash you are laying in. To keep the wave from becoming too flat, vary its color slightly. Here the low-lying portion on the left is rendered with more alizarin crimson than the portion on the right.

Finally lay in the water in the foreground, working around the white foam. Ultramarine, cerulean blue, alizarin crimson, and Hooker's green all come into

play here. For the dark pool of water on the left side of the immediate foreground, use strong brushstrokes with a definite sense of direction, and add some brown to your palette to suggest the underlying rock.

In the finished painting, the wave stands surrounded by a soft halo of white. The white pulls it away from the sea and sky and suggests its soft, yet dramatic, feel.

GENTLE WAVES

Deciphering the Subtle Colors Found in Waves

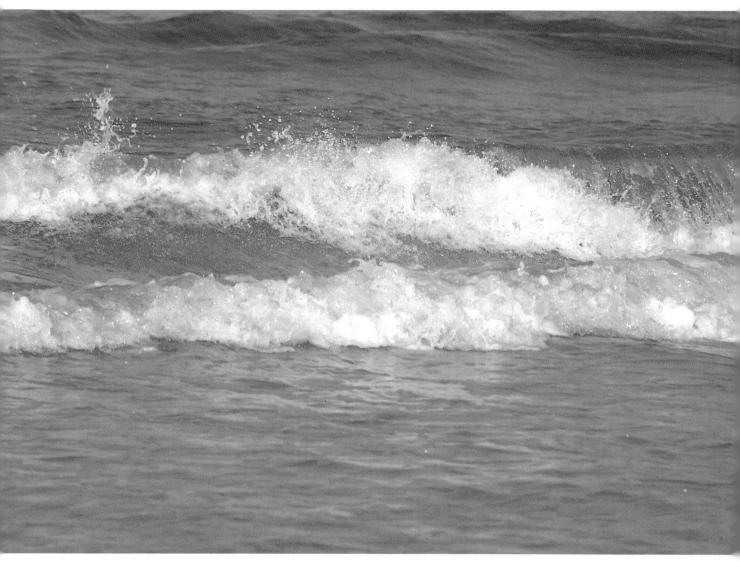

PROBLEM

Set against a blue background, waves can seem almost pure white, yet they are actually packed with color and filled with lights and darks. You have to be sensitive to these nuances in color and value to create a believable painting.

SOLUTION

Paint the water first; then turn to the waves. The blue of the water will give you something to react to as you build up the colors and values of the waves. ☐ Imagine that the scene is divided into three bands: the water behind the waves, the waves, and the water in front of the waves. Deal with each band separately.

Start with the water in the background. Working around the breaking waves, lay this water with ultramarine and cerulean blue, plus just a touch of burnt sienna. Now turn to the water in the foreground, painting it with cerulean blue, ultramarine, and new gamboge. To break up what could become a dull expanse of blue, make the water lightest in the center.

Gentle waves foam and bubble as they sweep toward a sandy shore.

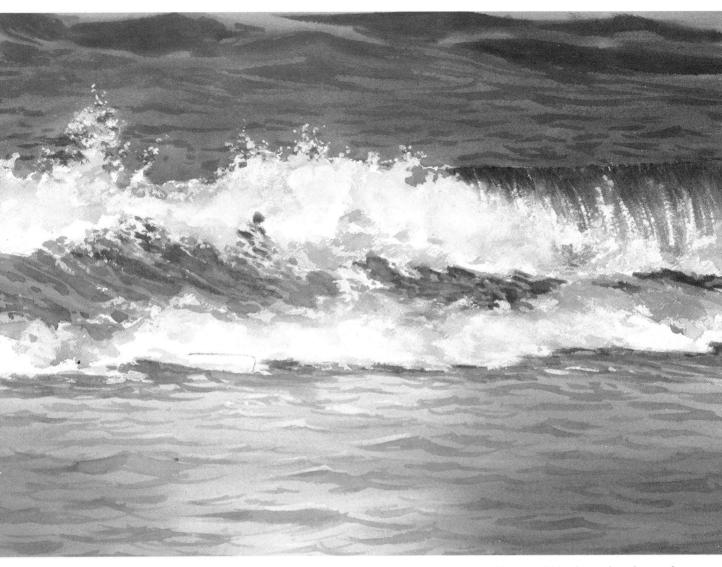

Before you turn to the central waves, go back and add long, undulating waves to the water in the background, using a slightly darker value than the one you originally put down. Then break up the water in the foreground by using shorter, choppier strokes.

Now it's time to paint the central waves. Starting with the darkest value, lay in the swell of the wave at the far right and the dark water that lies between the two waves. Try rendering them with a greenish hue, here made up of cerulean blue, ultramarine, and new gamboge. As you work,

give your brushstrokes a strong sense of direction; they have to capture the power of the moving water. The darkest value down, add the light spray that animates the waves. Use a very light wash of cerulean blue, alizarin crimson, and vellow ocher.

Stop and analyze your painting. At this stage, the chances are that it lacks punch. What it probably needs are stronger, more brilliant whites than the paper can provide. To make your painting sparkle, try two approaches. First, mix white gouache with a touch of new gamboge—straight

white would look too harsh—and dab it onto the paper to suggest the topmost portions of the spray. Next, use a drybrush approach to add the gouache to the turning wave at the right. As a final touch, let the gouache dry; then take a razor and scratch out bits of white to break up whatever areas still seem dark and heavy.

WHITE ON WHITE

Painting a White Bird Set Against Light Water and Waves

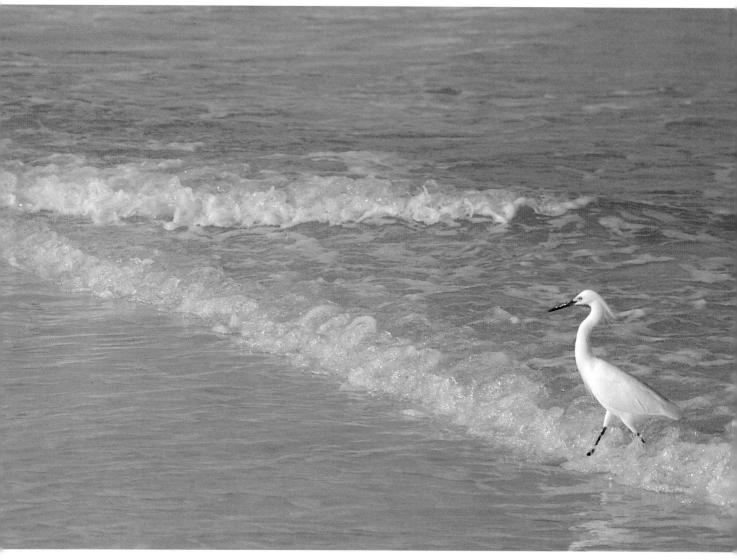

PROBLEM

Everything in this scene is light—the water, the waves, and even the bird. The egret is clearly the most important element in the composition, but it will be difficult to make it stand out against the water and waves.

SOLUTION

Mask the egret out before you start to paint. Develop the rest of the painting and then peel the masking solution off. To make the bird stand out clearly against the blue of the water, surround it with a thin band of black.

☐ Draw the egret and lightly lay in the lines formed by the waves; then mask the bird out with liquid frisket. Now cover the entire sheet of paper with a light tone of Payne's gray, cerulean blue, and yellow ocher.

When the paper is dry, begin to develop the water in the back-ground. Using a light wash made up of cerulean blue and Payne's gray, lay in the long horizontal

An egret strides easily through a softly swelling tide.

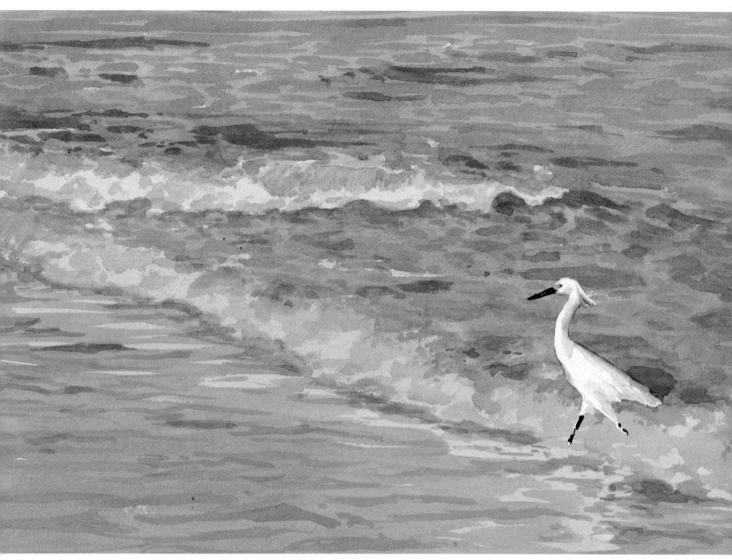

strokes that suggest the lapping water. Don't cover up all of the underpainting; let streaks of it shine through the darker wash. As you approach the two large waves, add yellow ocher and new gamboge to your wash, to produce a slightly greenish tone.

Use soft, gentle strokes to render the waves; continue using the greenish wash as you paint the two breakers and the water that lies between them. When you turn to the water in fore-ground, once again work with cerulean blue and Payne's gray. Let the paper dry.

To pull together the different sections of the painting, mix a wash of pale cerulean blue; then apply it to everything except the two breaking waves. Now peel off the masking solution and paint the shadows that define the egret's

head and body with Payne's gray and yellow ocher. A dab of cadmium orange represents the base of the bill; a deep mixture of ultramarine and sepia is perfect for the legs and the rest of the bill. To make the egret stand out against the blue backdrop, dilute the mixture of ultramarine and sepia, and run a fine line of the dark tone around the important contours.

SANDY RIPPLES

Relying on Values to Capture an Abstract Pattern

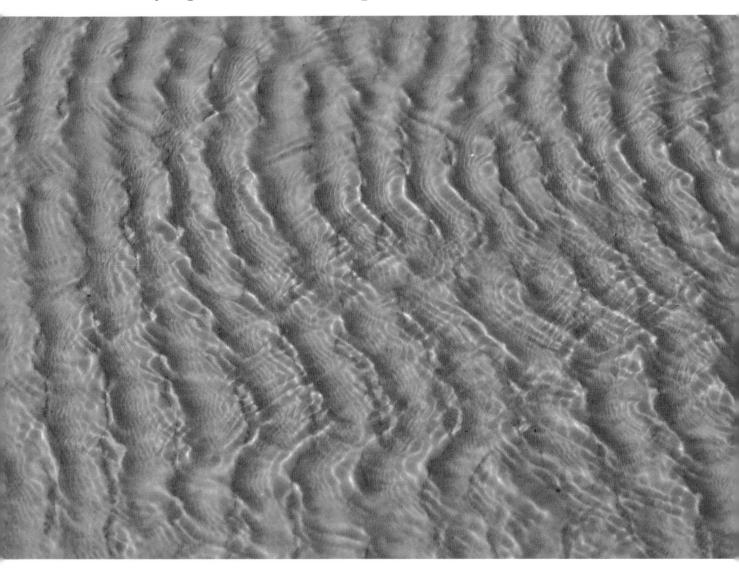

PROBLEM

This is an extremely difficult subject. Three elements must be captured: the sandy ridges, the clear water that ripples over the sand, and the highlights created as sunlight strikes the water.

SOLUTION

Approach the scene as though it were a value study. Search for three definite values—lights, darks, and a middle tone—and build up your painting by working from light to dark.

Get the lights down right away by toning the entire paper with a pale wash of yellow ocher. Let the paper dry. Now lay in the darkest value—the tips of the sandy ridges. Keep them as simple as possible; what you are aiming at is their general effect, not each and every ridge. To paint them, use sepia, burnt sienna, Payne's gray, and yellow ocher. While the darks are still damp, gently work in the middle tones, using a lighter value of the same hues.

Once the darks and the middle values are down, you'll probably find that the lights aren't bold enough. If that's the case, add

As water ripples over a shore, undulating patterns form in the sand below.

additional flickers of light by using opaque gouache; here white is mixed with yellow ocher, and the pigment is laid down with a small brush and undulating strokes.

At this point you've carefully built up your painting with three distinct values. All that remains to be done is to suggest how the water moves over the sand. Let the surface dry; then moisten a piece of paper toweling. Working diagonally, from the upper-right corner to the lower-left corner, carefully wipe out streaks of paint. The pale passages that result will suggest the motion of the water.

ASSIGNMENT

Water has fascinated men for centuries, and little wonder. It is constantly moving, creating endless abstract patterns. In this lesson you've explored how flowing water sculpts sand. Don't stop here.

After it rains or when the snow is melting, go outside and search for rivulets of water. On a sketch pad, quickly capture the patterns the water forms. If you live near a beach, look for little indentations in the sand; study how water flows into these pools and then slowly moves back toward the water.

Studying the ebb and flow of water can turn into a lifetime preoccupation—and one that can offer you a lifetime's worth of subject matter for your watercolors.

Index

41		
Abstract subjects, 376–77, 394–95	complex patterns, 202–3	snow/sky, 228–30, 248–50
Acorns, 58–59	cumulus, 198–201	strong/subtle, 260–61
apple tree, 132–37	flat, 206–7	textures/colors, 122–23
apples, 136–37	dark, 240–43	Cypress tree
blossoms, 132–35	at dawn, 222–25, 232–35	roots, 80–81
Ash tree, 108–11	dense masses, 194–97	trunks, 78–79
Aspen tree, 66–73, 86–89	dramatic	
leaves, 70–73, 354	in gray sky, 184–85	Dawn
Autumn foliage	simplifying, 172–73	clouds at, 222–25, 232–35
in forest depths, 52–55	strong color, 152–55	colors of, 158–59
hillside, 48–51	with gouache, 14, 198–201	dew at, 70–71
leaves, 40–41, 46–47, 74–75, 351	lifting out technique, 32	mountain, 251
reflections in water, 356–57,	light rays through, 174-77, 214-16,	silhouette against, 178–81, 252–53
360–63, 372, 375	232-35	over water, 160–63, 292, 293,
Autumn sky	painting around, 222–25	294-97
cloud formations in, 152-55, 236-37	perspective and, 206–7	in winter, 246–47
at dawn, 222–25	rain, 165–67	Deciduous forest. See Forest,
at sunset, 260–61	reflected in water, 332-35	deciduous
	shadow portion of, 152, 200, 204-5,	Depth, feeling of, 52–55
Backlighting, 36–38, 102	207, 274, 275	Dew, 70–71
Bark	soft, 204–5	Distance
birch, 61	staining with clear water technique,	establishing, 86–89, 184
walnut, 122	254–55	masses of color in, 48–51
white cedar, 144	storm, 158, 174-77, 186-88,	mountains in, 236–37
Beech tree, 52–55	194–97, 134	receding space, 206–7
Birch tree, 60–61	stratus, 182–83	Dogwood tree, 127–31
bark, 61	at sunset, 208–9, 217	flowers, 126, 130–31
Birds, wading, 293, 392–93	at twilight, 210–13	Drawing boards/tables, 15
Black oak tree, 118–21	wet-in-wet technique, 171, 182–83	Drawings, preliminary, 15
Blues, 19, 167	wiping out technique, 32, 168	Drybrush technique, 28, 106
sky	Cold-pressed paper, 13	Distribute teerinque, 20, 100
dark, 62–65, 112–15, 268–71	Color(s)	Earth tones, 19
graded wash, 109, 170, 172–73,	characteristics of, 16–17	Elm tree, 112–17, 138–41
179, 189, 196, 251	of clouds, 184	Eraser, 15
monochromatic, 164	of dawn, 158–59	highlights with, 30, 176, 303
warm/cool, 165–67	depth and, 52–55	ingingines with, 50, 170, 505
water, 282–85, 288	distant masses, 48–51	Ferns, 142-45
Branches	fog and, 56–57, 60	Flowers, 102, 121
snow-covered, 90–93, 316–19	mixing, 20, 77, 167	apple blossoms, 132–35
against winter sky, 138–39	monochromatic, 76–77, 124–25, 164	dogwood blossoms, 126, 130–31
Brush(es)	muting, 57	floating, 304–7
caring for, 13	palette, 19	goldenrod, 66–69
holding, 22	organizing, 20	white, 130–31
for rendering delicate lines, 109	of rainbow, 189	
types of, 12–13	of sky. <i>See</i> Blues, sky	wildflowers, 82, 270, 273, 274
types 01, 12–13	strong, 40–41, 112–15, 119, 121	Fog
Castus saguero 100 102		color/form and, 56–57, 60, 322–25
Cactus, saguaro, 100–103	temperature, 17	in forest, 56–57
City lights, reflected in water, 300–303 Clouds	of waves, 390–91	on lake, 294–97, 322–25
	wheel, 16	on mountainside, 83–85
altocumulus, 170–71	Complementary colors, 16, 17	in stand of birches, 60
billowy, 191–93	Contracts	on stream, 369–71
cirrus, 168	Contrasts	values and, 83–85
colors of, 184	lights/darks, 43–44, 126–29, 252–53	in winter sunrise, 246–47

Foliage	Hillside	reflected, 160–63, 219–21
against dark sky, 112–13	in autumn, 48–51	See also Highlights
dense, 76–77	in spring, 86–89	Light-to-dark approach, 214–16, 228,
seasonal, 110	Horizon line, 158	231
spring, 140–41	Hot-pressed paper, 13	
See also Autumn foliage	Hue, 16	Macro patterns, 99–100
sky through, 118–21	,	Maple tree, 36–47
See also Grasses; Leaves; Needles	Ice	autumn, 40–41, 46–47
Forest, deciduous	clinging, 330–31	leaf and stem, 43–44
dense foliage in, 76–77	coating, 290–91	Masking tape, 15
depths of, 52–55	crystals, 314–15	resist, 30
in fog, 56–57	mottled, 313	Masking technique, 30
hillside, 48–51	patterned, 312	Materials and equipment, 12–15, 303
snow-covered, 316–19	on stream edge, 344–47	Monochromatic colors, 76–77, 124–25,
Frisket, liquid, 30	Intensity, 17	164
Fronds, 72–73		Mood, and underpainting, 322–25
Frost-tipped grasses, 320–21	Lakes	Moon
	at dawn, 292, 293	crescent, 254–55
Geometric patterns, 94–95	fog over, 294–97, 322–25	full, 256–57
Goldenrod, 66–69	glittering, 378–79	at sunset, 219–21
Gouache	mountain, 282–85	Moonlight, 254–57
clouds, 14, 198-201, 332, 334	reflections on	Mountains
creating whites with, 33, 58	autumn colors, 356–57, 360–63,	and autumn sky, 236–37
flowers/grass, 68, 82, 273, 274	372, 375	at dawn, 251
frost, 320–21	bold/brilliant, 360–63	and desert sky, 202–3
ice, 290	mirrorlike, 332–35	distant, 266–67
leaves, 54	at sunset, 244–45	fog over, 83–85
pine needles, 93, 94	rocky shoreline, 372–75	lake, 282–85
raindrops, 310	sunset over, 244-45, 298-99	at sunset, 214–16
sky, 221	Larch tree, 96–99	storm in, 238–39
uses of, 14	needles, 99	
water jets, 364–67	Leaves	Needles
Grasses	aspen, 70–73, 354	larch, 99
field of, 187, 274, 275	autumn, 40–41, 46–47, 74–75, 351	pine, 93, 94–95, 149–51
frost-tipped, 320–21	contrast with bark, 122–23	Neon reflections, in water, 300–303
golden, 237	delicate/lacy, 40–41, 104–7, 140	
ice-coated, 312, 330–31	dew on, 70	Oak tree, 58–59, 62–65
moving, 155	floating, 308–9	acorns, 58–59
pond, 213	growing from trunk, 78–79	black oak, 118–21
prairie, 118–21	in ice, 313	Ocean
in snow, 226, 254, 256	maple, 40–44, 46–47	pounding waves, 380–83
tall, 173, 180	raindrops on, 72–73, 354	spray, 338–89
Grays, 19	reflected in water, 74–75	Overcast sky
Greens, 19	walnut, 122–23	water reflections and, 97, 326–29
mixing, 77	See also Foliage	winter, 90–92
monochromatic, 76–77	Lifting out technique, 32	
strong, 114–15, 119, 121	Light	Paints, selecting, 14
	afternoon, 66–69, 240–43	Palette, 14–15
Highlights	late, 191–92	colors on, 19
created by dew, 70–71	rain-filled, 266–67	organizing, 20
with eraser, 30, 176	backlighting, 36–38, 102	Paper
pattern formed by, 101–2	moonlight, 254–57	blocks, 14
with razor, 33, 378–79	rays of, 174–77, 214–16	right/wrong side, 13

size, 14	sparkling, 344–47	Storms
soaking, 26	at sunrise, 162	approaching, 268–72
storing, 13, 15	at sunset, 244–45	clouds, 158, 174-77, 186-88, 194-97
stretching, 14	unfocused, 358-59	rain, 266–67
textures, 13	Resist, 30	at sunset, 238–39
weight, 13–14	Ripples, in water, 54, 244, 293, 338,	Streams
Paper towel/tissue, 15, 303	394–95	foggy, 369–71
Patterns	Rivers	lily-covered, 304–7
abstract, 238-39, 394-95	contours of, 286–89	reflections on, 344–47, 358–59
in bark, 61	fallen logs/vegetation in, 336–39	rushing, 348–49
closeup, 149–51	reflections in, 96–98	in snow-covered woods, 326–29
in clouds, 168–71	of city lights, 300–303	white water in, 340–343
complex, 202-3, 308-9	waterfall on, 278–81	Subjects
geometric, 94–95	See also Streams	abstract, 376–77, 394–95
in ice, 312	Roots, cypress, 80–81	finding, 58
macro, 99, 100	Rough paper, 13	sharply focused, 28
picking out with white, 93		still life, 70–71
simplifying, 314–15	Saguaro cactus, 100–103	See also Patterns
soft/diffuse, 368	Salt, mottled effect with, 303	Summer sky
and texture, 142–45	Sandy ripples, 394–95	afternoon light in, 240–43
in values and highlights, 101–2	Scratching out technique, 33, 378–79	approaching storm in, 268–72
Pencil, 15	Secondary colors, 16	bright, 273–75
Photography, painting from, 180	Seedling, spruce, 82	fog in, 294–97
Pine trees, 86–95, 269	Silhouette(d)	Sun halo, in winter sky, 226–27
needles, 93, 94–95, 149–51	foreground, 258–59, 260–61	Sunrise. See Dawn
red pine, 146–48	against morning sky, 178–81, 252–53	Sunset
Ponds	at twilight, 140	in autumn sky, 260–61
at dawn, 160–63	Sky(ies), 157–275	clouds at, 208–9, 217
floating vegetation on, 308–9	desert mountain, 202–3	color-streaked sky after, 264–65
at twilight, 210–13	through foliage, 118–21	over lake, 244–45, 298–99
water jet in, 364–67	gray, 184–85	moon at, 219–21
Prairie	orange, 258–59	prairie, 262–63
grasses, 118–21	overcast, 90–91, 97, 326–29	storm at, 238–39
sunset, 262–63	rainbow in, 189–90	See also Twilight
Primary colors, 16	seasonal. See Autumn sky; Summer	Surf. See Waves
Tilliary colors, 10	sky; Winter sky	Swamp, 78–79, 80–81
Rain	separating from water, 292, 380–83	Swarip, 76–79, 60–61
cloud, 165–67	See also Blues, sky; Clouds; Dawn;	Techniques, 22–33
storm, 266–67	Light; Sunset; Twilight	Tertiary colors, 16
Rainbow, 189–90	Snow	Texture
Raindrops		
closeup, 310–11, 352–54	contrast between sky and, 228–30, 248–50	of bark, 122, 142–44 building up, 41
on leaves, 72–73, 354	-covered trees, 90–93, 316–19	creating with line, 61
sparkling, 355		_
-	grass clumps in, 226, 254, 256	and pattern, 142–45
on spider's web, 94, 310–11	in moonlight, 254, 256 Spattering technique, 32, 78, 80, 81,	of whites, 130–31
transparent, 354		Three-dimensional effect, 58
Razor blades, 15	116 Spidow's web proindrops on 04 05	Toothbrush, spattering with, 15, 32
highlights with, 33, 378–79	Spider's web, raindrops on, 94–95,	Trees, 35–155
Red pine tree, 146–48	310–11	apple, 132–37
Reds, 19	Sponges, 15	ash, 108–11
Reflected light, 160–63, 219–220	Sprays, water, 388–89	aspen, 66–73, 86–89, 354
Reflections in water, 96–98	Spruce tree, 82–85, 152–55	beech, 52–55
autumn foliage, 356–57, 360–63,	Squeezing out technique, 31	black oak, 118–21
372, 375	Still life subjects, 70	conifers, 48–51, 126–29
city lights, 300–303	Stippling technique, 31, 140, 141	cypress, 78–81
leaves, 74–75	Storage	dogwood, 127–31
mirrorlike, 332–35	of finished paintings, 15	elm, 112–17, 138–41
on overcast day, 326–29	of materials and supplies, 15	larch, 96–99

maple, 36-47 oak, 58-59, 62-65, 118-21 pine, 86–95, 146–51, 269 spruce, 82-85, 152-55 walnut, 122-25 white cedar, 142-45 willow, 104-7 See also Branches; Foliage; Forest, deciduous: Leaves: Trunks Trunks growth at base, 78-79 texture of, 142-44 **Twilight** clouds at, 210-13 filtered, 214–16 silhouette at, 140-41 See also Sunset

Underpainting afternoon light and, 240–43 mood and, 322–325

Value(s), 7 abstract pattern and, 394–95 closely related, 62–65, 83, 114, 286–89 controlling, 369–70 middle, 102 Violets, 19

Walnut tree, 122-25 black walnuts, 124-25 leaves and bark, 122-23 Washes flat, 22 graded, 24, 63, 83, 109, 170, 172-73, 179, 189, 195 mottled, 80, 303 Water, 277-395 blues, 282-85, 288 ripples in, 54, 244, 293, 338, 394–95 separating from sky, 292, 380-83 translucent, 364-65 transparent, 355, 372-73 in motion, 376-77 See also Frost; Ice; Lakes; Ponds; Rain; Raindrops; Reflections in water; Rivers; Snow: Streams: Waterfalls; Waves Water containers, 15 Waterfalls jet, 364-67 surging power, 278–81 wall, 368

Waves crashing, 384–87 gentle, 390–91 pounding, 380–83 sprays, 388–89

white bird against, 392-93 Wet-in-wet technique, 70, 83 for cloud masses, 171, 182-83 technique, 26-27 for water, 98, 293, 295, 296 White cedar tree, 142-45 Whites with gouache, 33, 58 masking out, 30 lifting out, 32 picking out patterns with, 93 scratching out, 33, 378–79 squeezing out, 31 texture of, 130-31 wiping out, 32, 168 White water, 340-43 Wildflowers, 270, 273, 274 Willow tree, 104–7 Winter sky contrast between snow and, 228-30, 248 - 50at dawn, 246-47 flat, 231 overcast, 90-92 sun halo in, 226-27 tree against, 62-65, 138-39 Wiping out technique, 32, 168

Yellows, 19, 259